ISLAND DREAMING
AMANDA LINDROTH DESIGN

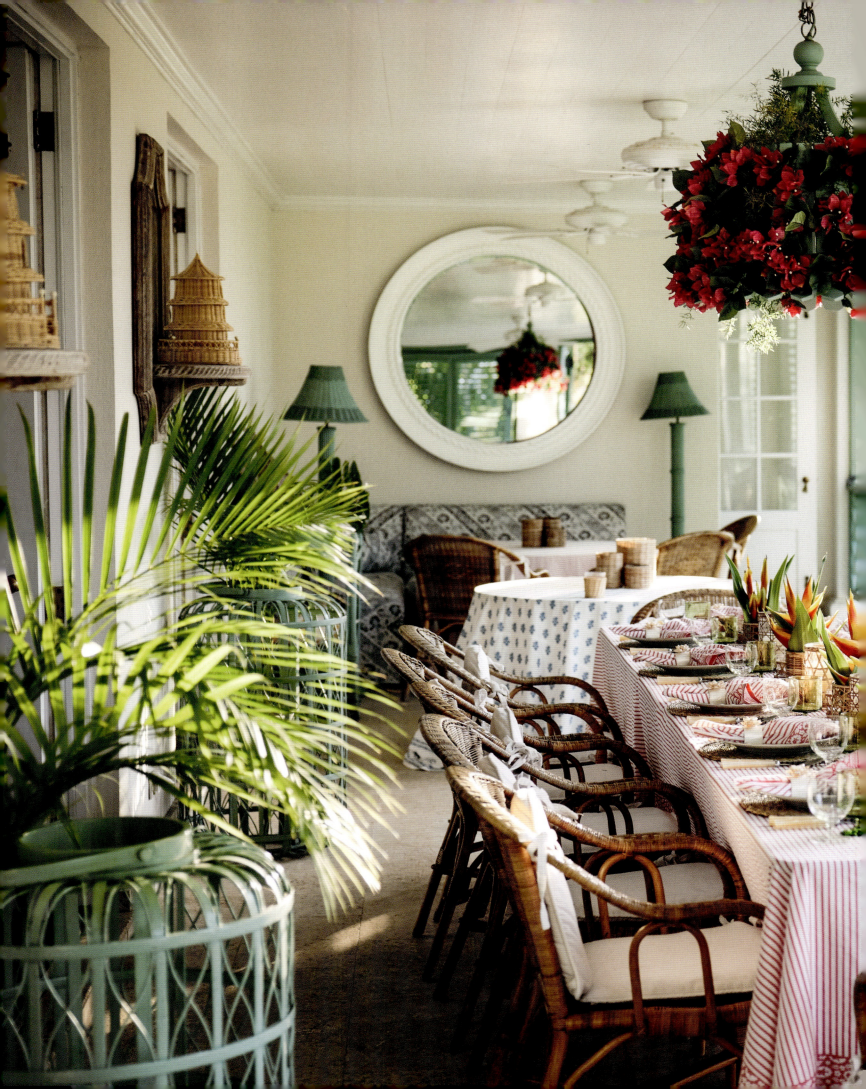

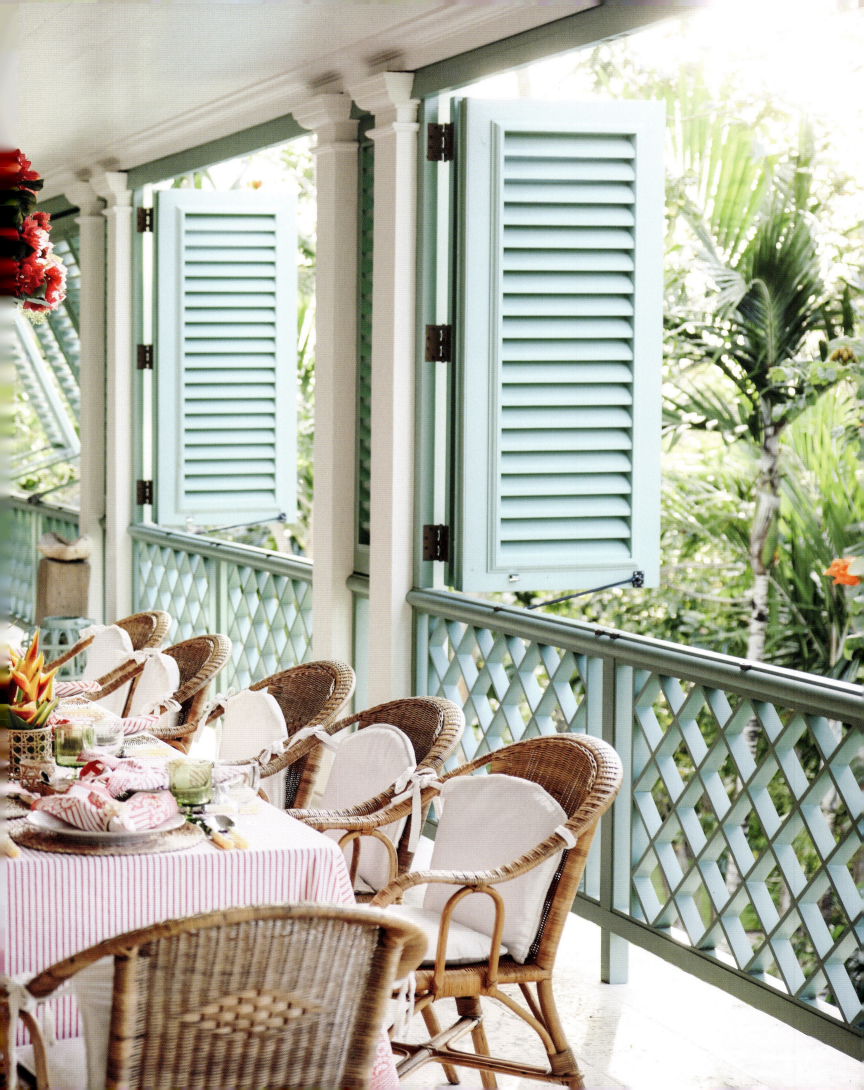

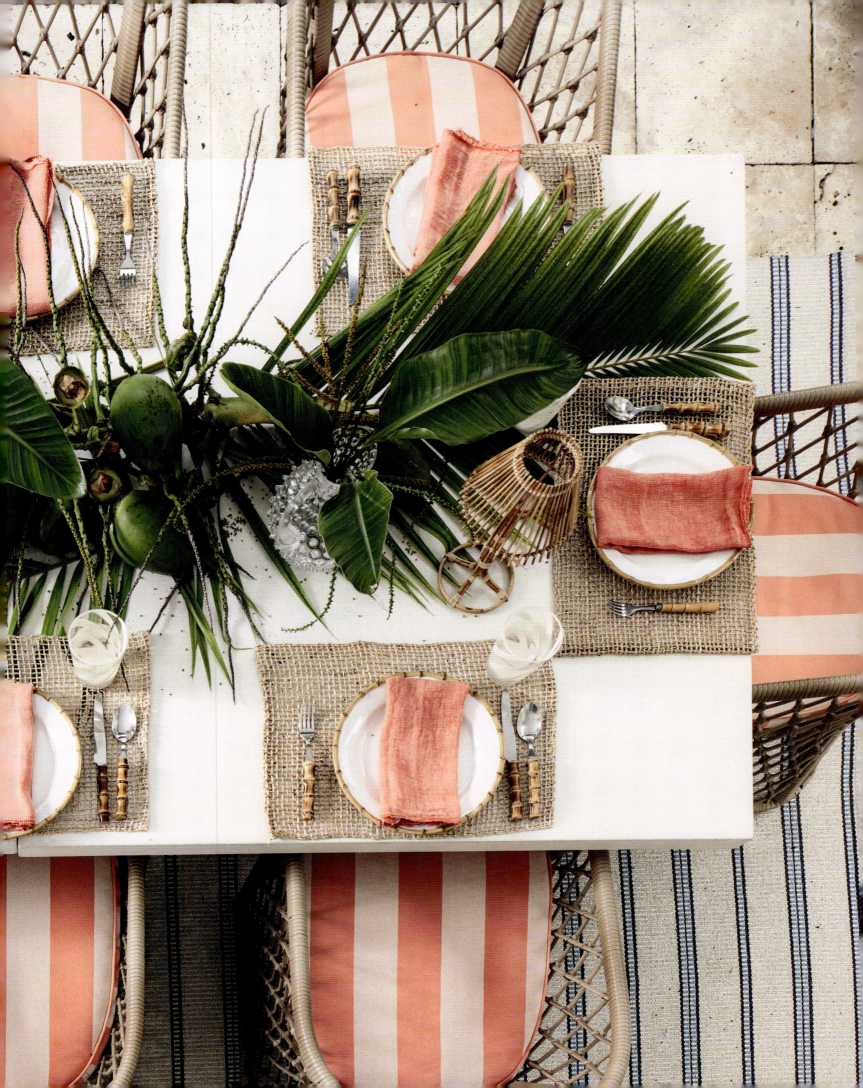

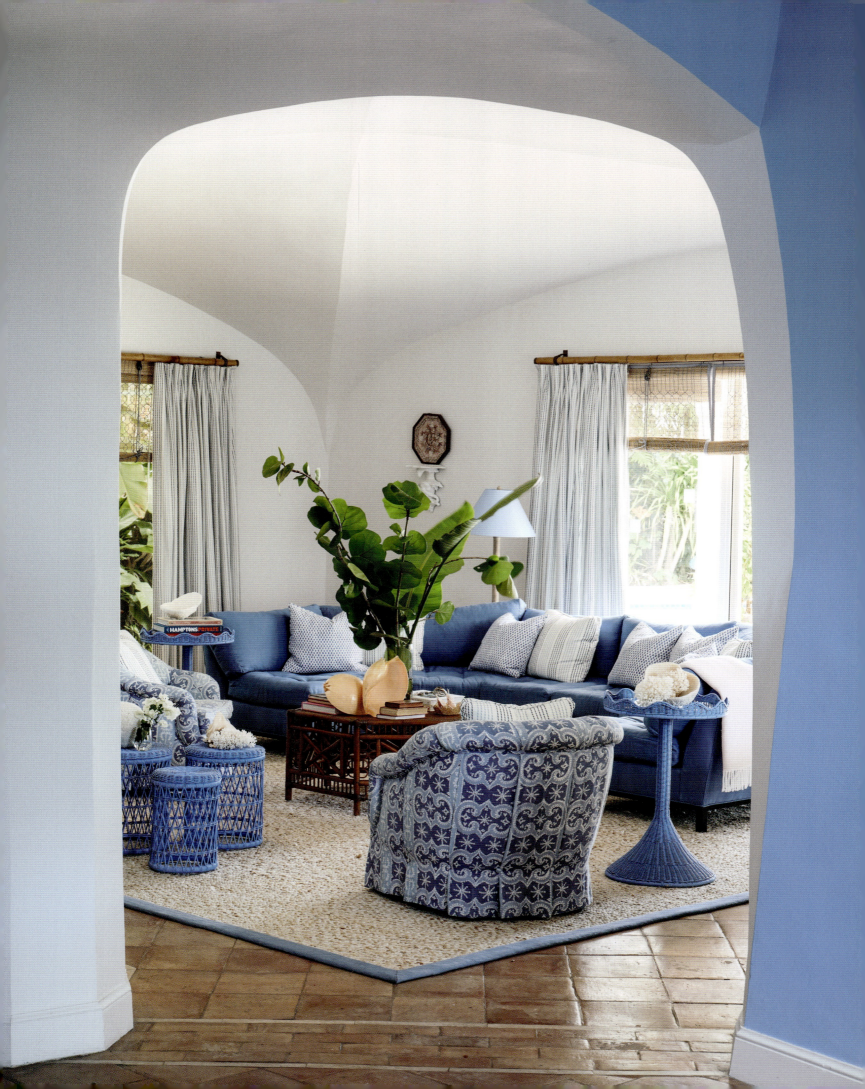

ISLAND DREAMING
AMANDA LINDROTH DESIGN

AMANDA LINDROTH

PHOTOGRAPHY BY
DYLAN CHANDLER

ILLUSTRATIONS BY
CARLISLE BURCH

VENDOME
NEW YORK • LONDON

CONTENTS

INTRODUCTION . 12

SUNSET POINT 6 . 18

WINDSONG . 30

LAZY DAISY . 50

PALMETTO COTTAGE . 72

LANI PO . 86

TIVOLI . 102

BLUE SKIES . 122

ALBANY . 134

COTTAGE 104 . 148

400 SOUTH OCEAN BOULEVARD . 160

TREETOPS . 168

3 GULLS . 178

BAKER'S BAY
FERRY TERMINAL . 192

GINA LISA . 198

LITTLEGATE . 204

LOVE SHACK . 228

LYFORD CLOSE . 240

KIPS BAY . 250

WILDERNESS
COUNTRY CLUB . 258

WORTH AVENUE . 266

FIFTH AVENUE . 276

PACIFIC HEIGHTS . 294

HIGH TIDE . 308

LEPIYOKI . 320

ACKNOWLEDGMENTS . 335

INTRODUCTION

NEW BOOK, NEW CHAPTER

Life is full of change, sometimes small and sometimes large. Since the publication of my first book, *Island Hopping*, in the fall of 2018, enormous changes, some planned and some not, have been a constant for me. The unexpected terminal diagnosis of my beloved husband, Orjan, in January 2019 and his passing in July 2020 was a shocking change for my daughter, Eliza, and me.

As Orjan's diagnosis coincided with the launch of *Island Hopping*, we canceled all book signings and speaking engagements and instead spent most of the winter of 2019 in Houston supporting his treatment. 2020 brought Covid and a spring unlike anything one could have imagined. Eliza came home to Lyford Cay from boarding school in the UK. The three of us hunkered down at Hope Hill (our house), together. Orjan was meticulously looked after and was not in pain.

The Bahamian prime minister at the time was a physician, and he imposed a hard lockdown on the island nation. We may have been under strict curfew, but the weather that spring was especially beautiful. We flung open the doors and windows and, with no airplanes flying overhead, no cars driving by, and no lawn mowers buzzing, only birdsong pierced the silence. We lived on our veranda, enjoying the gentle breezes, our gorgeous tropical surroundings, and especially being together as a family at such a poignant time.

The prime minister's Covid plan restricted most activities but allowed fishing. Eliza seized on this attractive exception, and in mid-March 2020, off we went to buy a mini, eight-foot-long Zodiac. The tiny inflatable was just big enough for her and a friend, one fishing pole, a cell phone, and their masks and snorkels. Big adventures in the tiny boat, zooming around the crystal-clear waters of Lyford Cay, helped ease the Covid restrictions.

At night, Eliza and I snuck around the cay in our "bubble," played Trivial Pursuit, and profoundly deepened our friendship in a way that has been, to this day, life-changing.

After Orjan's passing, it was time to get Eliza back to the UK. There were still no commercial flights in and out of the Bahamas, but the minister of aviation arranged for an Air Canada flight to transport all the children who were in schools abroad in mid-August. Being in the otherwise empty airport, with only boarding-school and college-age children checking in, was surreal. Eliza and a group of friends made their way first to Toronto, where they spent an uncomfortable night sleeping on the floor in the airport, as no hotels were open, then proceeded to London.

OVERLEAF LEFT: The living room at Hope Hill, my former house in Lyford Cay.
OVERLEAF RIGHT: The dining room at Ca'Liza, an earlier house of mine in Old Fort Bay.

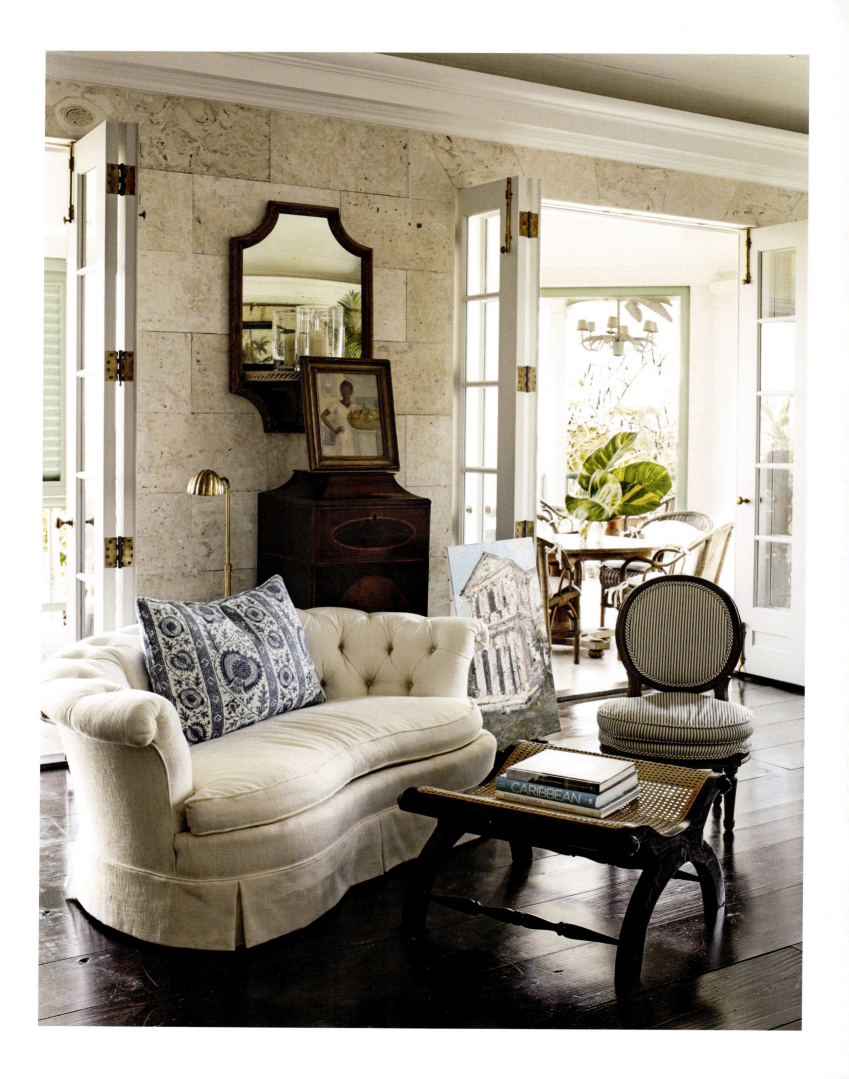

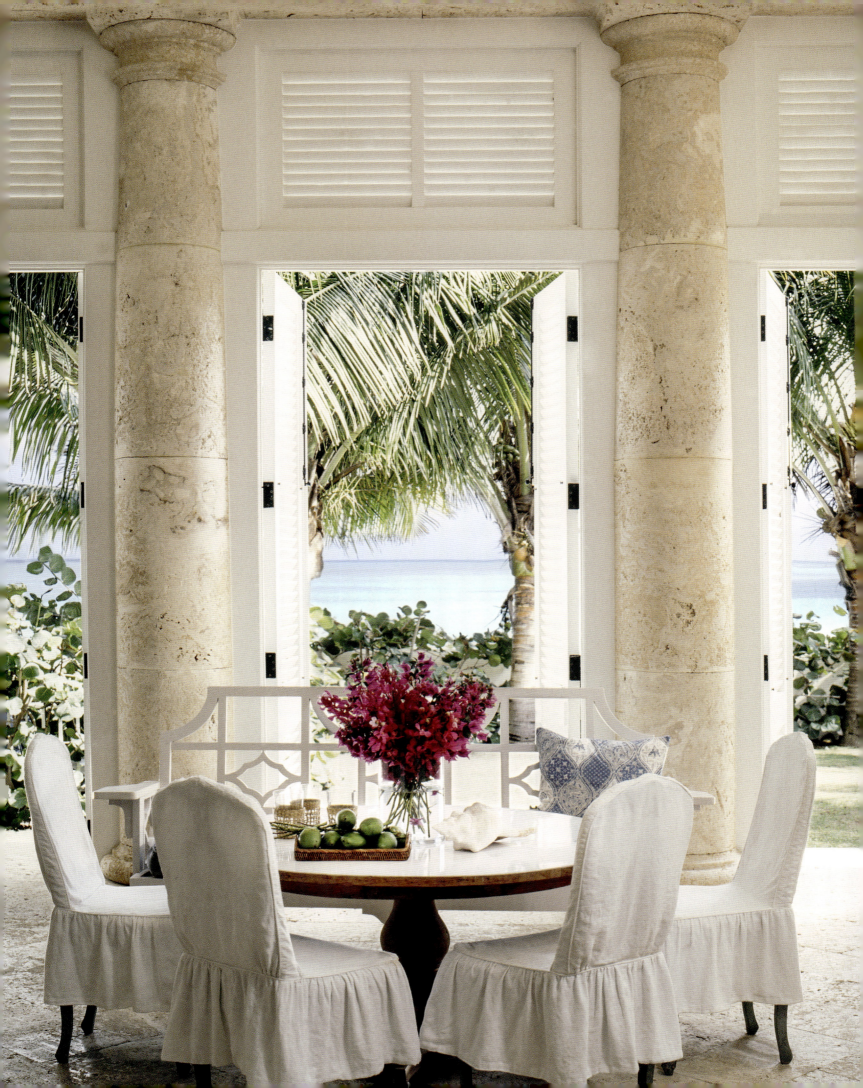

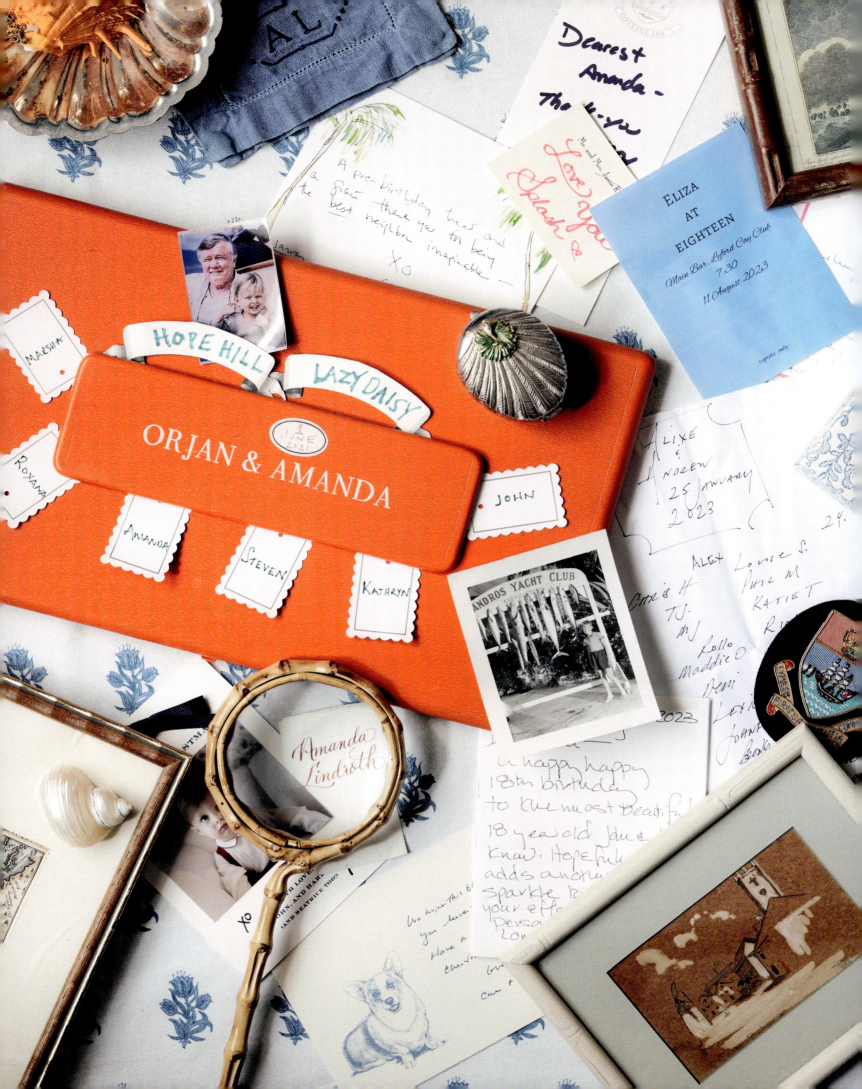

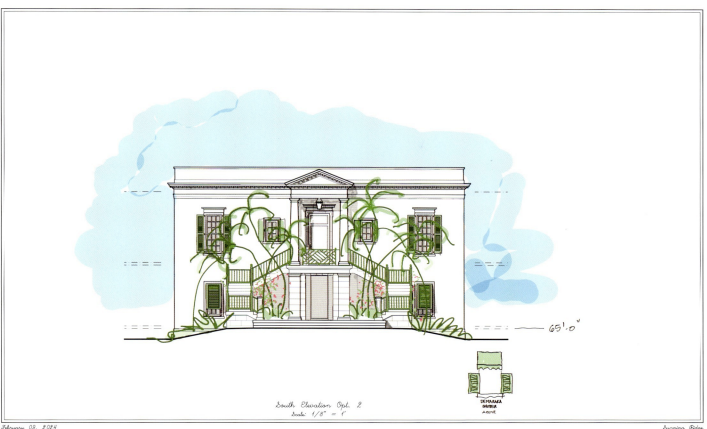

OPPOSITE: *Bits and bobs of daily life in Lyford Cay.*
ABOVE: *One of Maria de la Guardia's first renderings of my new house, Sunningridge.*

It was very important to me to change as little as possible after Orjan's passing. We had our usual full house at Hope Hill at Christmas. Parties and celebrations went on as they always had. The spring visit of our adored English houseguests had all its usual merriment.

Work was also a constant. Blessed with wonderful clients and the most loving, loyal, and supportive teams both at home and at work, I was able to complete beautiful residential, commercial, and hospitality projects. *Island Dreaming* presents many of these projects, from the Bahamas to Palm Beach, from Naples, Florida, to Manhattan, and even a mainland project in San Francisco.

It was sometime in 2022 that I admitted to John Fondas, my best friend, that I might be interested in building a new house. At first, he was simply flabbergasted. Hope Hill signified safety, comfort, and home. I did not take the decision lightly and spent many months thinking about it. Magically, a wonderful family was interested in Hope Hill, and in the spring of 2023, we reached a deal. More change—but this time considered and elected!

Eliza and I chose a lovely plot of land in Lyford Cay that is at the exact same elevation as Hope Hill and has the same extraordinary views. Architects Maria de la Guardia and Teófilo Victoria were Orjan's dearest friends and collaborators. They had designed our beautiful Ca'Liza eighteen years before and had redesigned Hope Hill in 2010. As soon as I told Maria about my plan, we started to dream and sketch.

The new house, Sunningridge, named after Orjan's childhood home, promises to be a source of new experiences and excitement for Eliza and me. We are endlessly blessed in every way and full of gratitude for all life's gifts, challenges, and changes.

AMANDA LINDROTH
Lyford Cay, January 2024

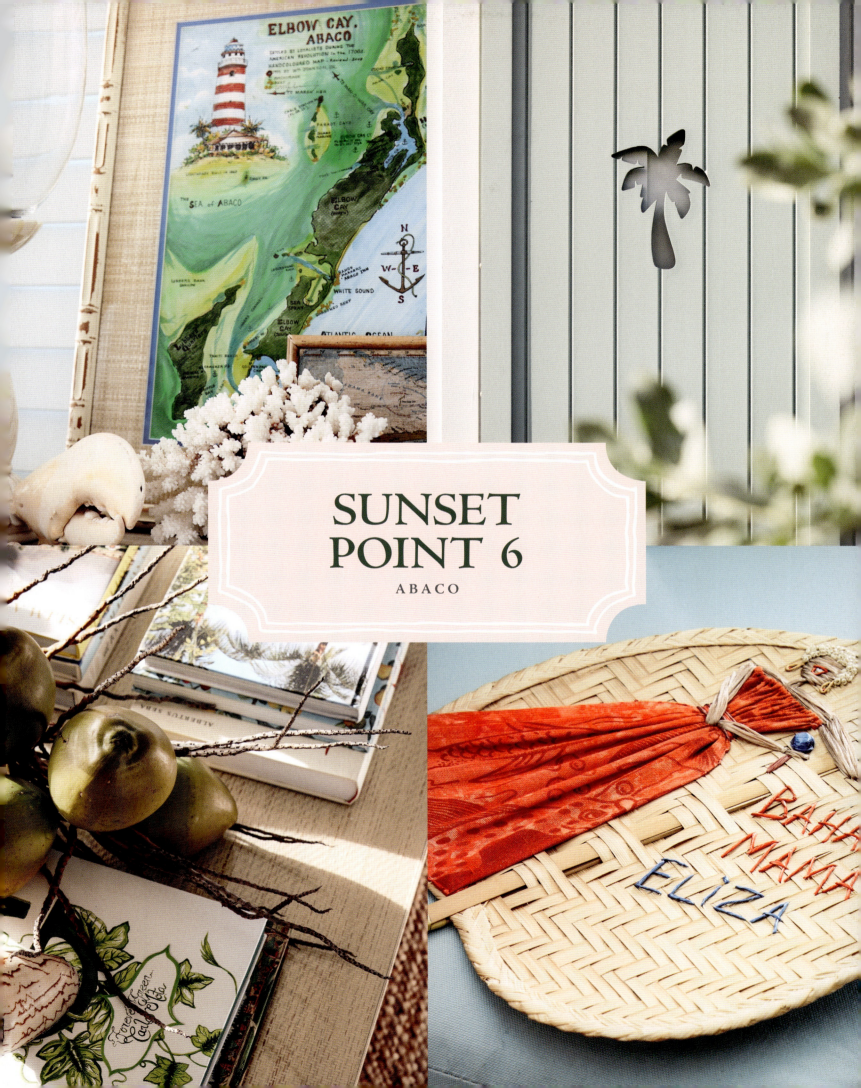

SUNSET POINT 6

ABACO

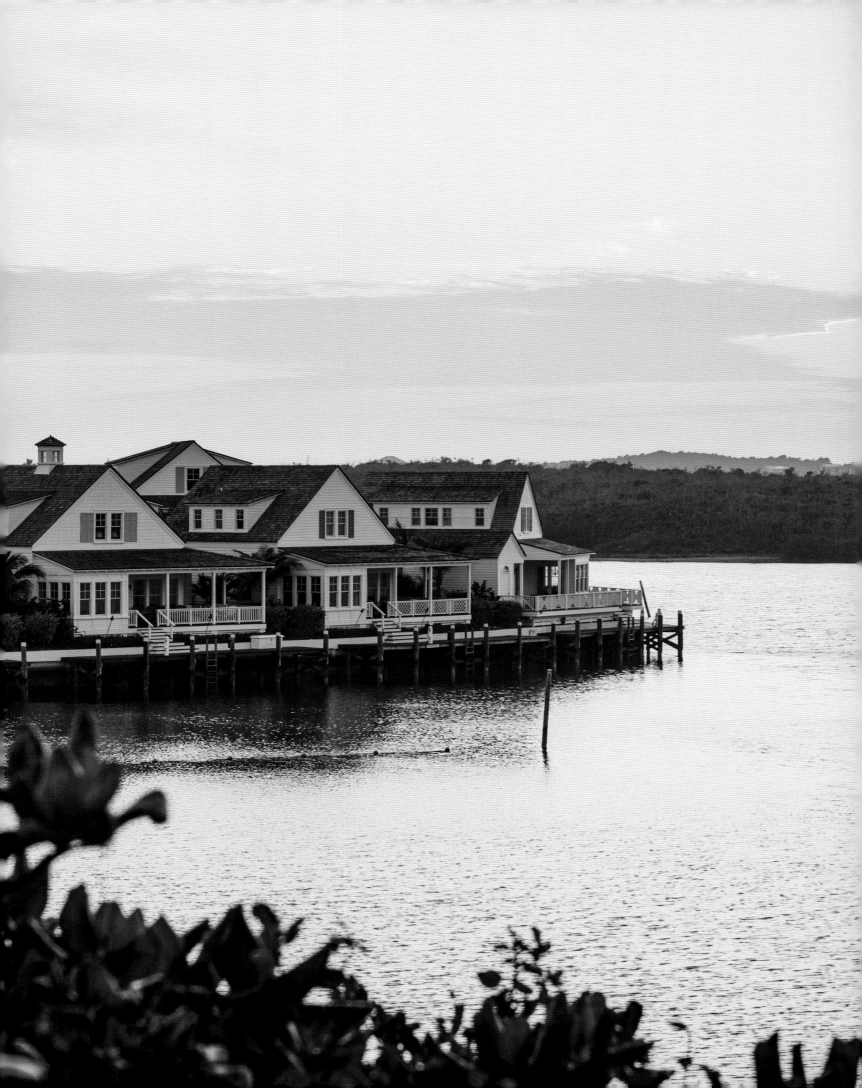

When my great friend Kerry Sullivan from Hope Town in Abaco recommended us for the Sunset Point project, we had no idea we would return year after year to work on its charming cottages.

Less than a decade ago, Sunset Point was just a sandy little peninsula jutting out into the beautiful Sea of Abaco. It is now a lush tropical paradise with a dozen or so white cottages that look as though they have been there for a hundred years.

The architecture, by Joe Cronk and Cliff Duch, is picture-perfect in scale and tone. The buildings were constructed with love and care by master builder Todd Cash, Kerry's husband. Todd grew up going to Hope Town, and the dimensions of Abaco's traditional saltbox architecture are somehow embedded in his cellular memory. He always has a ready solution for any building dilemma and is a true gift to work with.

Sunset Point's owner, Dan Sullivan, entrusted us with the first two cottages before there were buyers. The first cottage was installed on a Friday in late August 2019, only to be hammered by epic, devastating Hurricane Dorian one week later. Most of the ground-floor interior, including the kitchen appliances, the walls, and all the furniture, was washed out to sea. Brave Dan wasted no time putting the team back together, and we rebuilt and refurnished it in record time. We have since completed a few more.

For Sunset Point 6, we worked for wonderful clients from Florida. Number 6 sits at the end point of the little peninsula and has panoramic views of the sea. Our clients, who use the house on weekends and holidays, wanted the interior to reflect the magic of the surrounding blue-green water and foster a spirit of calm to facilitate relaxation. We upholstered big, comfy sofas and chairs in white and covered pillows in hand-screened Quadrille and Les Indiennes fabrics. The result is fresh and crisp and perfect for a wonderful break from busy weekday lives.

OPPOSITE: *A glorious sunset at Sunset Point 6.* OVERLEAF: *The inviting sitting room is appointed with a jute rug, white slipcovers on the cushy sofas, and local Bahamian maps lining the walls. Pillows covered in a hand-screened aqua batik from Quadrille inject just the right pop of color.*

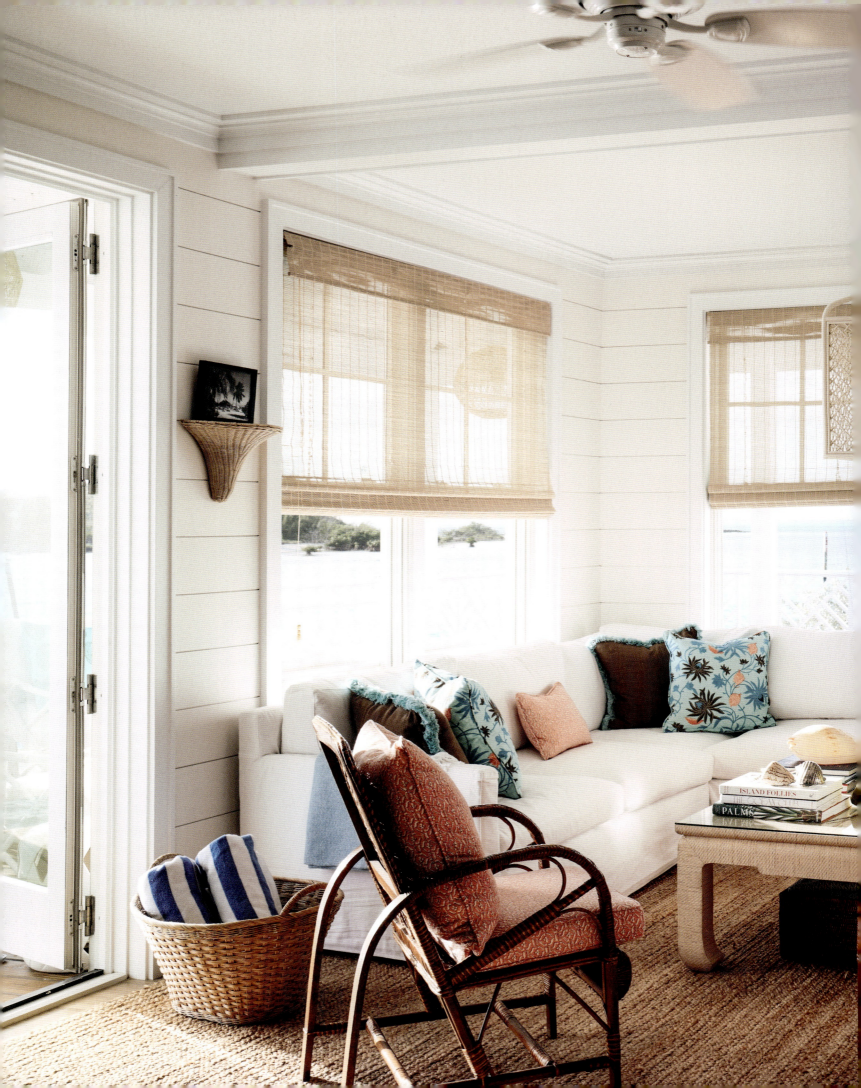

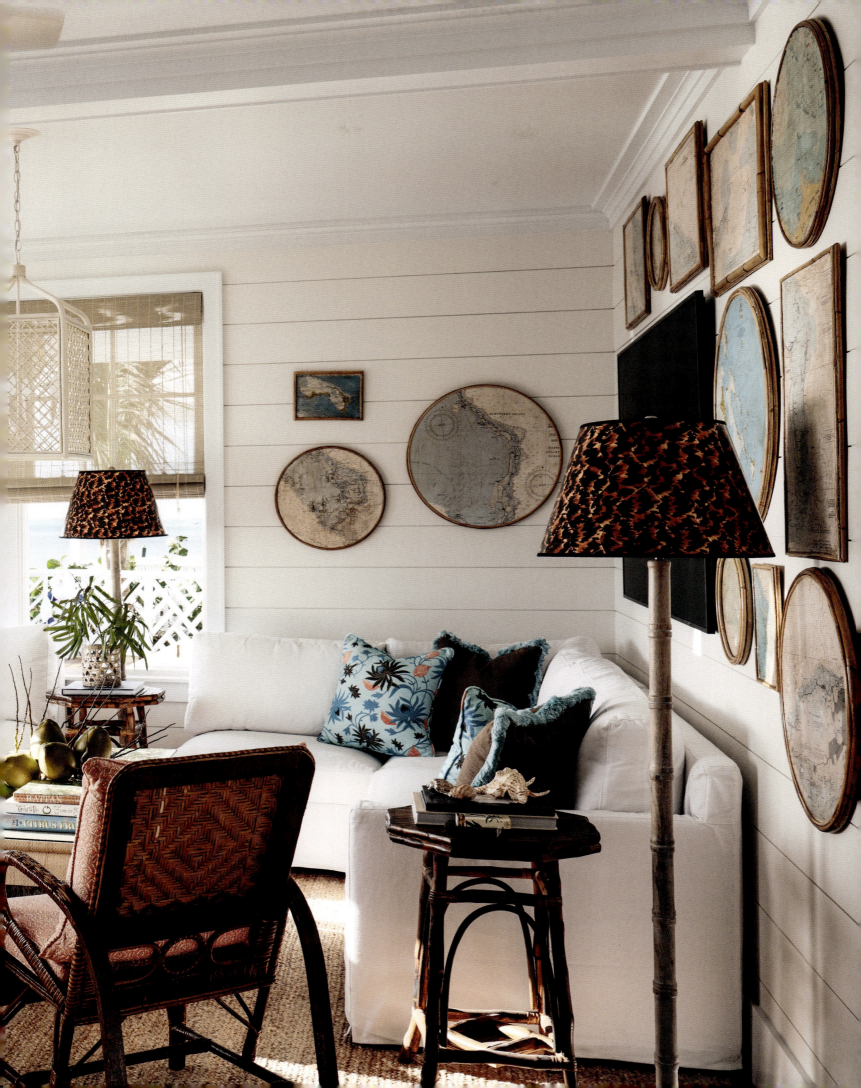

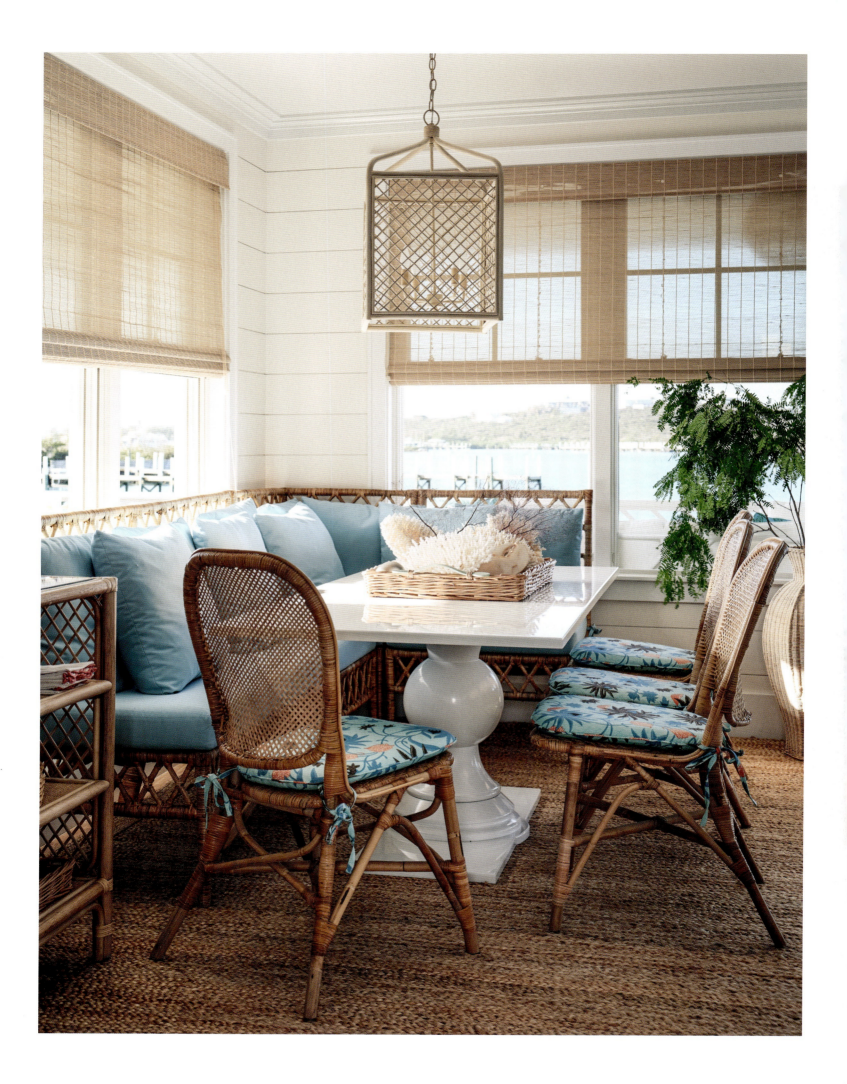

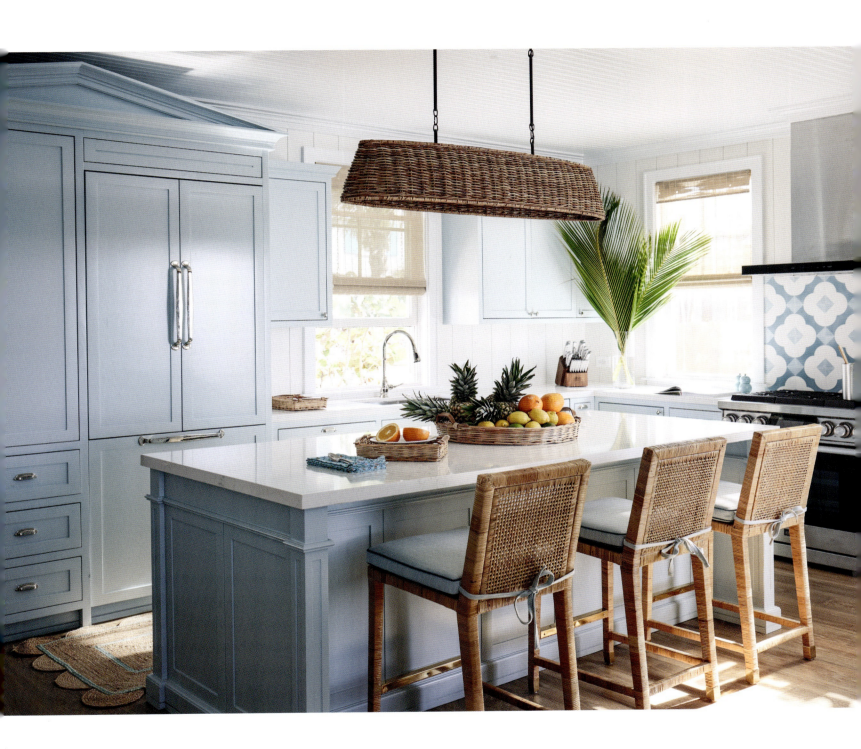

OPPOSITE: *In the breakfast nook, the chair cushions are covered in the same Quadrille batik as the pillows in the sitting room.* ABOVE: *A pretty, ice-blue kitchen with a happy, encaustic-tile backsplash.*

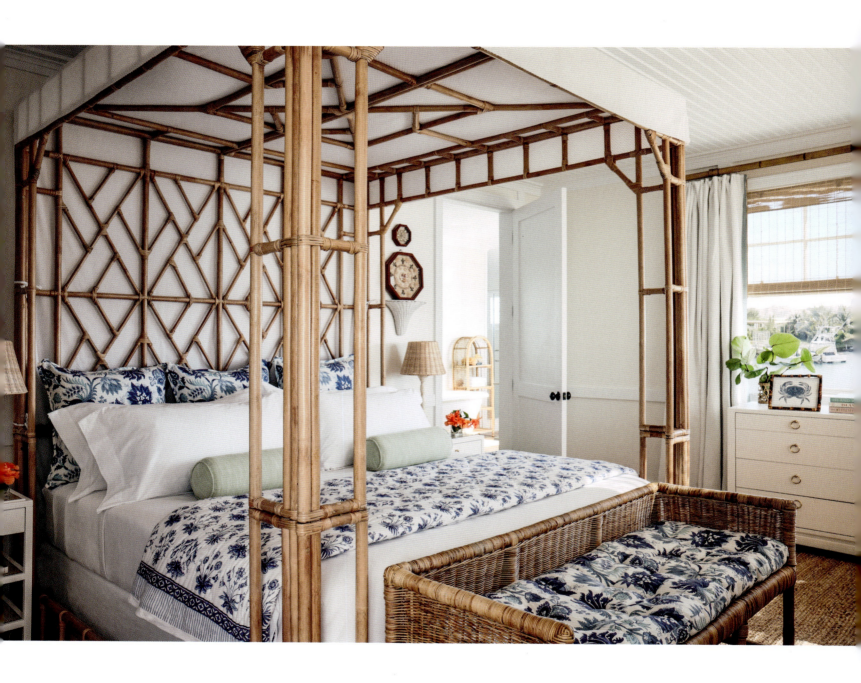

ABOVE: *An iconic rattan four-poster bed from the Lindroth collection presides in the cozy primary suite.* OPPOSITE TOP: *A faux-bamboo bed flanked by lamps with rakish Bahamian shades fits snugly in a dormer loft bedroom.* OPPOSITE BOTTOM: *A pagoda-shaped headboard from the Lindroth collection lends charm to a guest suite.* OVERLEAF: *Faux-bamboo outdoor seating populates the Sunset Point veranda, which offers the best sunset view.*

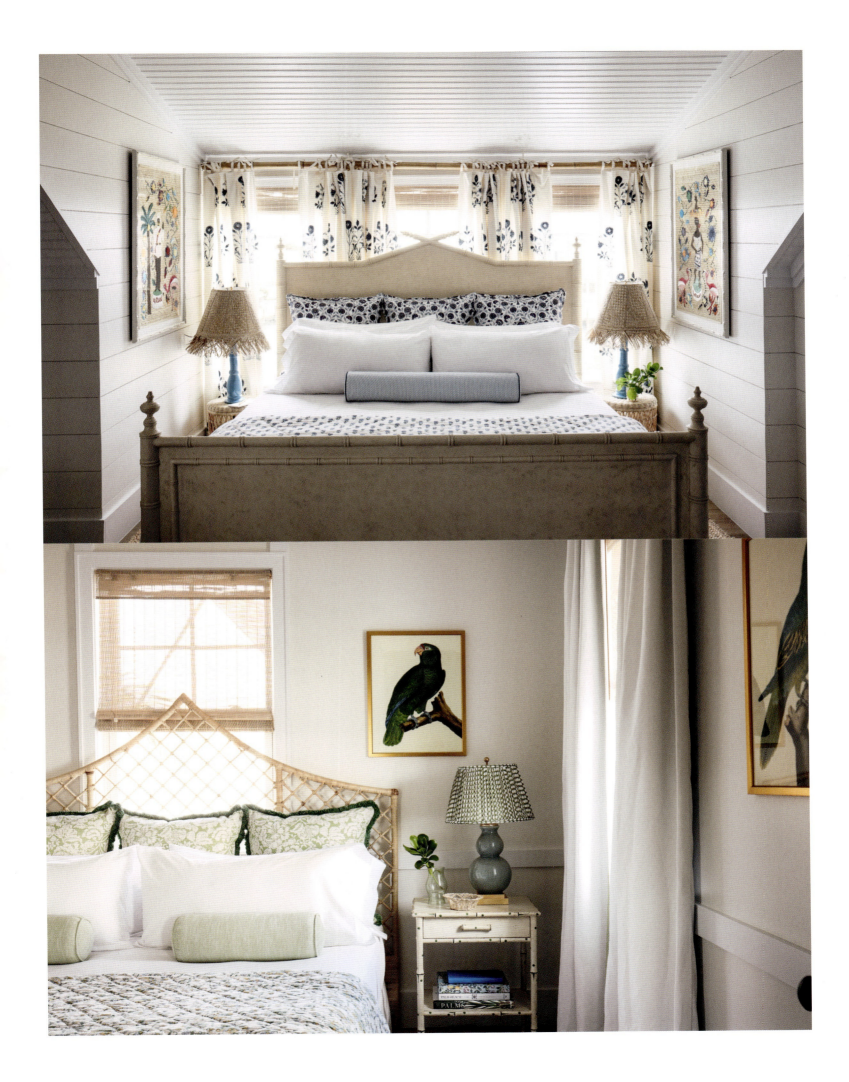

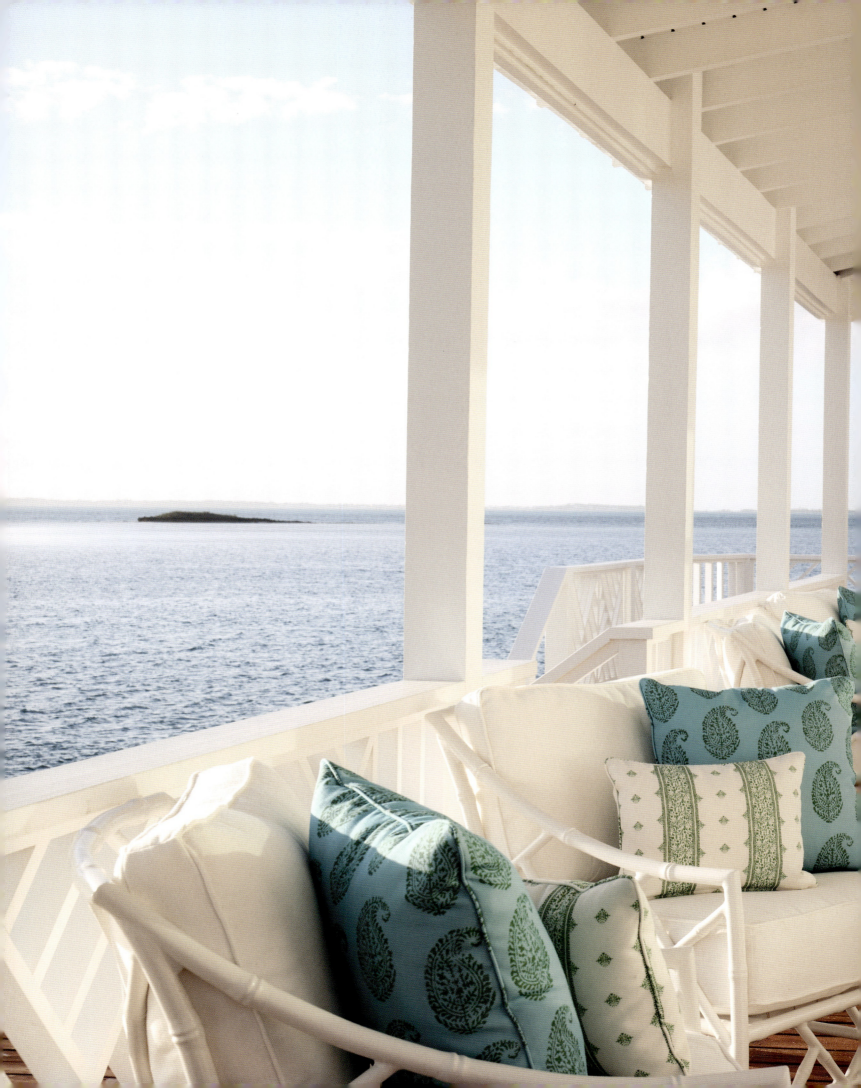

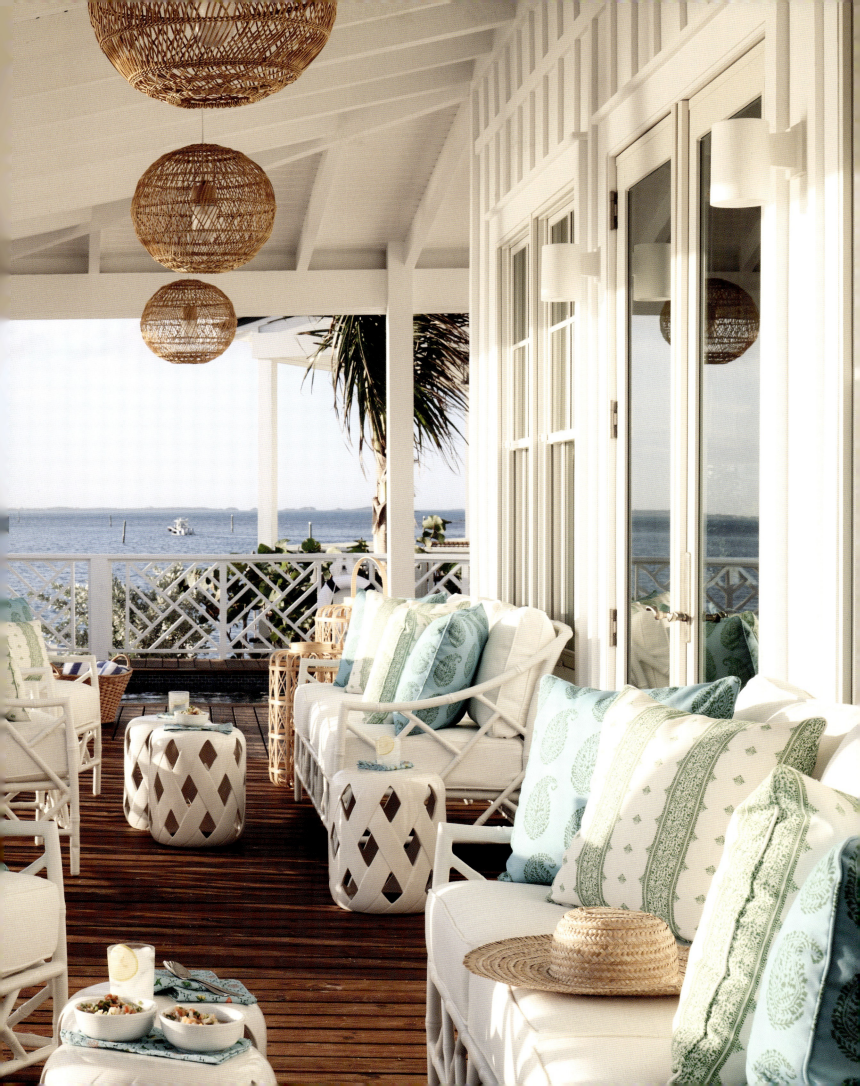

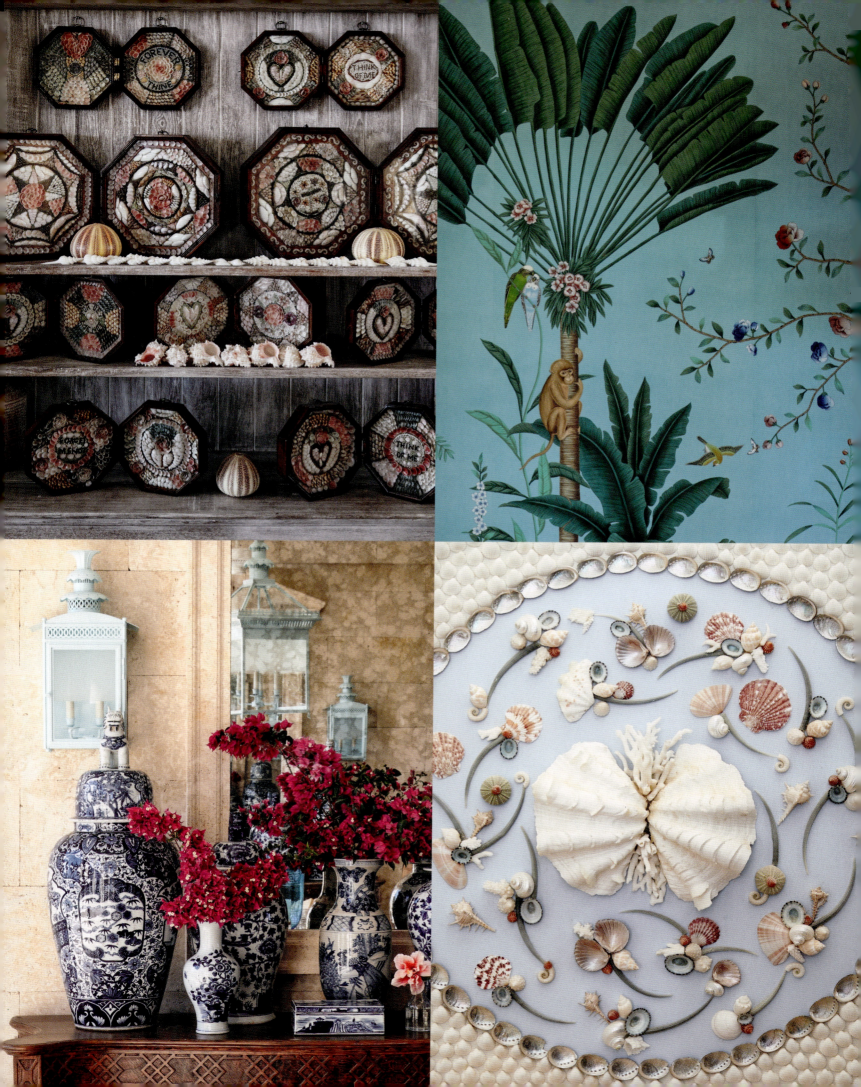

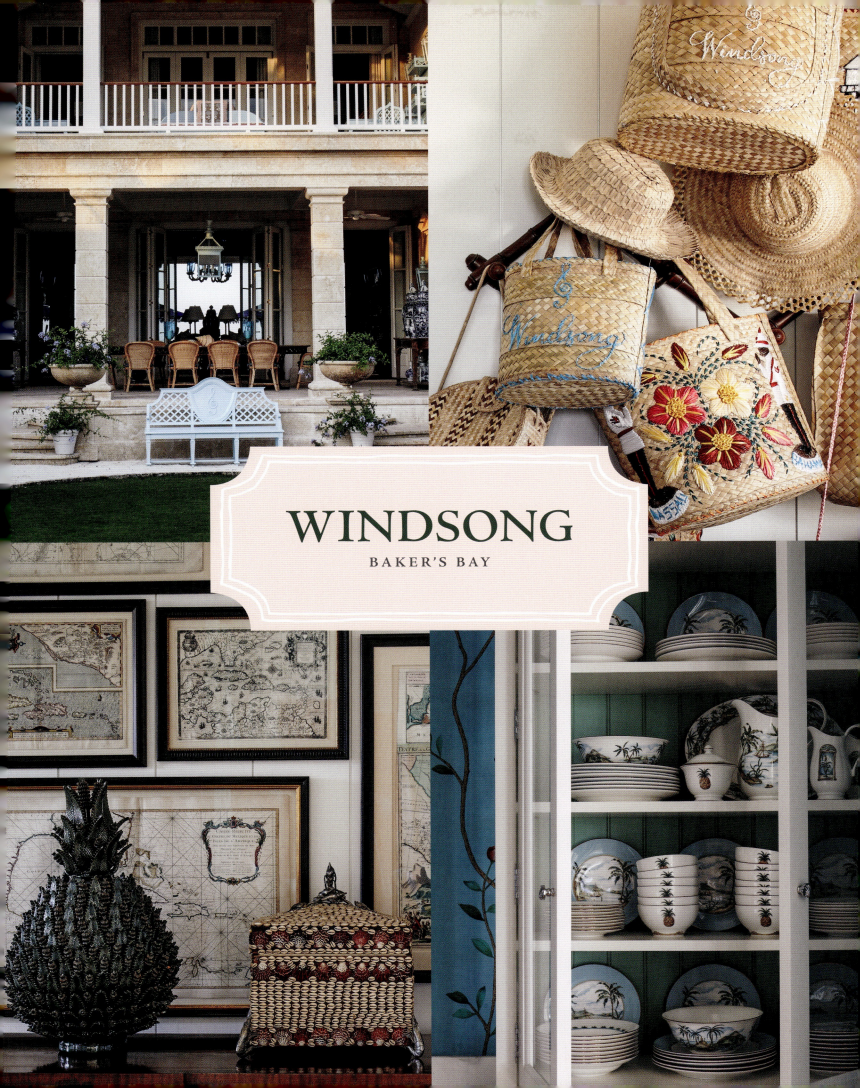

WINDSONG
BAKER'S BAY

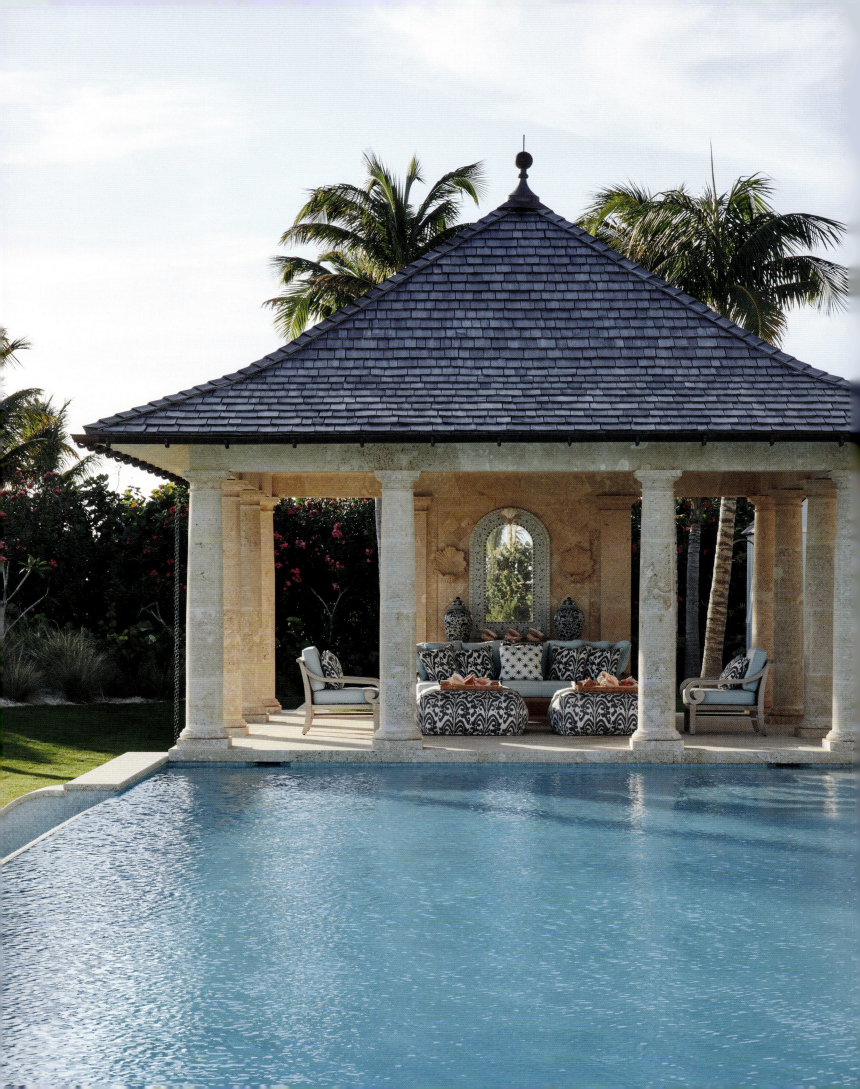

In 2016, out of the blue, I received a text and a subsequent call from a friend I had known since his undergrad years at Duke, asking if I could help create a perfect hideaway for his young family at Baker's Bay in the Abacos. My friend had married a great beauty with perfect taste. She was an amazing collaborator in the dream that became Windsong.

The coral-stone Palladian house, designed by architects Maria de la Guardia and Teófilo Victoria, has a formal layout and character, but because the family has active young children, it is layered with seriously playful moments.

The kitchen is swathed in a gorgeous, hand-painted, tropical-themed de Gournay wallpaper with an aqua ground. An elaborately shell-encrusted powder room, inspired by the eighteenth-century Georgian architect Robert Adam, is counterbalanced by the bold aqua-and-white horizontal stripe covering the walls in the family room, creating the effect of an oversize cabana.

The primary bedroom's hand-stenciled, Indian-pattern-inspired walls envelop a four-poster bed draped in hand-embroidered linen. A rare collection of octagonal antique sailor's valentines (a surprise gift from husband to wife) populates two giant teak cabinets at each end of the living room. Architect Maria de la Guardia added an octagonal molding on the ceiling as a playful nod to this most romantic of gestures.

The rare combination of the clients' unstinting love and care, the architects' impeccable design, and the impossibly beautiful location made Windsong a wondrous project for us to be involved in.

OPPOSITE: *A stately pavilion provides welcome shade and extreme comfort at the edge of the pool.*
OVERLEAF: *A collection of antique sailor's valentines and coral stone–clad walls lend history and visual interest to this comfortable yet formal living room. Note the octagonal molding on the ceiling—a playful echo of the shape of the antique sailor's valentines.*

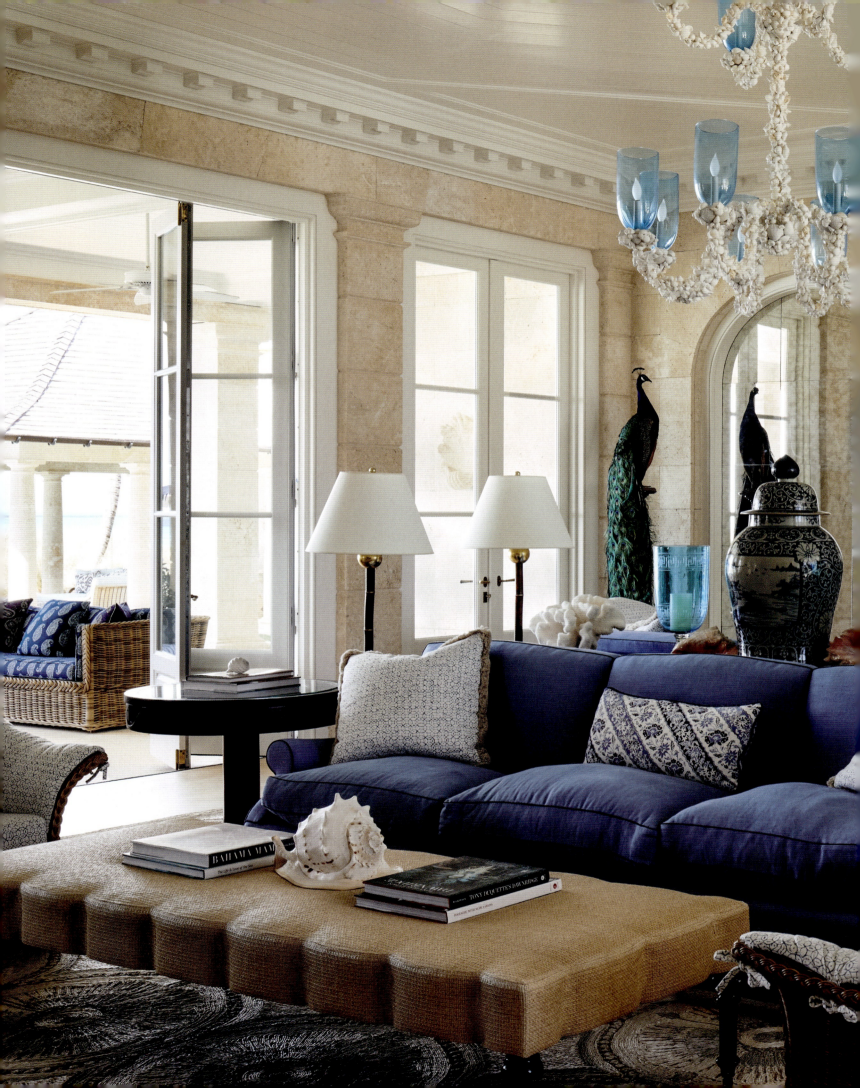

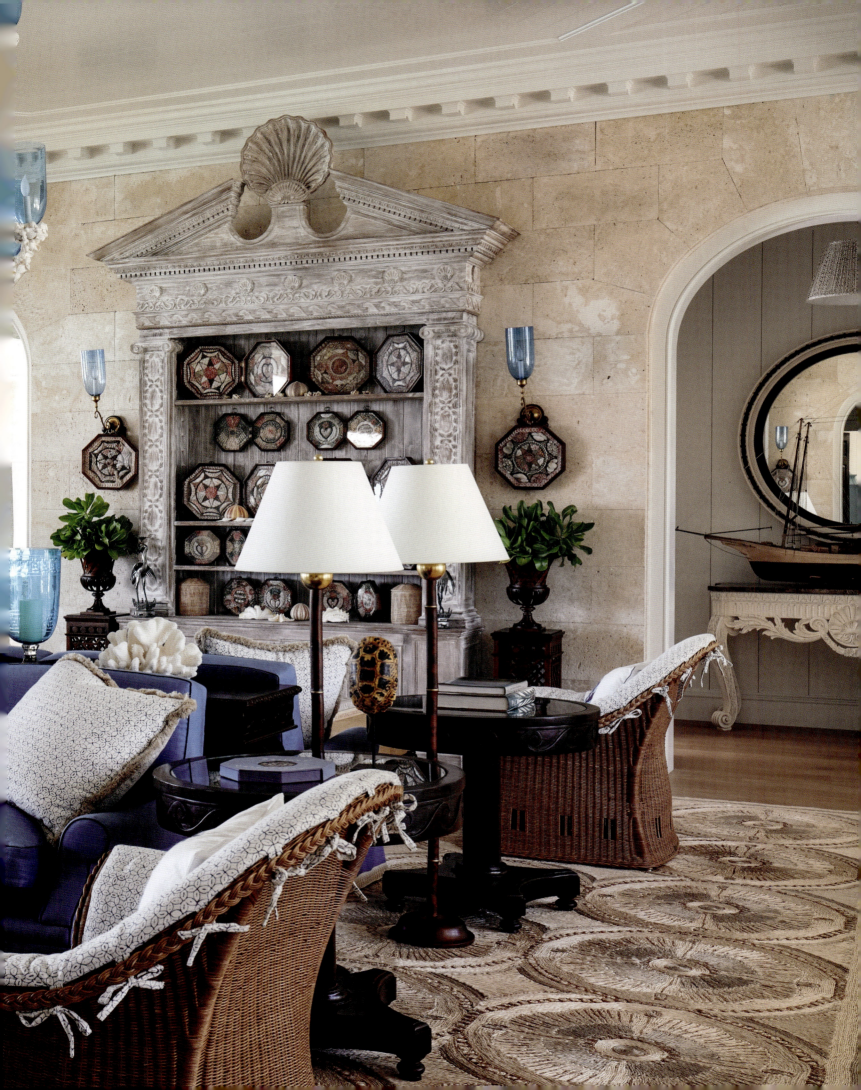

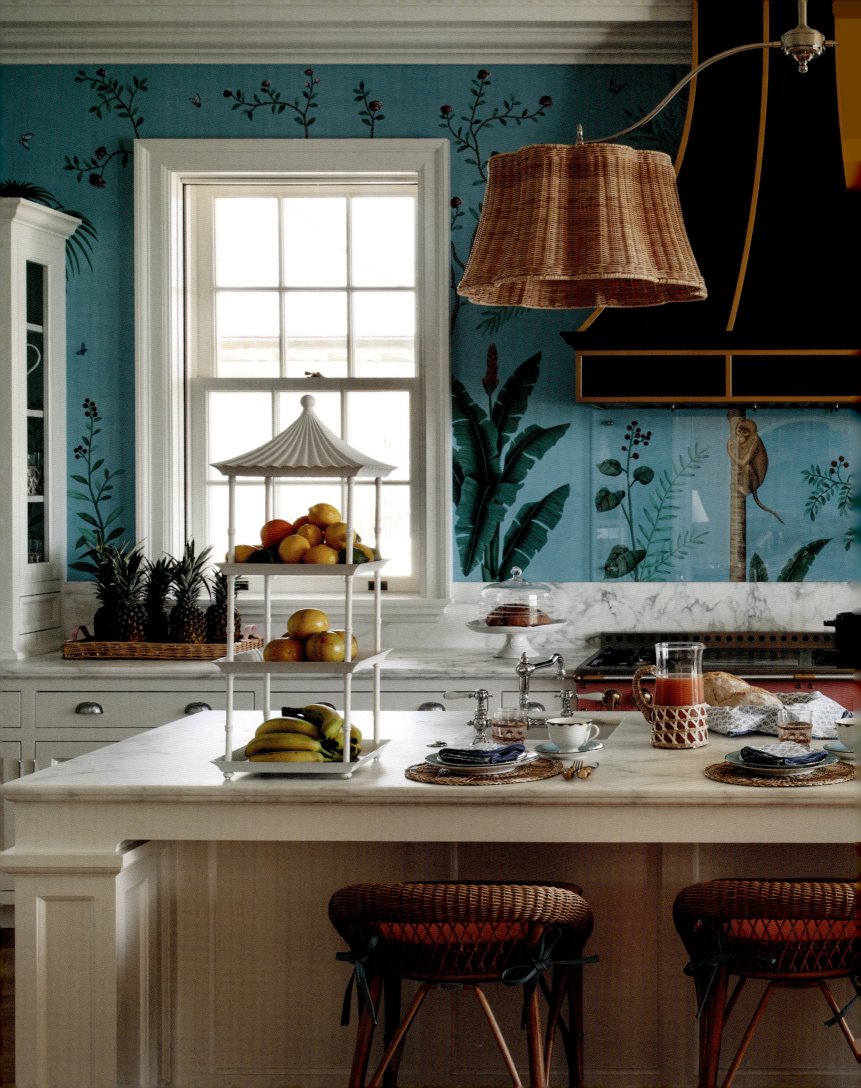

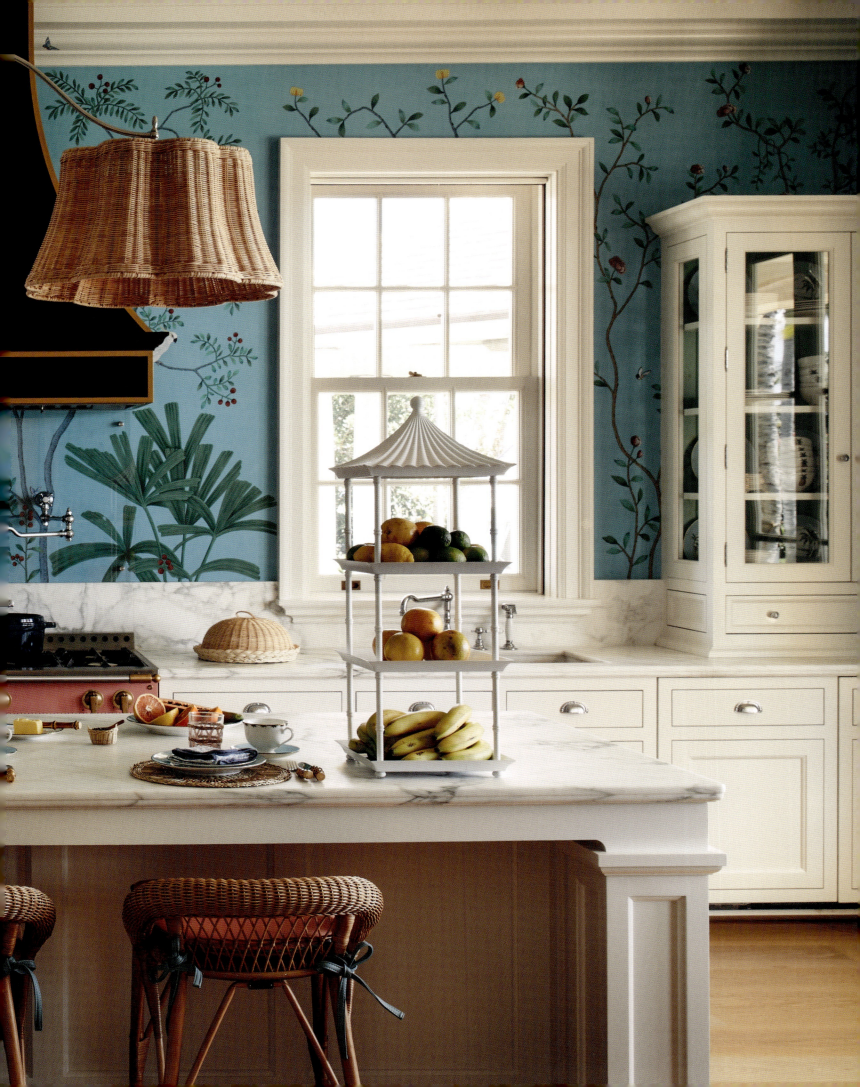

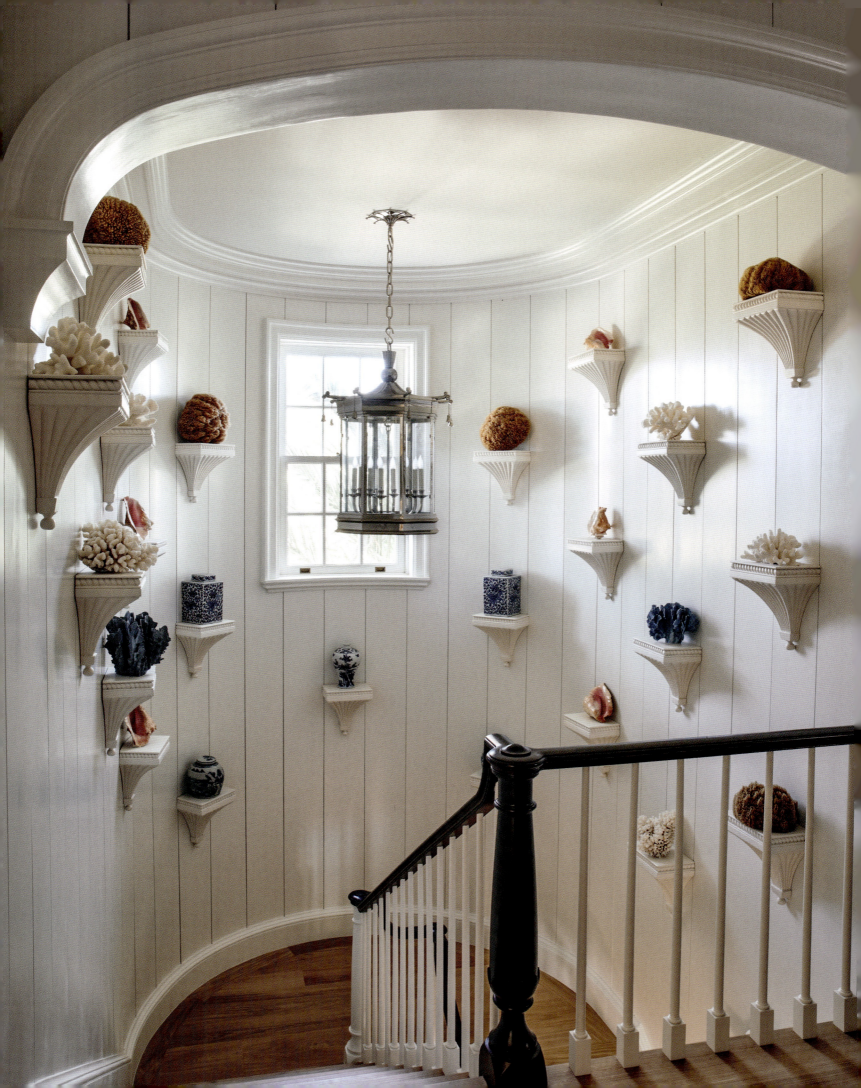

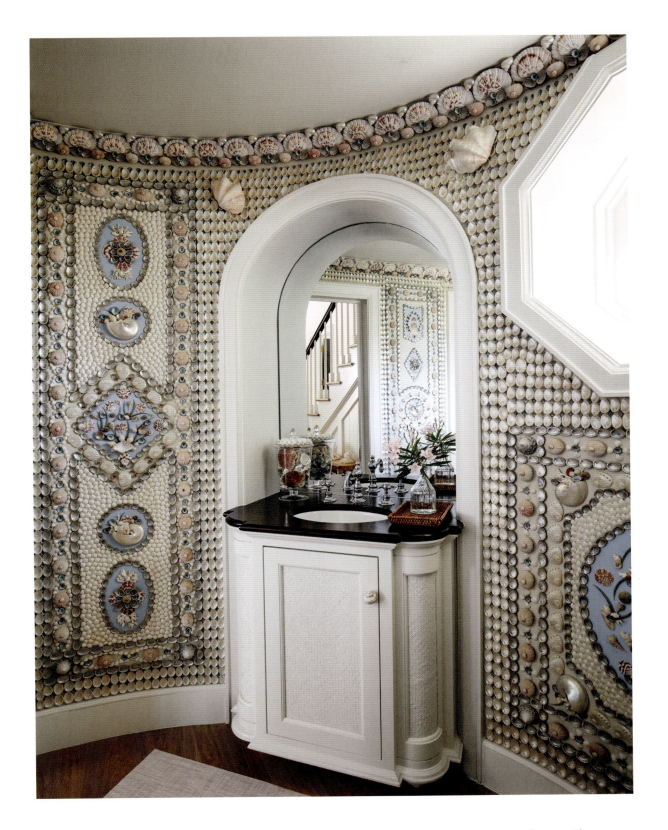

PRECEDING PAGES: *A pink La Cornue stove and a hand-painted de Gournay panoramic wallpaper with an aqua ground give the large kitchen warmth and charm.* OPPOSITE: *Treasures from the sea, mounted on brackets on the vertically clad shiplap wall, adorn the stair hall.* ABOVE: *Linda Fenwick's magical, shell-encrusted wall covering in the powder room was created in York, England, and shipped to the Bahamas.* OVERLEAF: *In the family room, overscale stripes, sofa, and ottoman create the effect of a luxurious cabana.*

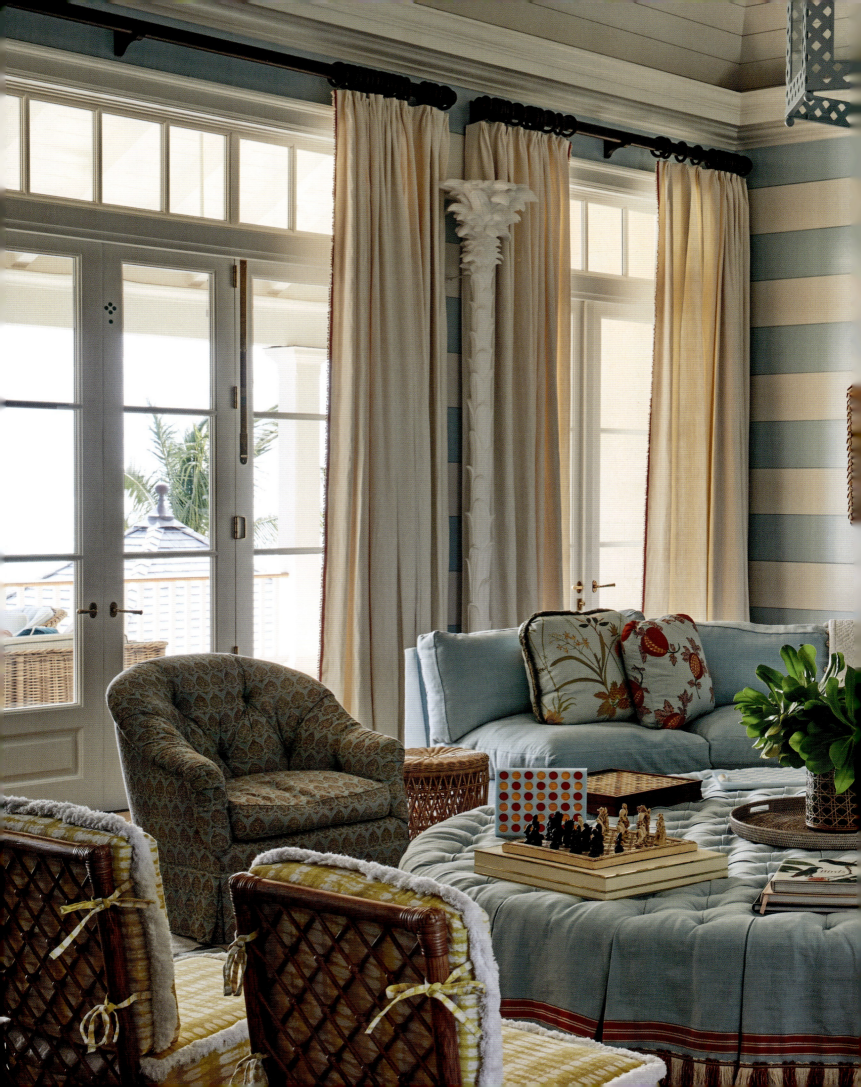

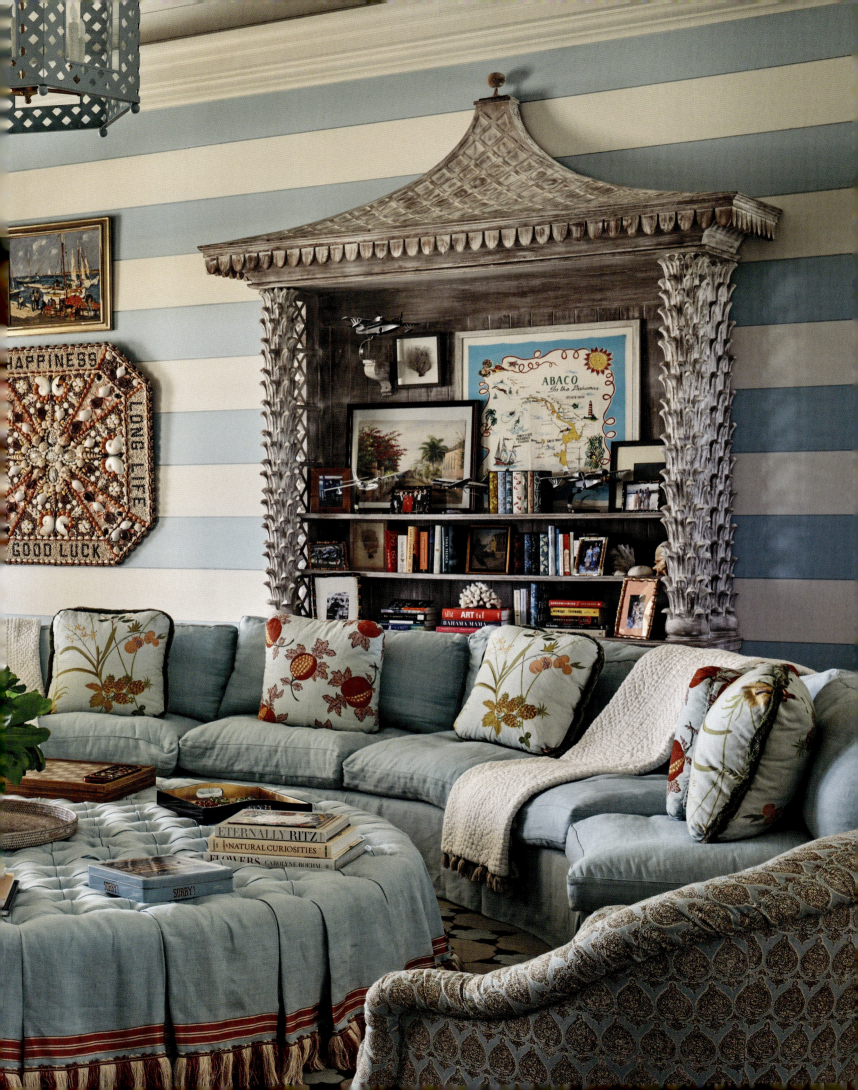

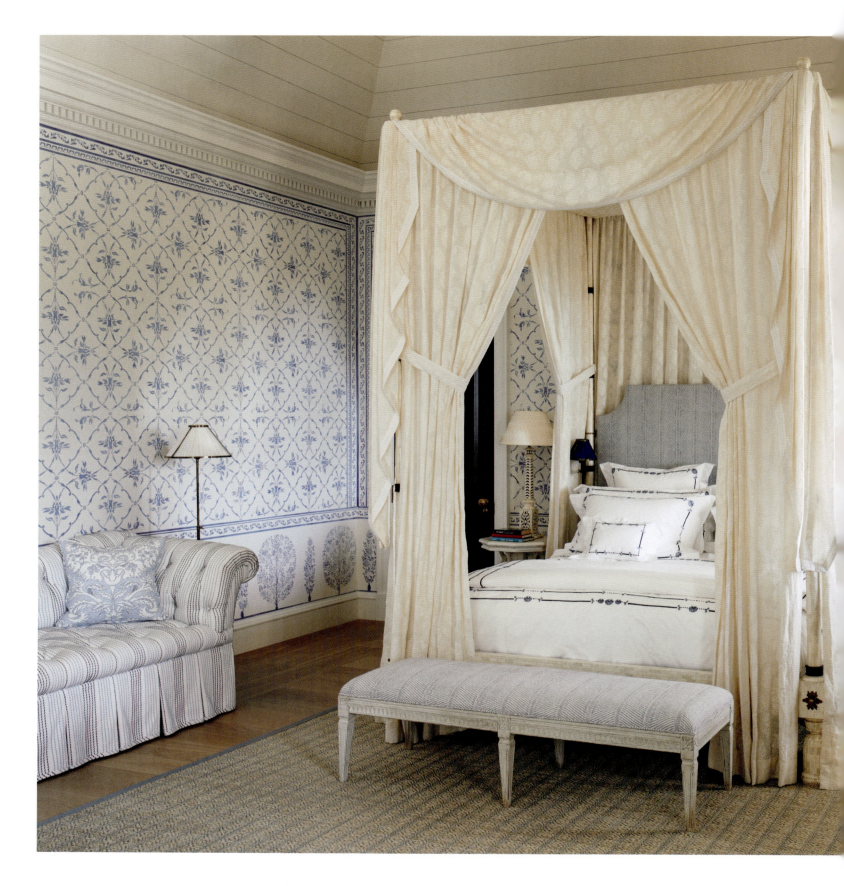

ABOVE: Walls hand-stenciled in an Indian motif by Brian Leaver lend an ethereality to the primary suite. OPPOSITE TOP: Sheer Ralph Lauren linen curtains and bed hangings add to the suite's delicacy. OPPOSITE BOTTOM: Cane-fronted cabinets and a cheerful coral chandelier infuse the primary bathroom with island charm.

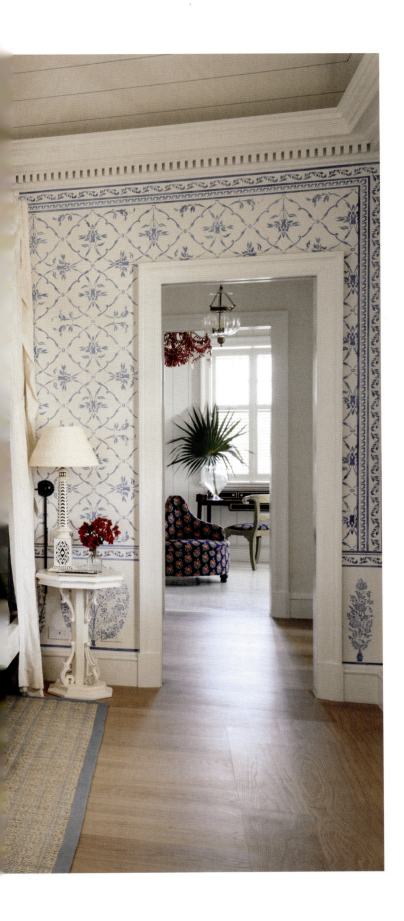
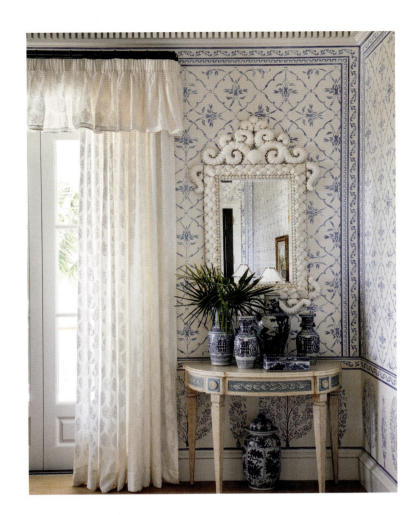
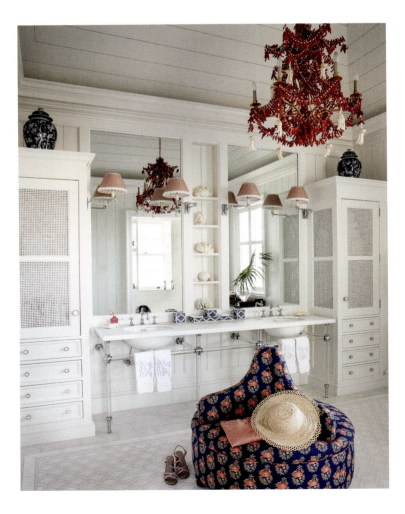

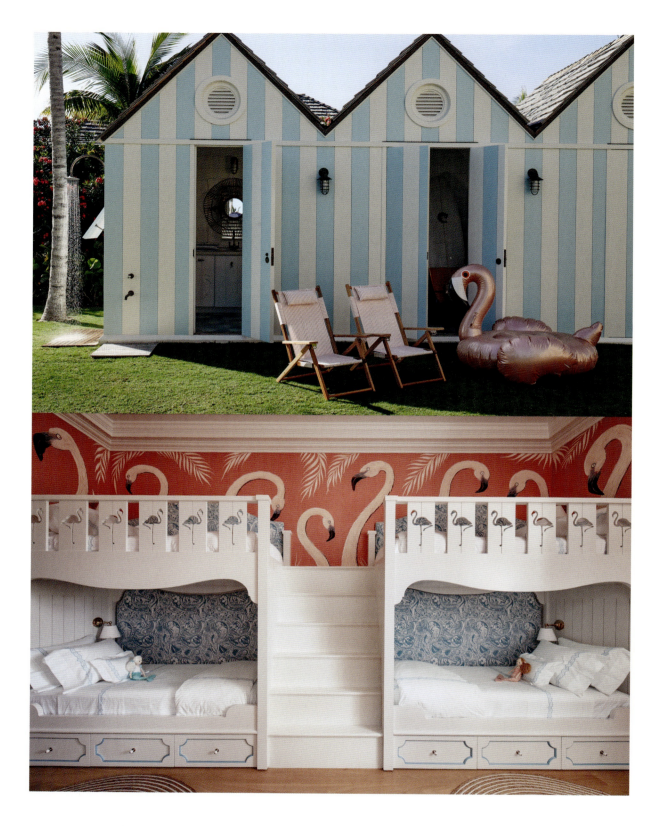

TOP: *Steeply pitched poolside cabanas house pool toys, toilets, and hot showers.* ABOVE: *Flamingo-adorned slats keep the upper bunks safe. On the walls, Brian Leaver painted their friends to match.* OPPOSITE: *Jean Chau from Two Worlds Arts made the charming children's beds, inspired by an image of a bed in an English country house.* OVERLEAF: *The dining loggia faces a lushly landscaped courtyard. The table is by the Raj Company, the chairs are by Bonacina, and the lantern pendant and sconces are from Charles Edwards.* PAGES 48–49: *A view from the beach of the coral stone–clad Windsong amid palms and miles of green lawn.*

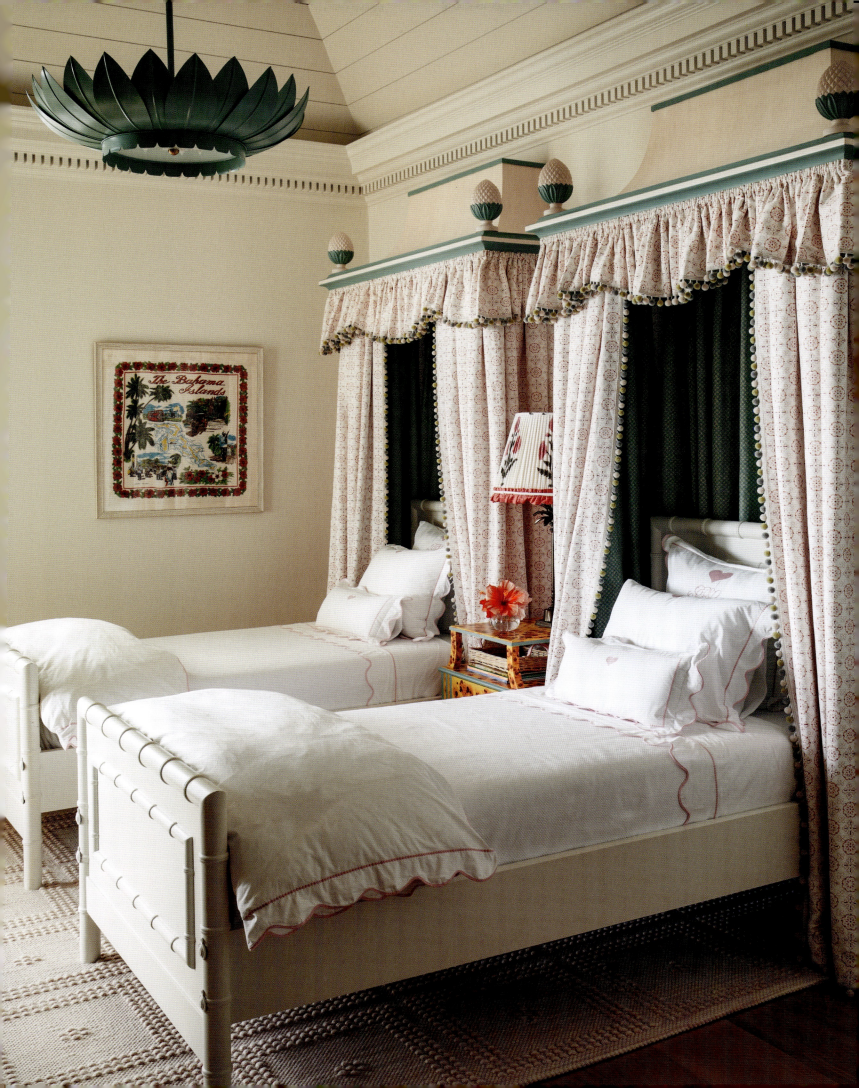

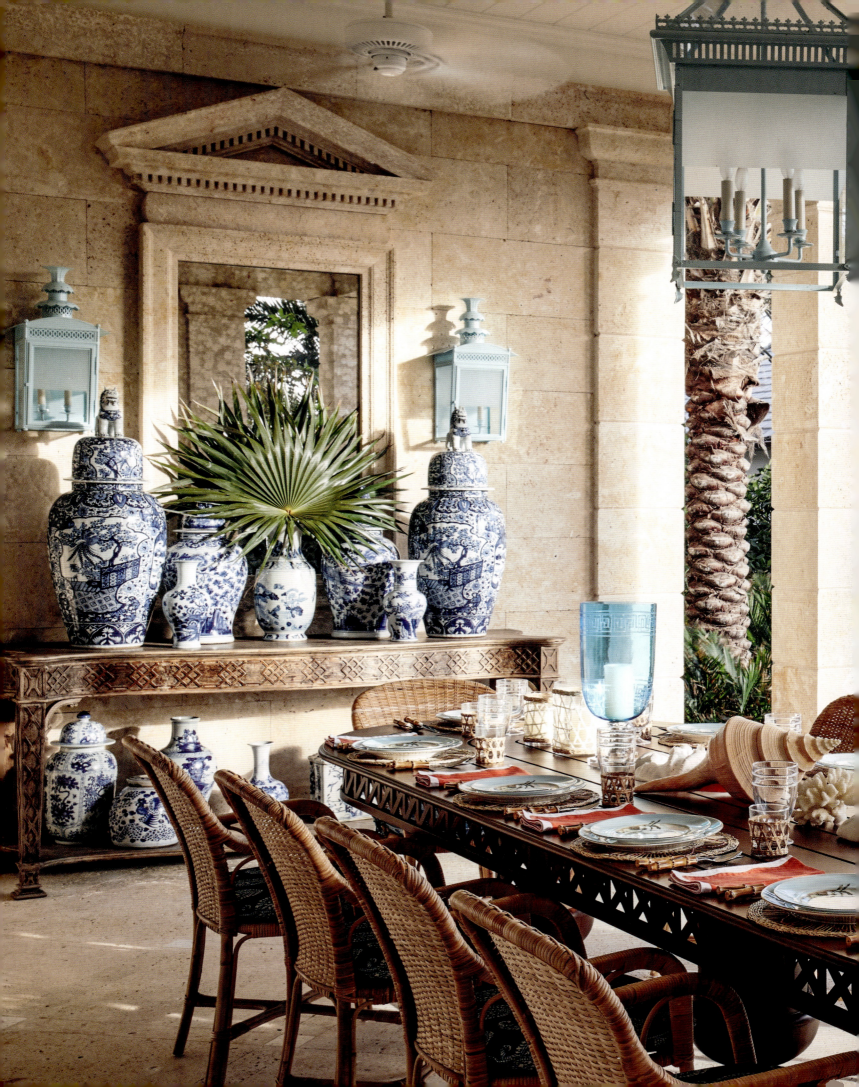

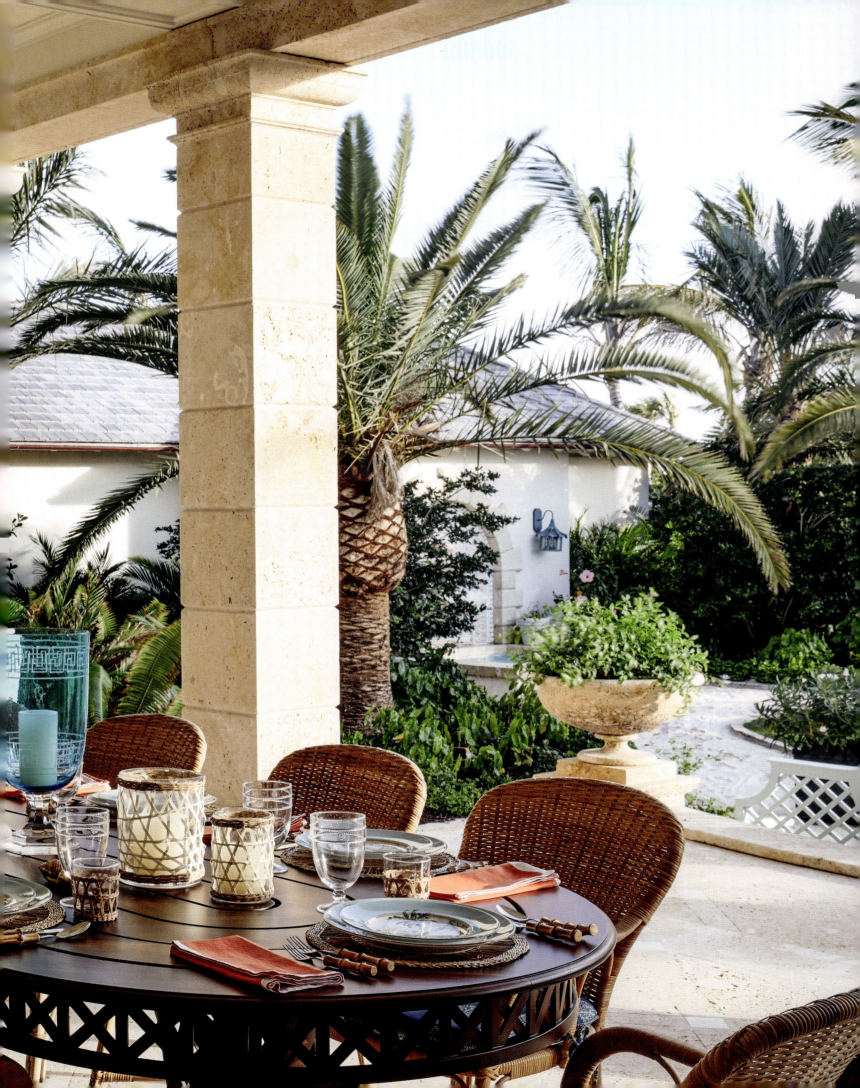

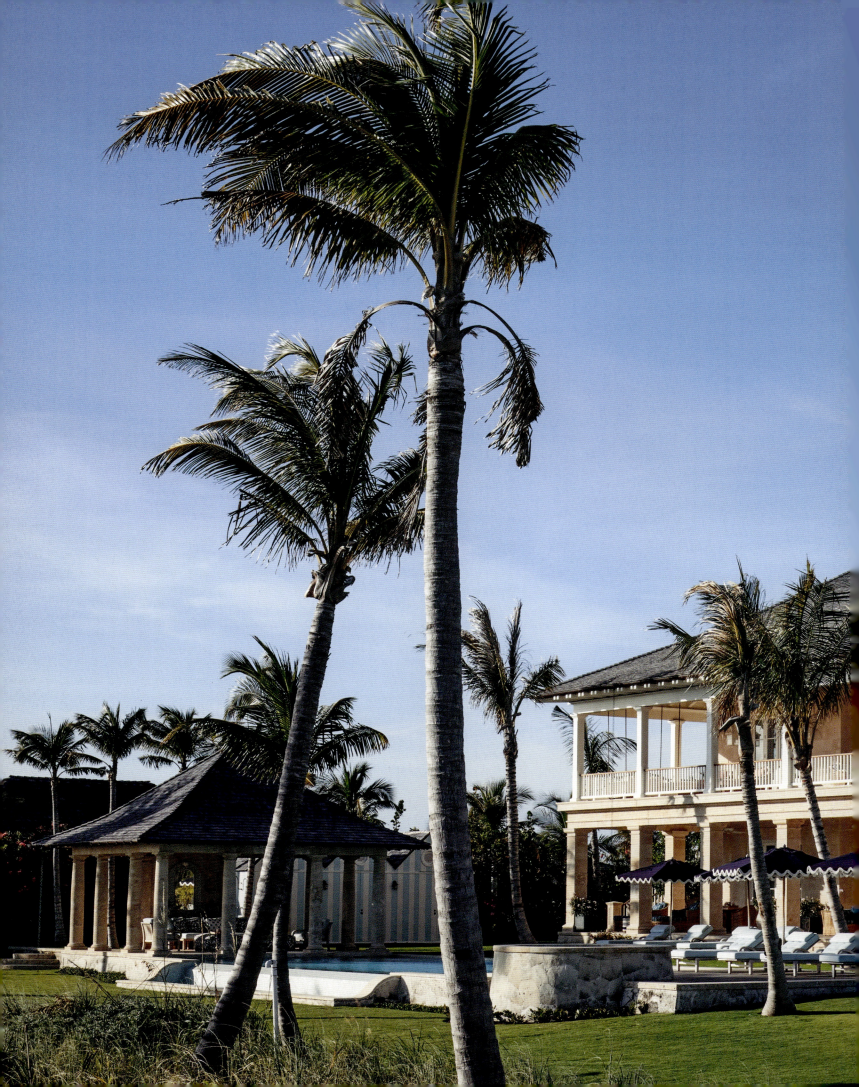

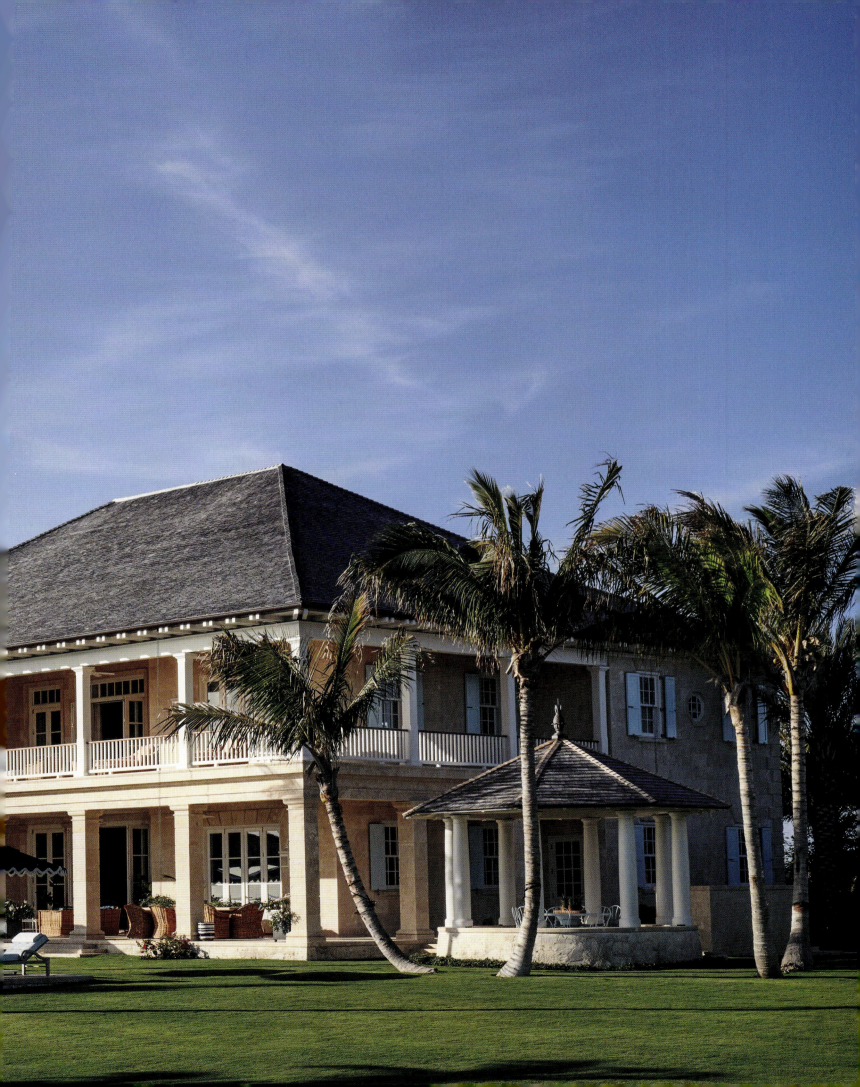

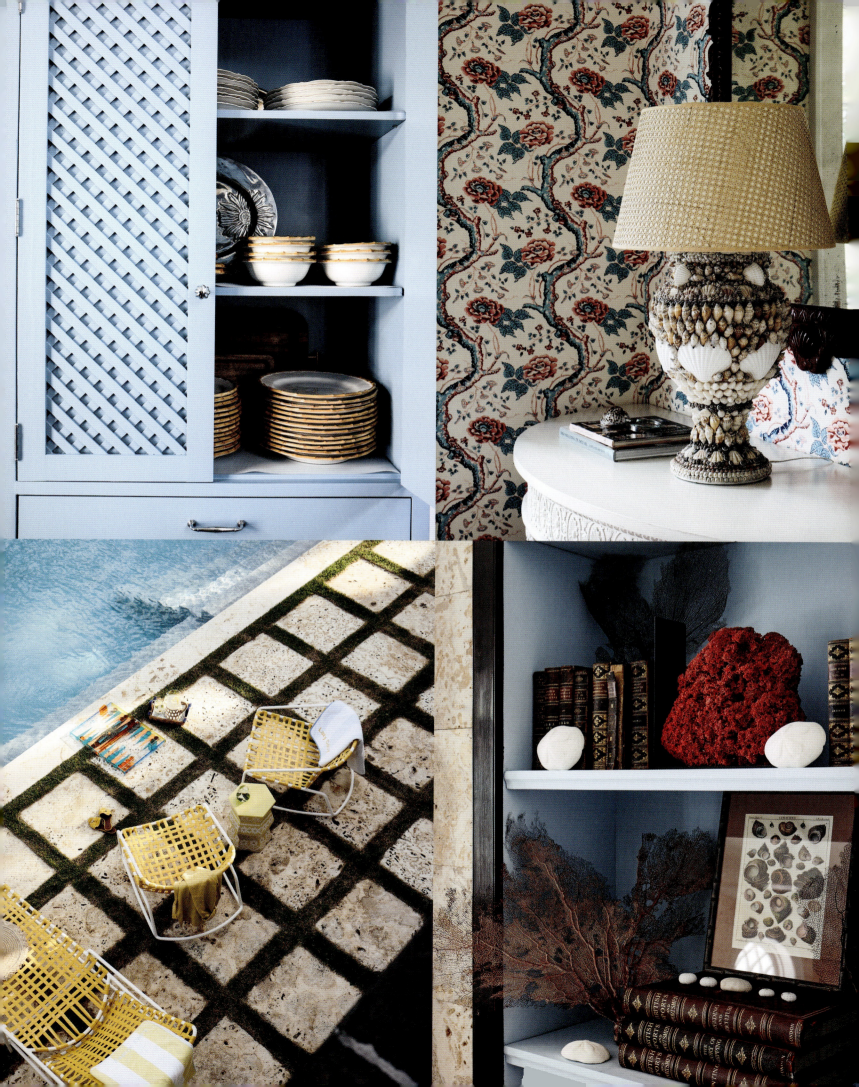

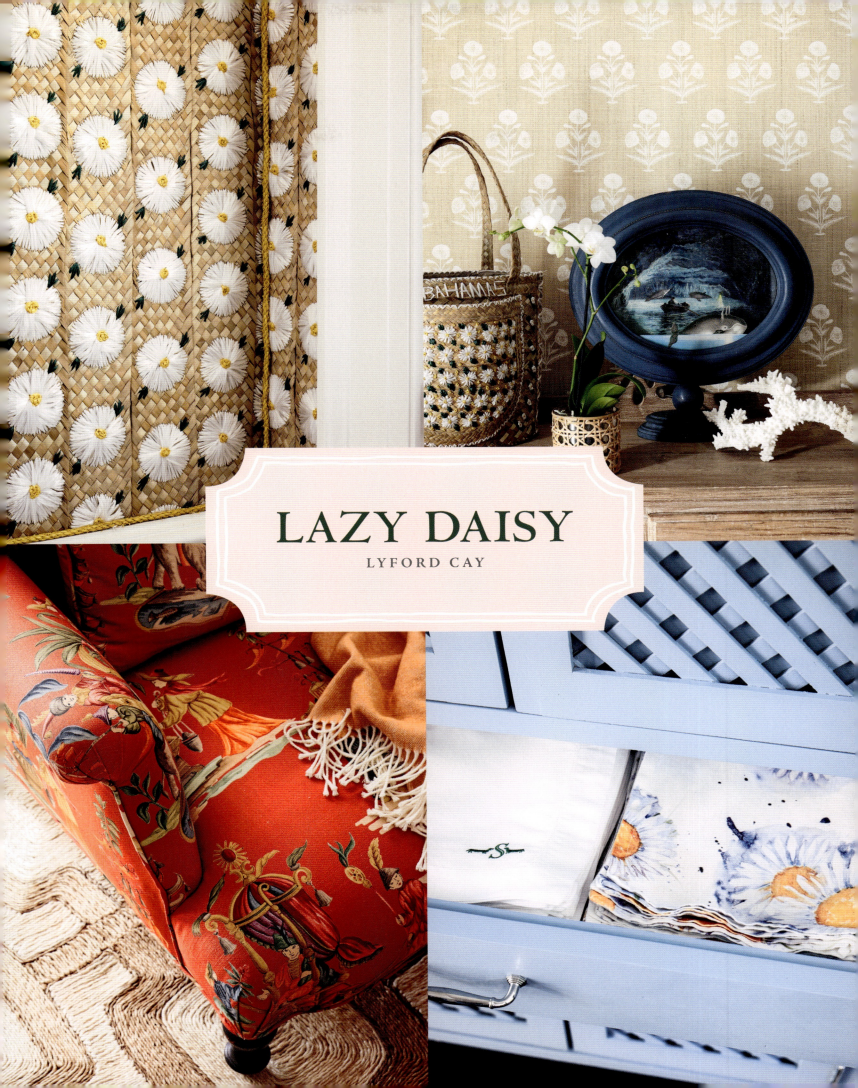

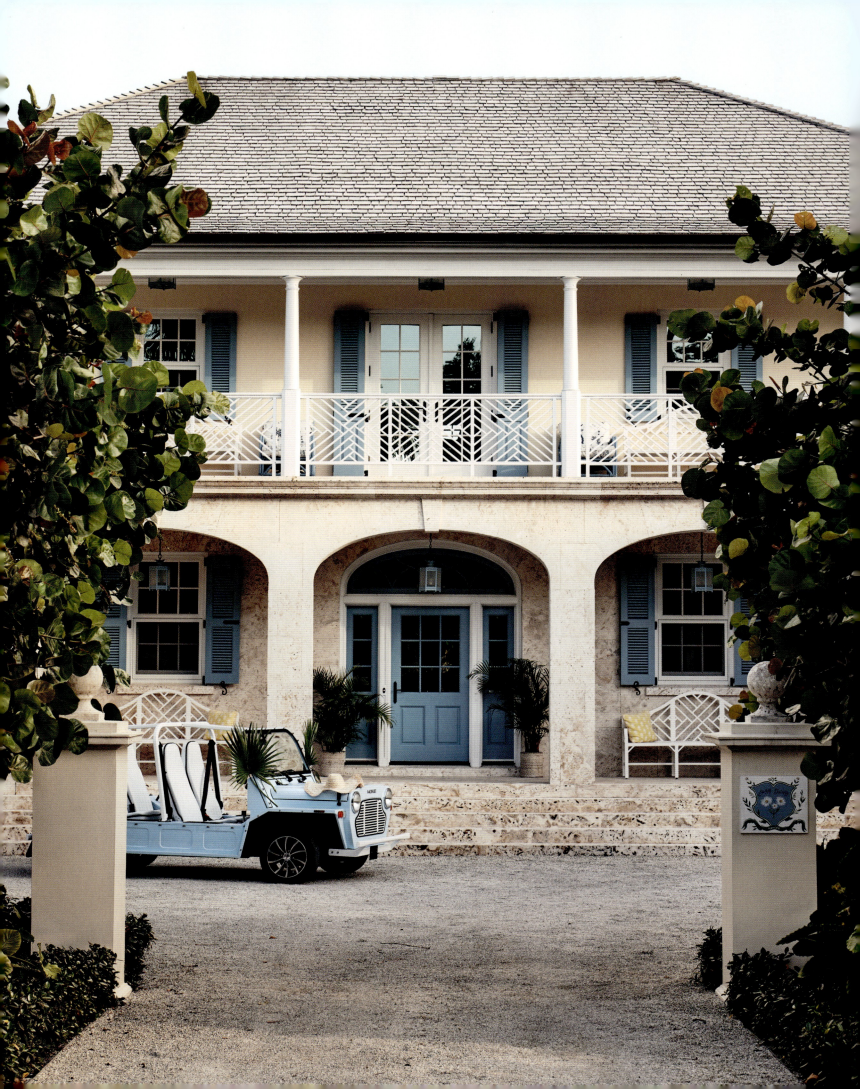

I n my twenties, when I was living in London, our friend group was a solid core of a half-dozen couples who were all working hard and starting families. We had dinner at least once a week and lunch every Sunday. On one such Sunday, we all marveled as baby Marguerite took her first steps, enticed by a chocolate-chip cookie that was dangled across the room as the prize. It was a special time with special memories. And in a remarkable bit of magic, everyone in this friend group has found their way, one by one, to the Bahamas.

A few years ago, when baby Marguerite's parents wrote to say they were contemplating building a house in Lyford, their email found its way to my junk-mail folder. After I heard through the grapevine that they were thinking about this, I bravely started to write an email to offer what I thought was unsolicited assistance, only to discover their months-old, unanswered correspondence!

How lucky I was to be able to help these beloved friends with the house that ultimately became known as Lazy Daisy, named after baby Marguerite, a grandmother Marguerite, and my friends' enchanting four-year-old granddaughter, Marguerite.

Marguerite is, of course, French for "daisy," and a daisy motif appears on everything from napkins to wallpaper, dishes to hand towels, and many other sundry items. We all jump whenever we see something daisy-embellished to add.

The daisy motifs are playful and fun, but the house was conceived as a "proper" abode in the classical Caribbean idiom. My friends live in a David Adler masterpiece in Fort Worth, one of only two Adler houses built in Texas. Originally built for a mother and daughter, the two majestic houses stand side by side. When tasked with assisting my friends with their island home, I knew I had a lot to live up to and could not let our end down!

I recommended that they hire architect Kiko Sanchez; they took my advice and got right to work dreaming and drawing. The mandate was clear from the start: the house had to be family-centric with the anticipation of lots of grandchildren in the near future. There are three grandchildren now and more in the works, as the original baby Marguerite and her two brothers are married or about to be.

The house has bedrooms galore, including a big bunk room that can sleep a veritable army of children. In the accompanying bathroom is an amusing bathtub from Drummonds in the UK

OPPOSITE: *The entrance to Lazy Daisy, flanked by sea grape trees.*
The matching color of the shutters and the Mini Moke was a bit of good luck.

that features portholes. When it arrived, we were tickled, if a bit shocked, to discover that the portholes are actually operable—surely an accident waiting to happen.

The house has all the bells and whistles of a Caribbean house of previous centuries: Palladian windows, mahogany floors, coralina walls inside and out, and verandas on both the first and second floors on both sides of the house. When the doors and windows are opened, there is a lovely cross breeze, all contemplated and planned.

The beautiful, lush garden surrounding the house and the long pool, flanked by the best garden follies on the island, were designed by Fernando Wong.

When the family is in residence, one can often find them congregated on the back veranda, laughing and playing games, seated on giant vintage rattan sofas and chairs we found in the Midwest and had trucked and shipped here to create this perfect family spot.

We could not be more delighted by all the magic that happens at Lazy Daisy, and we are so grateful to have been a part of it all.

RIGHT: *In the living room, the sofas are upholstered in Quadrille's Kalamkari and the rug is a Patterson Flynn abaca.*

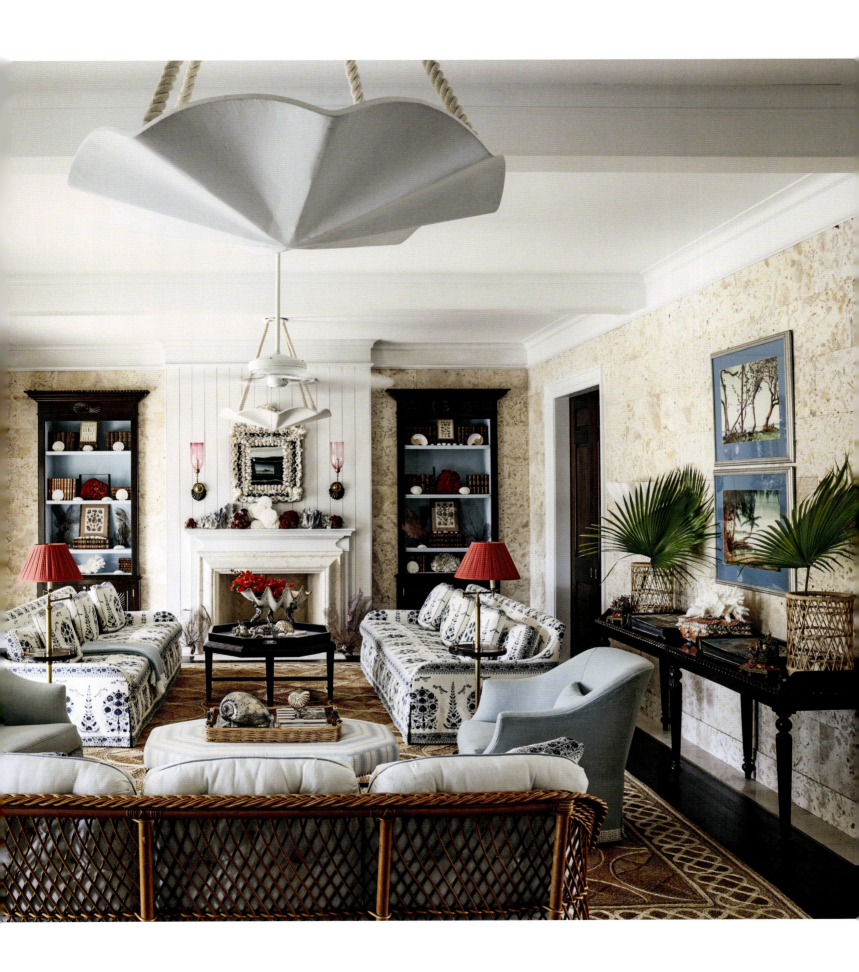

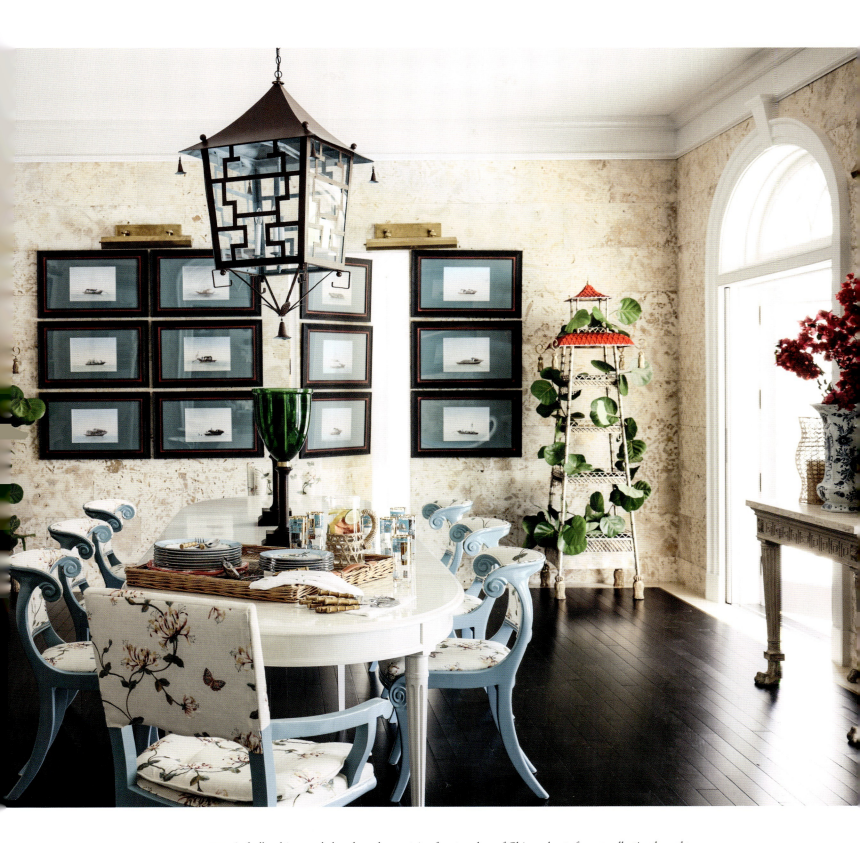

OPPOSITE: A chalk-white curule bench anchors a trio of watercolors of Chinese boats from a collection brought home to Sweden by the Swedish East India Company. ABOVE: In the dining room, more watercolors of Chinese boats cover a wall, including a jib door. Sea grape branches from the garden jauntily climb the metal pagoda étagères, which the clients purchased from the Greenbrier Hotel gift shop.

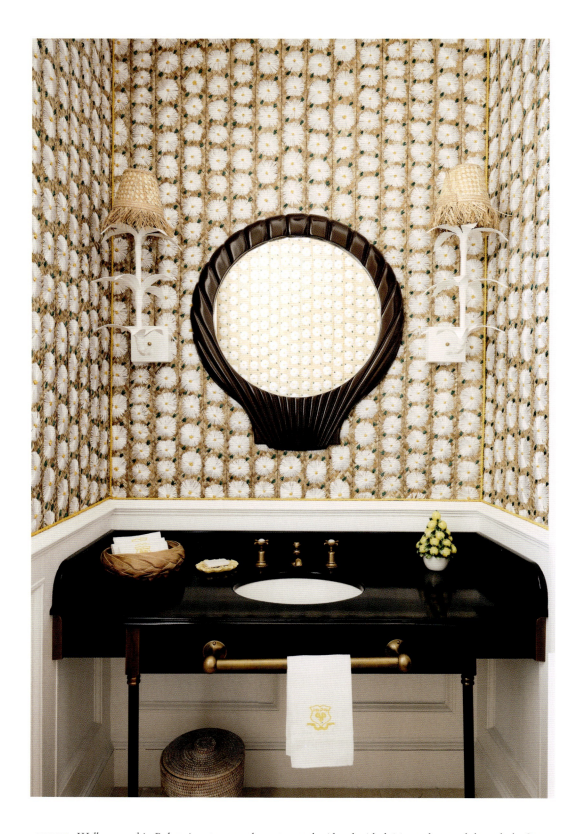

ABOVE: Walls covered in Bahamian straw work, custom embroidered with daisies and sourced through the Straw Shack in Nassau, enliven the powder room. OPPOSITE: Charming watercolors of the Bahamas hang above a vintage Bielecky Brothers sofa. OVERLEAF: In the kitchen, old-fashioned, geometrically patterned black-and-white linoleum floors and black soapstone countertops anchor the whimsically trellised cabinets and range hood.

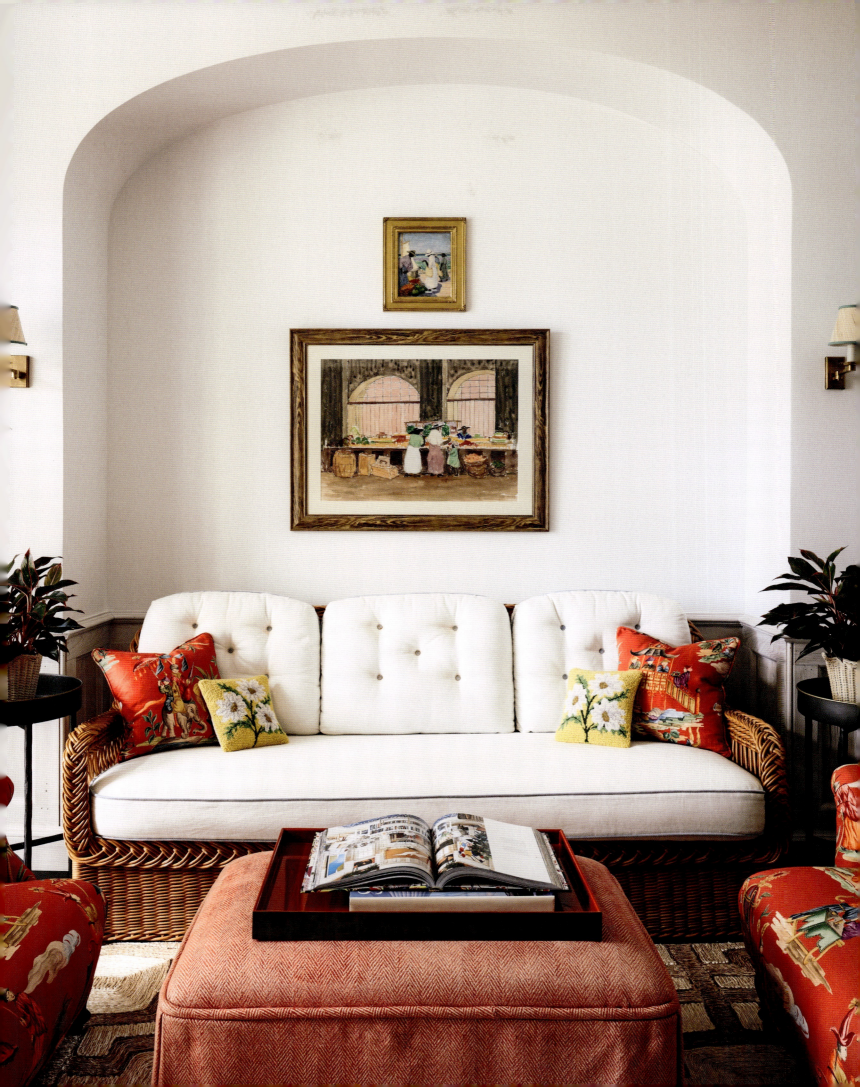

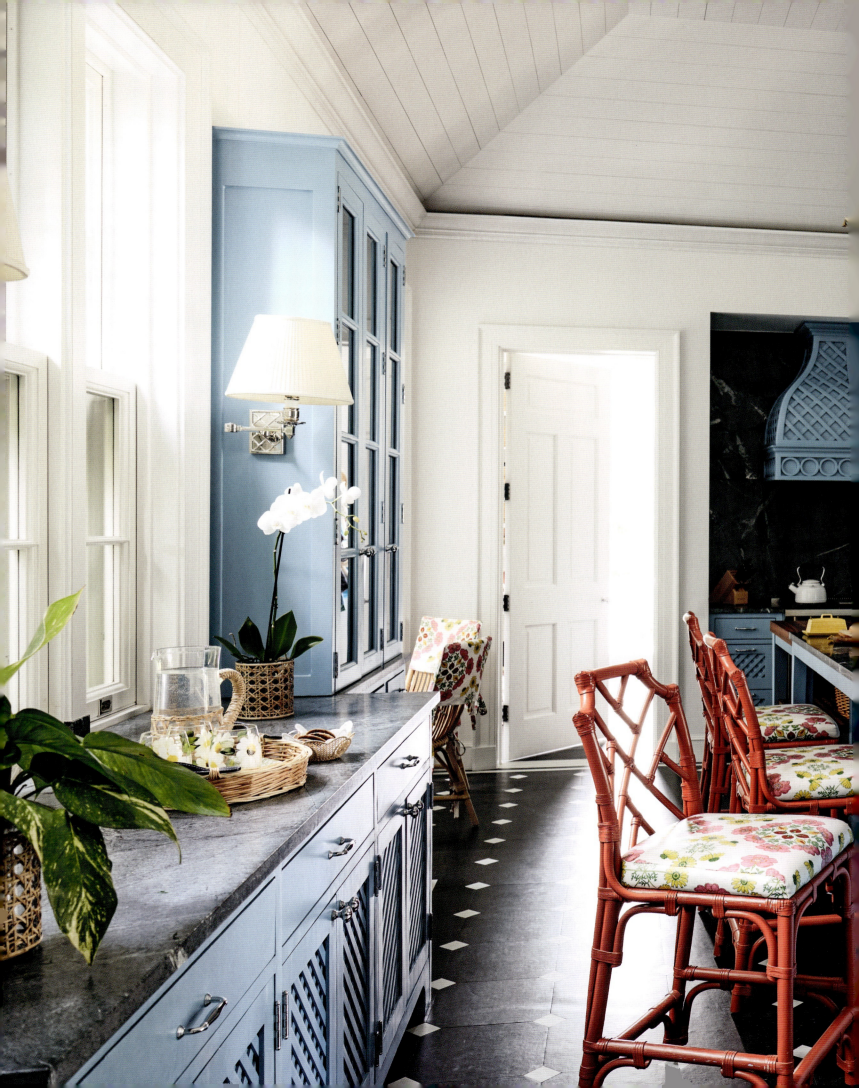

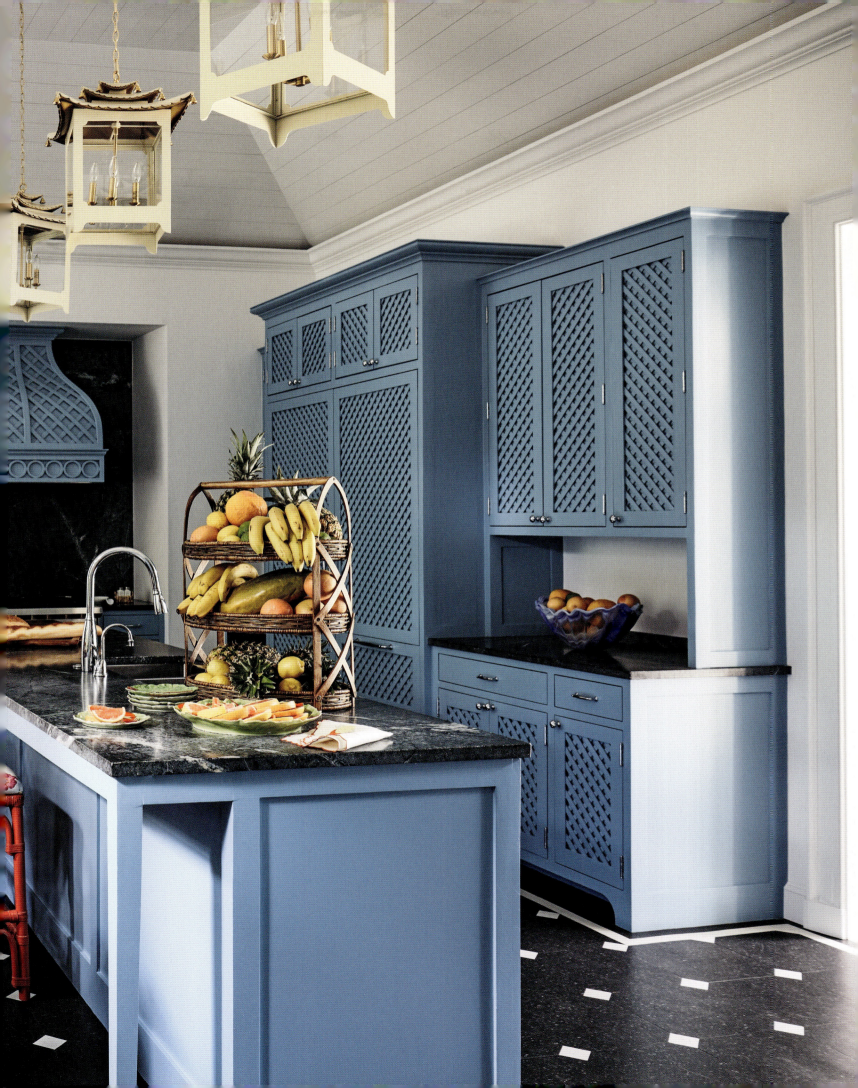

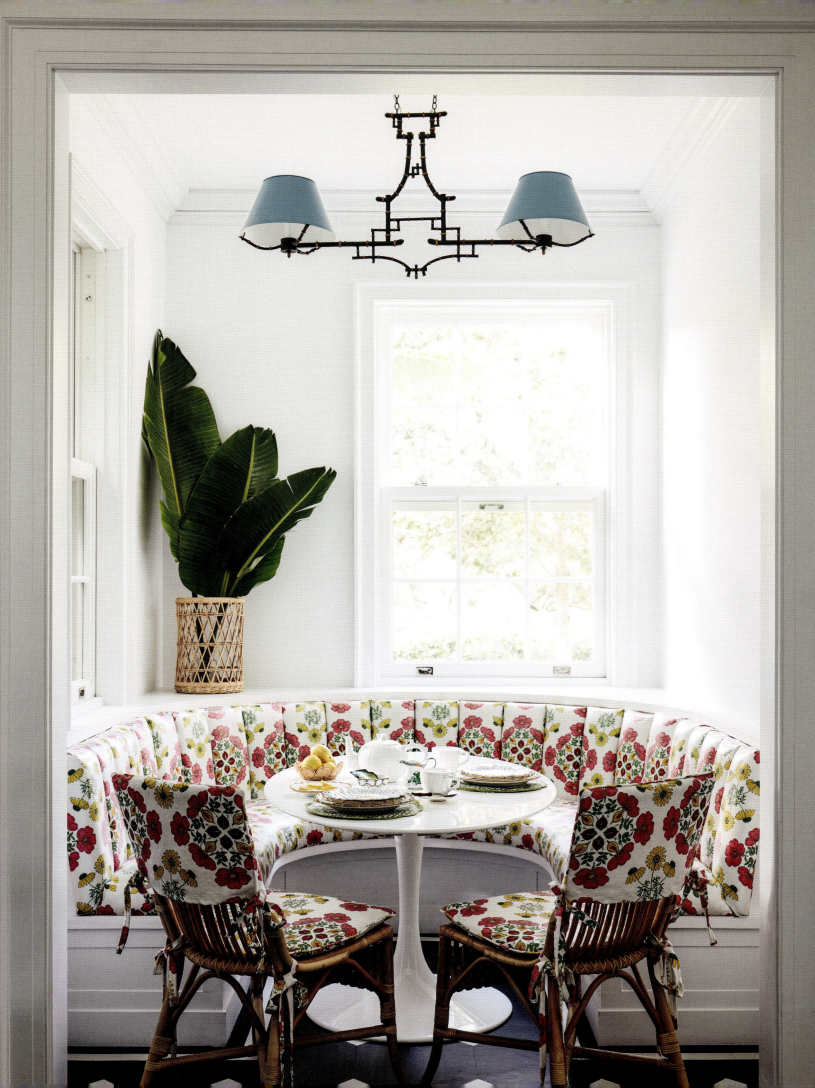

OPPOSITE: *The chairs and a built-in banquette in the cozy breakfast nook are clad in a daisy-and-poppy-patterned fabric from Raoul Textiles.* RIGHT: *In the pantry, the cabinets have a decoratively frilly design.* BELOW LEFT: *Tall, trellised cupboards hold tableware.* BELOW RIGHT: *Glass-fronted cabinets display an amusing collection of Royal Bayreuth Lobster porcelain bought at auction.*

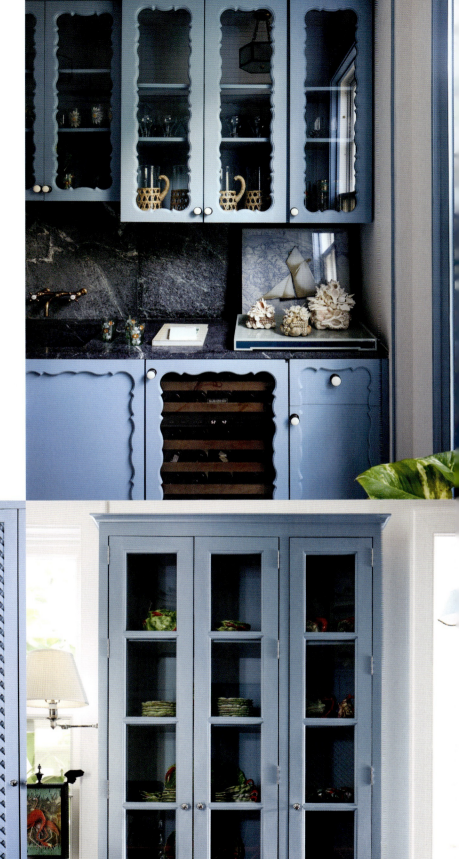
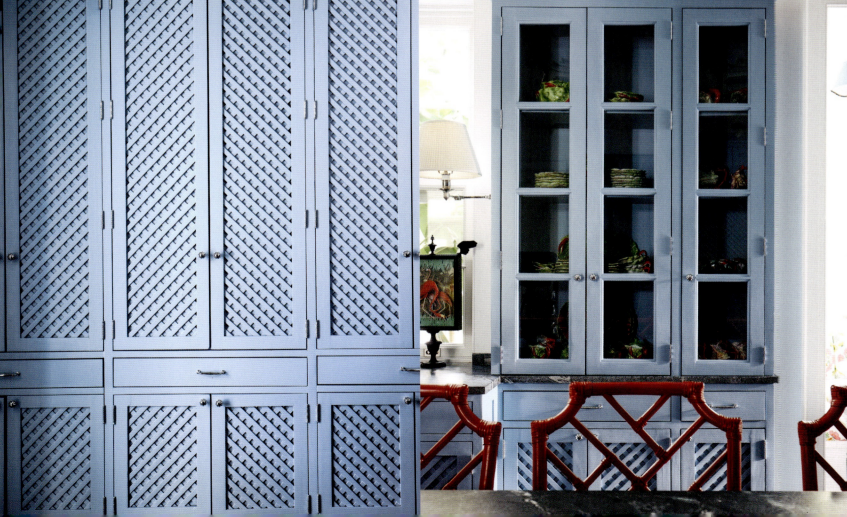

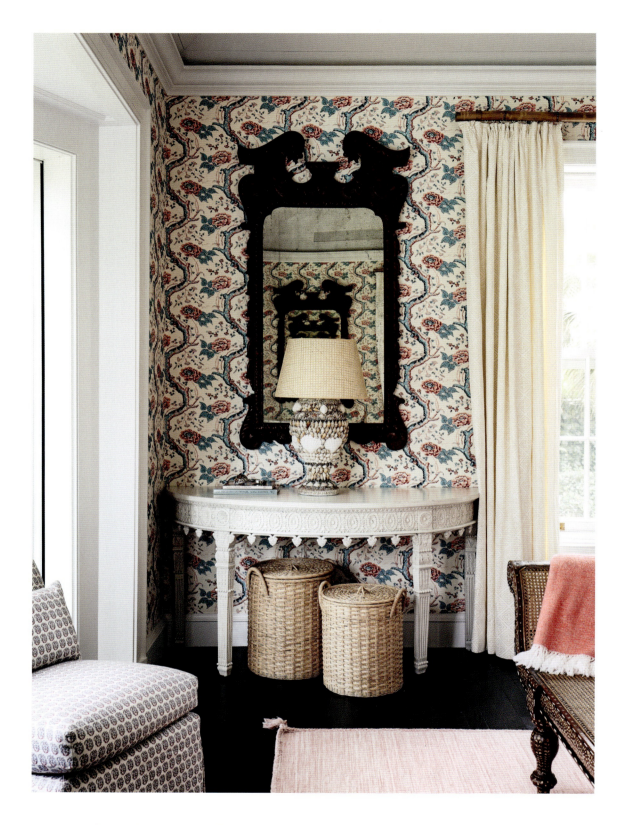

ABOVE: Local wallpaper installer Wellington Pinder applied Quadrille's Tree Peony to the walls of the primary bedroom. A pair of red, pedimented mirrors and white demilune consoles add charm. OPPOSITE: The bedroom is furnished with a glamorous, sky-high four-poster bed draped in white linen and an elaborately inlaid, cane-seated Indian settee. The pillows and shams wear D. Porthault pillowcases.

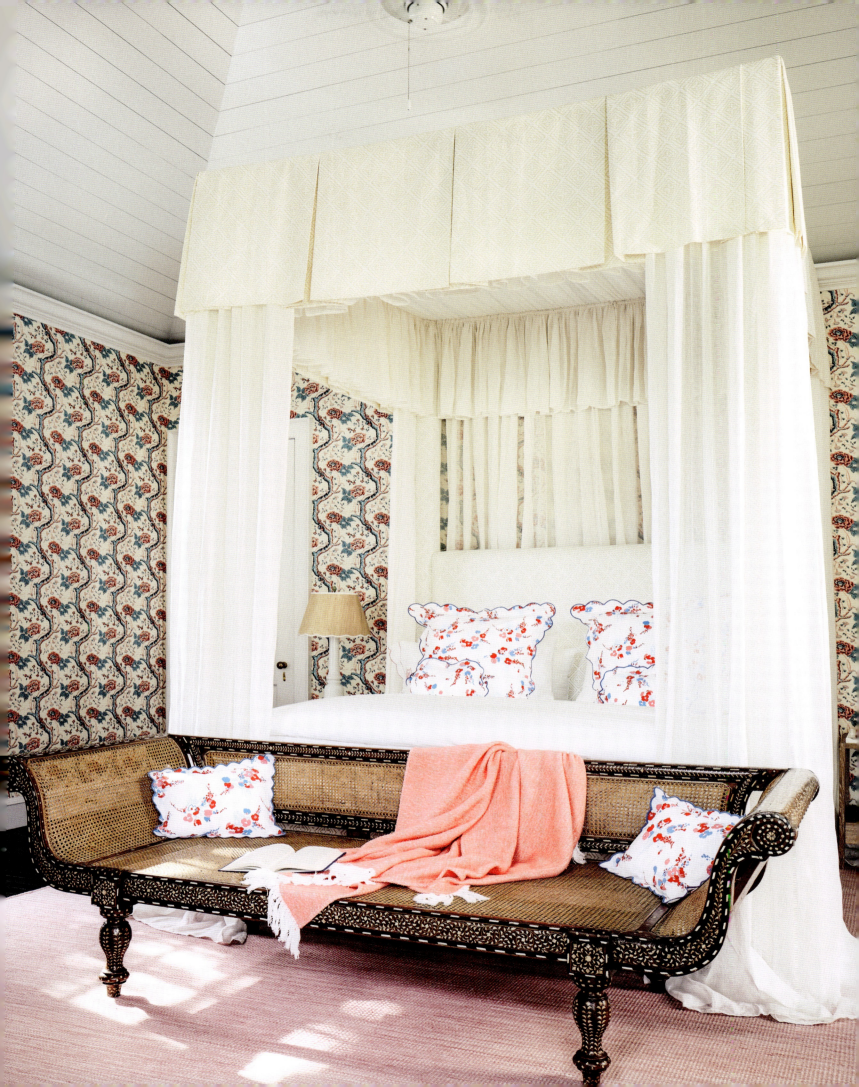

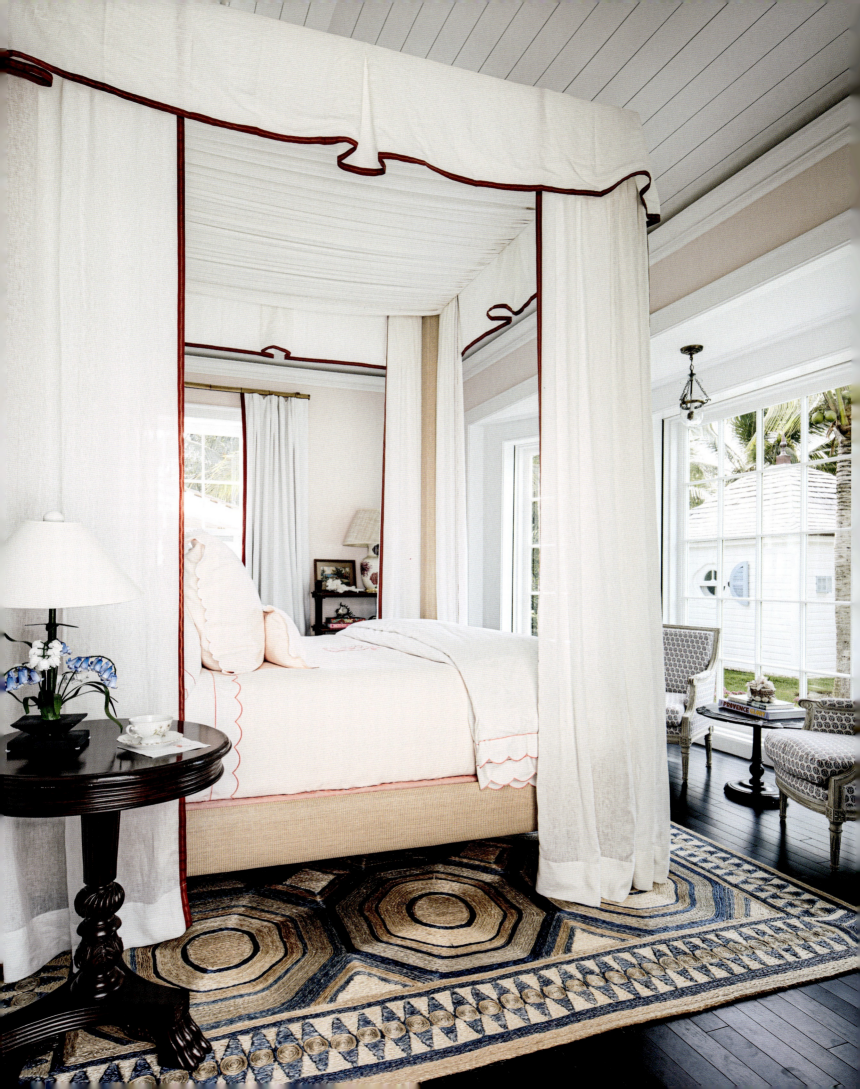

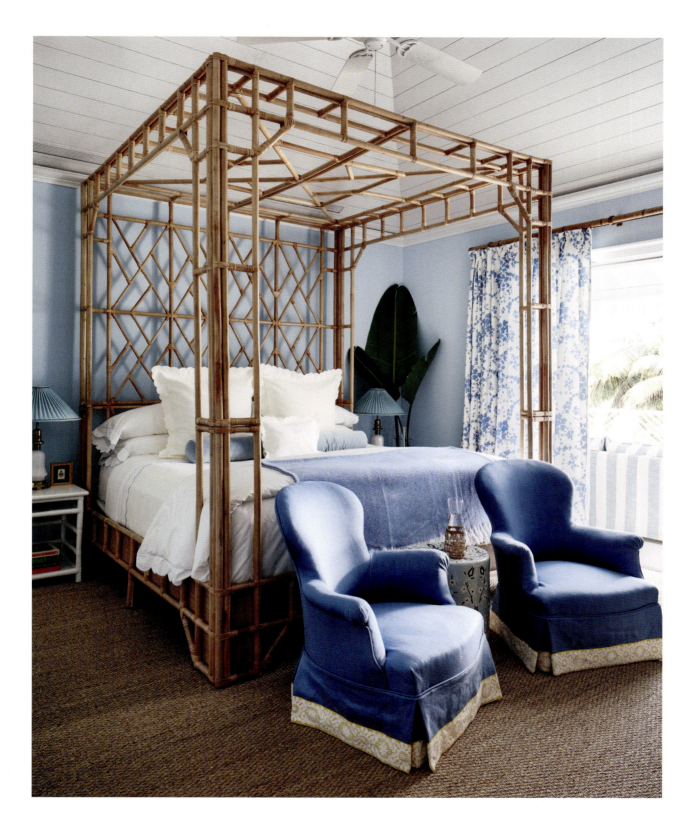

OPPOSITE: *In this guest room, pale pink Matouk bed linens dress the airy four-poster bed made by local upholsterer Lathen Ferguson.* ABOVE: *Another guest room features a Lindroth rattan four-poster bed.* OVERLEAF: *A Raj Company teak four-poster bed, Matouk linens, and Alessandra Branca's Papavero printed-seagrass wall covering create a soothing atmosphere in this guest room.*

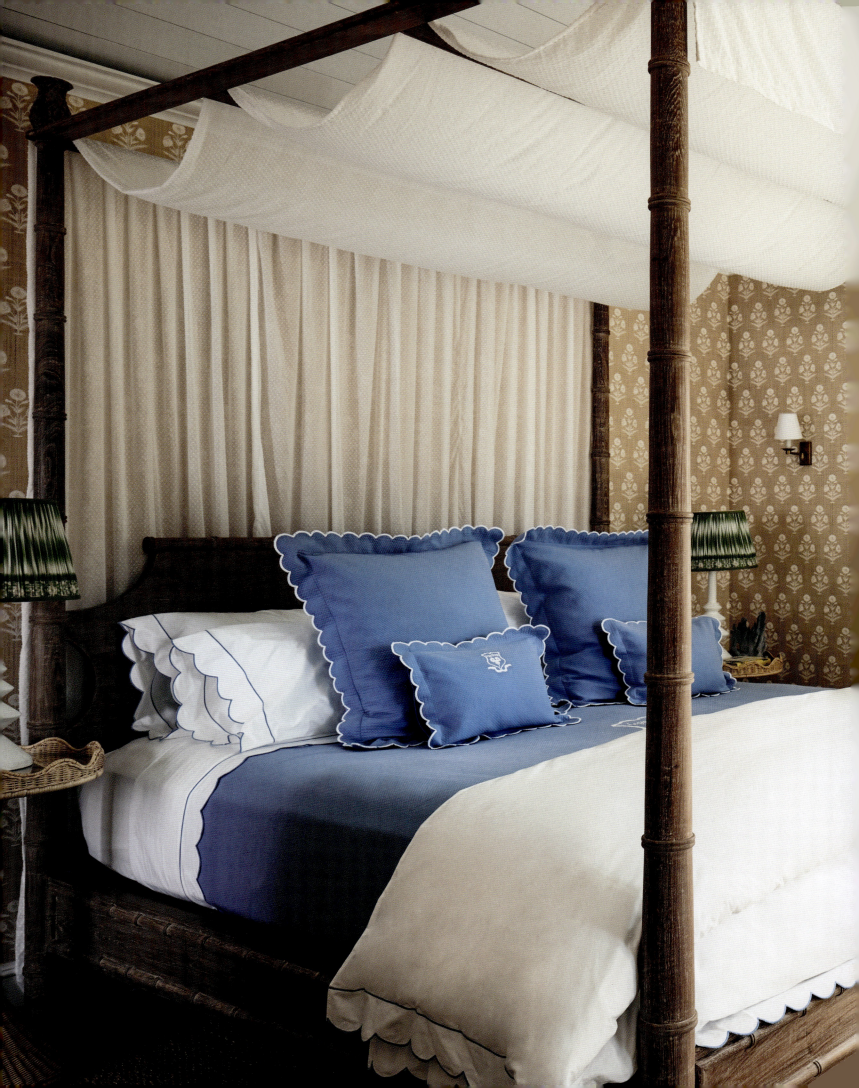

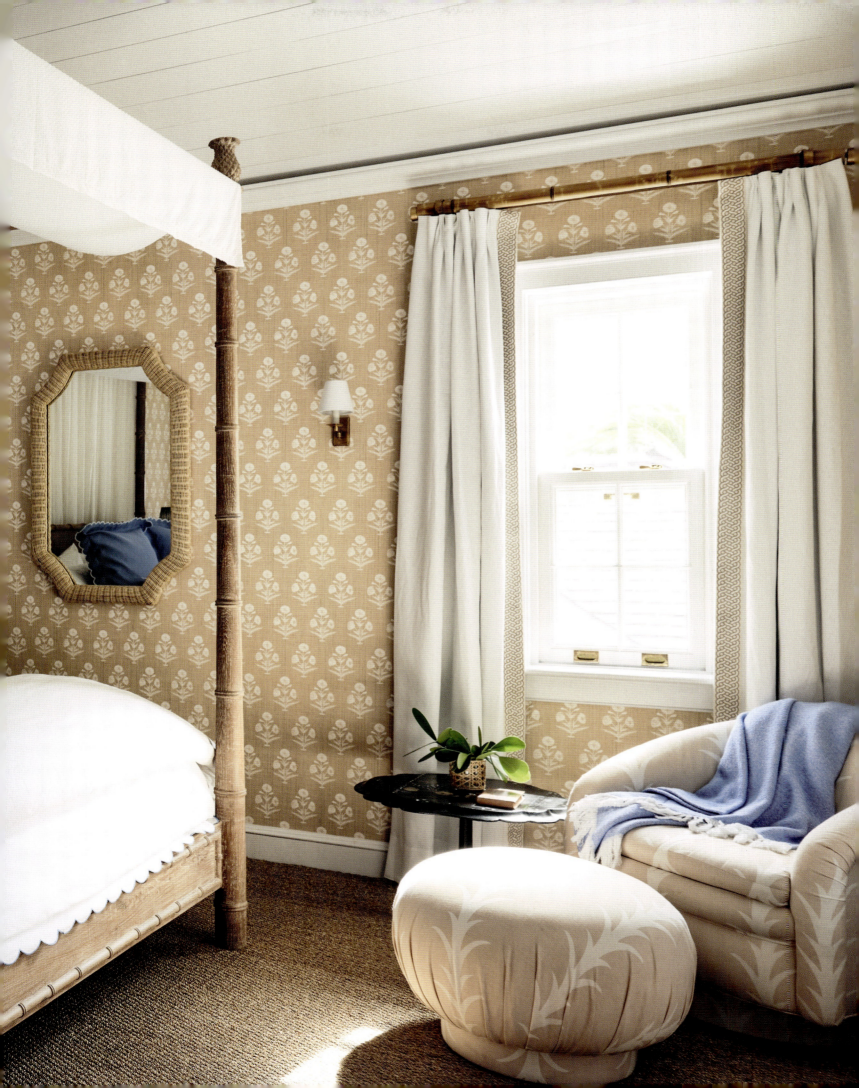

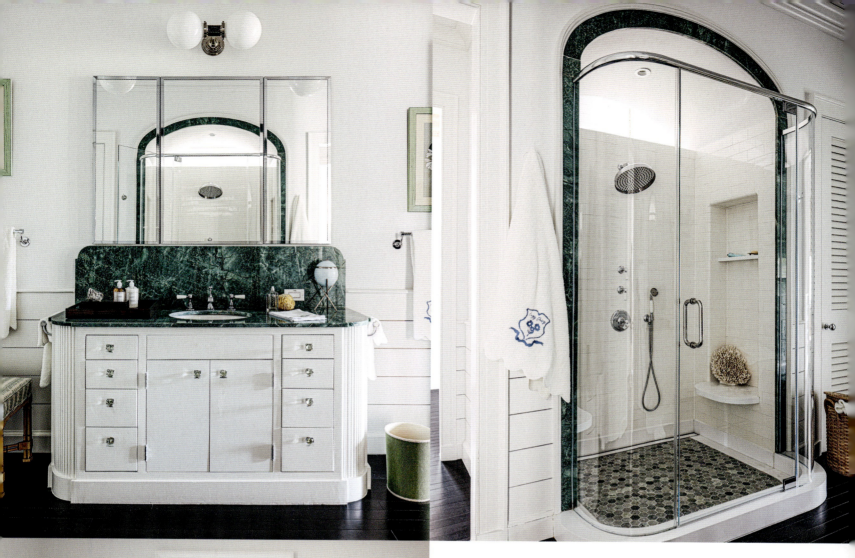
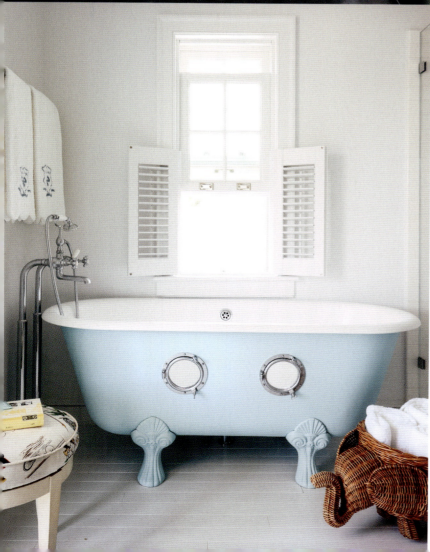

CLOCKWISE FROM ABOVE LEFT: A shiny white vanity boasts a Ming Green marble top and backsplash. Ming Green marble also rims this unique shower, which was inspired by one designed by Maria de la Guardia. Antique shell prints hang above a freestanding cast-iron tub. Stunning blue Makuba marble covers the top, backsplash, and shelf of a vanity in a guest bathroom. A bathroom and dressing room enfilade features pink quartz countertops, monogrammed Lazy Daisy towels, and upholstery and blinds in Quadrille's Henriot Stripe. An amusing bathtub with working portholes was painted robin's-egg blue to lend charm to a children's bathroom.

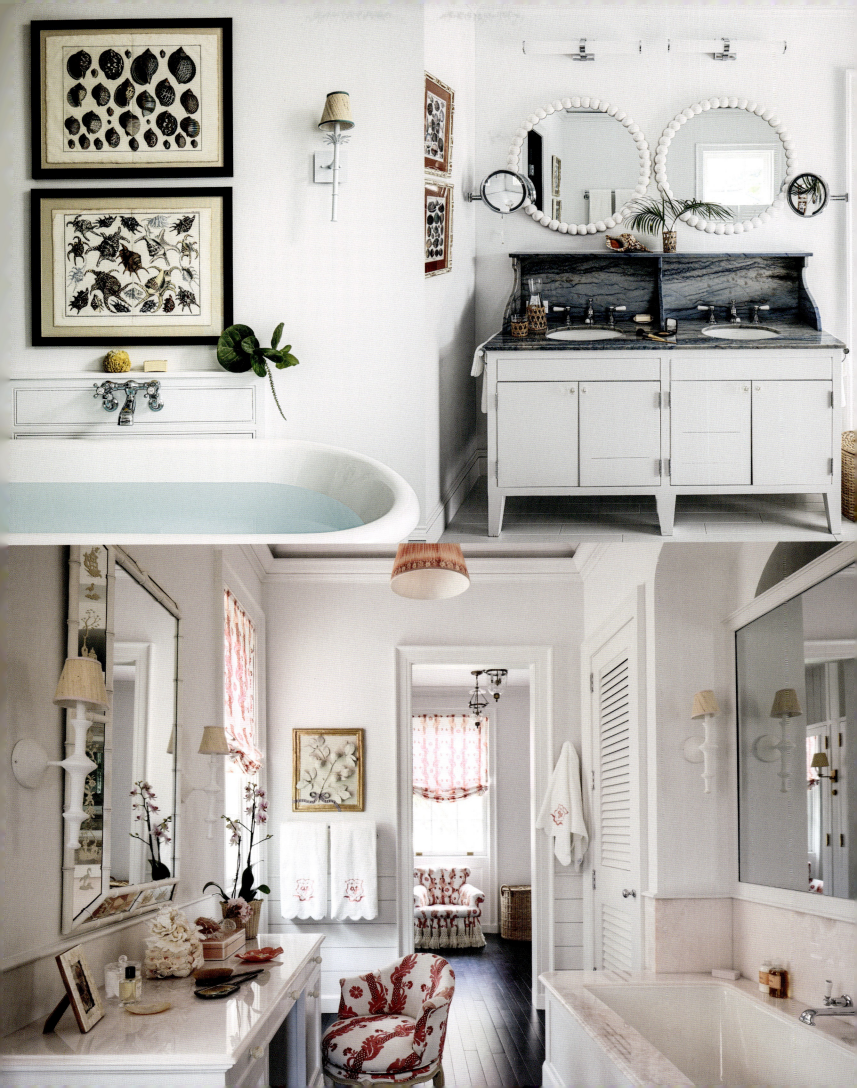

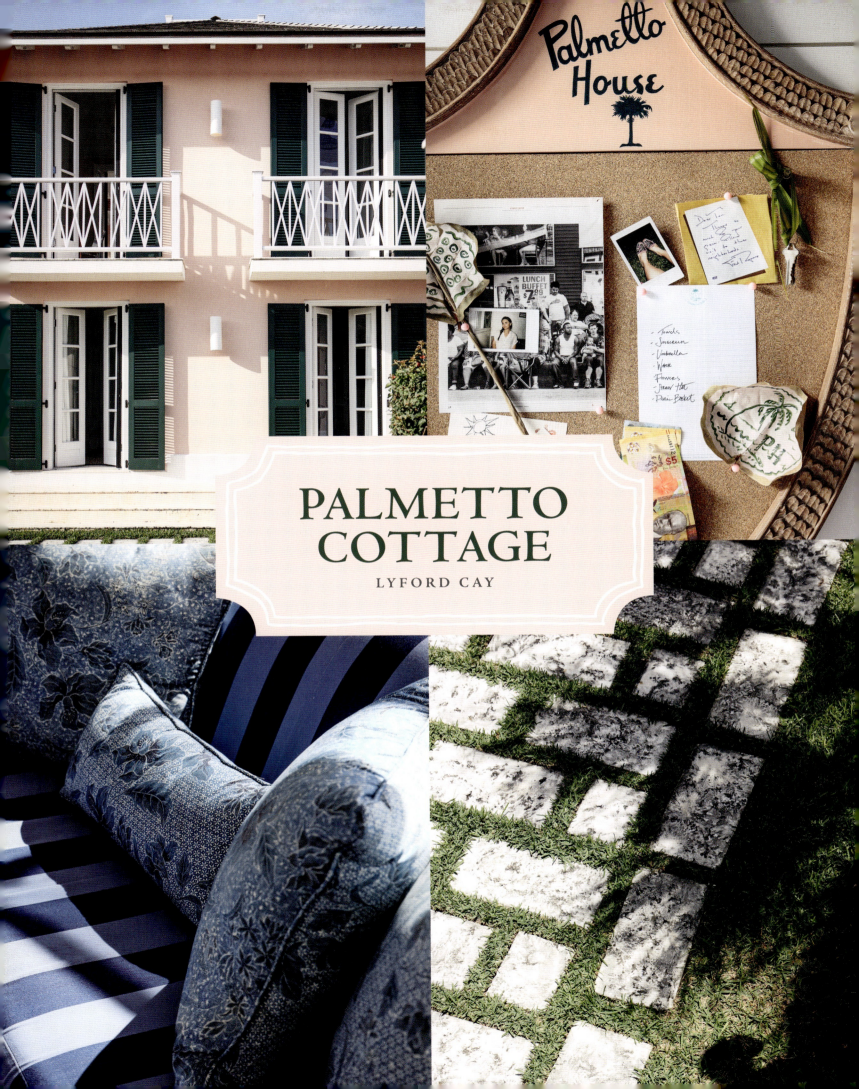

PALMETTO COTTAGE

LYFORD CAY

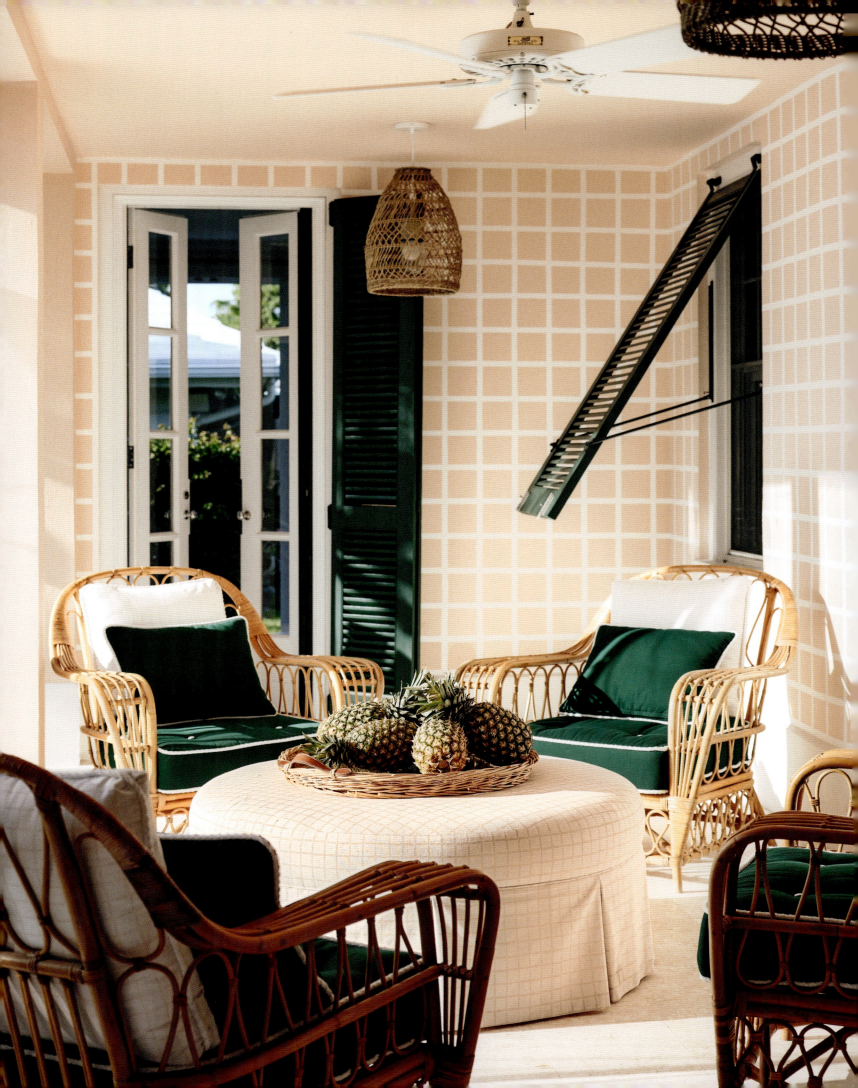

Having redone Palmetto House—our friends' main house in Lyford Cay—a number of years ago, we were delighted to be asked to build a folly of a guesthouse on the side of the property. The mandate was to devise a guesthouse for visiting friends and family that could also double as a place for everyone to gather for cocktails. Apart from the three guest bedrooms and an office, the entire entertaining space is open air on three levels. The owners were initially skeptical about opening the living room on the second floor to the elements but now can't imagine it without the cooling breezes year-round.

An amusing "widow's walk" on the roof is the ideal spot for a sunset cocktail. It is worth the tricky cocktail-in-hand climb up the spiral staircase to see the beautiful setting sun over Clifton Bay and the Lyford Cay Club beaches. There is not another like it in Lyford.

Architect Kiko Sanchez designed the cottage. Wanting the ultimate Lyford look, we "borrowed" a Lyford-y idiom, painting a trellis motif on the walls of the covered sitting room on the ground floor. An ottoman is upholstered in a fabric that mimics the trellis—a lucky find. Fabrics are deliberately basic and robust. We used a dark green high-performance fabric to match the shutters on the ground floor and navy stripes and batiks on the second floor.

The bedrooms are furnished with four-poster beds draped in Quadrille printed cottons and capacious hand-carved, cerused-teak armoires for easy and neat unpacking. Built-in closets accommodate hanging clothes and luggage. The spaces were designed to be compact but impeccably solicitous of guests. Each room also has a special notice board for invitations, images, and secret messages. It is a playful gesture unique to this cottage.

A small office was included in the plan. It is a quick walk from the main house and a quiet place to work away from the normal comings and goings of a busy and happy holiday house.

The owners consider the little folly chic, playful, practical, and the most quintessentially "Lyford" structure built in many years We designed it to be full to the brim with guests during the weeks of the year when Lyford is at its most dazzling: Thanksgiving, Christmas, and Easter. We look forward to Palmetto House's annual New Year's Day Fried Chicken and Champagne open house, when we all gather for a New Year's toast at the top of the cottage at sunset.

OPPOSITE: *The crisscross pattern on the walls was created by local artist Therron Davis. The "matching" fabric on the ottoman is from Tillett Textiles.* OVERLEAF: *An open-air living room on the second floor has views of both the sea and the golf course and is cooled by breezes all year long.*

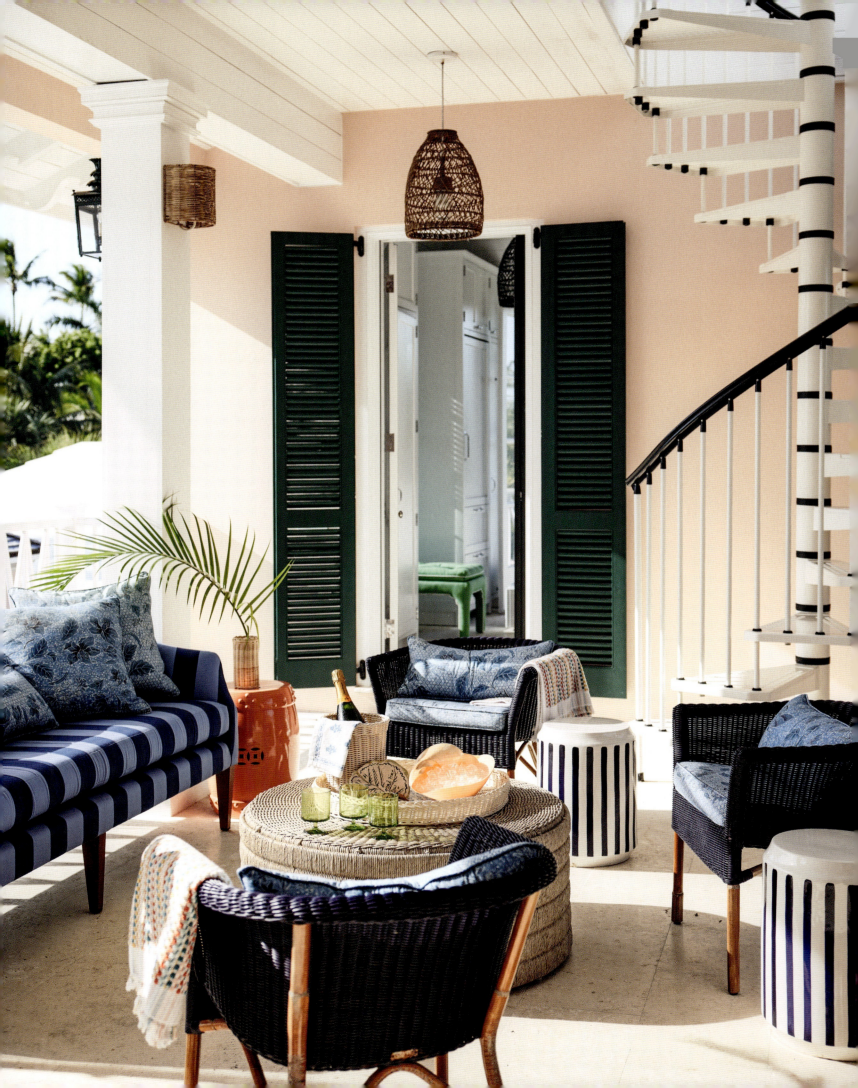

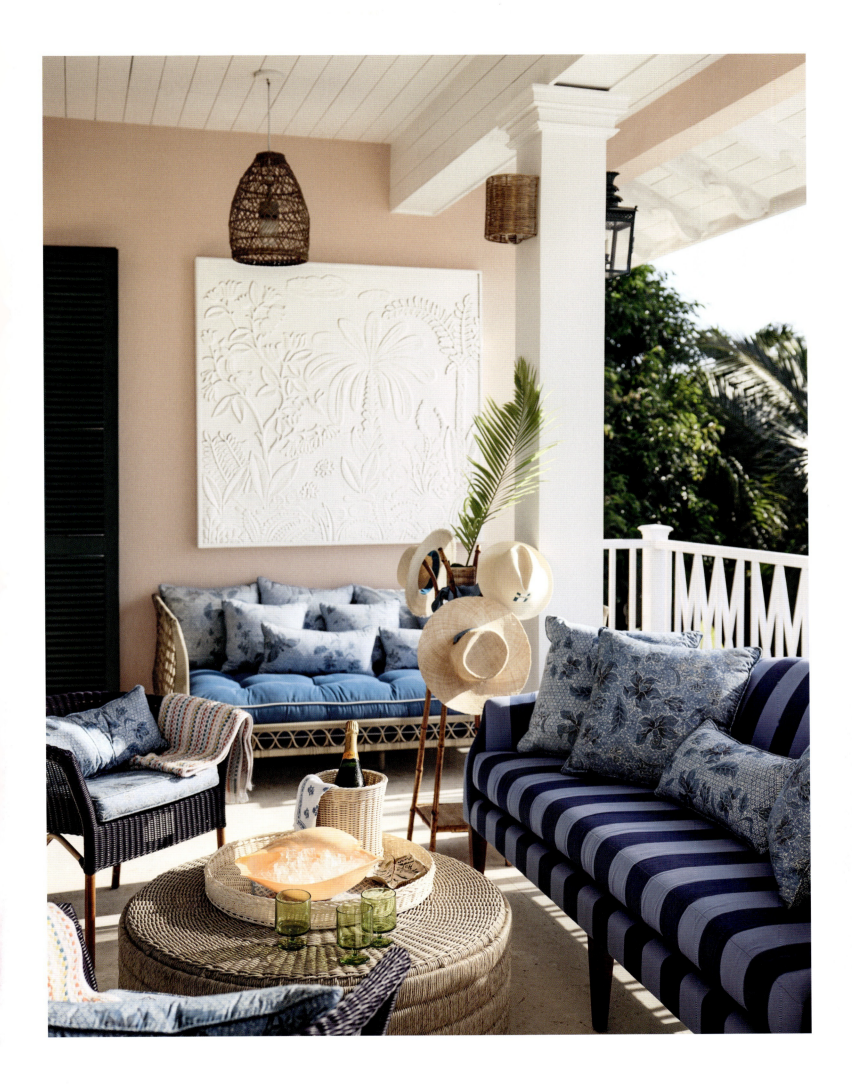

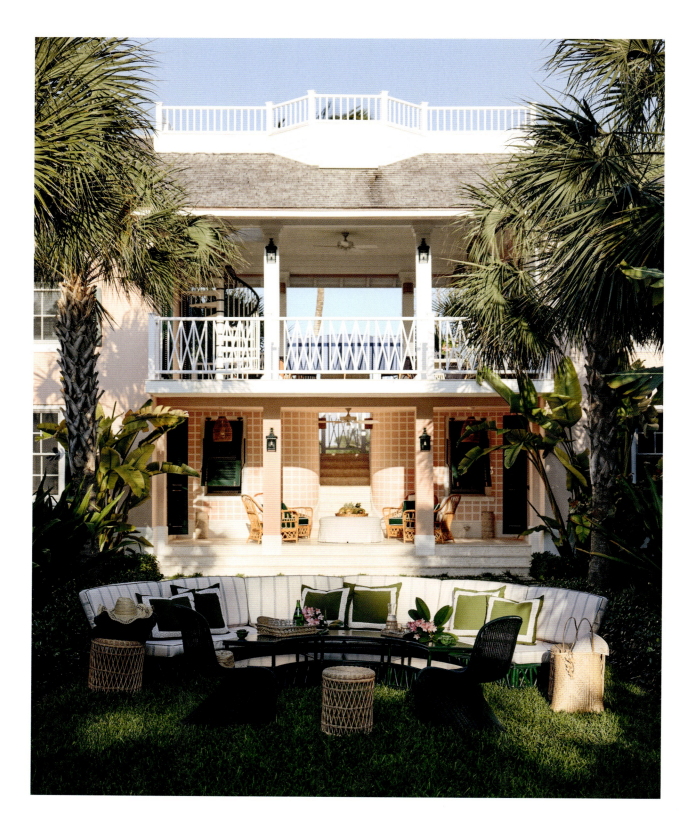

ABOVE: A giant vintage rattan sofa is shielded from direct sunlight by the tall palms. It is the perfect place to read a book or take an afternoon snooze. OPPOSITE: Exterior views of the charming guesthouse, including its famed "widow's walk," designed by Kiko Sanchez of FGS Design.

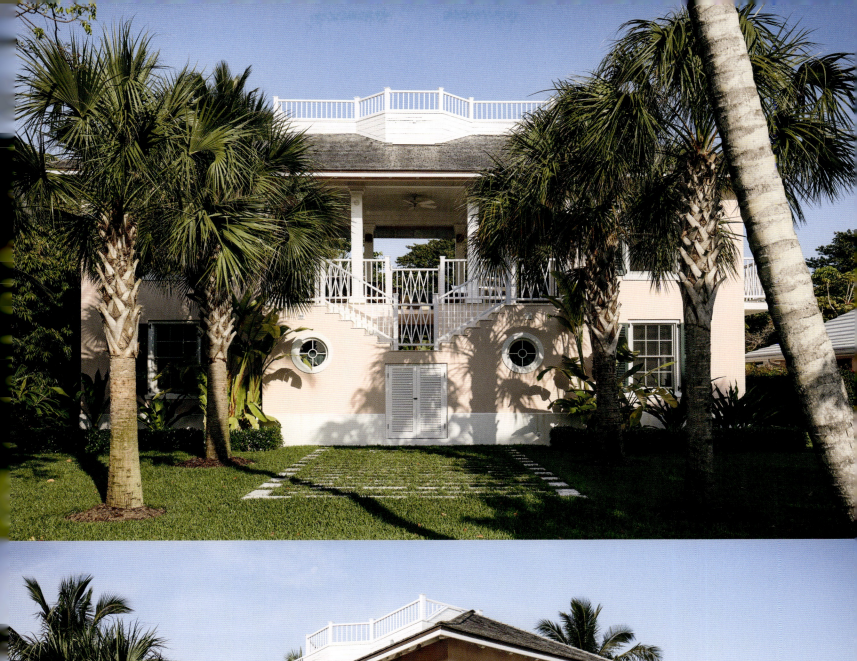
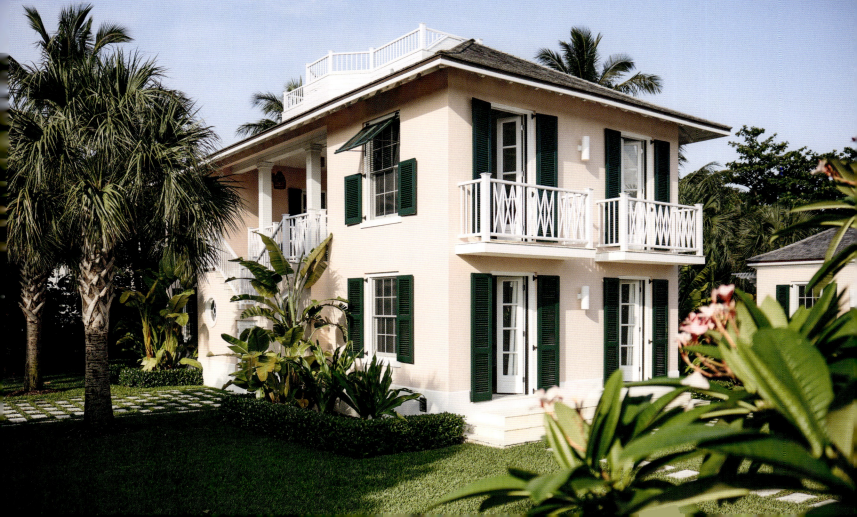

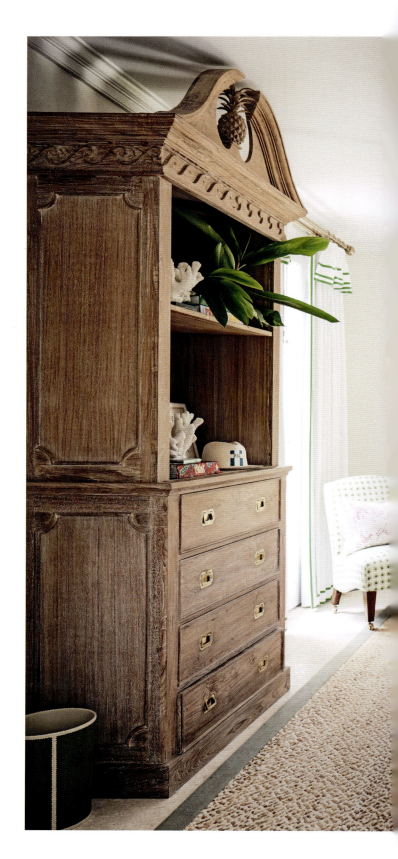

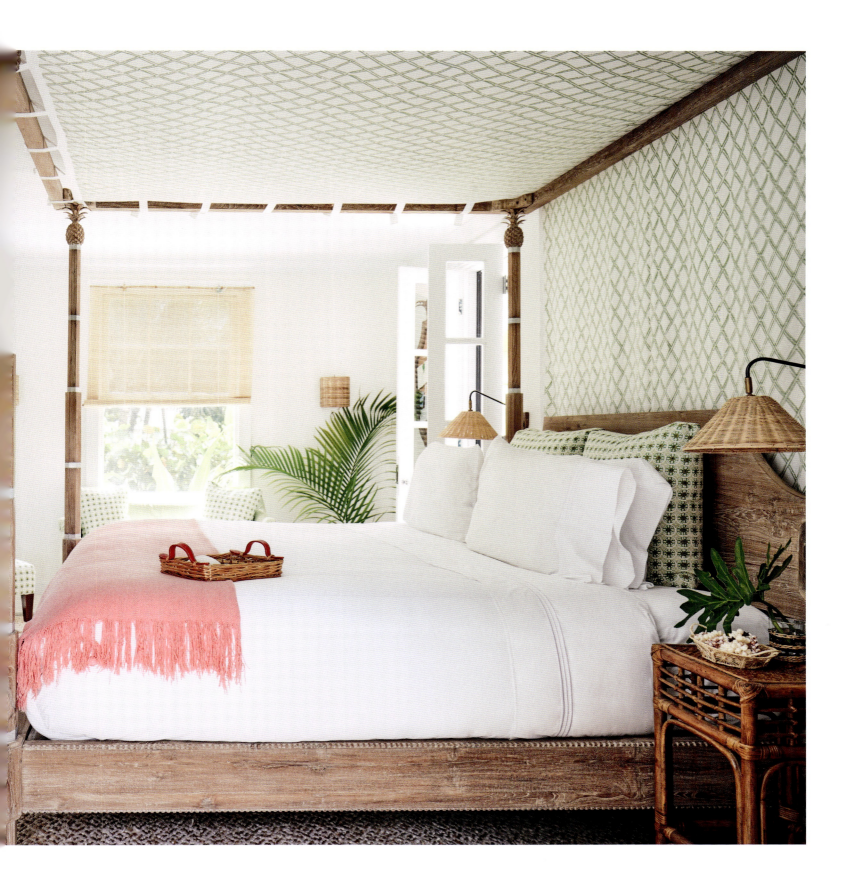

OPPOSITE TOP: *A Raj Company cabinet ornamented with carved waves and a pineapple.*
OPPOSITE BOTTOM: *A throwback to analog times, the charming notice boards that the Raj Company has created for Palmetto Cottage encourage visitors to post invitations and photos.* ABOVE: *In one guest suite, a Raj Company bed is draped in China Seas' Lyford Diamond Bamboo fabric.* OVERLEAF: *In another guest suite, a nearly identical Raj Company bed is draped in China Seas' Lyford Diamond Blotch.*

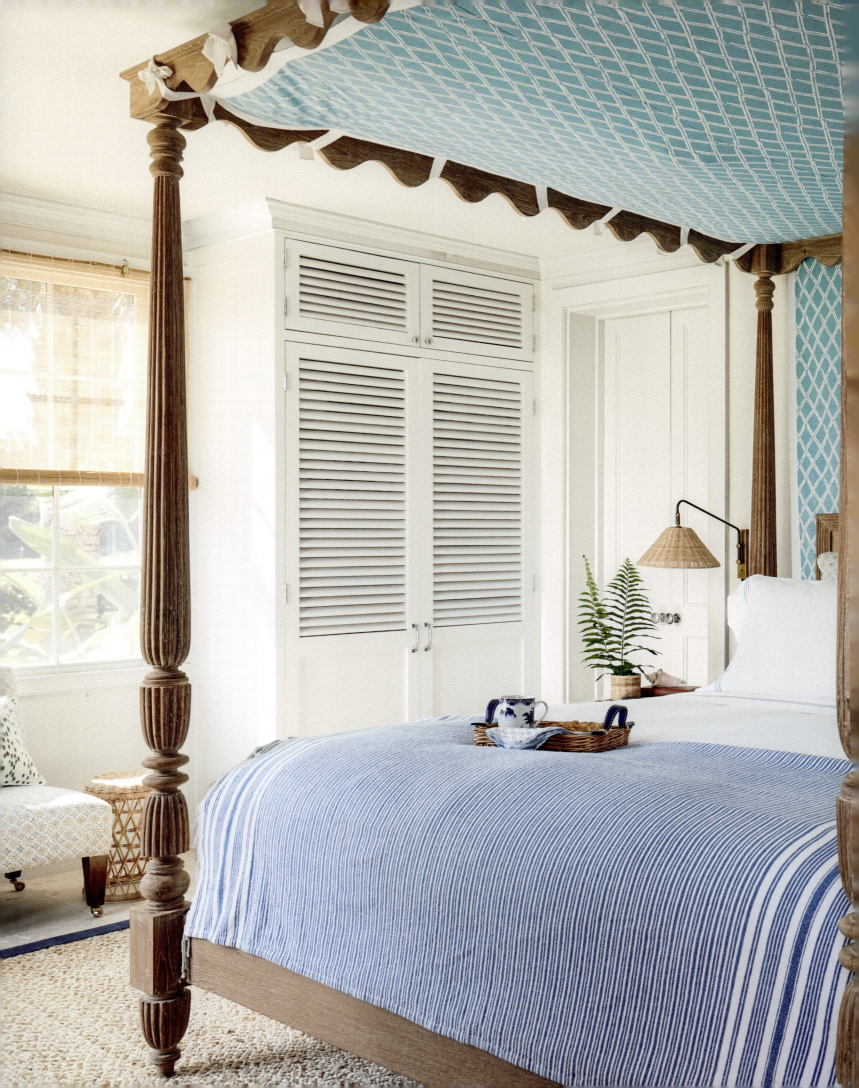

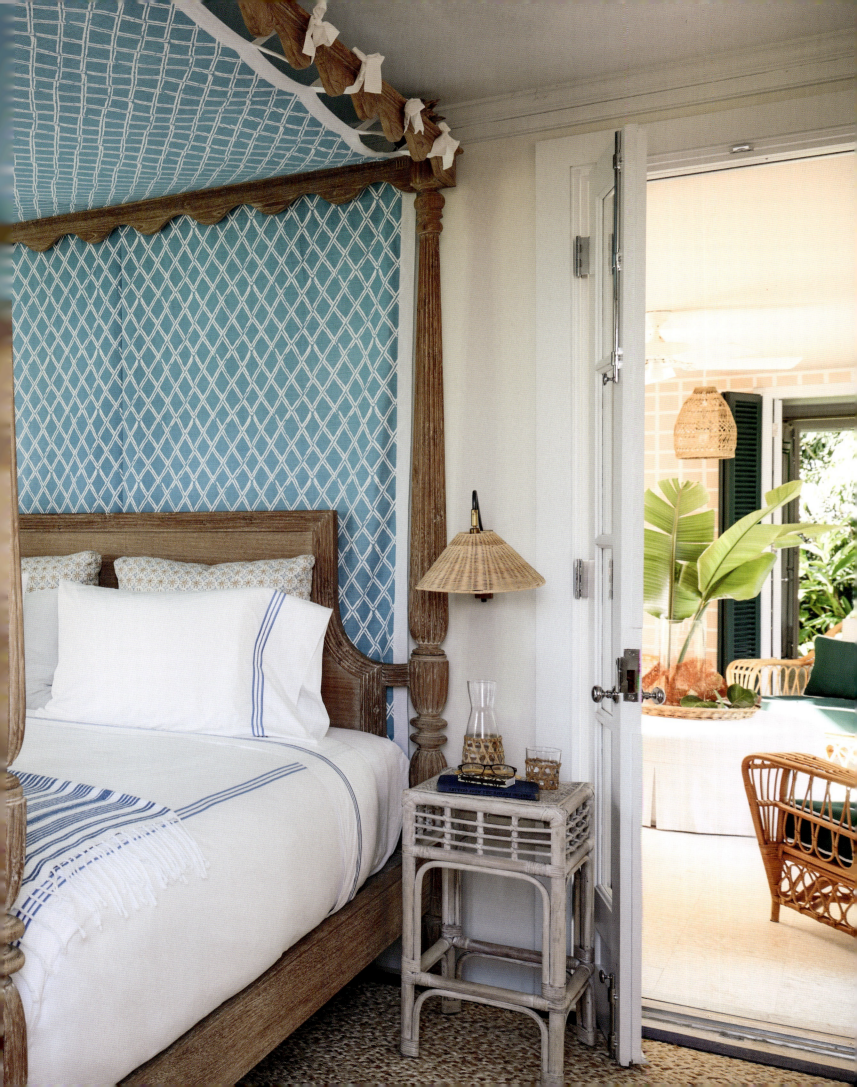

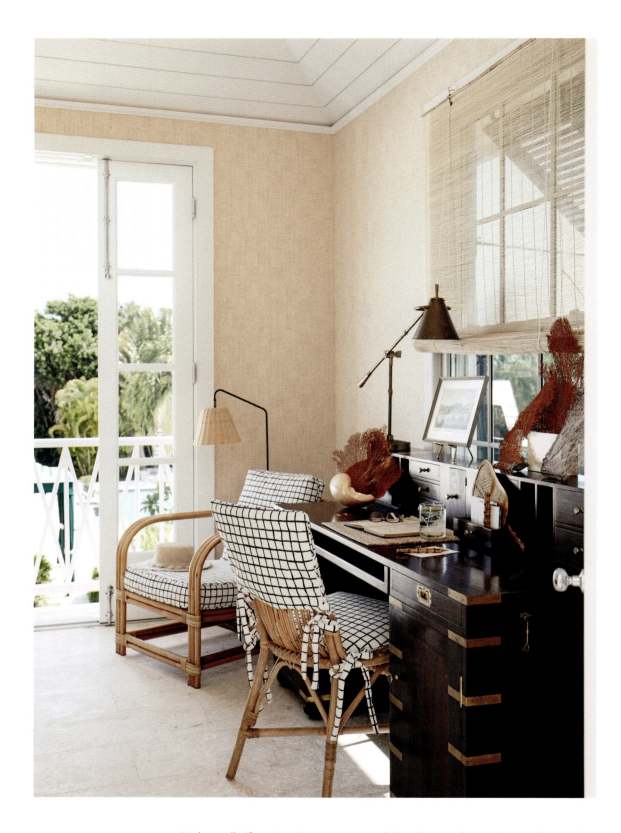

ABOVE AND OPPOSITE: *In the small office, a Raj Company custom desk and rattan chair with its cushion and back covered in a Tillett Textiles fabric create a relaxed, secluded spot for Zoom calls and other work.*

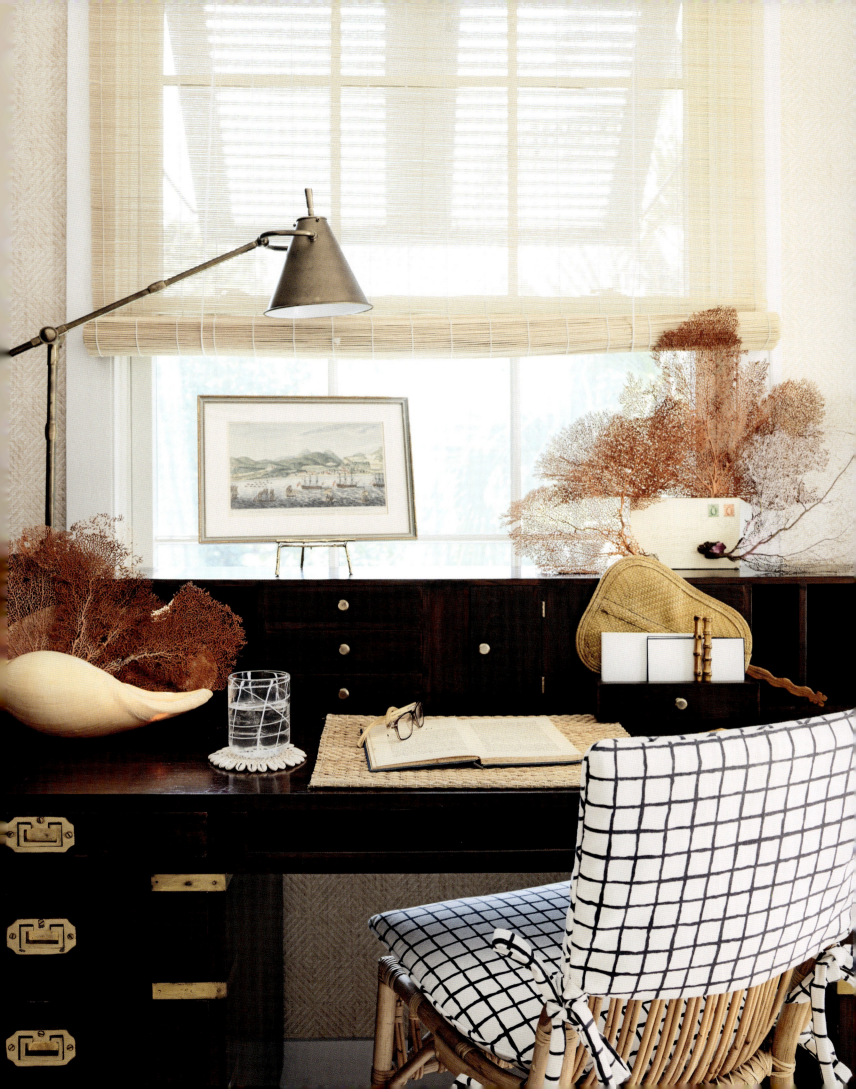

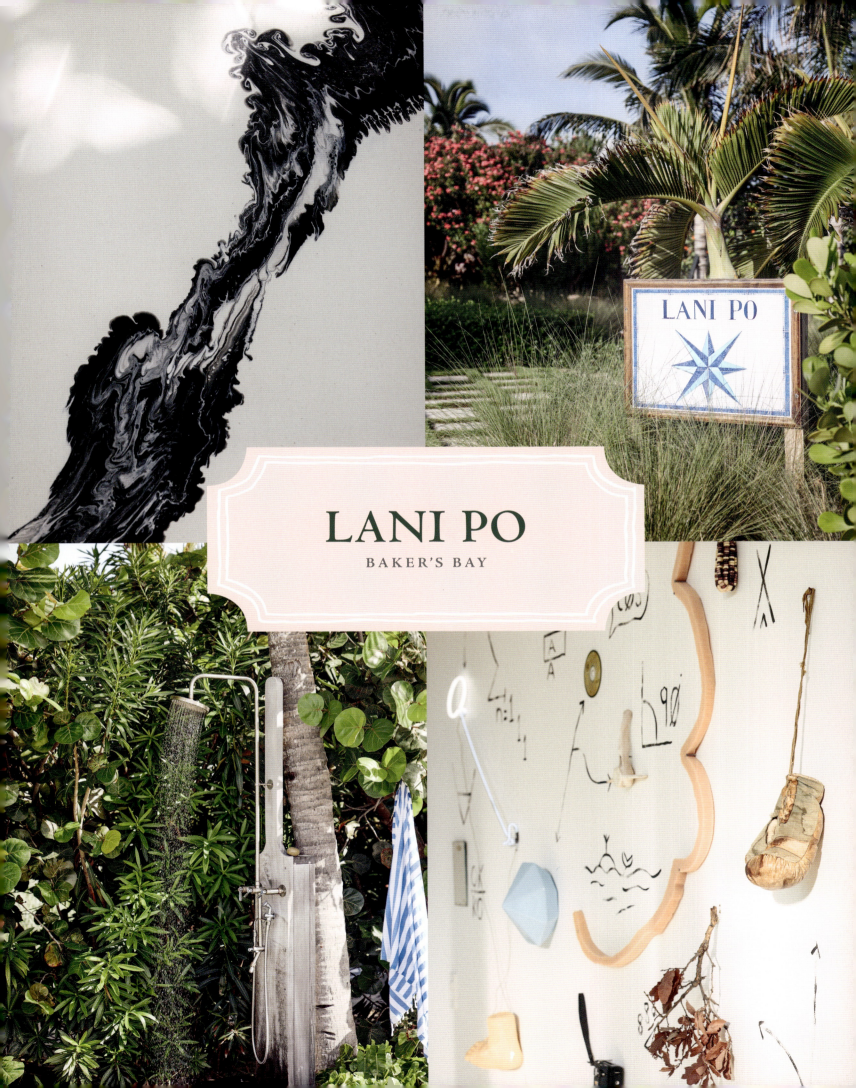

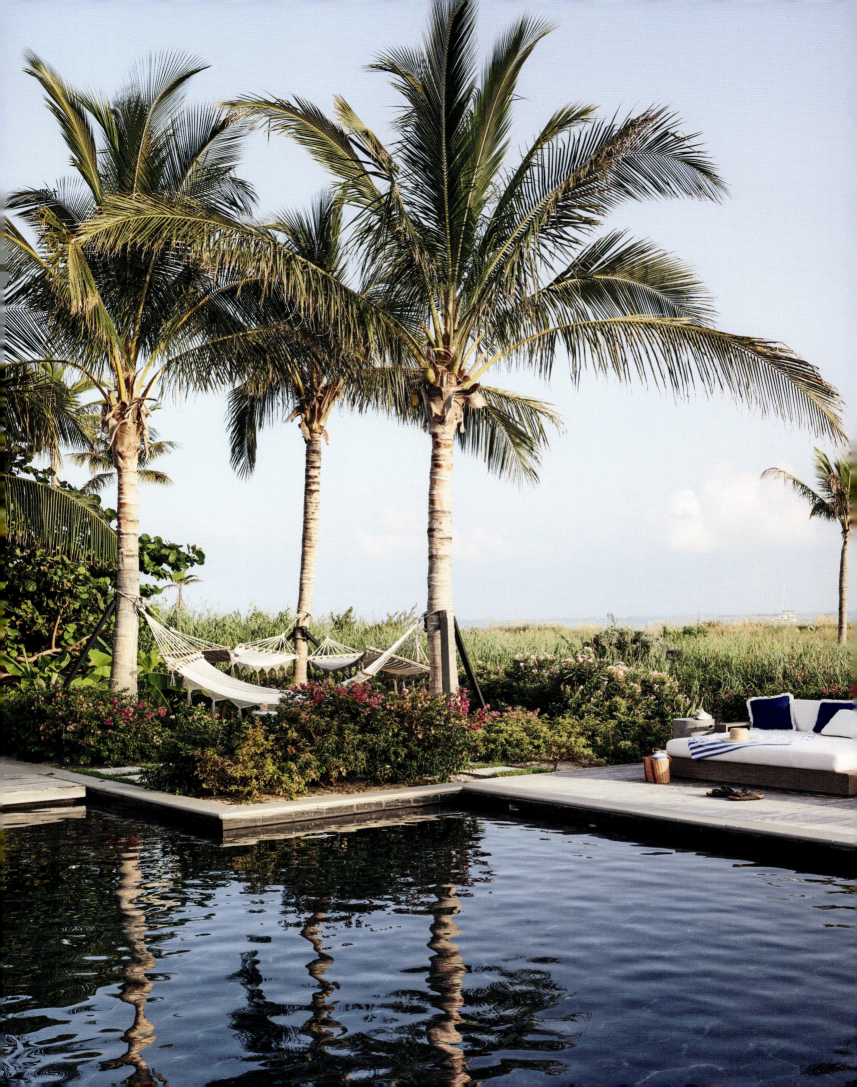

The opportunity to redesign Lani Po after Dorian, the devastating 2019 hurricane that destroyed almost everything on Abaco and the Abaco Cays in the Bahamas, is really a tale of the "two Ivanas."

Ivana M contacted me from London via Instagram about five years ago. She had admired a few things in my home collection and arranged to buy them. She then spontaneously said, "When you are in London, I will take you to Oswald's for lunch." We immediately became great friends.

To say that Ivana M is the epitome of original chicness and style is a great understatement. Her homes, her tables, her look, and her generosity are internationally renowned. During our lunch at Oswald's, she said, "You must meet my friend Ivana B. She needs you! Her house was destroyed in the hurricane."

Ivana B is also a world-class beauty, tastemaker, and joy to be with. When we met in the Abacos to see the house in its nascent rebuilding stage, we dreamed up a modern scheme to go along with the modern language of the original house. Like so many of the houses in Baker's Bay, on Great Guana Cay in the Abacos, the house had an open-plan kitchen and living area. Ivana B already had a few fun pieces, including a Dolphins and Sharks chair, a modern chair upholstered entirely in dolphin and shark stuffed animals. That was the starting point.

The next step was a visit to a concrete-floor specialist in Broward County, Florida. Ivana had an idea for a shiny white concrete floor dramatically streaked with irregular black lines. We were enlightened and excited, and the Florida team conceived the design, gathered the materials, and came to the island to execute the most original floor we have ever done.

A cobalt-blue French stove and hood gave the kitchen its punch, and we chose zellige tile in a bold blue-and-white zigzag for the backsplash. We tented the vestibules on either end of the great room in blue-and-white-striped Italian linen from Busatti and refreshed the bedrooms with canopy beds and airy island palettes. The walls of the primary bedroom are hand-stenciled after a design found in a favorite book of traditional Indian motifs. We had the linen curtains done in Chikan embroidery that matches the walls. A charming children's room features bunk beds and a cheerful wallpaper strewn with giant blue polka dots.

We are so fortunate to have worked on the redo of this wonderful family beach house and to have made lifelong friends with the two Ivanas in the process.

OPPOSITE: *An amusing grouping of hammocks is made possible by the placement of the palms at Lani Po.*
OVERLEAF: *Magis Spun chairs animate the courtyard.*

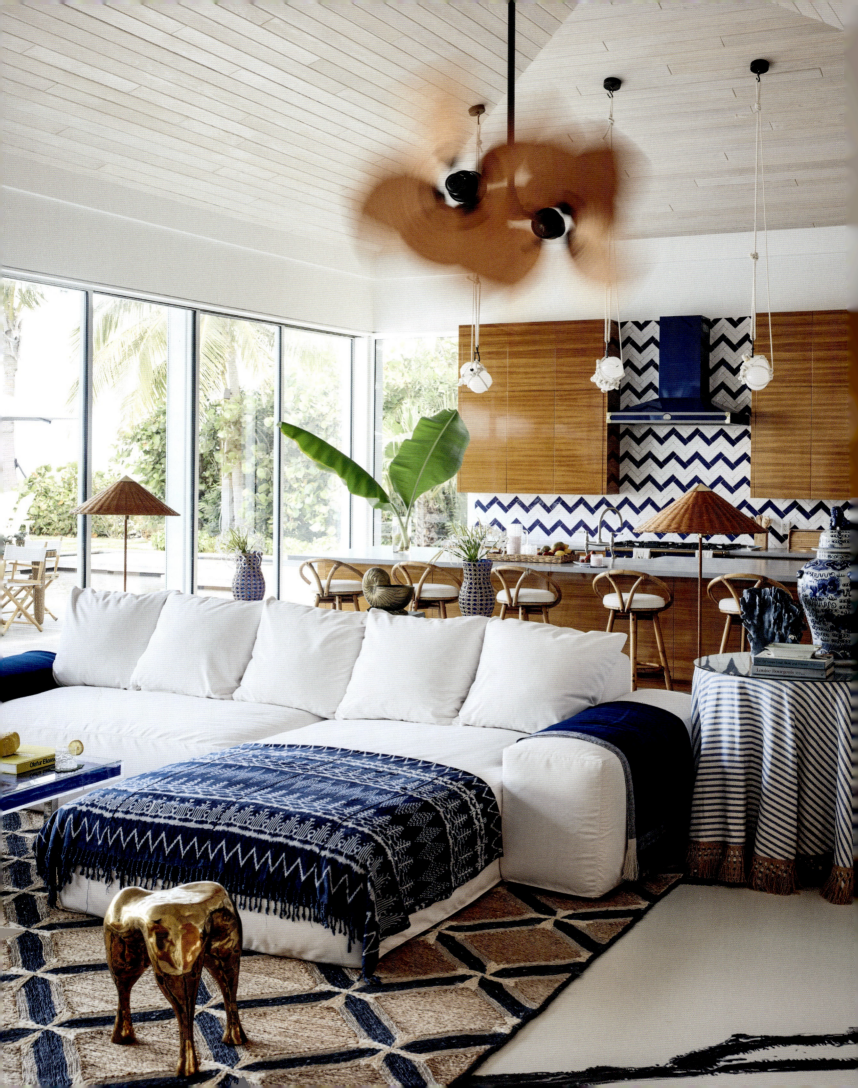

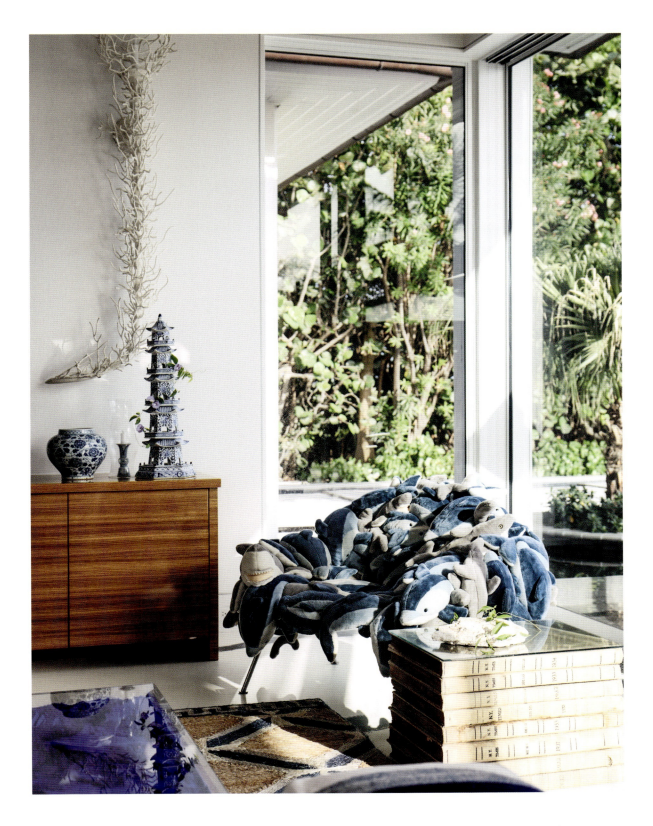

OPPOSITE: A Haas Brothers stool adds whimsy to the comfortable seating in the great room. Lindsey Adelman's Knotty Bubbles chandeliers illuminate the kitchen island. ABOVE: A Campana Brothers Dolphins and Sharks chair is accompanied by a side table made of bound vintage New York Times newspapers, 1926–1936. One of a giant pair of climbing coral sconces is mounted over the credenza. OVERLEAF: The backsplash of zellige tiles in a blue-and-white zigzag pattern anchors the kitchen. The near and far vestibules are tented in blue-and-white-striped linen. Here, as throughout the house, the shiny white concrete floor is dramatically streaked with irregular black lines.

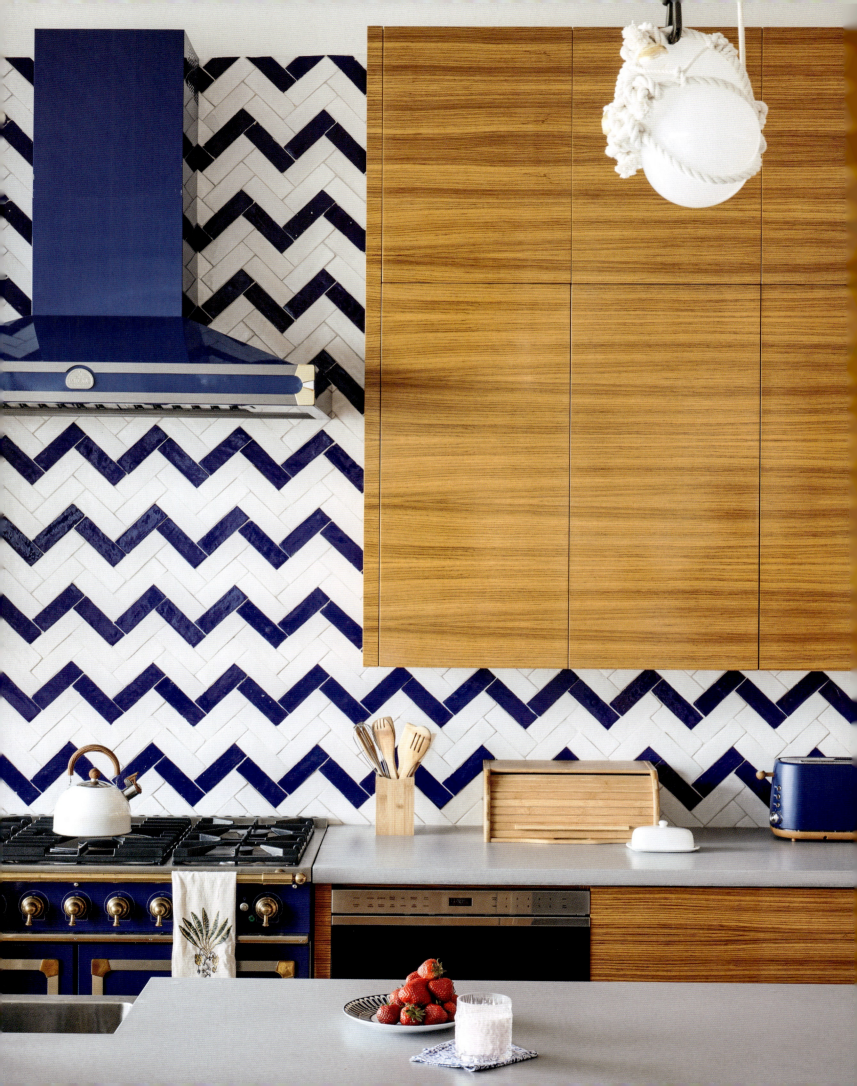

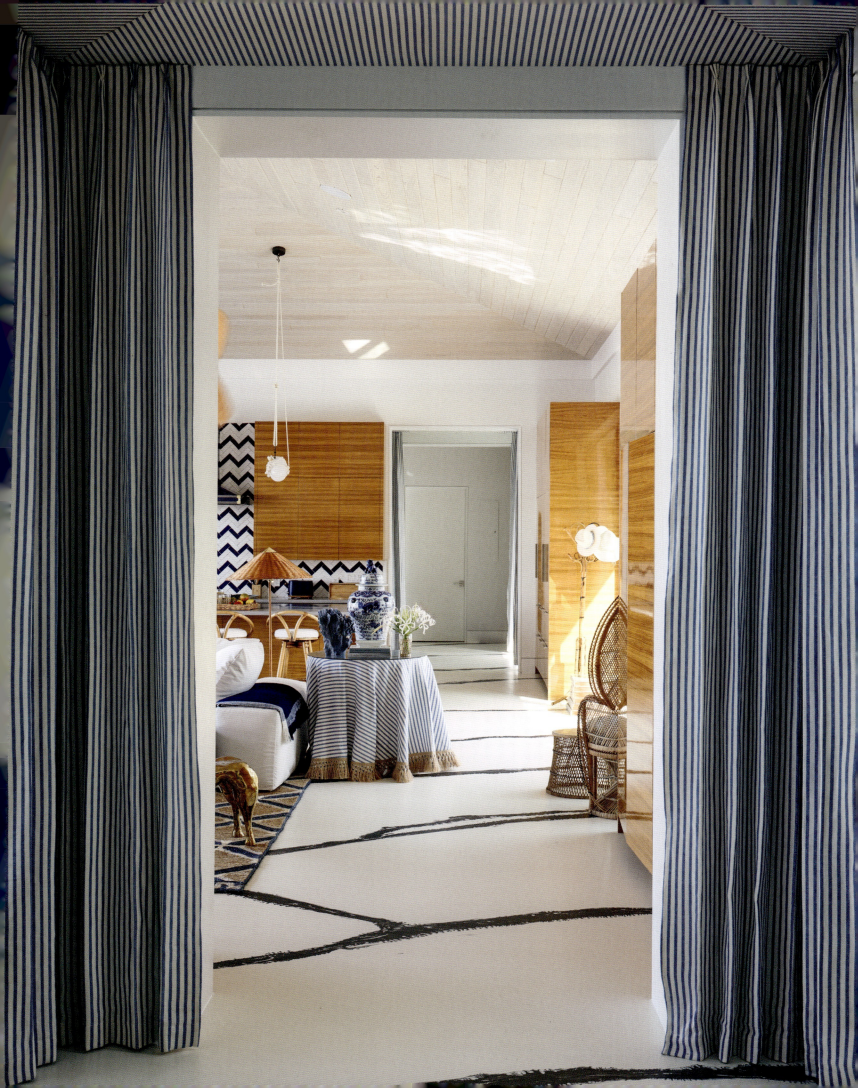

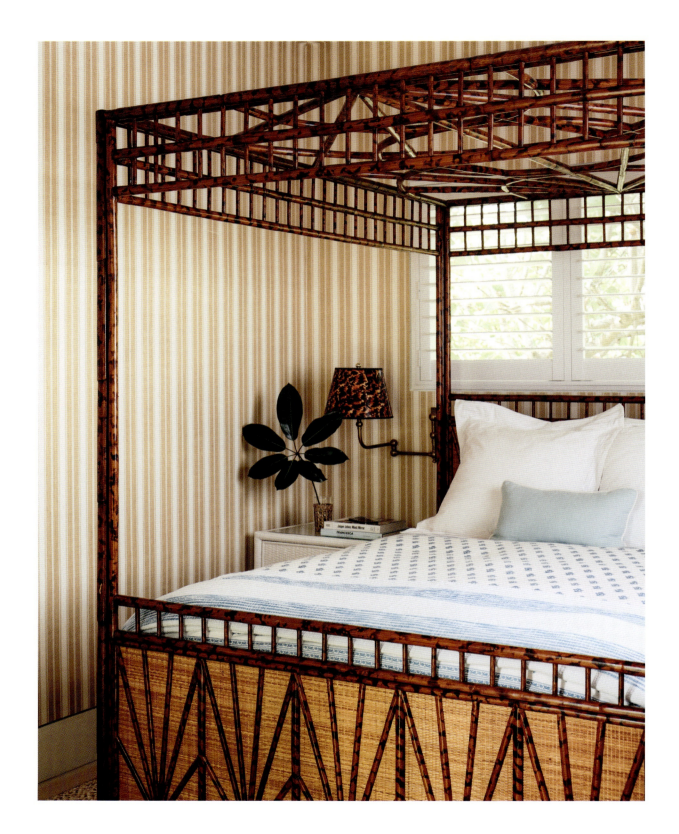

ABOVE: *A vintage Maitland-Smith bed found by the client, block-printed bed linens, and a shiny tortoiseshell-patterned lampshade infuse a guest room with an island vibe.* OPPOSITE: *This charming twin bedroom is swathed in a khaki-and-white-striped Busatti linen.* OVERLEAF LEFT: *The primary guest suite features a floating bed suspended from ropes, a headboard covered in a Raoul fabric, and Bahamian straw work on the walls.* OVERLEAF RIGHT: *A post-surrealist wall of wonder by Gabriel Rico animates the children's wing.*

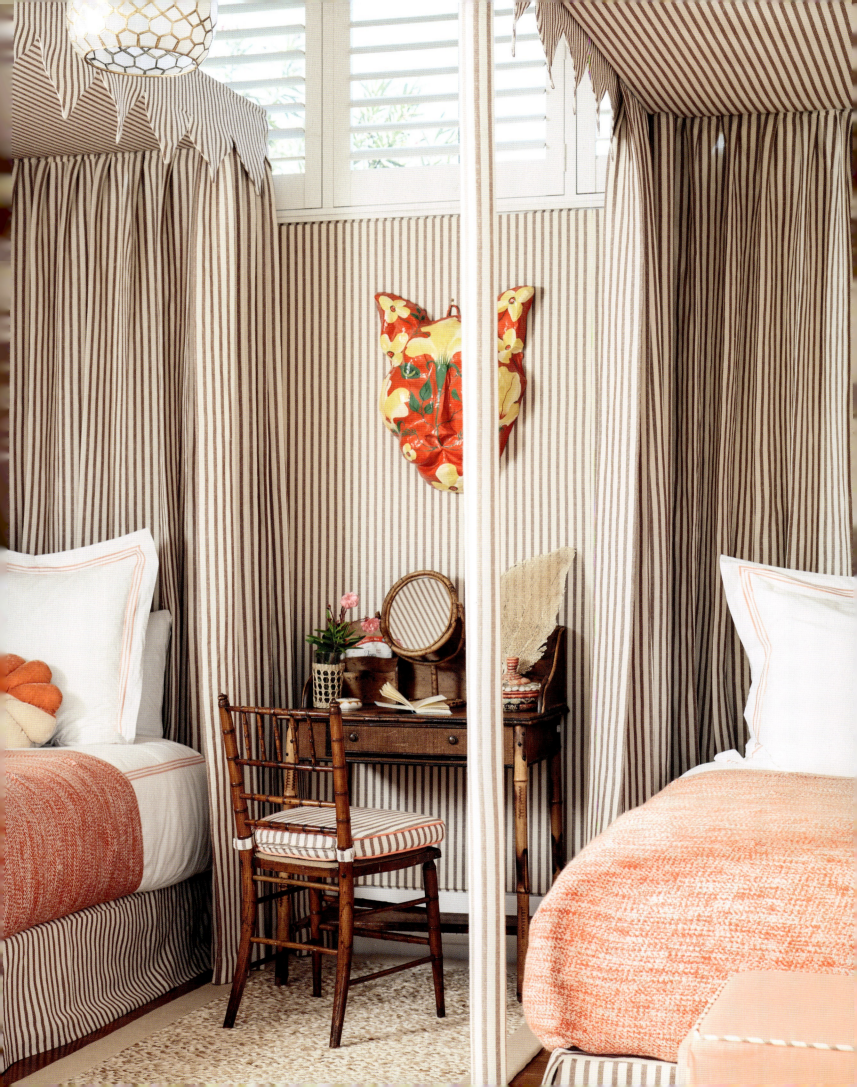

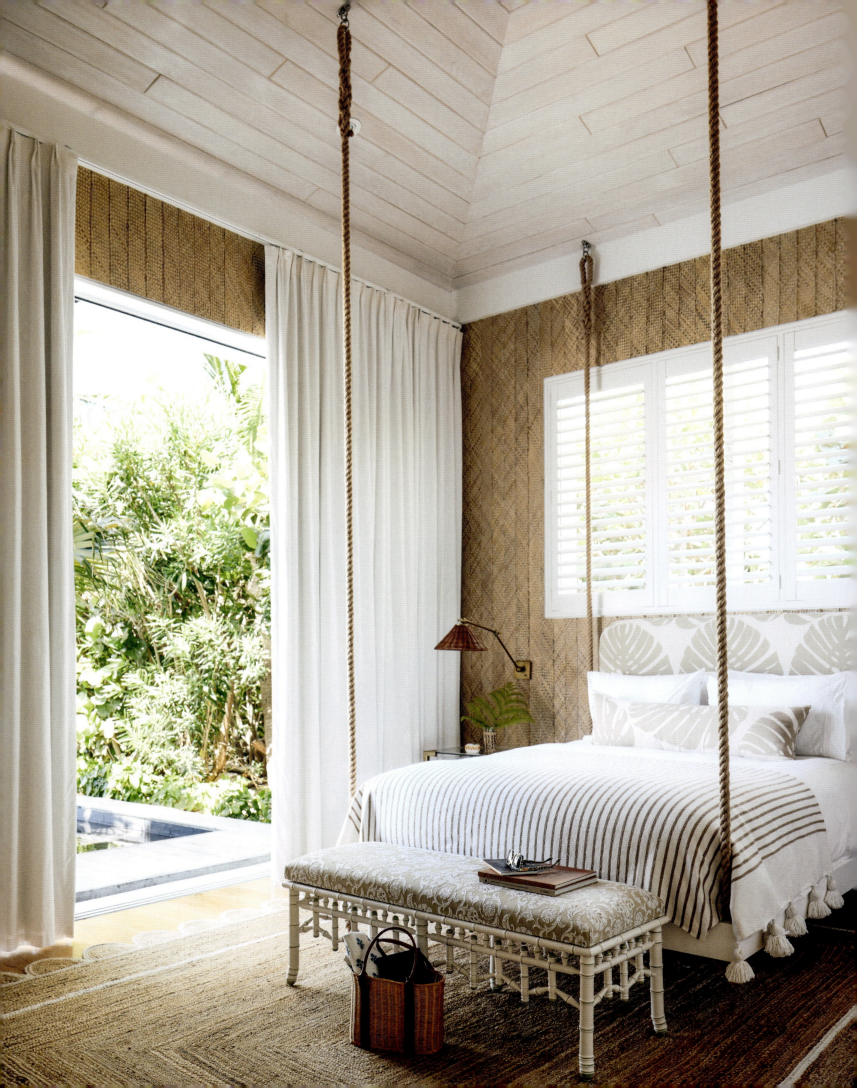

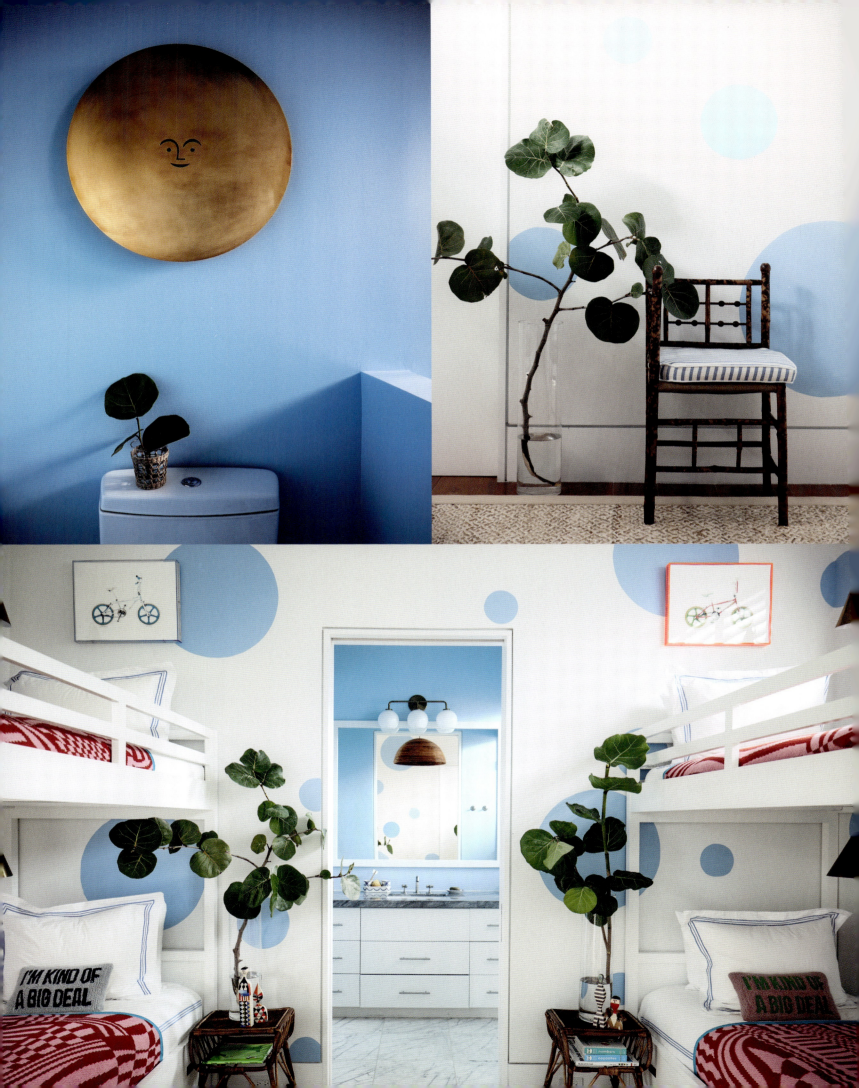

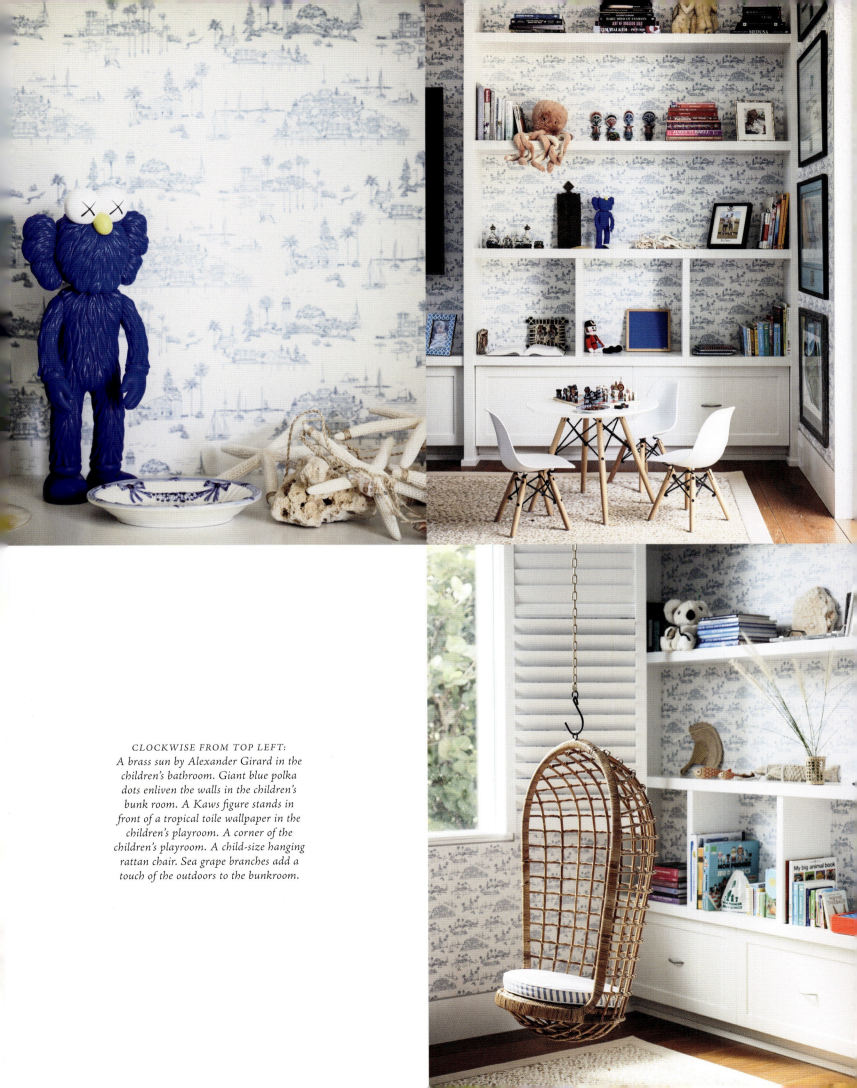

CLOCKWISE FROM TOP LEFT:
A brass sun by Alexander Girard in the children's bathroom. Giant blue polka dots enliven the walls in the children's bunk room. A Kaws figure stands in front of a tropical toile wallpaper in the children's playroom. A corner of the children's playroom. A child-size hanging rattan chair. Sea grape branches add a touch of the outdoors to the bunkroom.

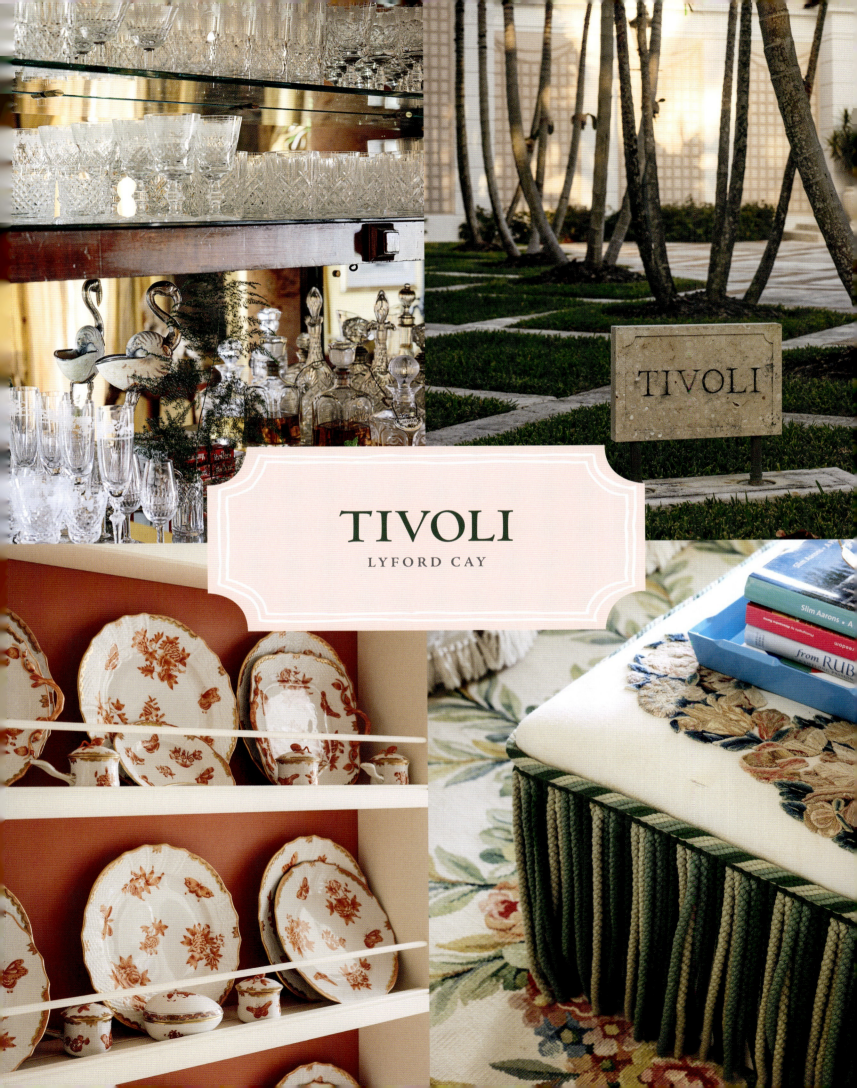

TIVOLI

LYFORD CAY

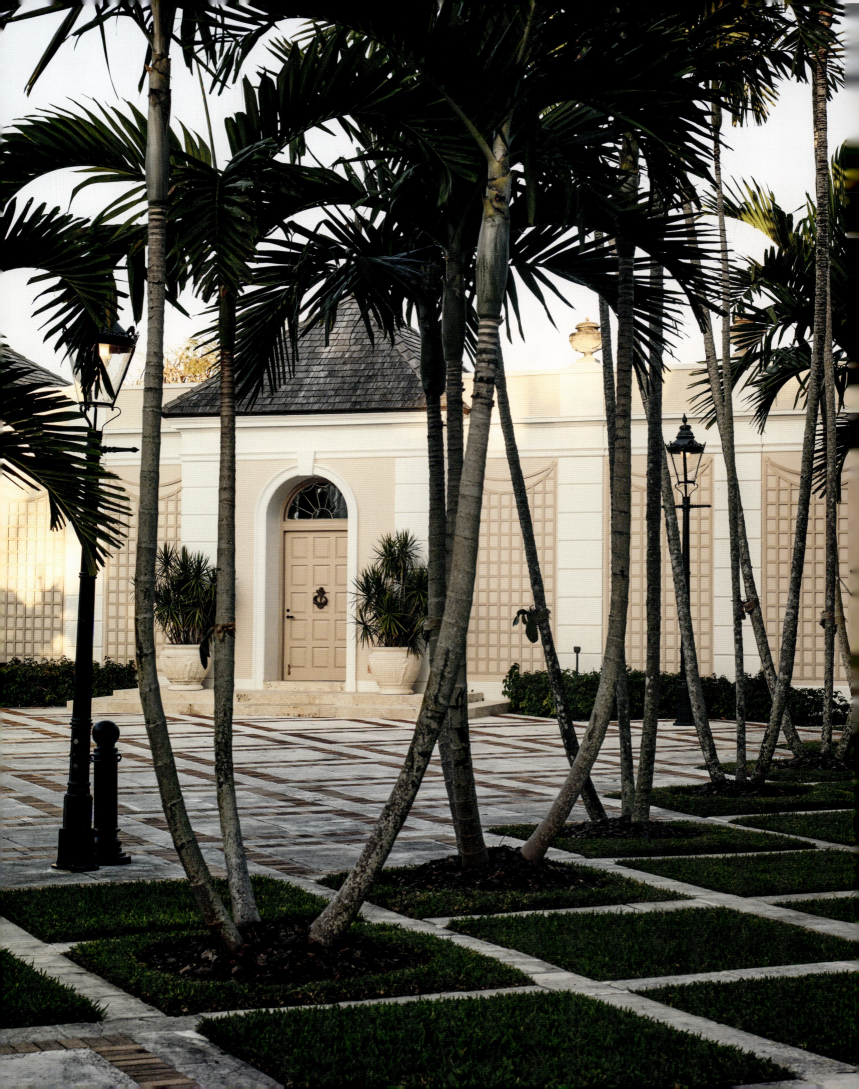

It must be said right off the bat that Tivoli was not my invention. It was created in 1992 by a great client, a great architect, and a great designer. The client was a grand and lovely Spanish lady of taste and means, the architect was the late, great Henry Melich, and the designer was the equally great Imogen Taylor of Colefax and Fowler.

The house caused quite a sensation in Lyford when it was new because of its grandeur and its famously elaborate interior. Wild guesstimates of the cost of the interior were bandied about at the time. The great Spanish lady had a penchant for lavish dinners and fun. An invitation was much sought after.

Fast-forward to the late 1990s: the great lady came no more, and the house sat in benign neglect. She had been so benevolent to her staff that a few stayed on for many years, keeping the garden tidy and the house safe and secure.

During those years, a certain family with taste and a love of beautiful things dreamed of making the house their own. Eventually, they found a way to communicate with the Spanish lady and in time succeeded in purchasing it from her. Finally, they were able to undertake its restoration. That is when we came in.

In spite of the benign neglect, including a decade with no electricity or water and a happy family of raccoons that had made a cozy nest, the house was in remarkably good shape. There was water damage in only two small places. The windows and doors were sound, and the hardwood floors were miraculously intact. The striate walls in the drawing room were carefully restored by the painter who had done them originally. The tattered taffeta curtains in that room were mended just enough.

We selected fabrics to replace all the upholstery and meticulously updated all the bedrooms, including the primary, with new beds, lighting, wallpaper, and curtains. In the dining room we added two sterling-silver shell chandeliers with shiny, green-lacquered shades.

Architect Kiko Sanchez reworked a maze of back-of-the-house rooms—kitchen and pantries—to create a wonderful new kitchen that looks like it has always been there. A giant French stove and a room for china make this area of the house very special.

Another major change was the repurposing of the groin-vaulted wine cellar into a late-night party grotto à la Annabel's in London. Lush red velvet loggia sofas and velvet tiger-print poufs create a louche spot for Lyford frivolity. The grotto, which is also known as the "dungeon," is but one part of the new incarnation of this legendary house.

OPPOSITE: *Tivoli's formal front façade and motor court, bordered by a regimented line of palm trees.*
OVERLEAF: *The formal living room, designed by Colefax and Fowler in 1992 and refreshed by us in 2018.*

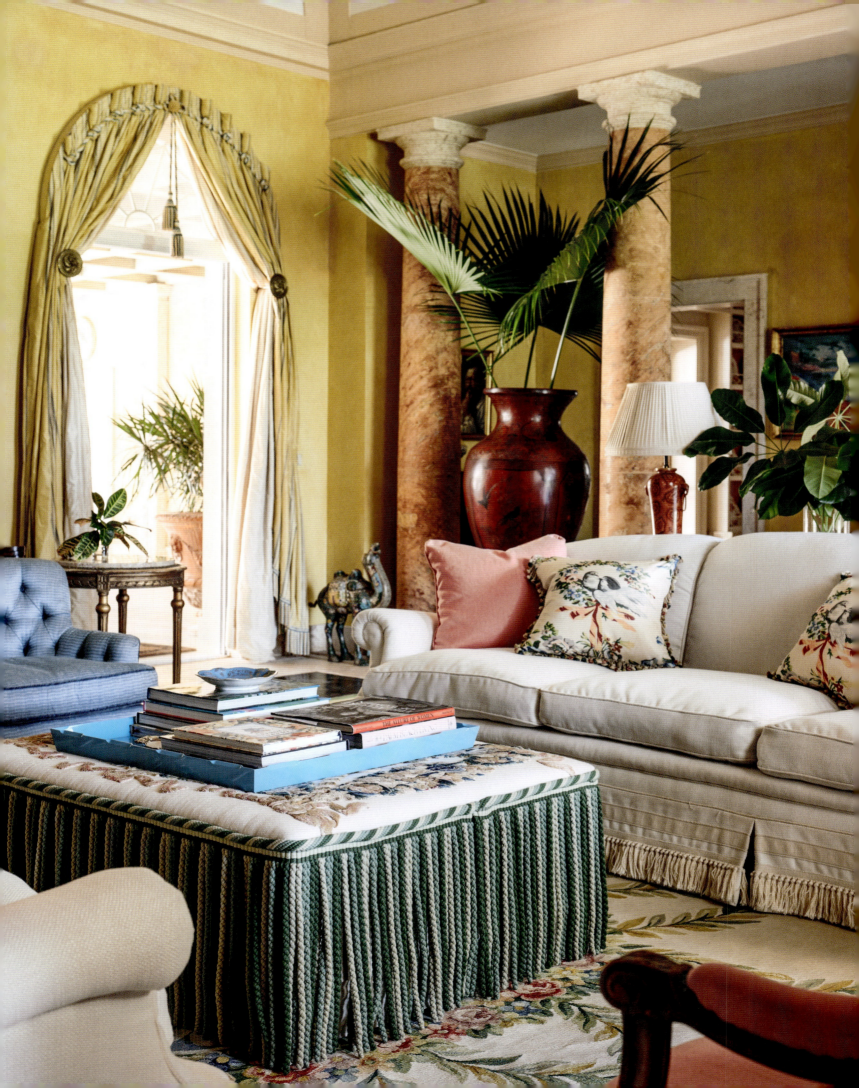

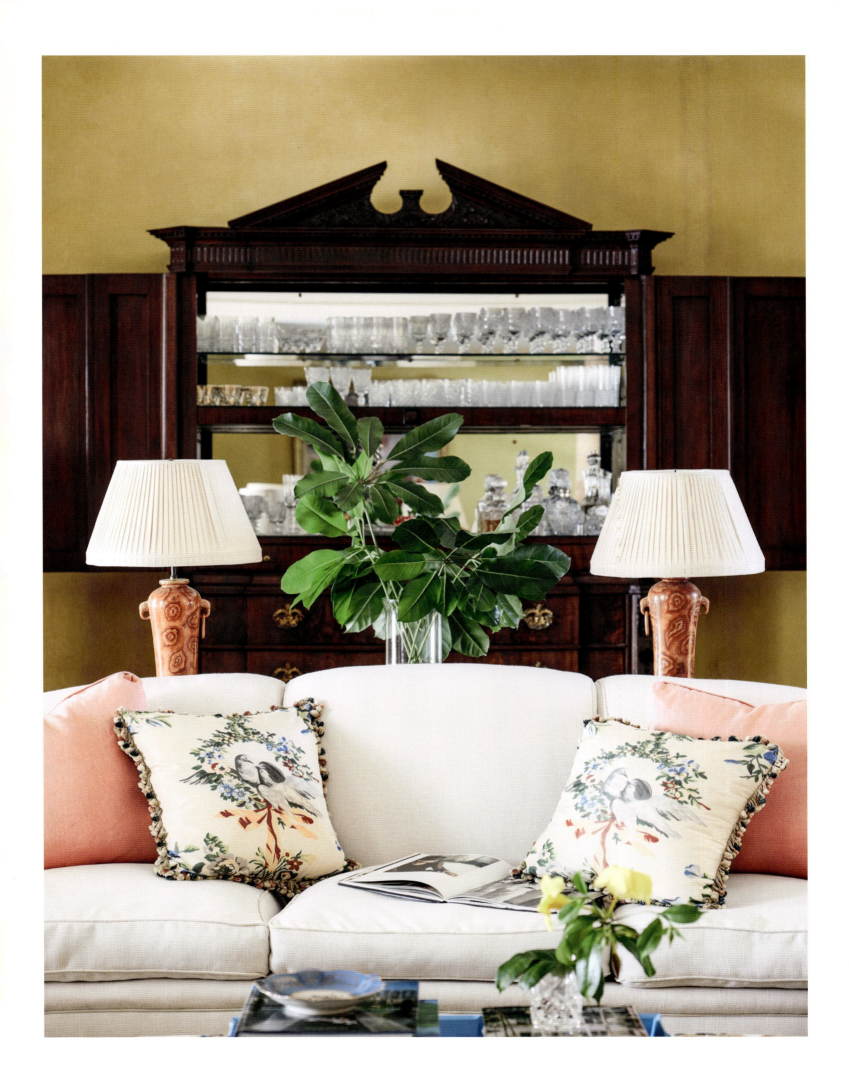

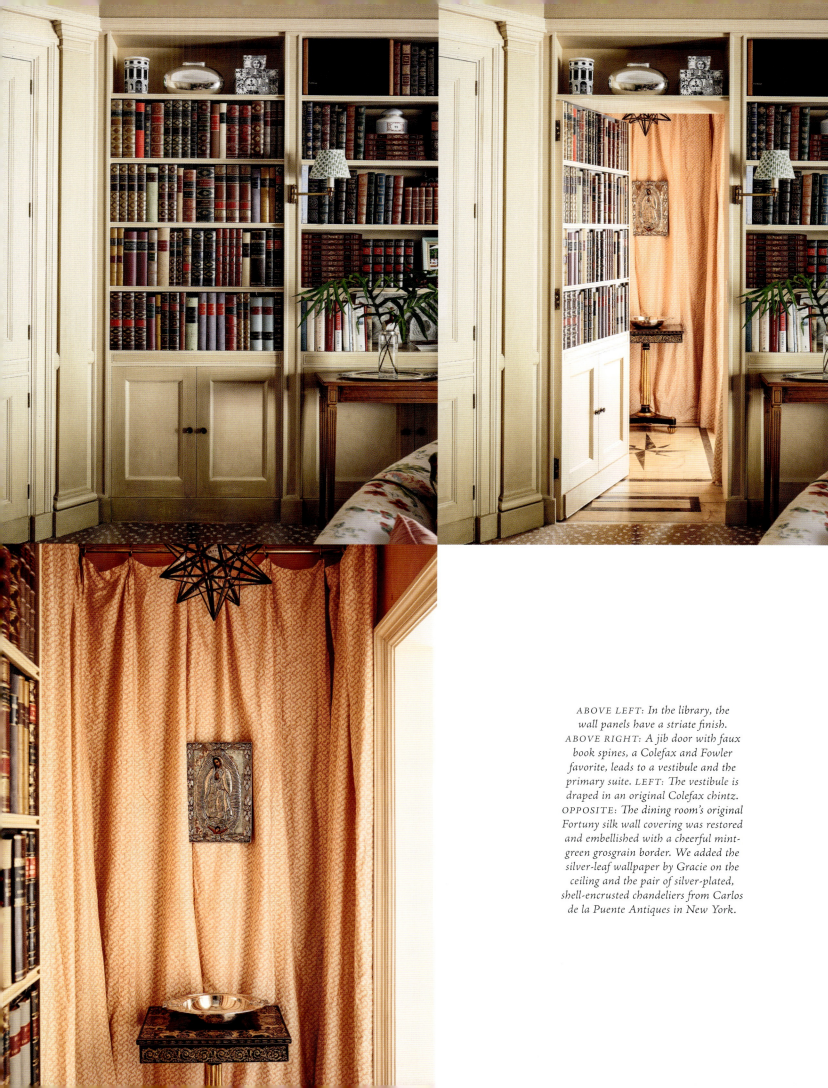

ABOVE LEFT: In the library, the wall panels have a striate finish. ABOVE RIGHT: A jib door with faux book spines, a Colefax and Fowler favorite, leads to a vestibule and the primary suite. LEFT: The vestibule is draped in an original Colefax chintz. OPPOSITE: The dining room's original Fortuny silk wall covering was restored and embellished with a cheerful mint-green grosgrain border. We added the silver-leaf wallpaper by Gracie on the ceiling and the pair of silver-plated, shell-encrusted chandeliers from Carlos de la Puente Antiques in New York.

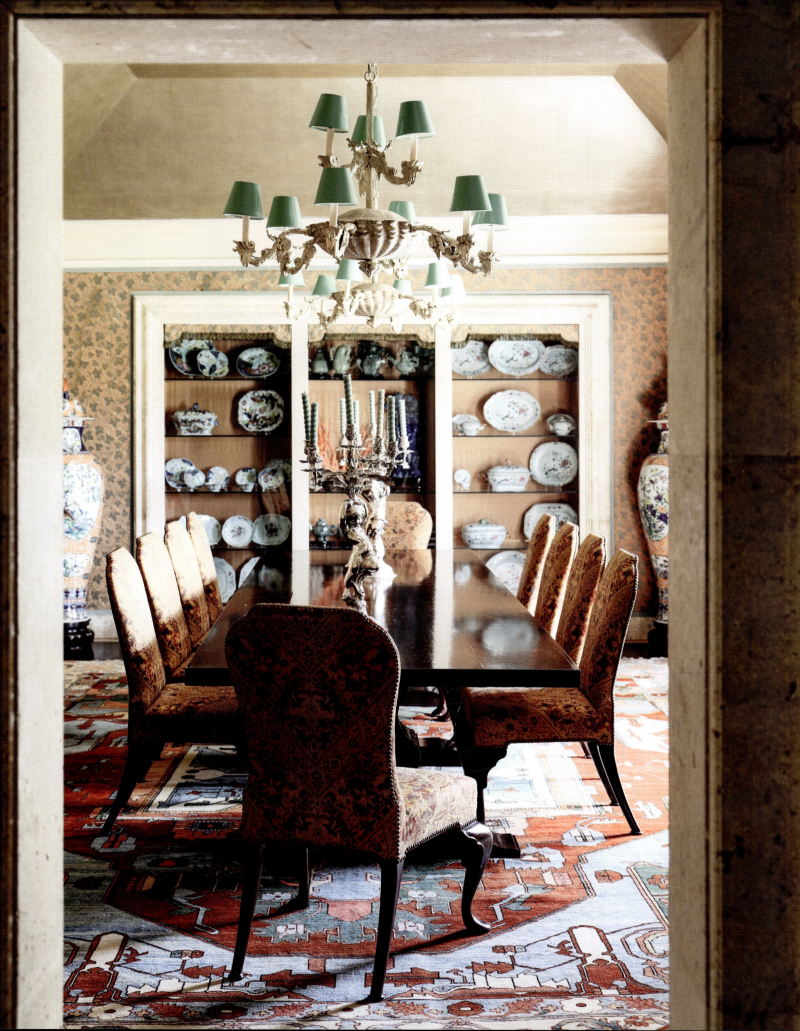

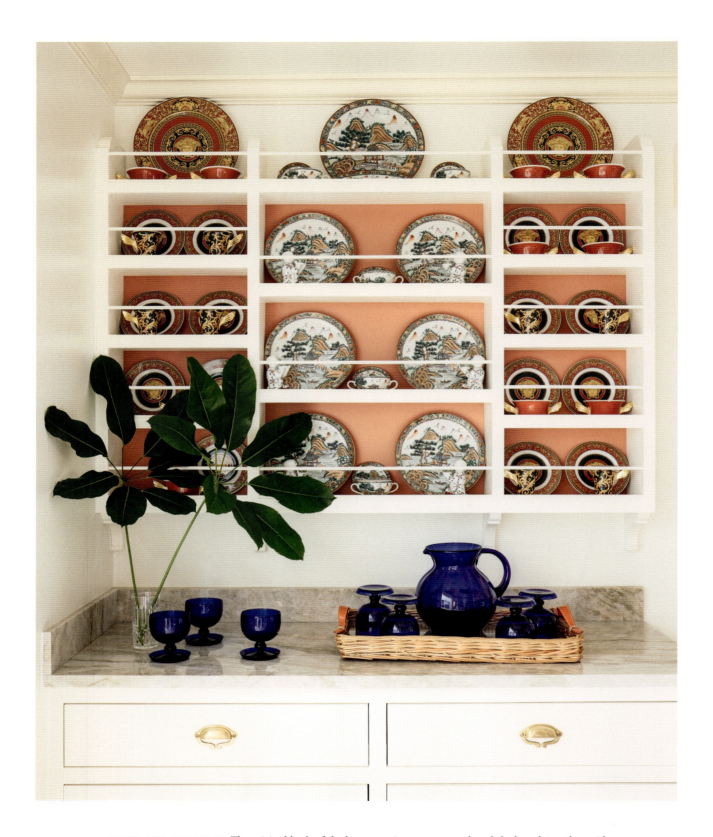

ABOVE AND OPPOSITE: *The original back-of-the-house service rooms were demolished, and, together with architect Kiko Sanchez, we designed a more workable kitchen that looks as though it has always been there. The new enfilade of rooms begins with a china room, which has a Soane Britain brass bar cart at its center. In the kitchen beyond is a custom Raj Company circular island and benches.* OVERLEAF: *A newly designed guest room features a hand-painted de Gournay panoramic wallpaper, bedding by Leontine Linens, and a sofa and chair upholstered in a custom-colored Zig Zag pattern from Quadrille.*

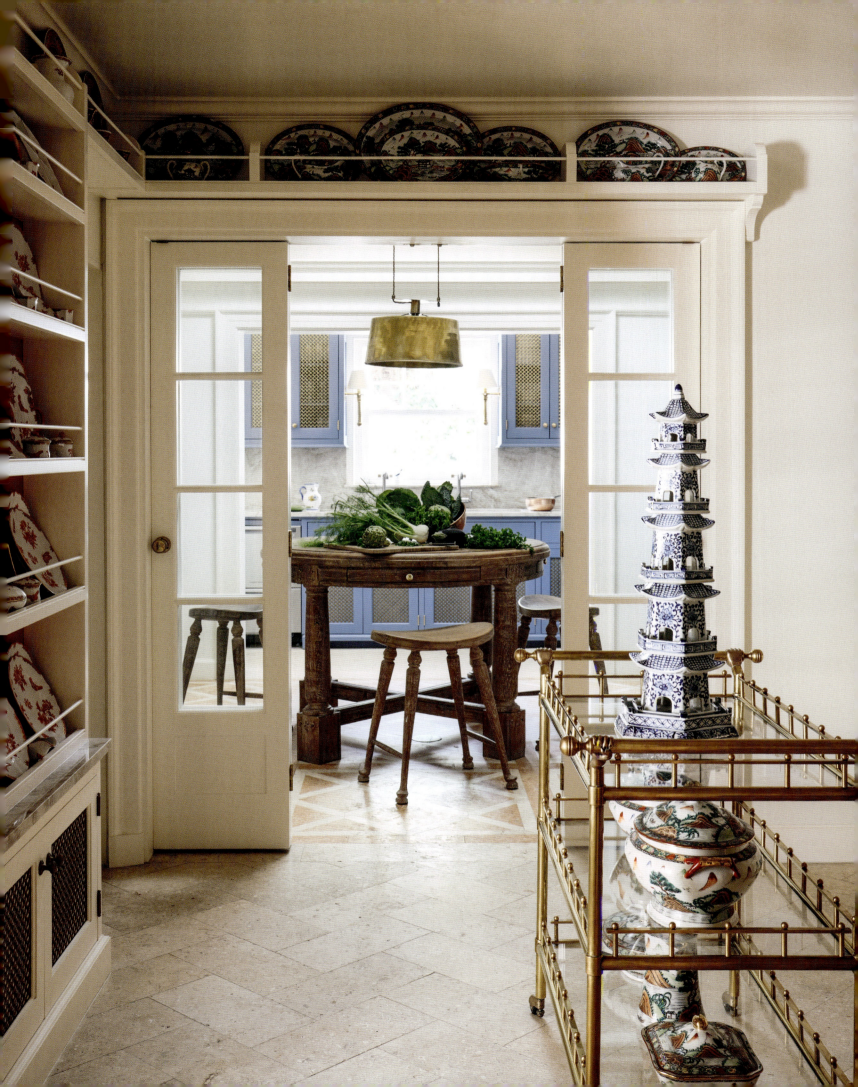

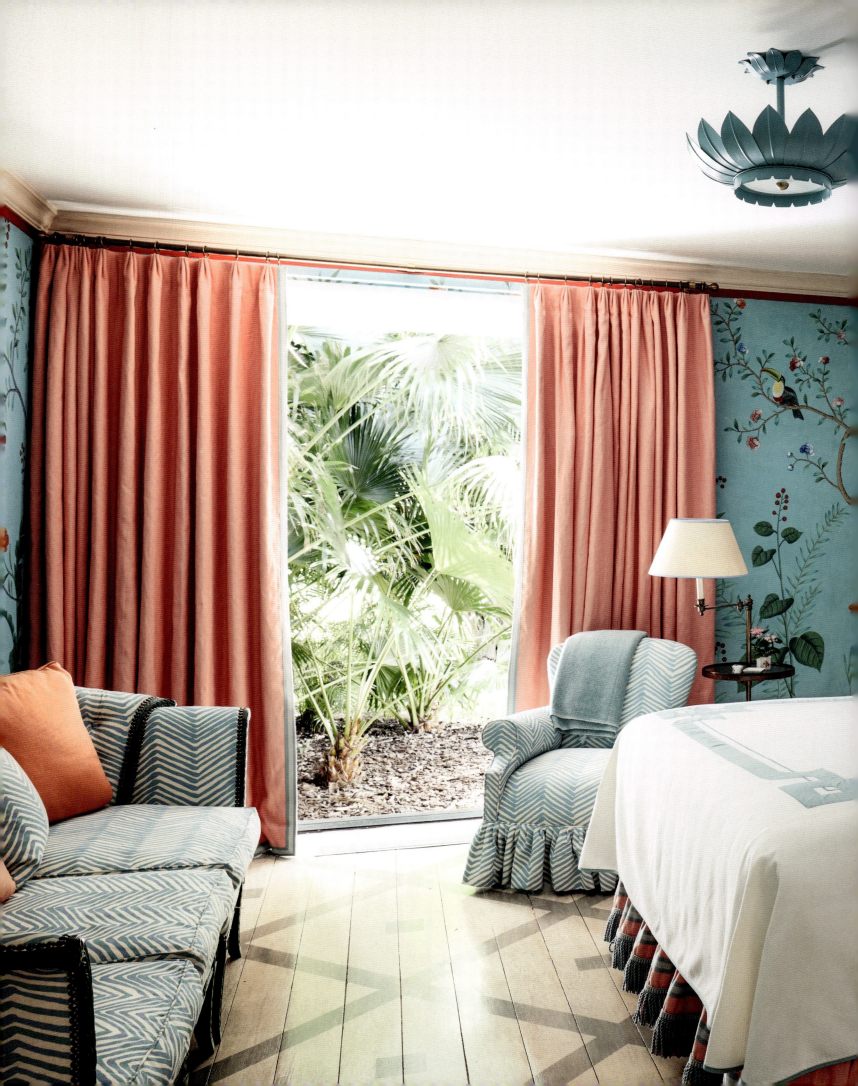

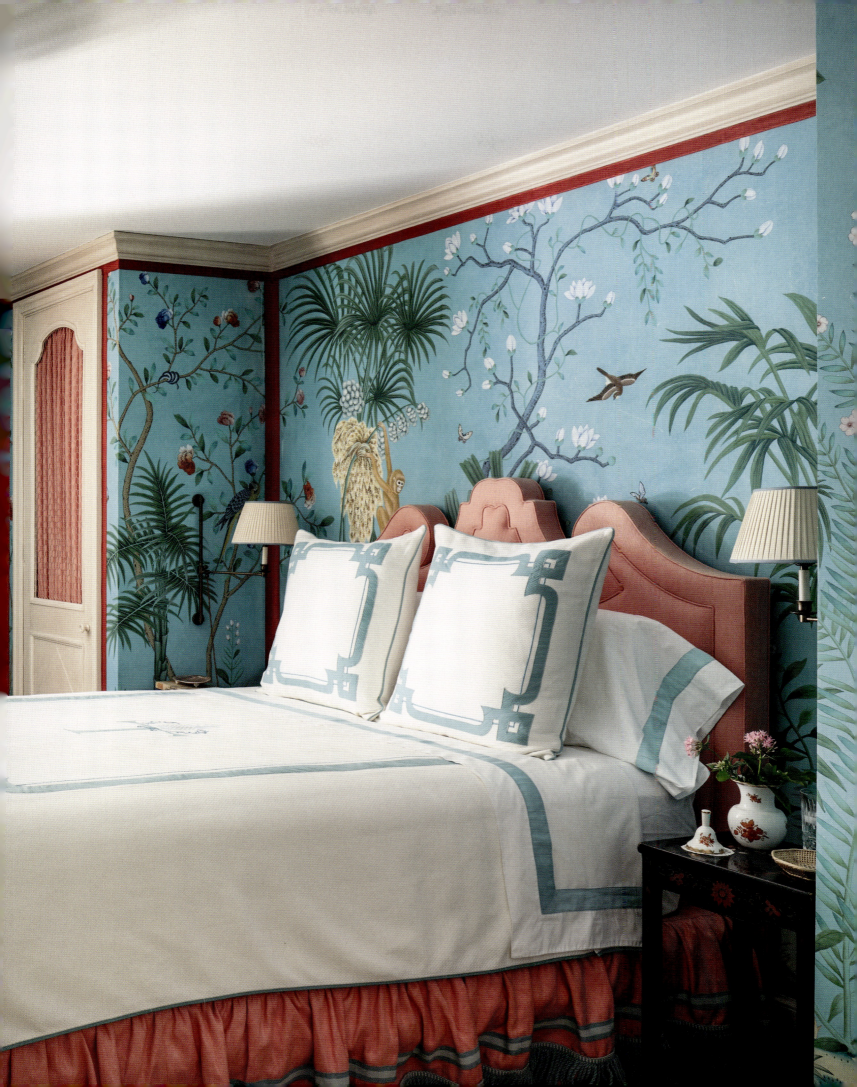

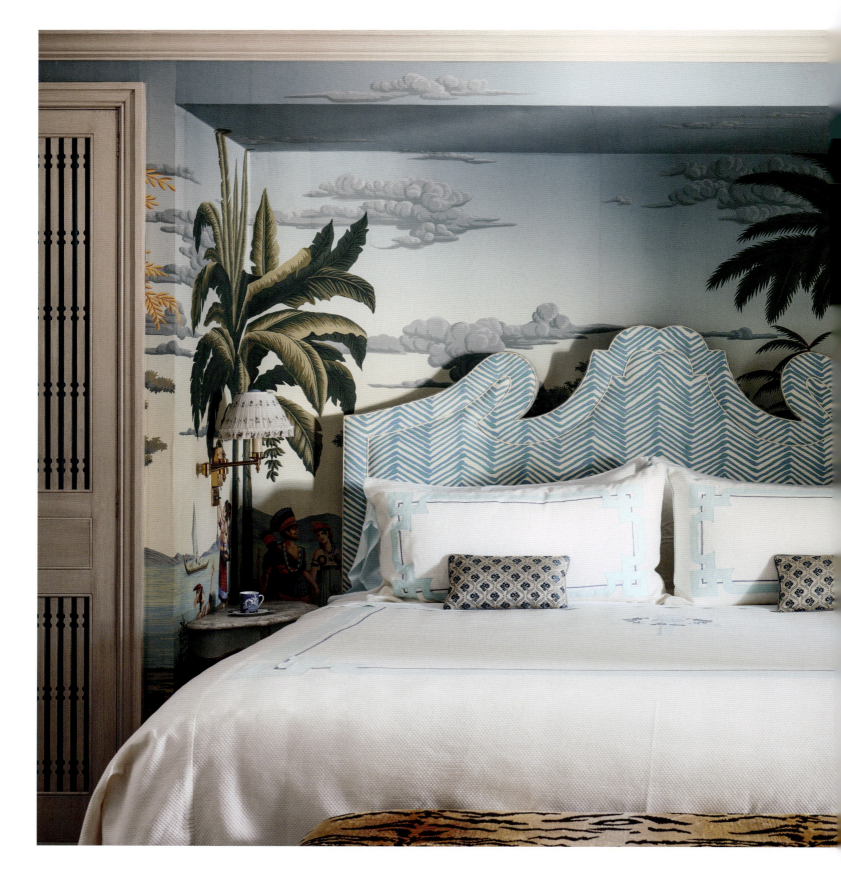

ABOVE: *Another panoramic de Gournay wallpaper envelops a second guest room. Here, too, the bedding is by Leontine Linens, and the headboard is upholstered in Quadrille's Zig Zag pattern.*
OPPOSITE TOP: *In a corner of this guest room, a mad hatter club chair is also upholstered in Quadrille's Zig Zag pattern.* OPPOSITE BOTTOM: *The original in-room clawfoot bathtub was painted in stripes by Colefax and Fowler. This whimsical detail helped inform the redecoration of the room.*

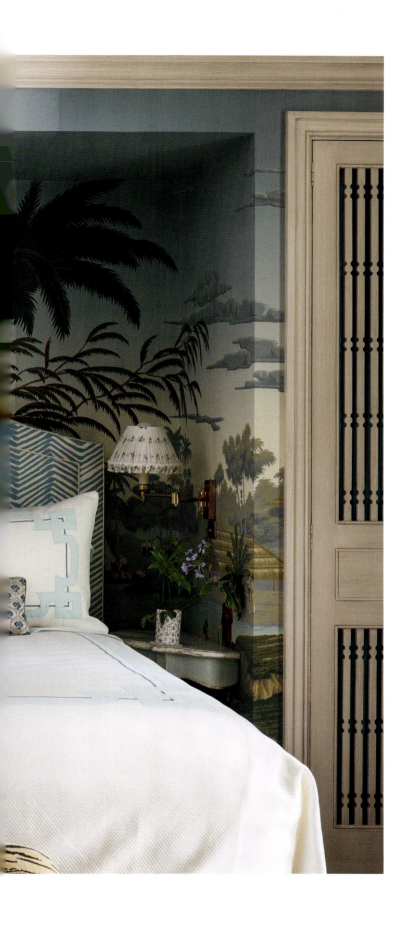
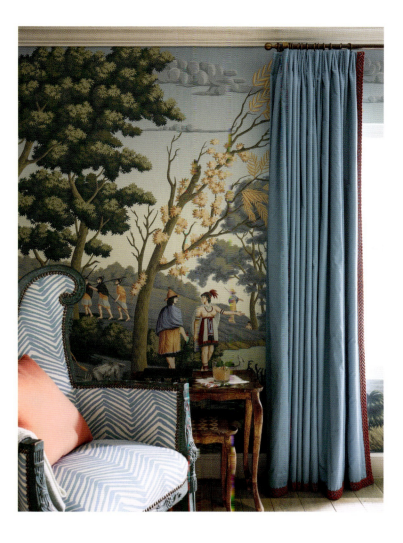
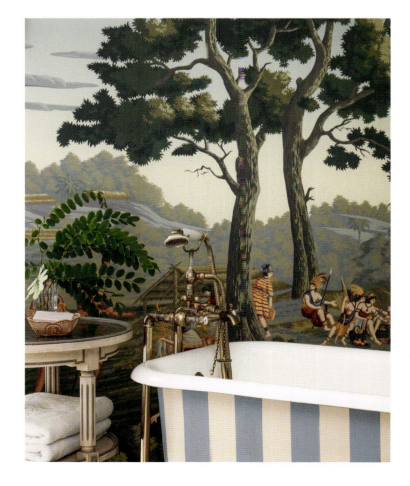

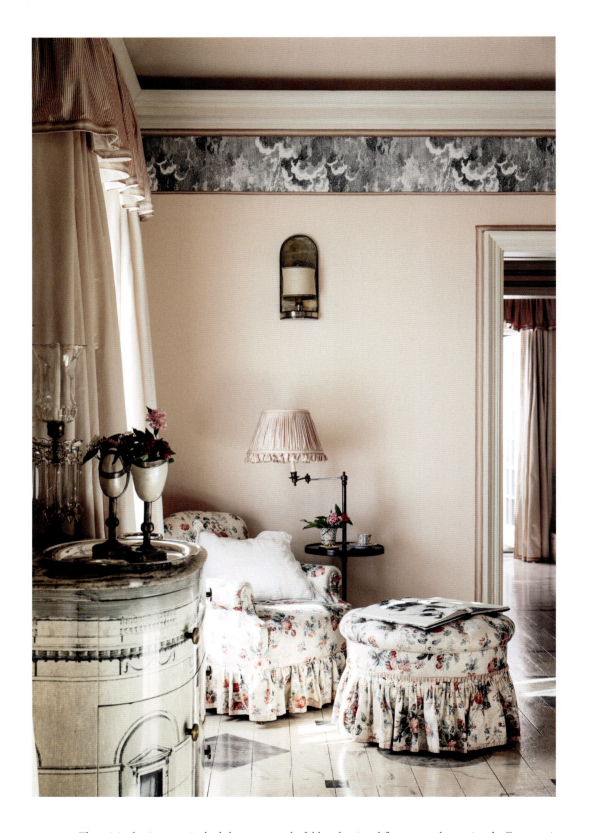

ABOVE: *The original primary suite had the most wonderful hand-painted floors, complementing the Fornasetti furniture. We refreshed the floors, walls, and all the upholstery. Just beneath the crown molding, we added a frieze of Cole and Sons' Fornasetti-like wallpaper on the striate walls.* OPPOSITE: *A charming new bed that we found on Chairish resonates with the marvelous Fornasetti secretaire and flanking chairs.*

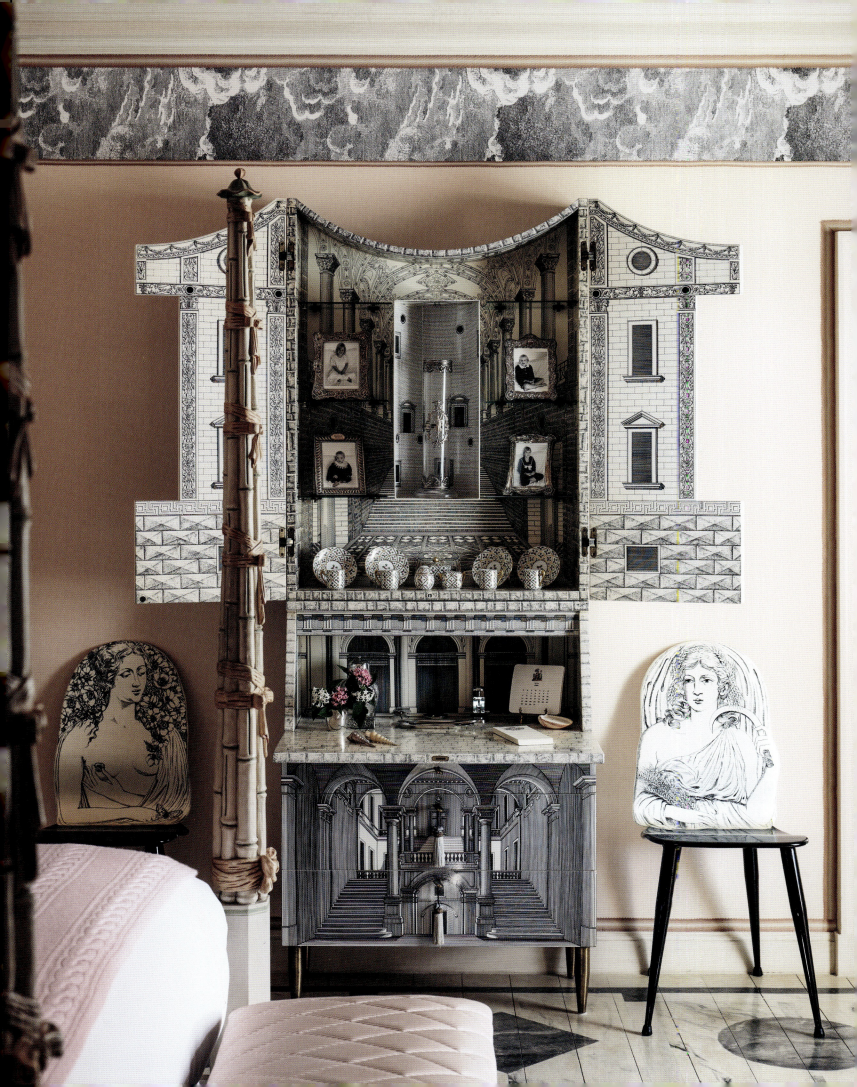

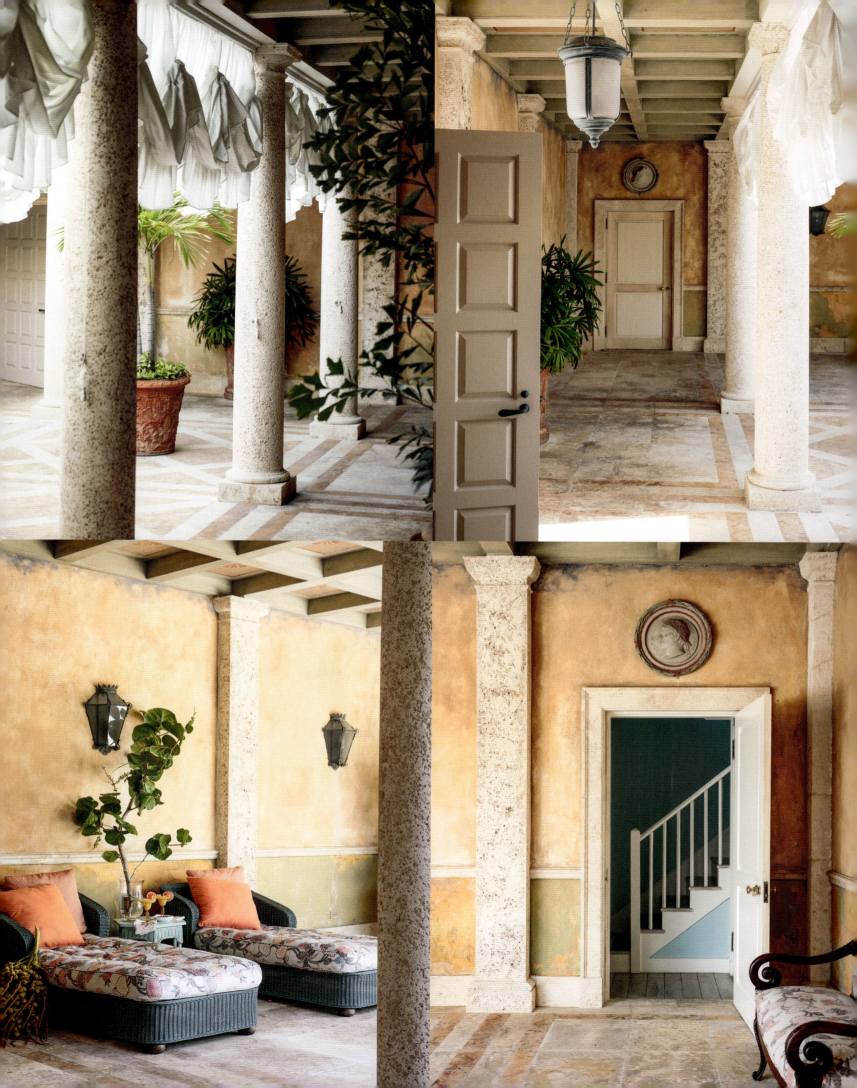

OPPOSITE TOP LEFT AND RIGHT: Glimpses of the Pompeiian-like courtyard. We replaced the original Colefax and Fowler–designed curtains, a copy of those in Piazza San Marco in Venice, with a performance fabric from C&C Milano. OPPOSITE BOTTOM: The original rattan chaises in the courtyard were lovingly restored by Abilities Unlimited in Nassau. We recovered them in Quadrille's Turtle Batik. Jamb in London supplied new sconces. RIGHT: The groin-vaulted wine cellar below the library and guest suite. BELOW: A newly designed party room, locally known as the "dungeon," was inspired by the old Annabel's and 5 Hertford Street in London. OVERLEAF LEFT: New McKinnon and Harris chaises surround the long, mosaic-lined pool. OVERLEAF RIGHT: An aerial view of the stunning pool and surrounding landscape.

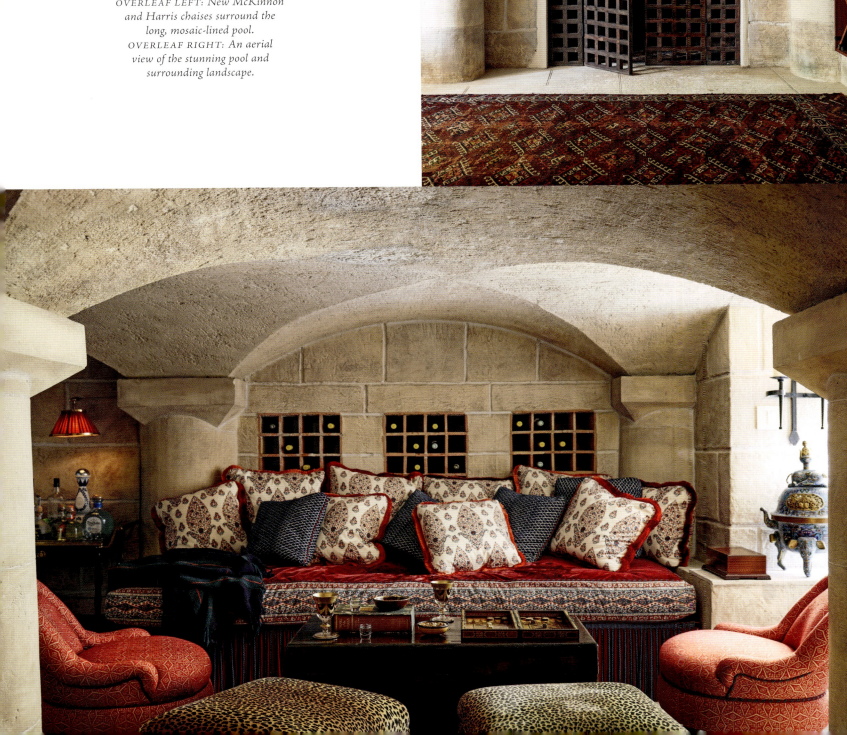

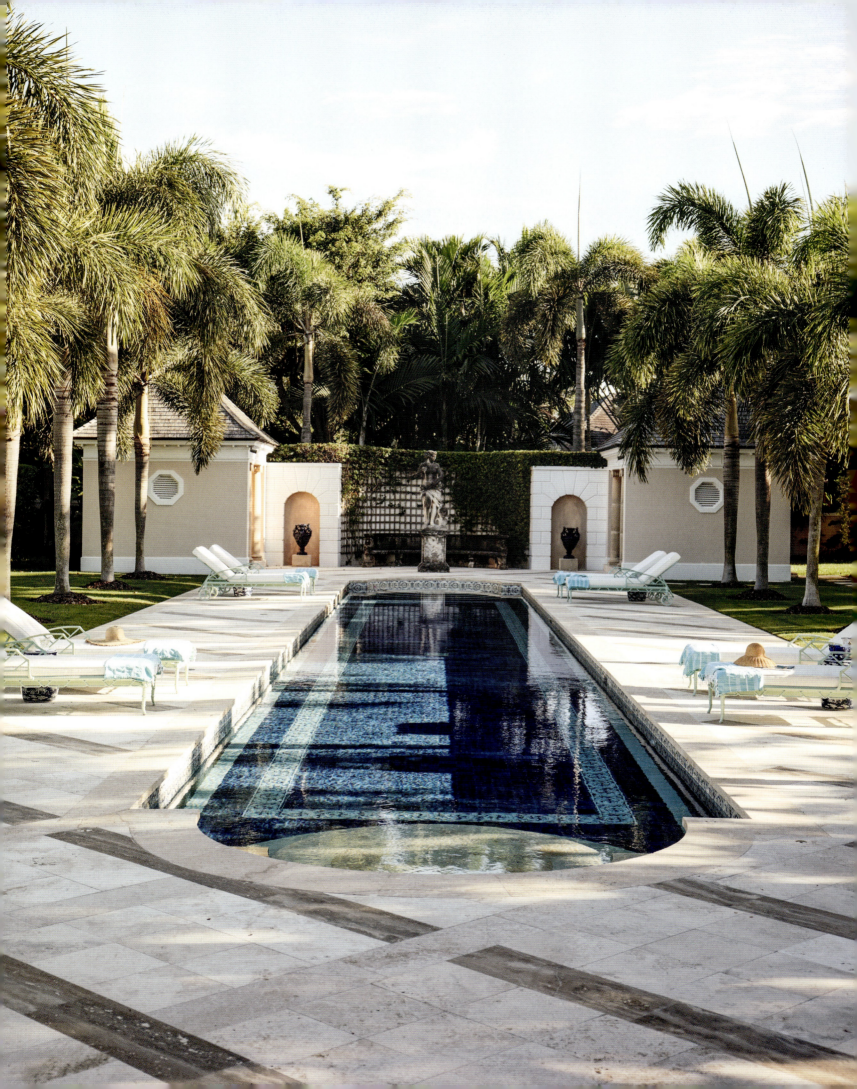

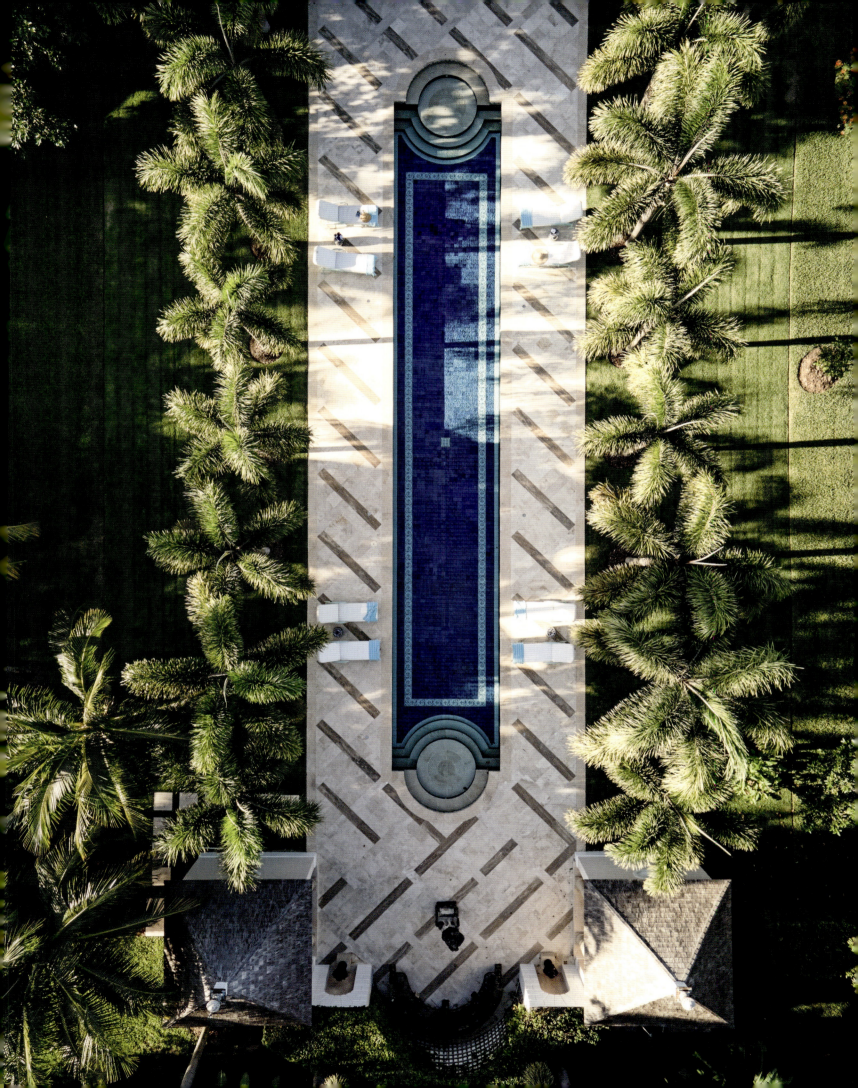

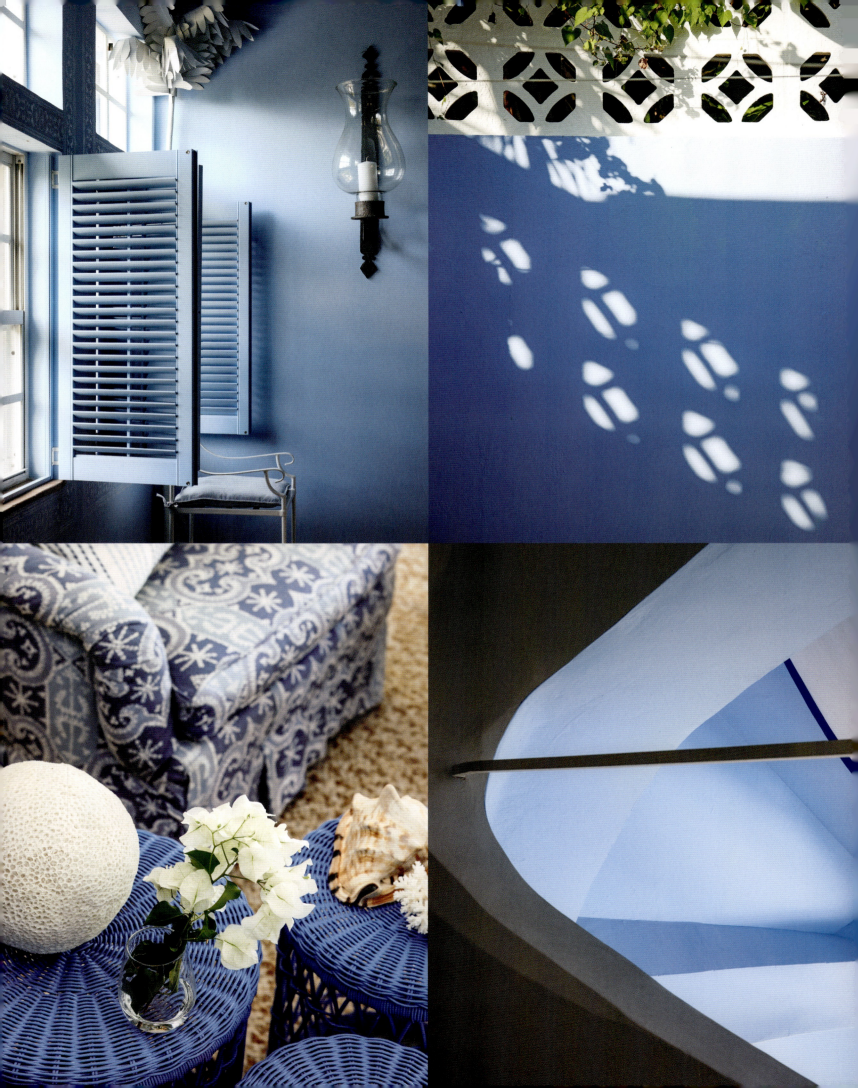

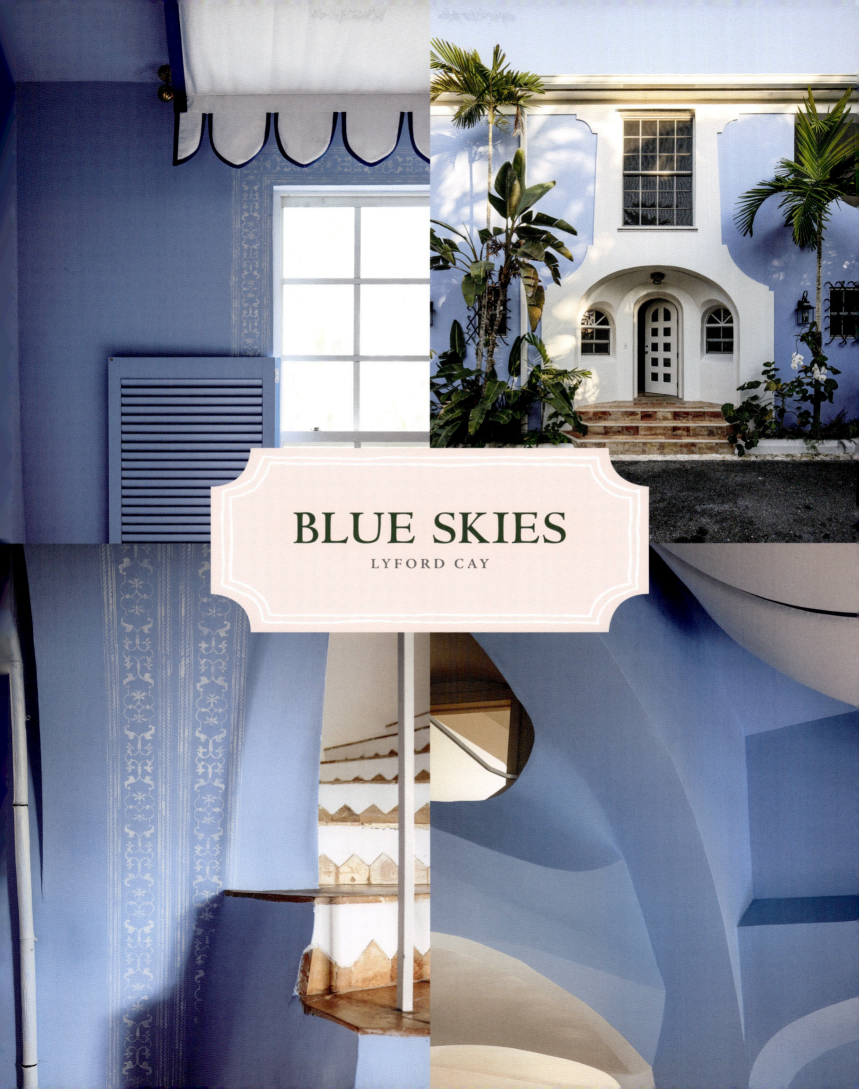

BLUE SKIES

LYFORD CAY

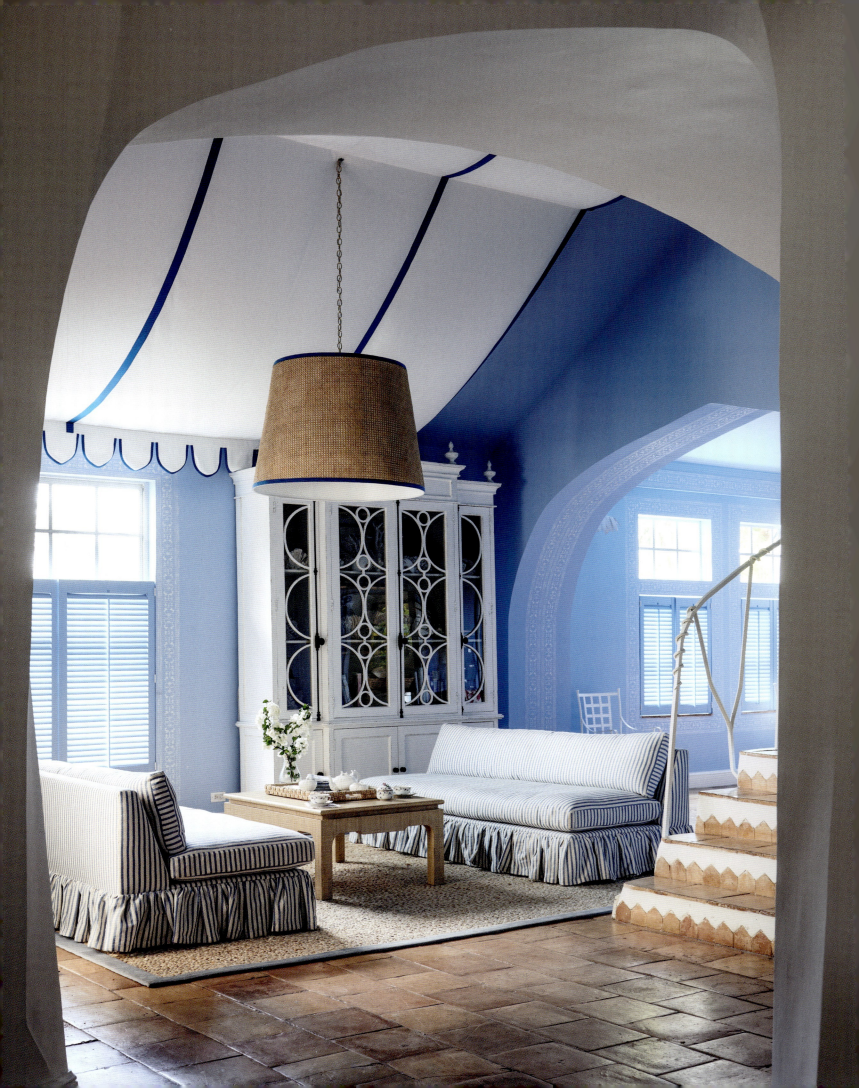

As interior designers, we are constantly faced with challenges, most of which involve finding work-arounds for rooms that have architectural quirks or flaws such as low ceilings, little natural light, or poorly proportioned windows. We all have our little tricks for finding solutions to these challenges.

At Blue Skies, a townhouse built in Lyford Cay in the 1980s, the challenge was actually trickier. The building was designed by Savin Couelle, one of the most famous and innovative architects of the mid- to late-twentieth century. He was among the architects responsible for the distinctive style of the villas of the Costa Smeralda, a stretch of coast in northeastern Sardinia developed in the 1960s and 1970s by the Aga Khan.

Couelle and his father before him were renowned for designing organically shaped houses that blend into their natural settings. The architecture is marked by curved walls and vaulted ceilings, niches and surprises. The interiors are often more sculptural than architectural. In short, there is not a single right angle, not a square room.

While on vacation in Sardinia some time ago, two enterprising Lyford Cay friends discovered Couelle's beautiful houses. Smitten by their unique design and thinking it could be perfect for the Bahamian climate, they commissioned Couelle to build a series of townhouses on a beautiful hill in Lyford Cay, on the site of a previous house also called Blue Skies. These townhouses have been coveted ever since.

I confess to almost panicking when asked to give this beloved home a facelift. An earlier generation of the owner's family hadn't met the task of responding to the artistry of the design and had installed a rather traditional interior. I felt strongly that we needed to honor the artistry and try to live up to it by creating something that was both family friendly and friendly to the curves and sculptural look of the architecture. The first decision was to insert some comfort and the second was to not overly decorate, as the room geometry was enough to carry the day.

In the entrance foyer, we saturated the walls in a rich blue and picked out the baseboards and doors in a bright coral. Coral banding also outlines the cross vault in the ceiling. A winding staircase leads up from the foyer to the piano nobile, where the living and dining rooms are located. The organic staircase railing is signature Couelle.

We furnished the living room with lots of soft seating covered in blue cotton solids, stripes, and batiks. In a seating area between the living and dining rooms, we added tenting for a visual

OPPOSITE: *The tented seating area between the living and dining rooms.*

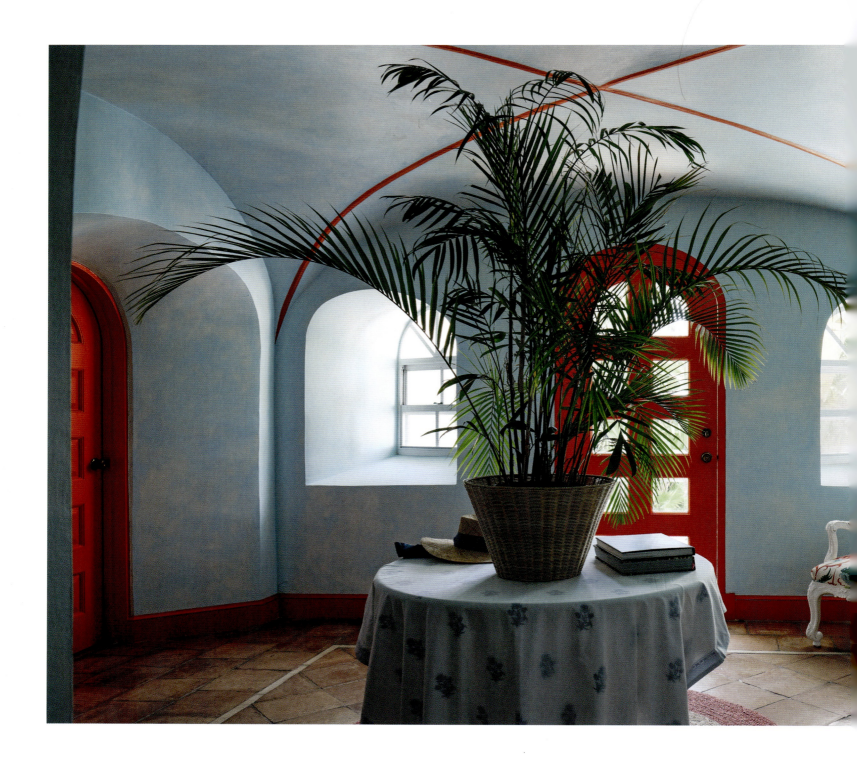

transition. In the dining room, a subtly stenciled frieze suggests ancient Mediterranean decoration. We used a clean blue-and-white palette throughout the house to honor its name, adding a few splashes of hot pink and coral to complement the scheme.

The Blue Skies houses are major architectural landmarks in Lyford and a lasting testament to Couelle and the two great, beloved gentlemen who commissioned them.

ABOVE AND OPPOSITE TOP: *The entrance foyer was painted a soft blue, and the cross vault of the ceiling, baseboards, and doors were picked out in a vibrant coral.* OPPOSITE BOTTOM: *A sneak peek into a small office off the foyer reveals a tropical bird painting in a coral frame.*

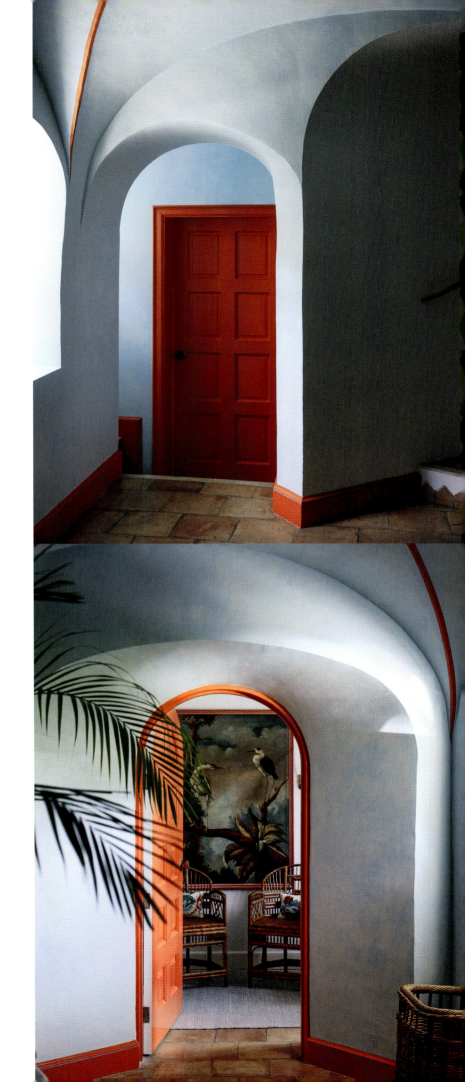

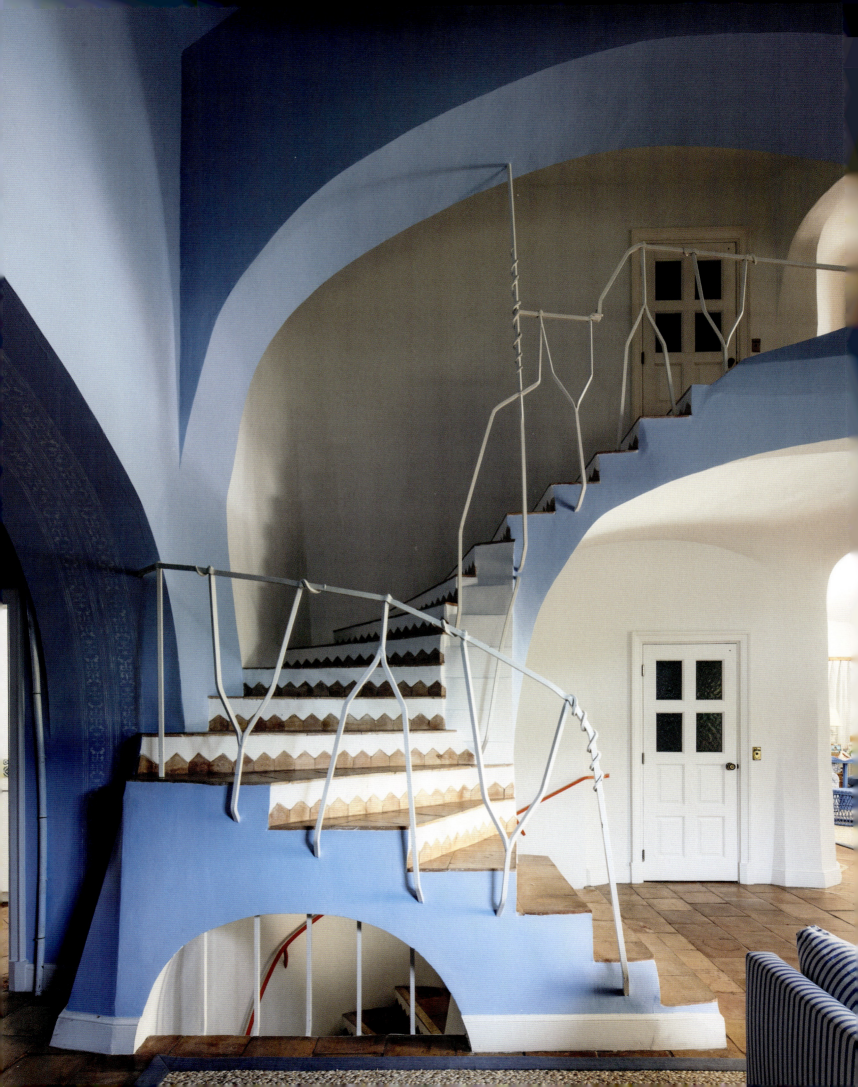

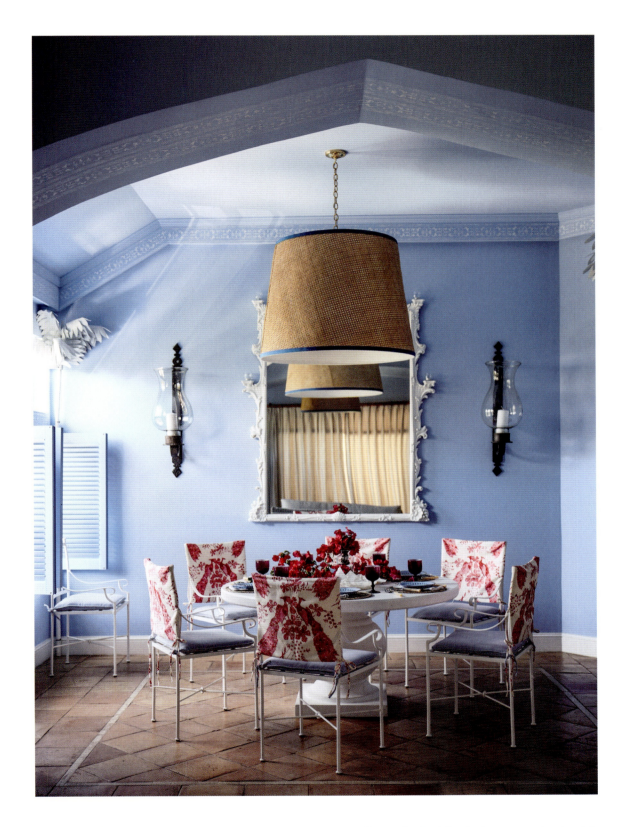

OPPOSITE: *The Coulle-designed stair rail is idiosyncratic and typical of his work.* ABOVE: *The dining room is painted the same serene blue as the stair hall. Brian Leaver designed the stencil for the frieze, and local artist Therron Davis implemented it. The overscale pendant was made by Heath & Company. Quadrille's Peacock Batik in fuchsia dresses up the backs of the metal chairs. Lindroth designer Caroline Sands painstakingly hand-made the delicate bamboo-and-metal palms in the corners.*
OVERLEAF: *In the living room, a Highland House sofa is covered in a deep blue linen. Patterned blue-and-white fabrics from Raoul Textiles, Schumacher, and Sister Parish create a layered look. Bamboo curtain rods from the Antique Drapery Company and chik blinds from India frame the views of the landscaping.* PAGES 132–33: *A view of the bougainvillea-surrounded pool.*

BLUE SKIES · 129

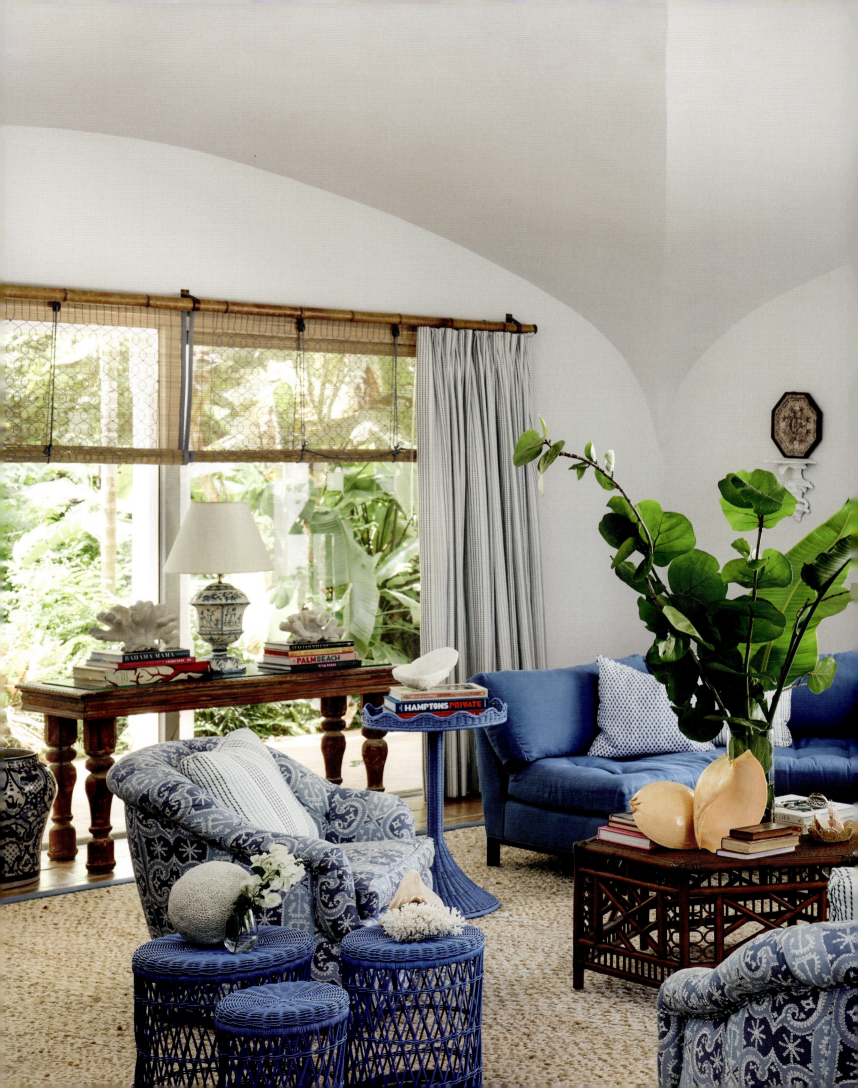

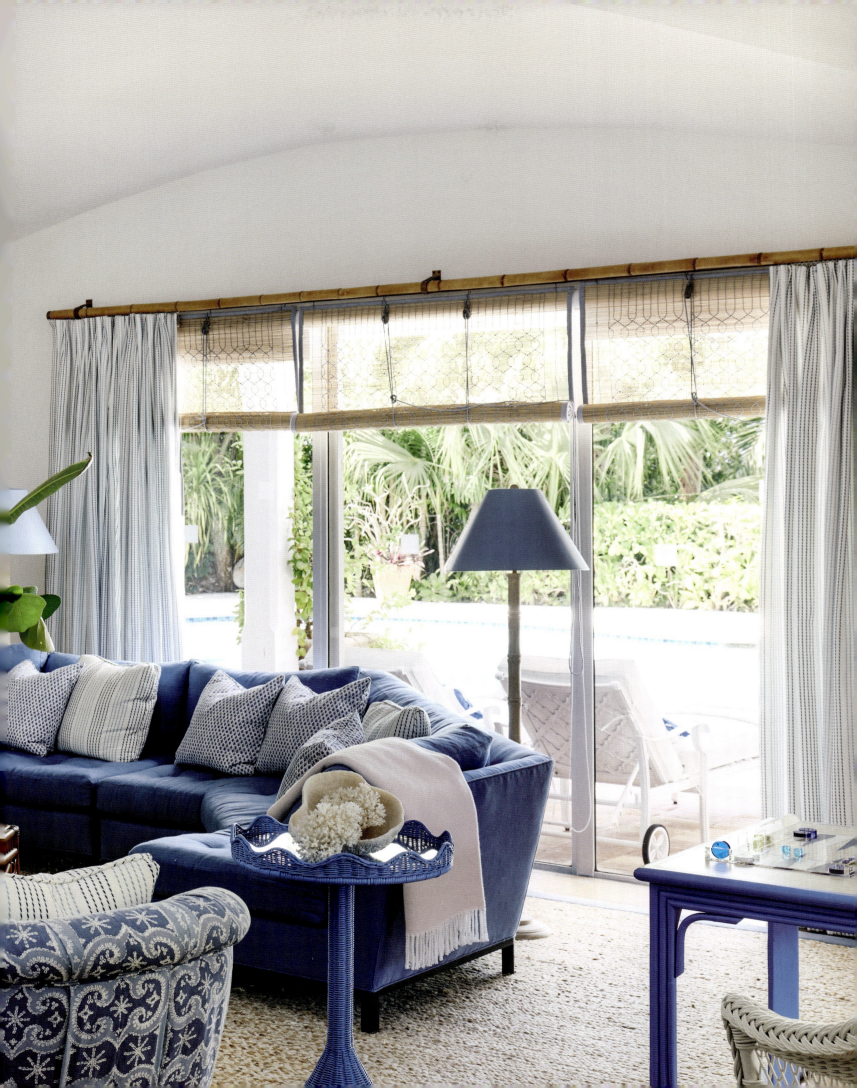

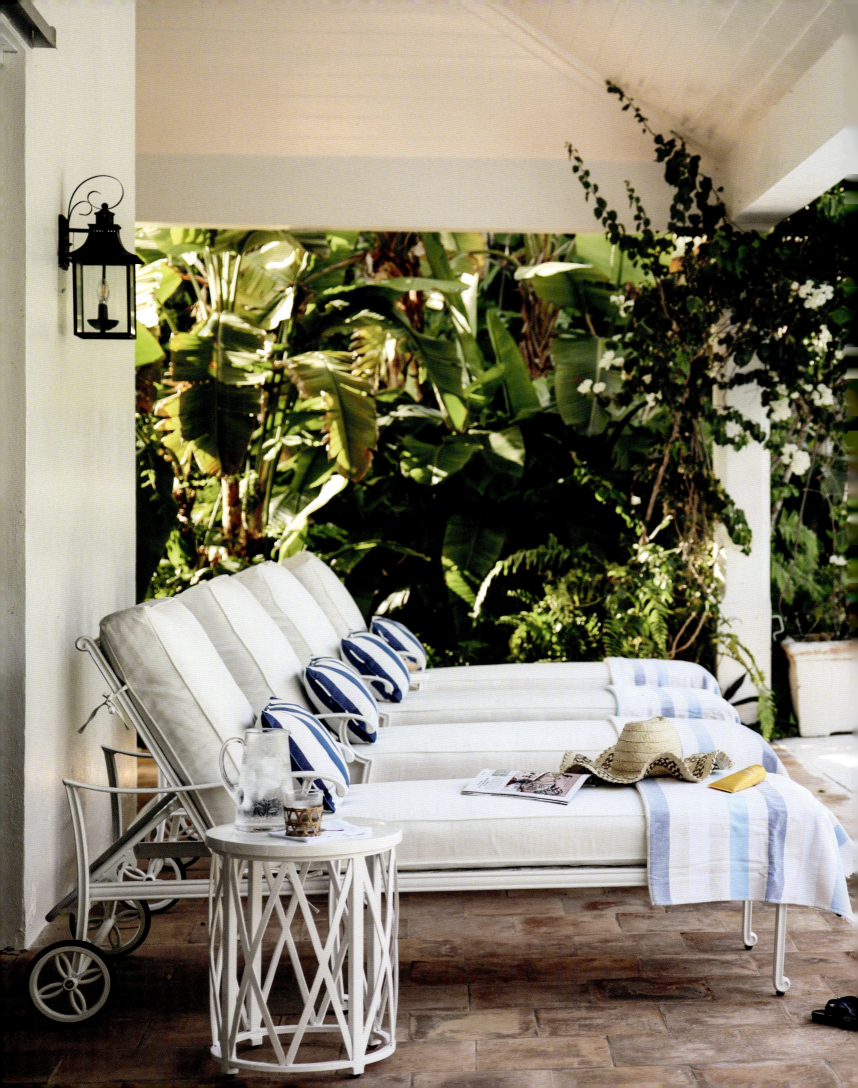

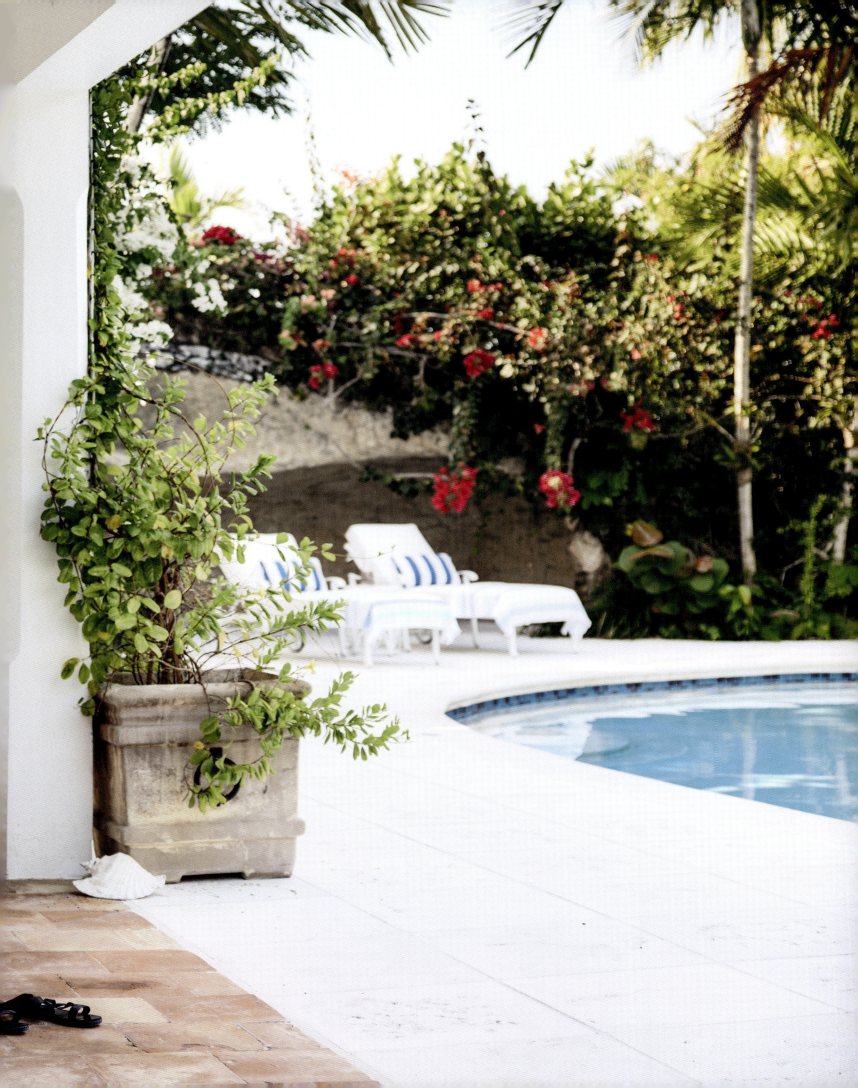

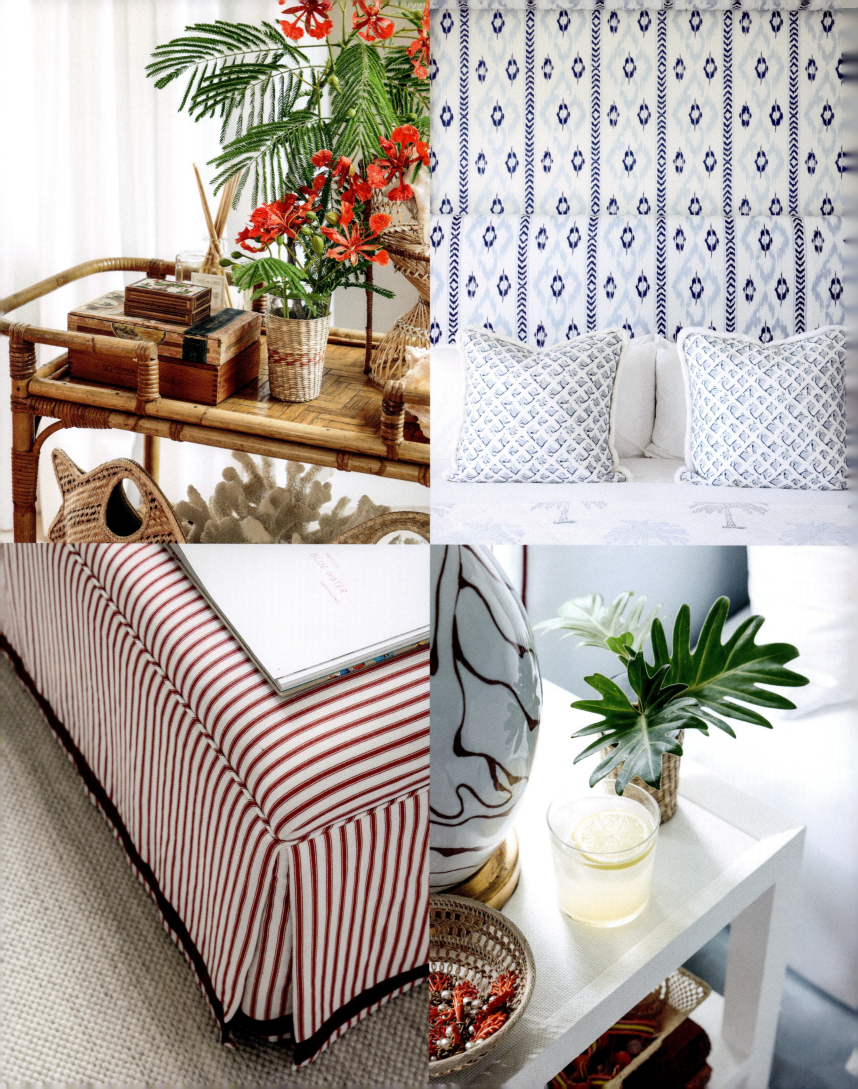

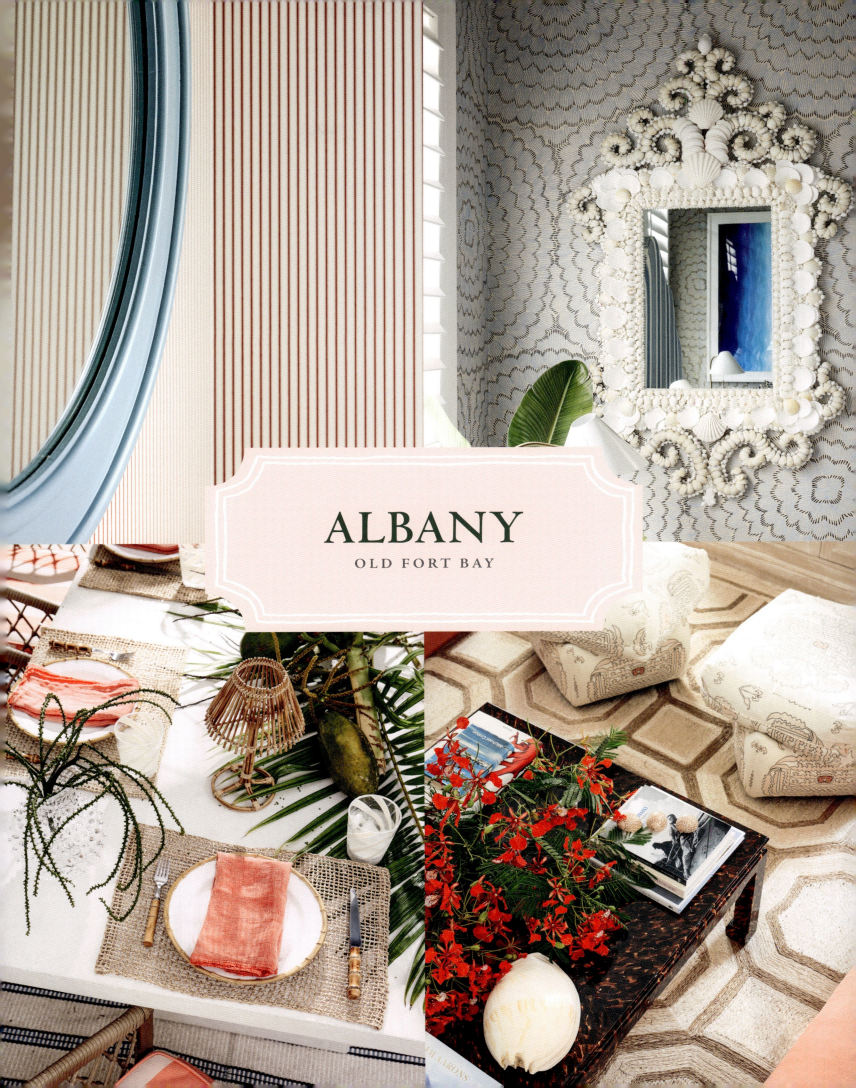

ALBANY
OLD FORT BAY

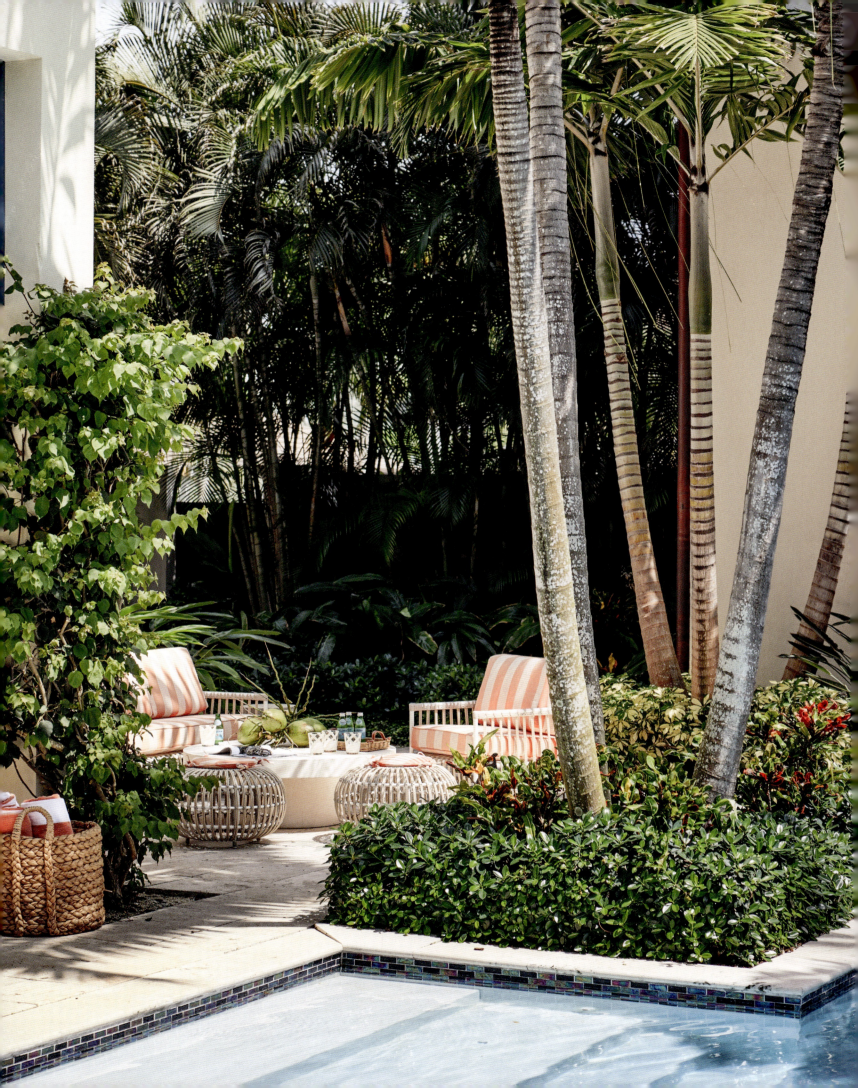

Imagine our happiness when we were asked to design a lovely house for a wonderful family from Texas at the Albany Bahamas resort community in Old Fort Bay on New Providence Island. It was our first house at Albany, and I admit that we wanted to hit it out of the park.

Our clients were experienced in the process and very quick with decisions. I do not recall many face-to-face meetings. Proposals were sent and received, marked up and commented on, and updated with such speed and efficiency that we were astonished.

The house was big, built as a spec house with tons of bedrooms and flooded with natural light. It was a perfect clean slate to create a colorful and happy home for this family.

Starting in the open living/dining/kitchen space, we painted the walls a warm taupe and anchored the living area with bright coral sofas from John Saladino. We then added a few Lindroth favorites, including Patterson Flynn abaca rugs, Soane Britain Rattan Daisy hanging lights, and China Seas hand-printed linen batiks on club chairs. We hung chic, custom-made Indian blinds with coral borders and threading in the windows, complemented by voluminous white linen curtains that frame the view of the lush tropical landscaping surrounding the house. For the dining area, we chose favorite chairs from Bonacina and a Soane Britain wicker table. Overhead hangs an overscale, hand-painted, faux-tortoiseshell pendant.

Because the house has extra-high ceilings and Sheetrock walls, we used miles of different wallpapers to cozy it up. The house has not only plenty of bedrooms but also a multitude of places to play, including an outdoor bar, a screening room, and a wonderful veranda for dining. We did everything we could to make sure each of these spaces was engaging. It was so much fun creating a private wonderland for this lovely family.

OPPOSITE: *A cozy poolside seating area amid mature palm trees.*

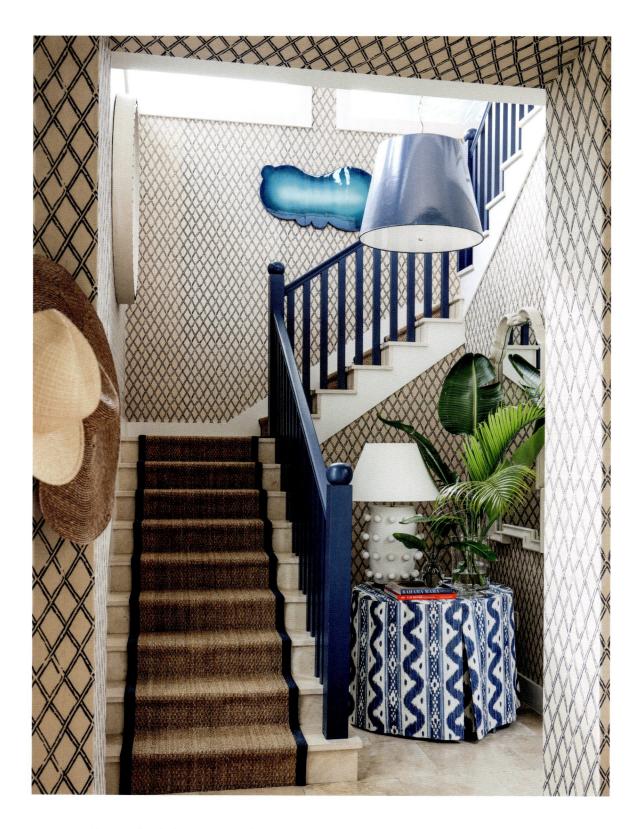

ABOVE: China Seas' Lyford Diamond Bamboo, printed on natural seagrass, envelops the stair hall. OPPOSITE: In the dining area, chair cushions in China Seas' New Lotus Batik add a bit of playfulness to the Soane Britain table and Century Furniture chairs. A hand-painted, faux-tortoiseshell pendant by Heath & Company lends pizzazz. OVERLEAF: Giant coral sofas by John Saladino pack a punch in the living area. Chik blinds from India and club chairs and ottomans upholstered in Quadrille's Clementine contribute subtle patterning. A favorite Soane Britain Rattan Daisy pendant brings a touch of lightness. PAGES 142–43: A Bernard Thorp ikat covers almost every square inch of this guest suite.

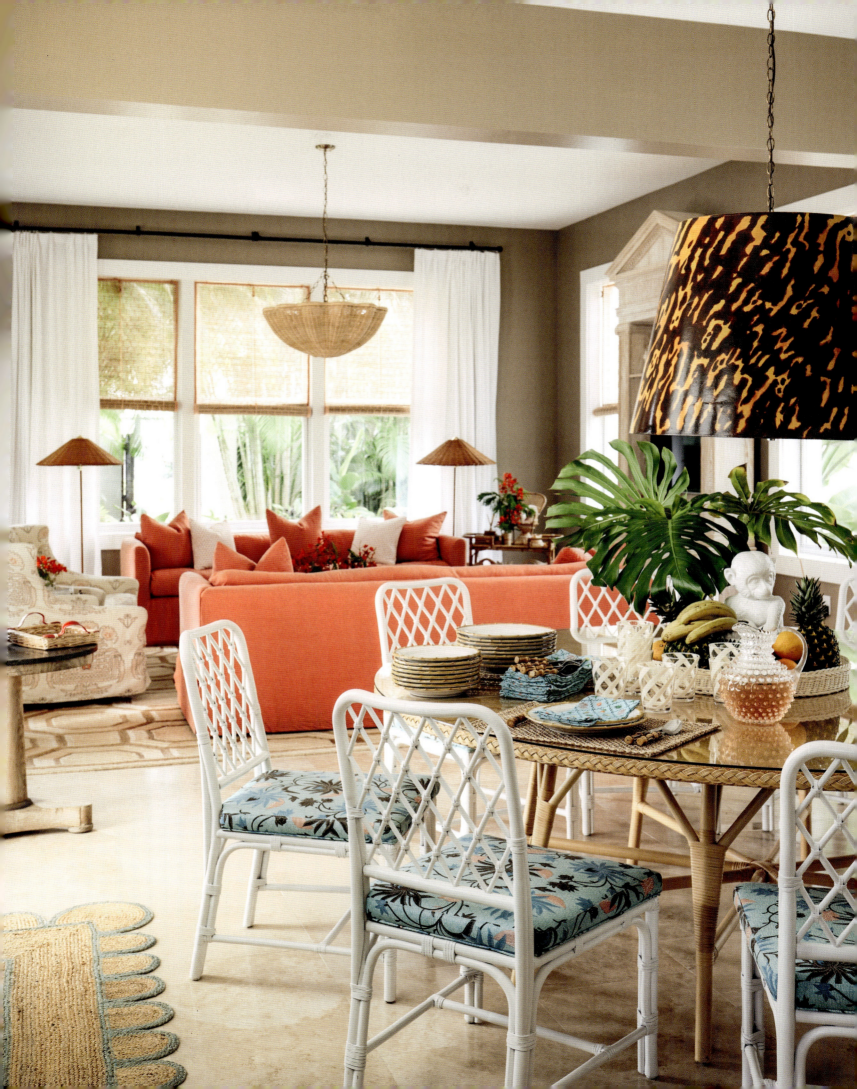

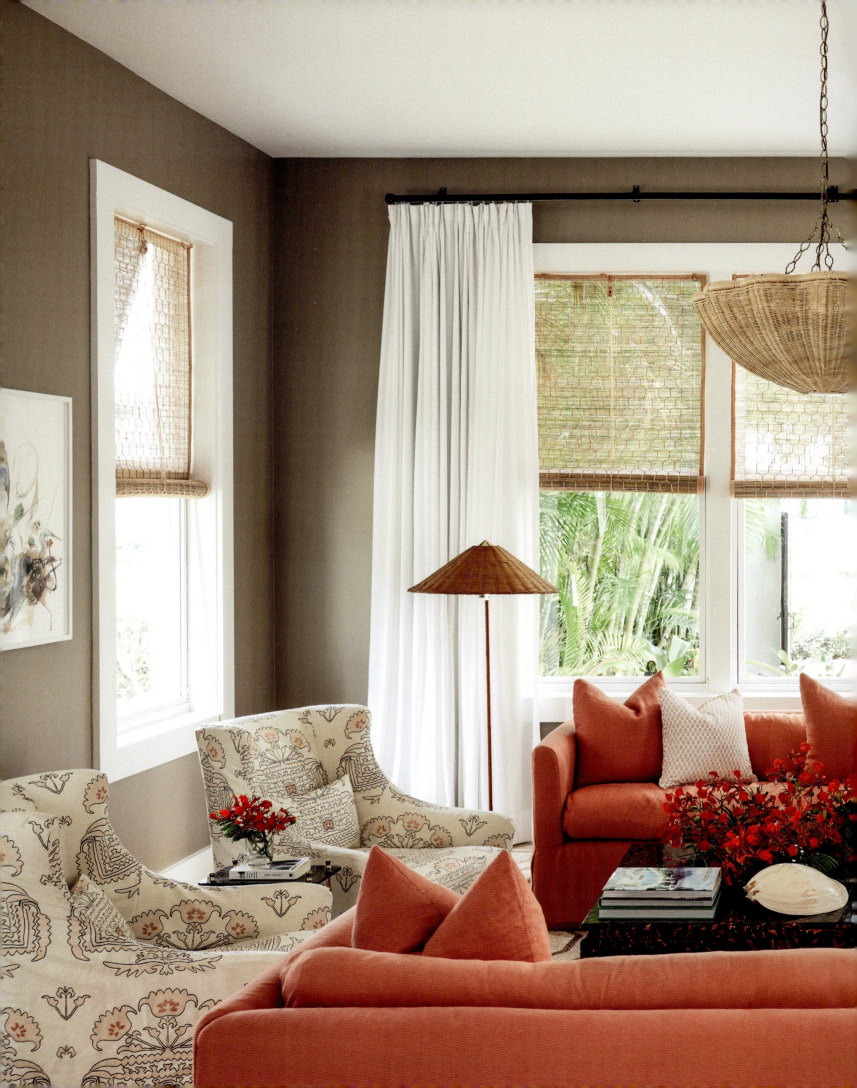

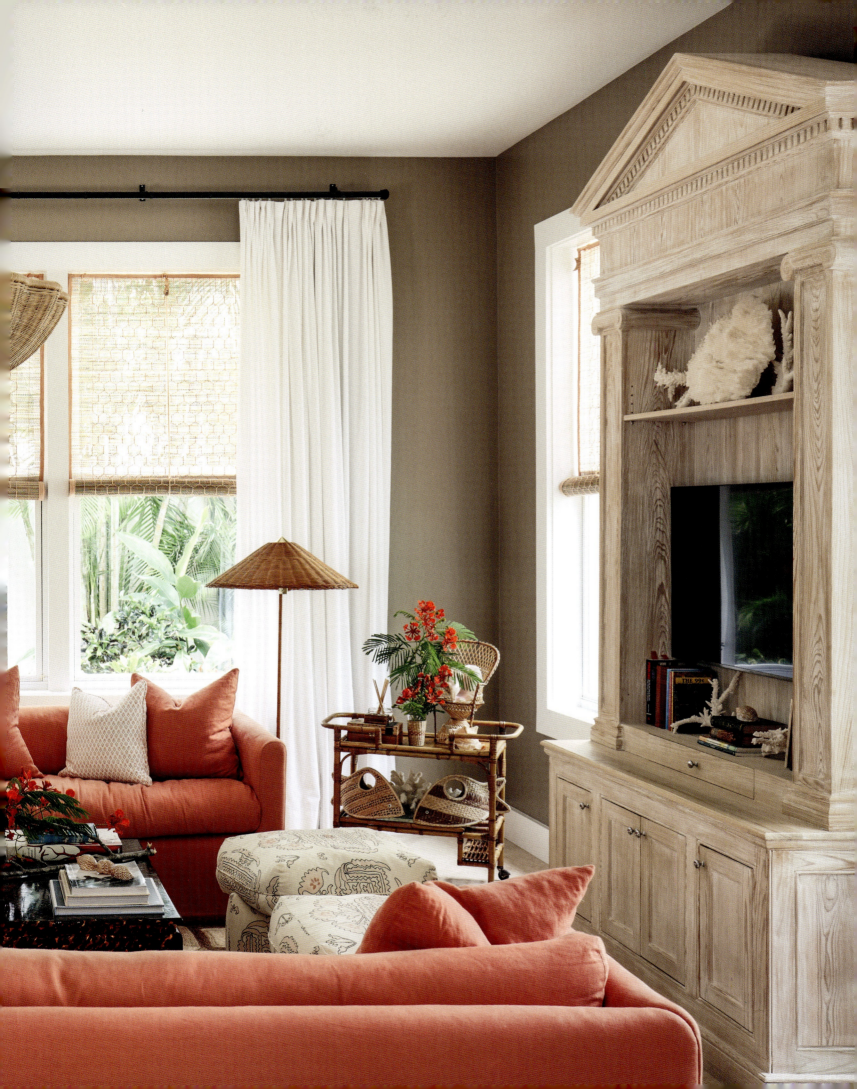

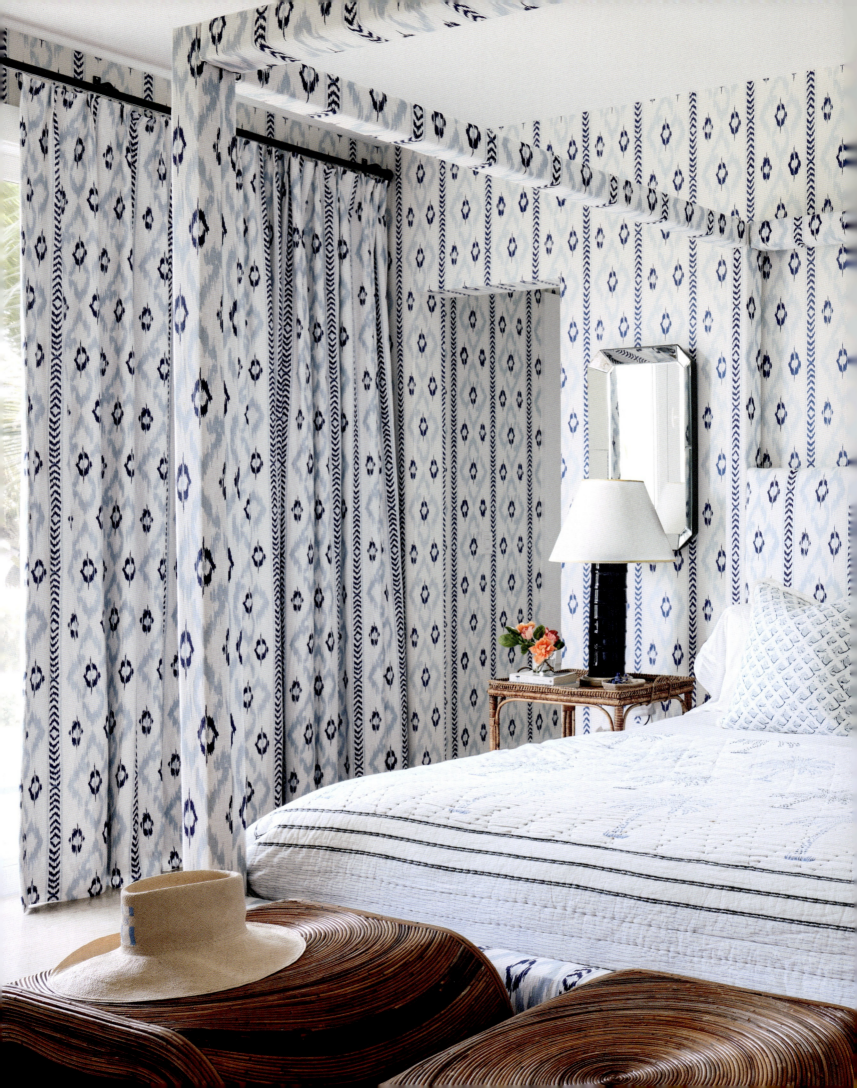

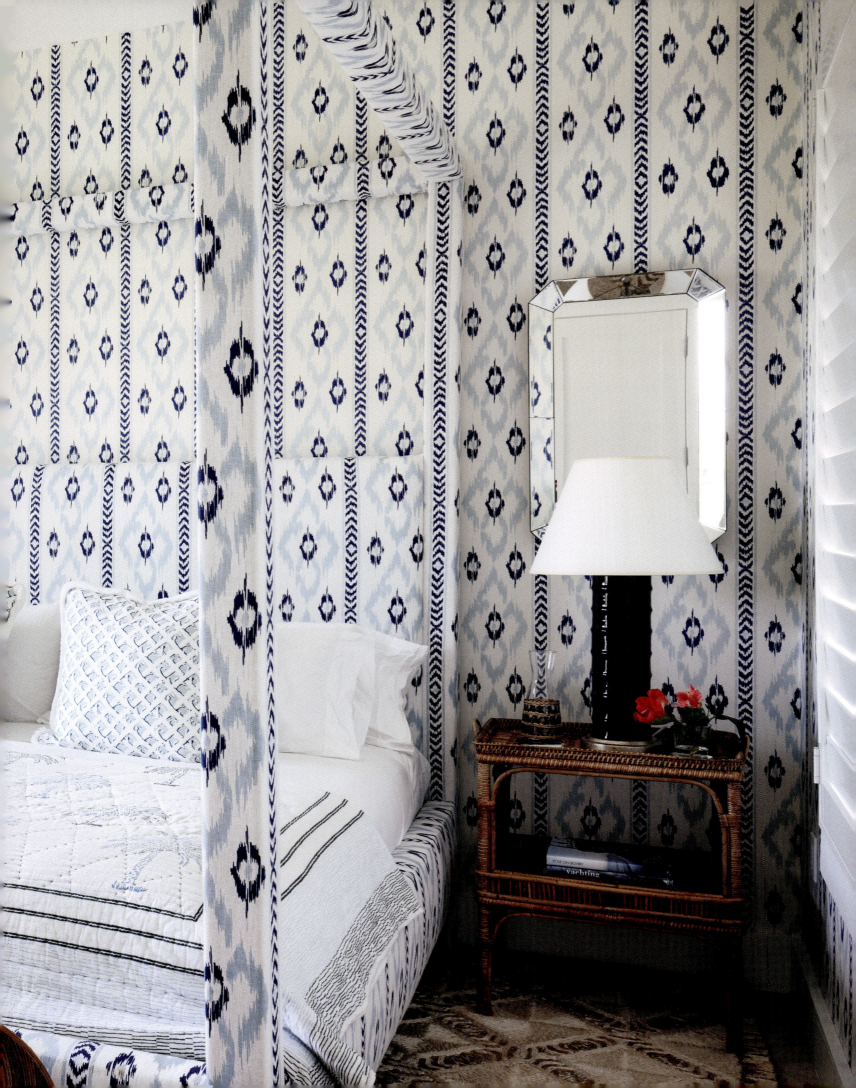

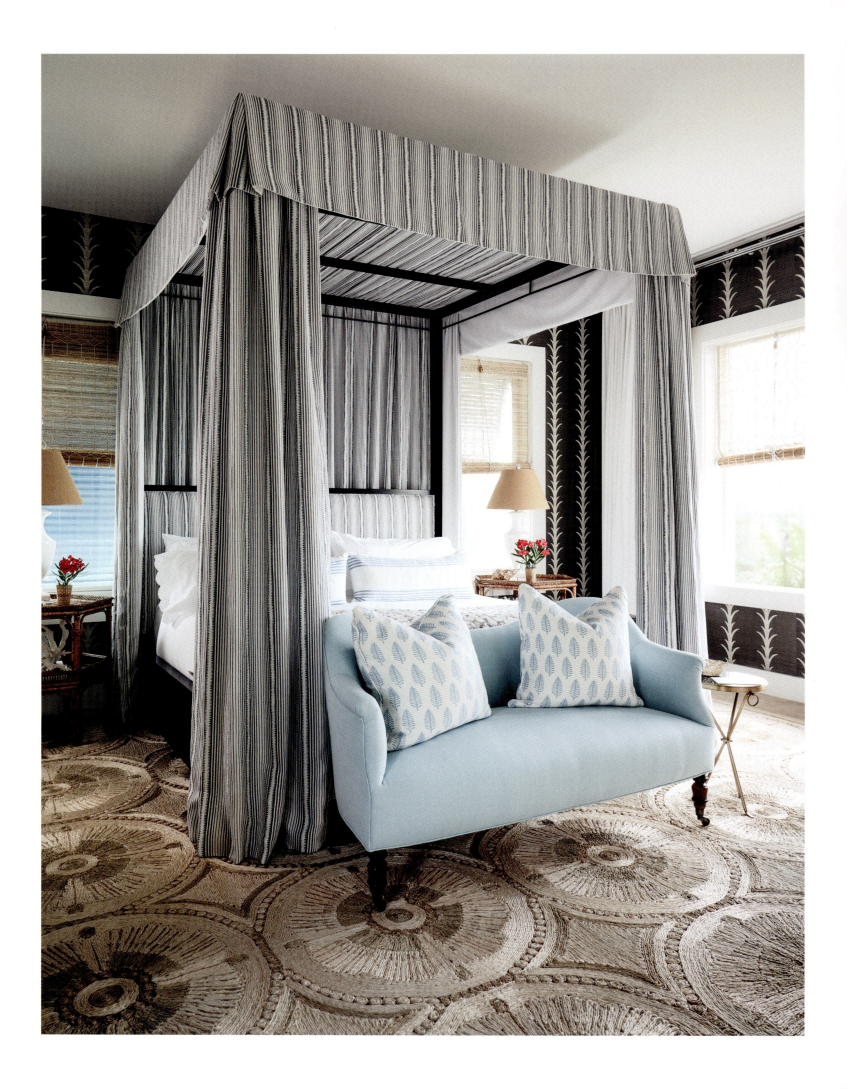

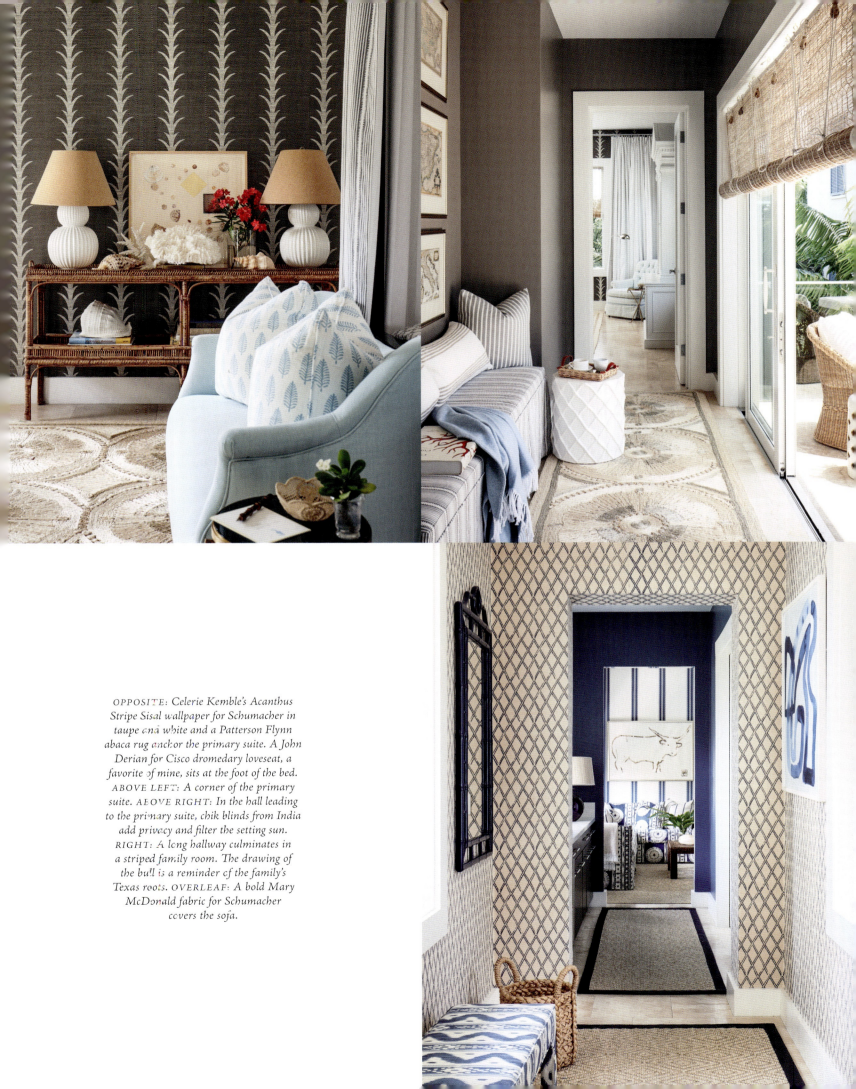

OPPOSITE: Celerie Kemble's Acanthus Stripe Sisal wallpaper for Schumacher in taupe and white and a Patterson Flynn abaca rug anchor the primary suite. A John Derian for Cisco dromedary loveseat, a favorite of mine, sits at the foot of the bed. ABOVE LEFT: A corner of the primary suite. ABOVE RIGHT: In the hall leading to the primary suite, chik blinds from India add privacy and filter the setting sun. RIGHT: A long hallway culminates in a striped family room. The drawing of the bull is a reminder of the family's Texas roots. OVERLEAF: A bold Mary McDonald fabric for Schumacher covers the sofa.

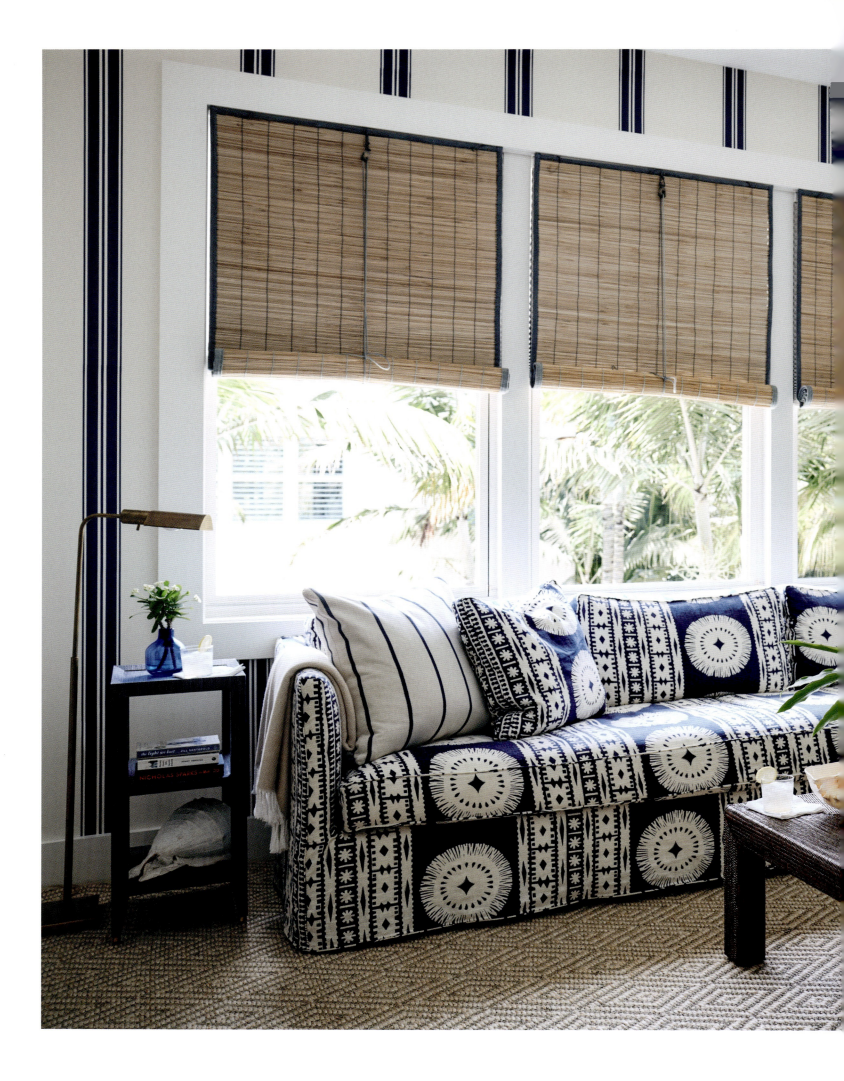

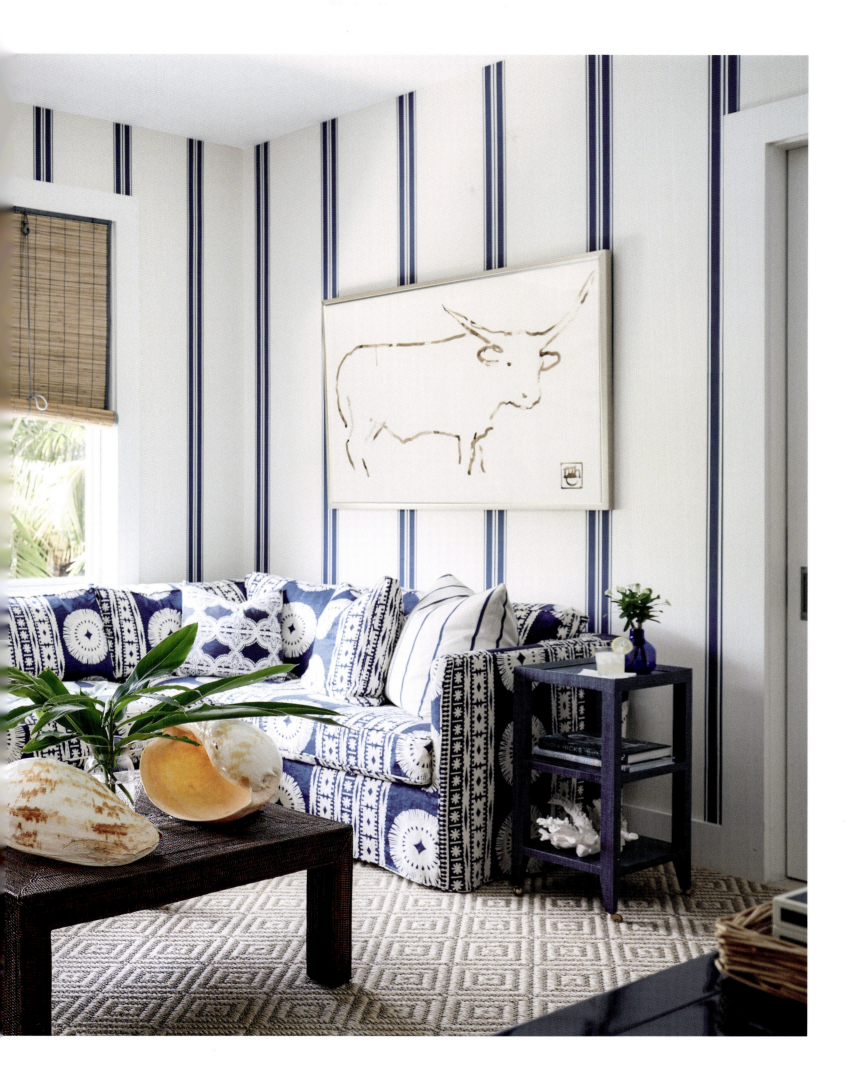

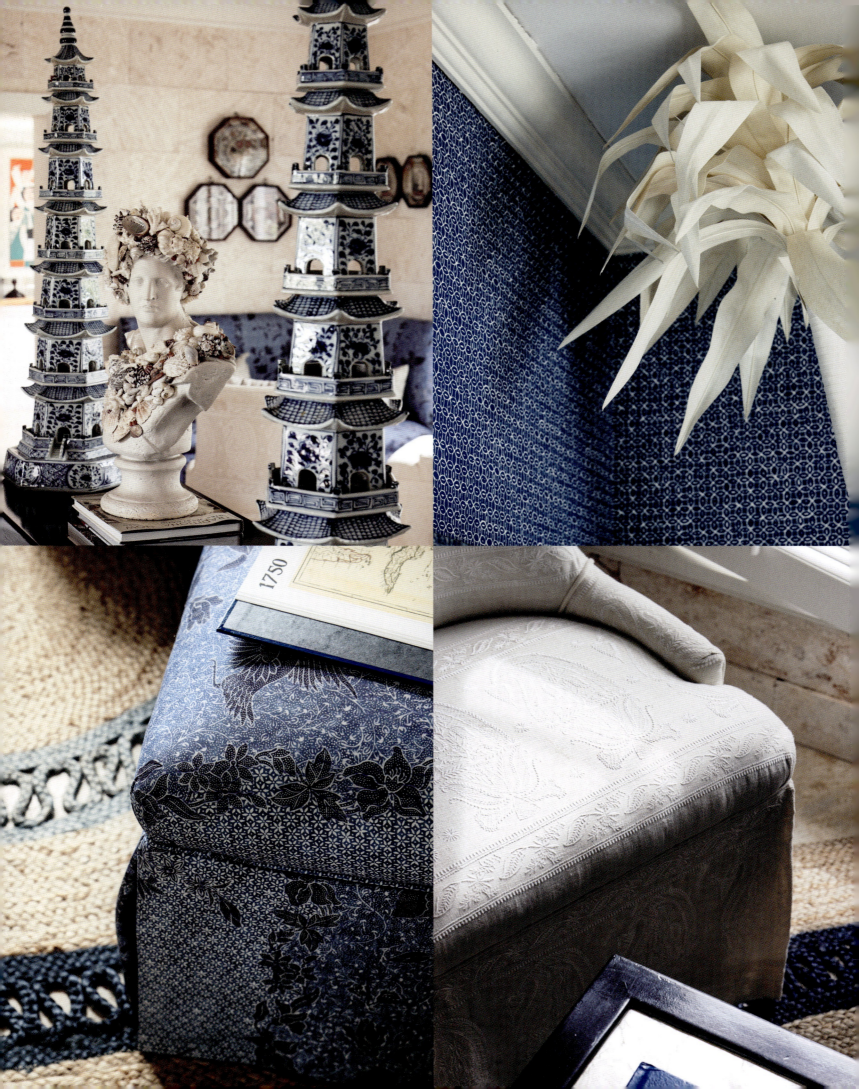

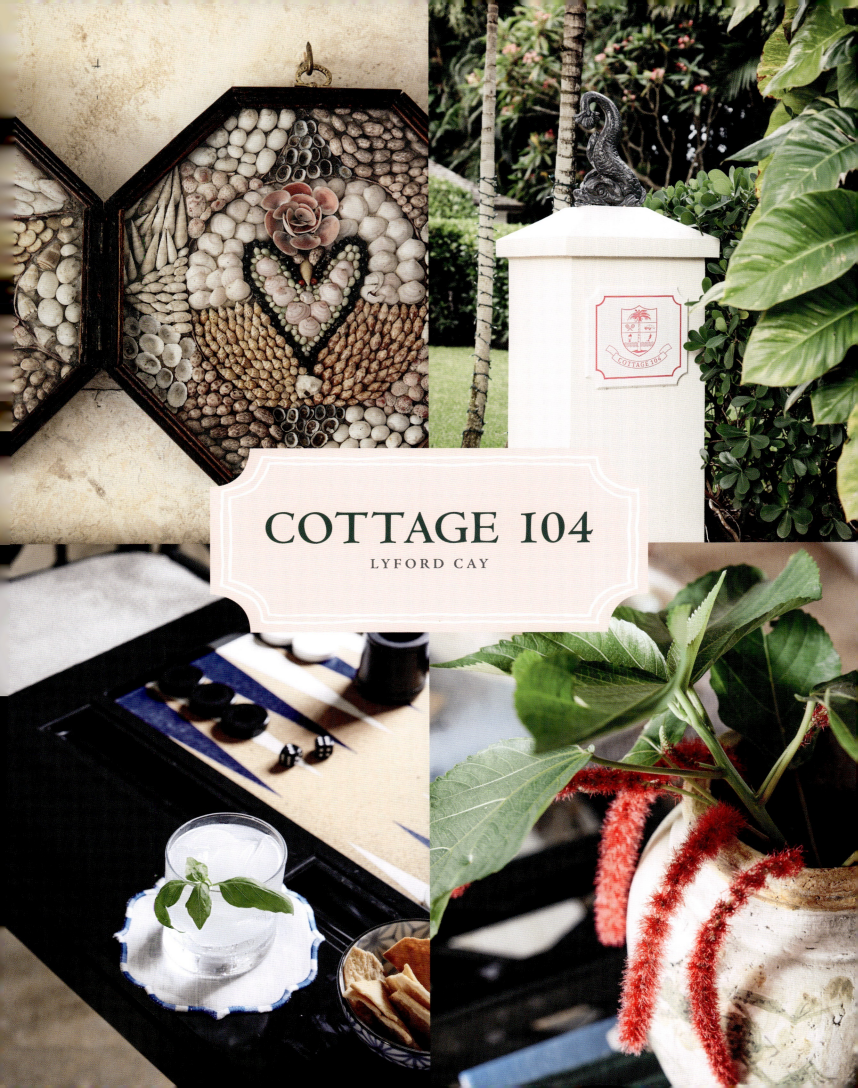

COTTAGE 104
LYFORD CAY

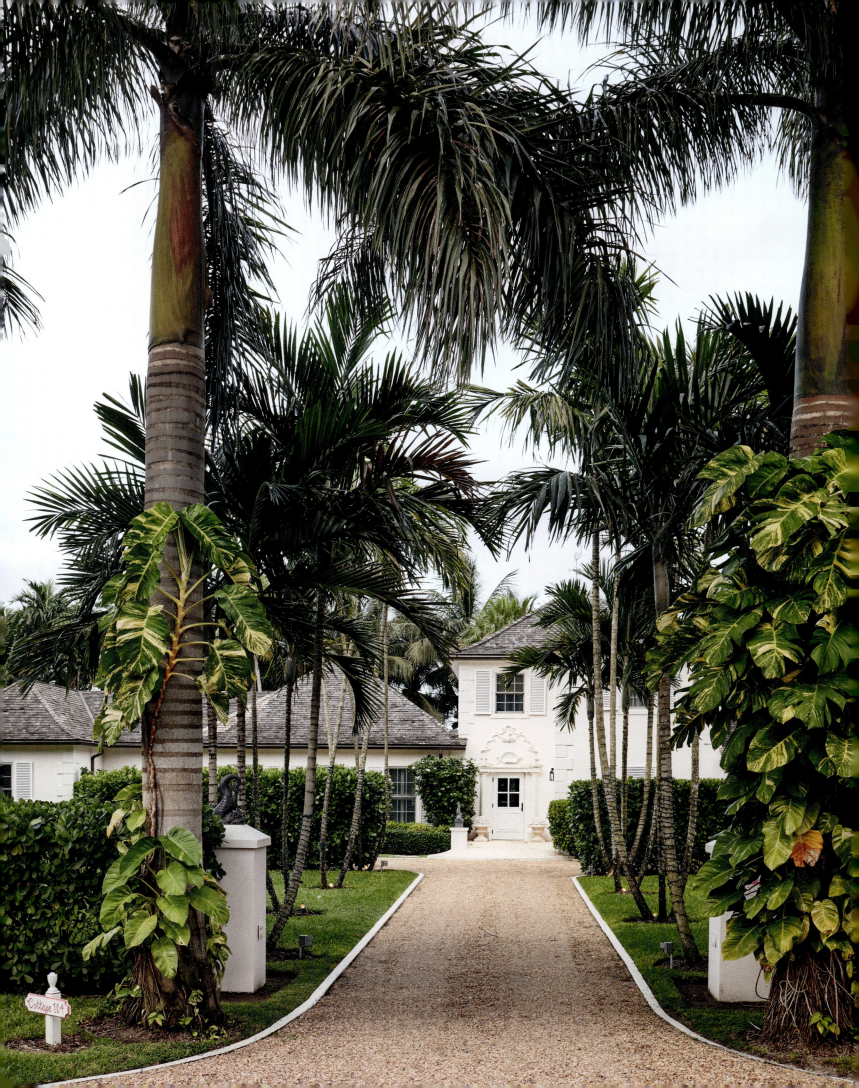

When a close friend called in late September 2016 and asked us to redesign the interior of a house they were closing on, we were thrilled. There was just one catch. My friend said it had to be completely finished before the annual Member Guest Tennis Tournament at the Lyford Cay Club, which was scheduled to begin seven weeks later. The house was known to us, as we had done it for the previous owner, another beloved friend.

Never one to shy away from a challenge, I said yes, we would do it, and I put two of the most energetic members of my team on the case. It is important to remember that Lyford Cay is on an island in a foreign country with all the attendant shipping complications, customs documentation, paperwork, and inevitable delays these conditions can cause. I still said yes!

But my agreement was contingent on two requirements: 1) We could buy only items "in stock" and 2) the money tap had to be wide open so that we could charter freight planes and keep the 24/7 design/ship/install machine rolling. Both terms were instantly accepted, and thus began a crazy couple of weeks of long Zoom calls with the client, scouring websites, buying all kinds of beautiful things, and having a great time doing it.

On one call, a pair of blue queen-size headboards for the boys' room caught our fancy. The website revealed that the only in-stock color was mustard yellow. Pivot to the yellow, and they look chic and are loved to this day.

We had only one bump along the way. After a big day of approved selections on October 15, Lyford got hit with a giant, Category 4 hurricane called Matthew on October 16. The island was devastated. Our houses ran on generators for a week. The roads were impassable. Cars were impaled with palm fronds. My friend called to check whether we were all okay and to see if I had managed to order the wallpaper for the hallway. I giggled and told her about the power outages and current conditions. We laugh about it to this day, but we made the deadline and have such a story to tell!

Since then, we have layered the house with treasures, including a fine collection of rare sailor's valentines, collected one by one as they are found, and beautiful tropical paintings.

Before moving into the house, the family had stayed in the very last of the club cottages, Cottage 103, for all family holidays for three decades. After long debate, the new house became known as Cottage 104 and has a "logo" that is amusingly similar to the Lyford Cay Club shield but with family symbols replacing the club's symbols.

OPPOSITE: *Soaring palms line the drive leading to Cottage 104's charming entrance.* OVERLEAF: *In the living room, a William Skilling painting enlivens one corner. A few examples of the client's precious collection of sailor's valentines can be seen to the left. Scott McBee's illustrations of crabs in blue and gold flank the doorway to the veranda. Coral-stone walls and pecky cypress ceilings, a Lindroth favorite, wrap the room.*

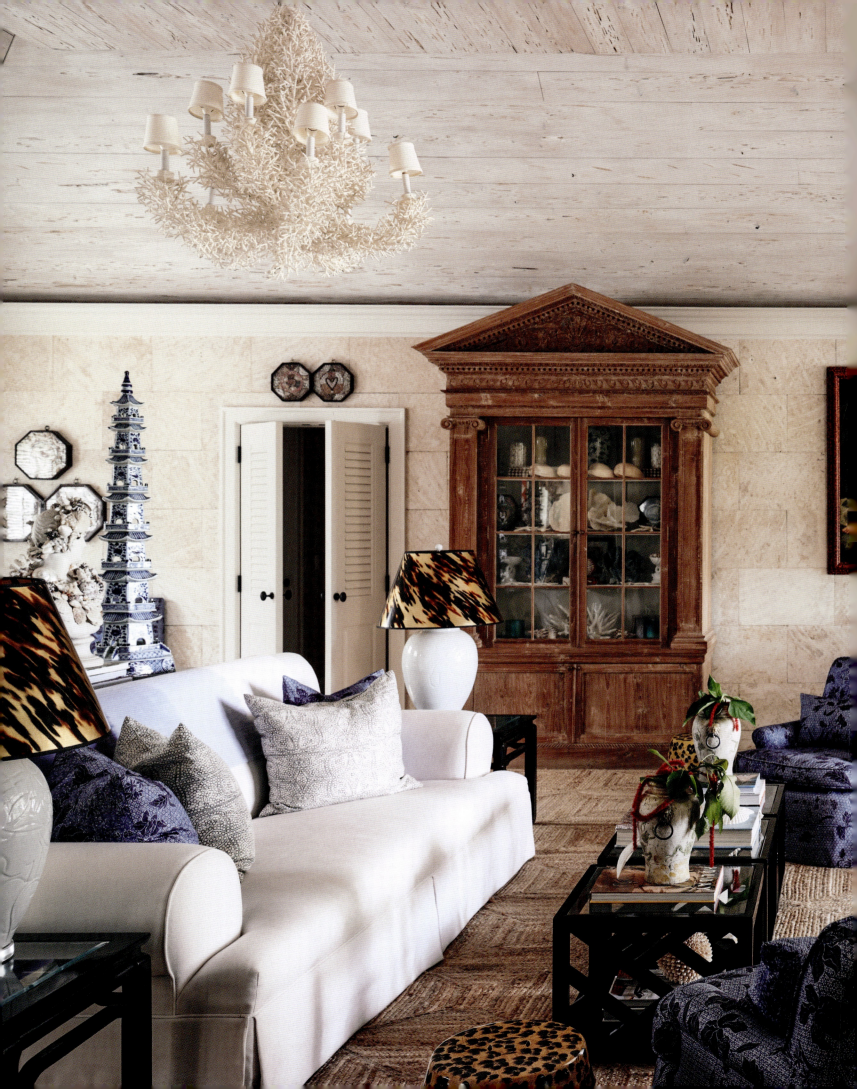

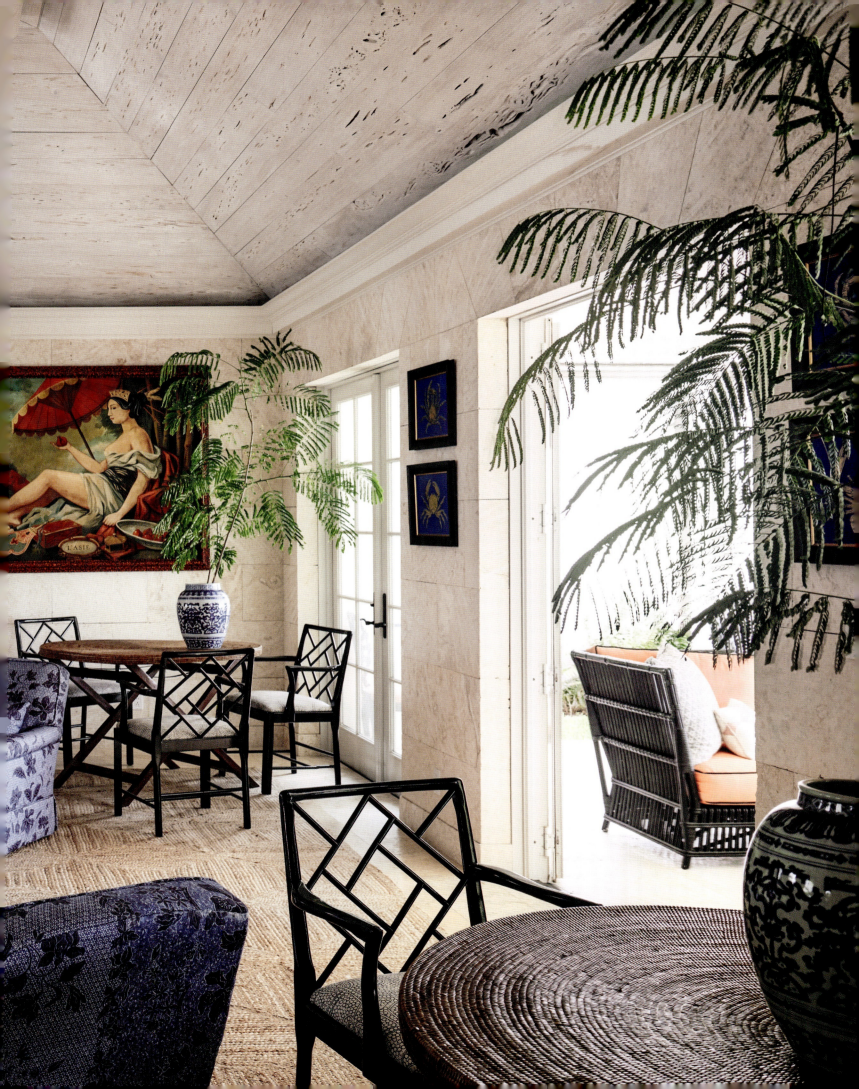

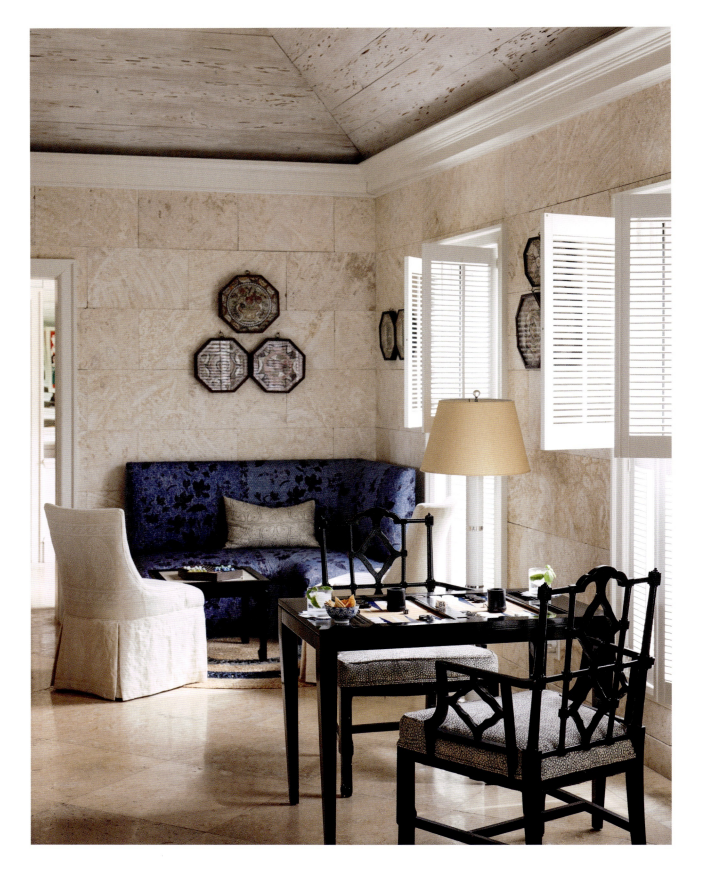

ABOVE: *A corner banquette covered in China Seas' Antik Batik softens a corner beneath some of the client's beautiful sailor's valentines.* OPPOSITE TOP: *The mirrored entrance foyer is furnished with vintage Crespi rattan waterfall tables and Mario Lopez Torres mirrors.* OPPOSITE BOTTOM: *On the opposite side of the entrance foyer are works by local legend Amos Ferguson.*

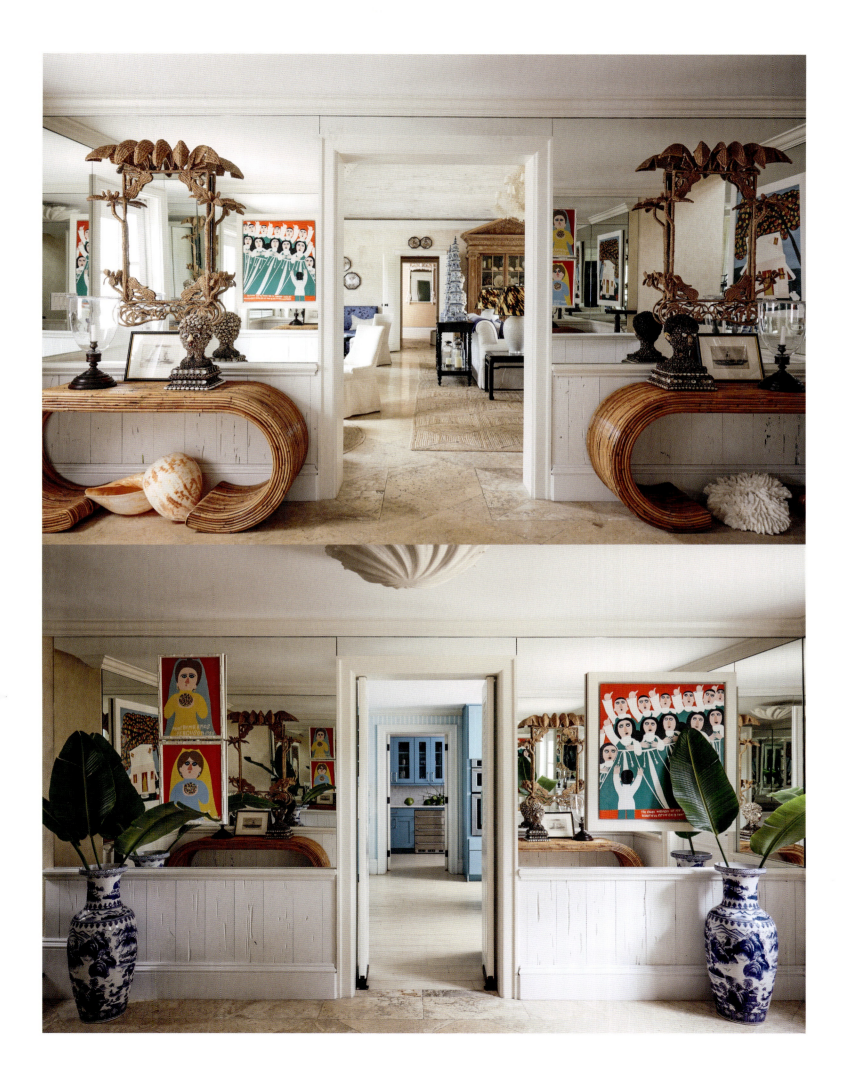

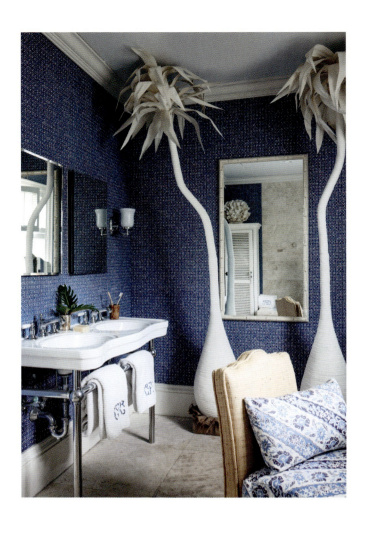

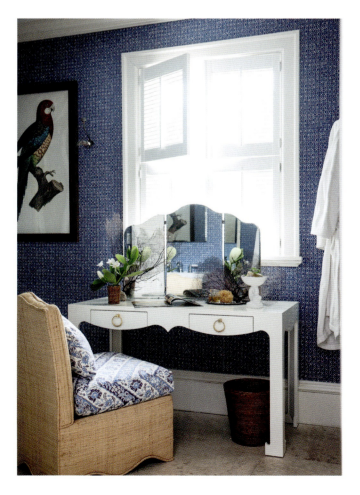

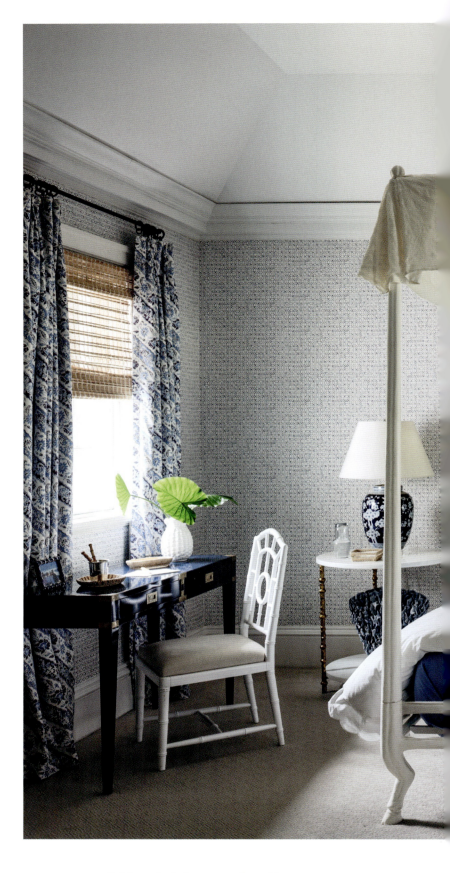

ABOVE LEFT: Quirky and wiggly canvas palms add amusement to the primary bathroom. China Seas' Melong Batik in a deep blue wraps the walls. LEFT: A dressing table is accompanied by an Oomph slipper chair with cushions in China Seas' Lim Diagonal.

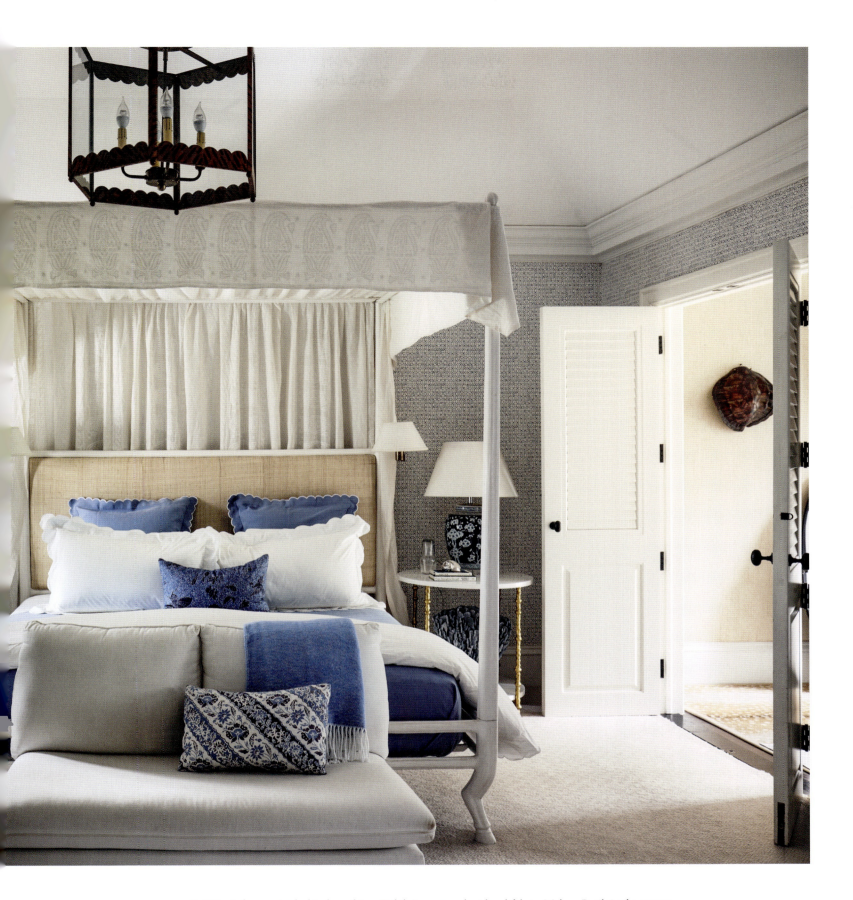

ABOVE: *A four-poster bed is draped in a Ralph Lauren embroidered fabric. Melong Batik in the reverse colorway of the bathroom version covers the walls, and Lim Diagonal is used for cushions and curtains. A Coleen and Company Scalloped Lantern with a tortoiseshell finish completes the space.* OVERLEAF: *On a pair of black-painted Bielecky Brothers sofas, cheerful coral performance-fabric cushions echo the bright, similarly colored bougainvillea in the garden. The party lights strung between the palm trees are lit every night when the family is on the island. It is a charming and festive gesture that the community loves.*

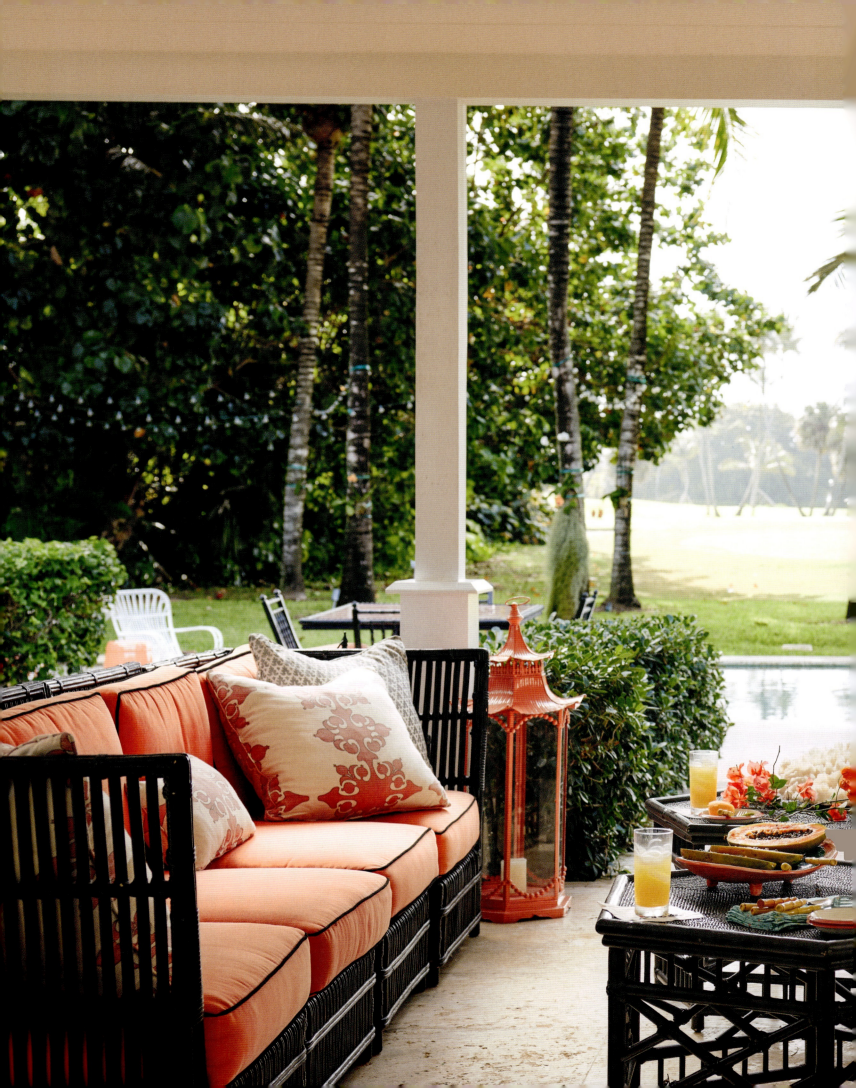

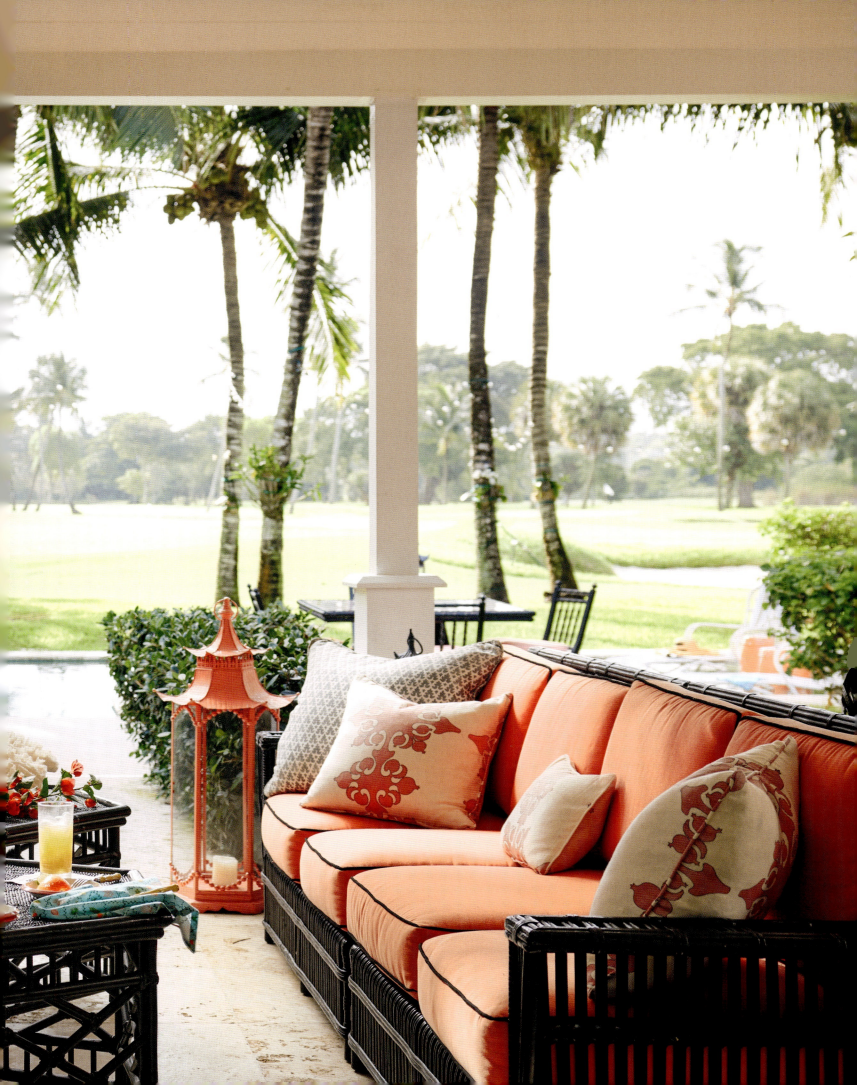

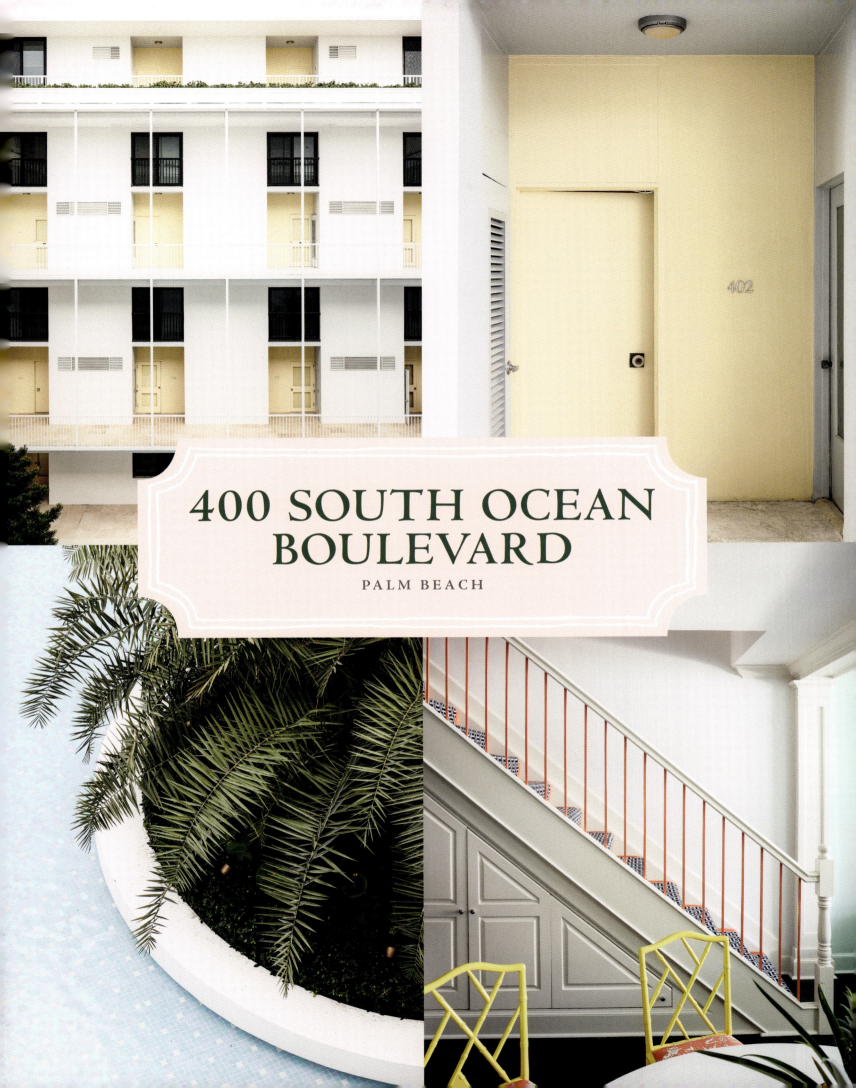

400 SOUTH OCEAN BOULEVARD

PALM BEACH

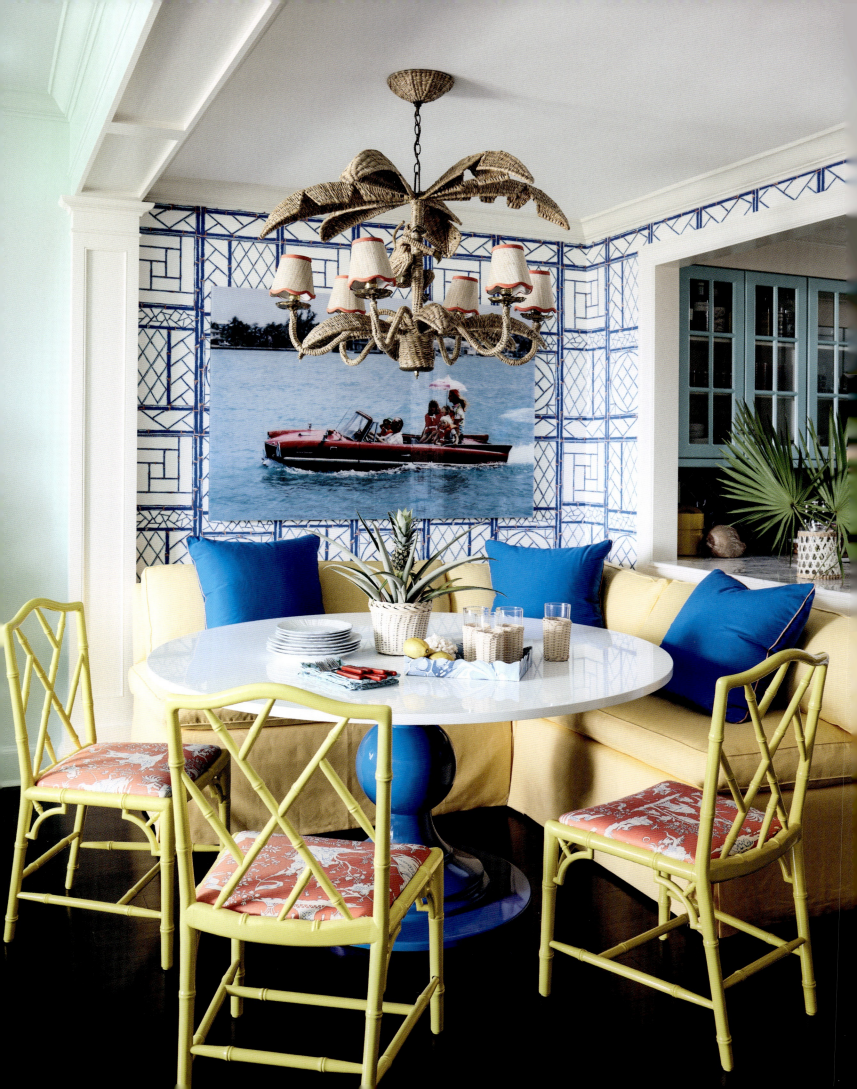

In January 1964, legendary photographer Slim Aarons gathered a group of Palm Beach's high-society women, dressed them in Lilly Pulitzer, and dropped them into the fountain of the iconic apartment house at 400 South Ocean Boulevard, designed by architect Edward Durell Stone. The photo, to this day, is one of the best representations of that moment in Palm Beach's history. The architecture was clean and modern, the dresses were sleeveless and cheerful, the socialites were barefoot, and some wore scarves around their heads, presumably to protect their hair while driving around the tiny island in Fiat jollys and other charming open-air cars. Fast-forward to today, and the building with the fountain is still one of the most coveted of all in-town addresses in Palm Beach.

We were overjoyed when our clients called us from their house at the Greenbrier in West Virginia and asked us to give their new spot an update. On our very first call, both the husband and wife explained their love of color on color. Their previous decorator was the late Carlton Varney, whose wild use of color was his trademark. We were going to have to up our game.

We started with an aqua-lacquered great room. For the adjacent dining nook, we chose Lyford Trellis in French blue for the wallpaper and a taxi-cab-yellow banquette, as if to say "Let the party begin!" Boldly colored and patterned fabrics and wallpapers in the bedrooms, including one lacquered in Kelly green, complete the mission.

It is poignant that this building was first made famous by social ladies in colorful clothes. Our clients are certainly doing their part to keep the same color and social vibe alive at 400 South Ocean Boulevard.

OPPOSITE: A mash-up of colors enlivens the breakfast nook. OVERLEAF: Highly lacquered walls, varied patterns, and contrasting colors somehow coalesce seamlessly in the great room.

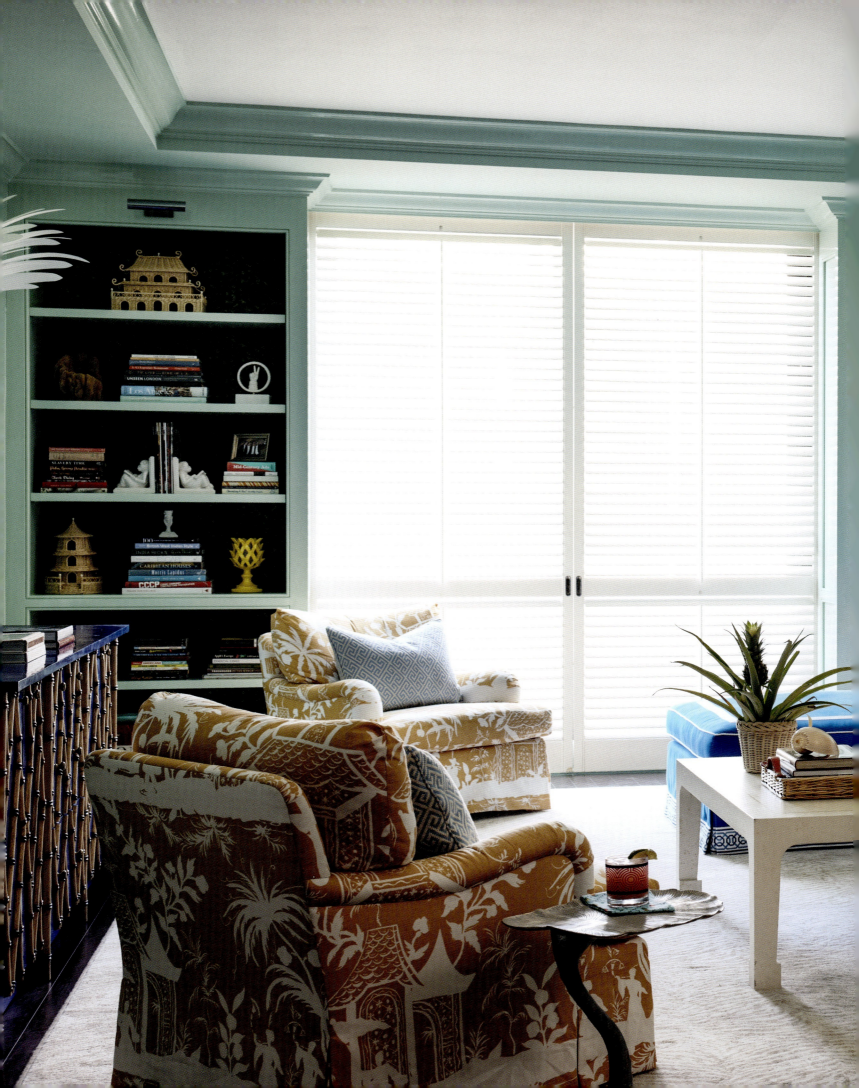

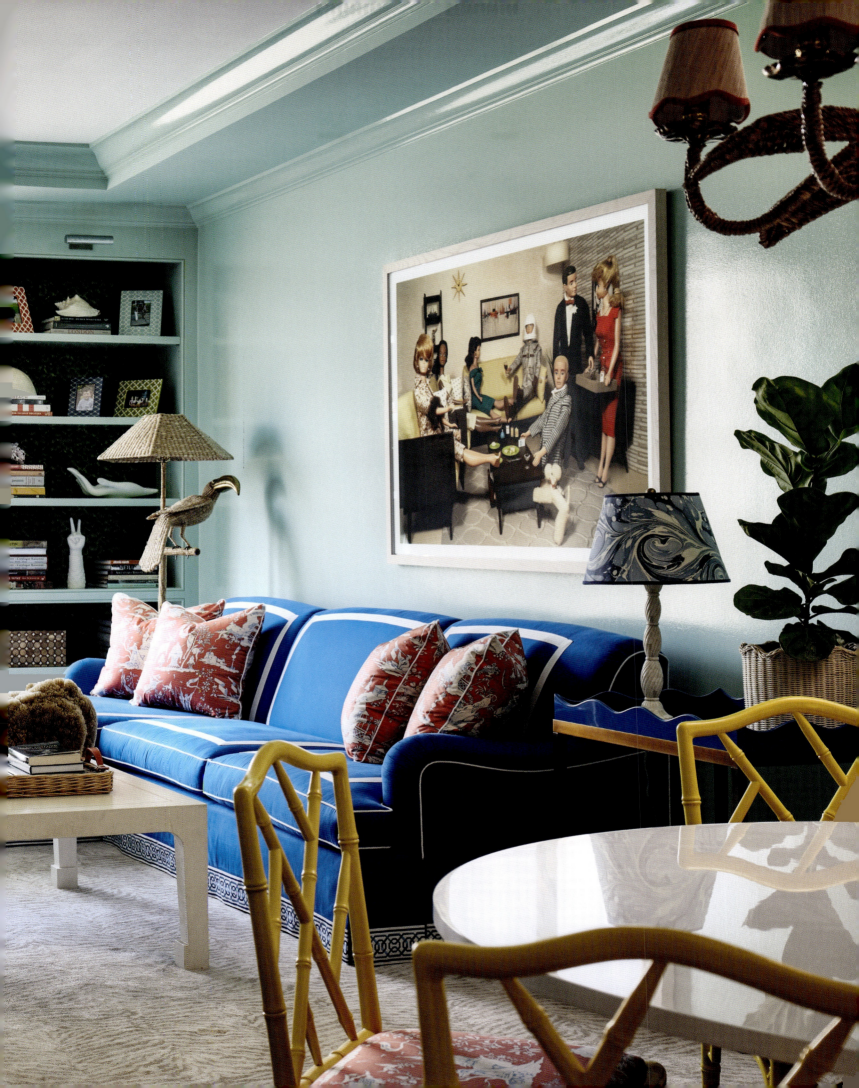

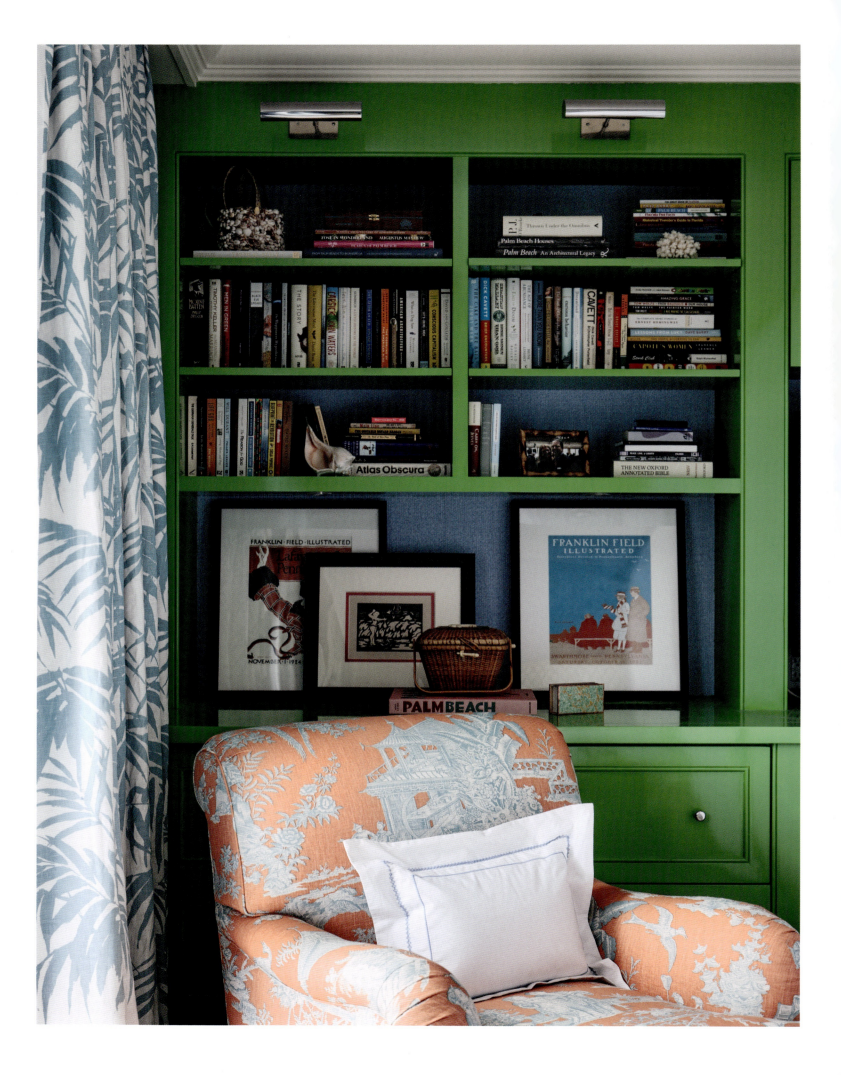

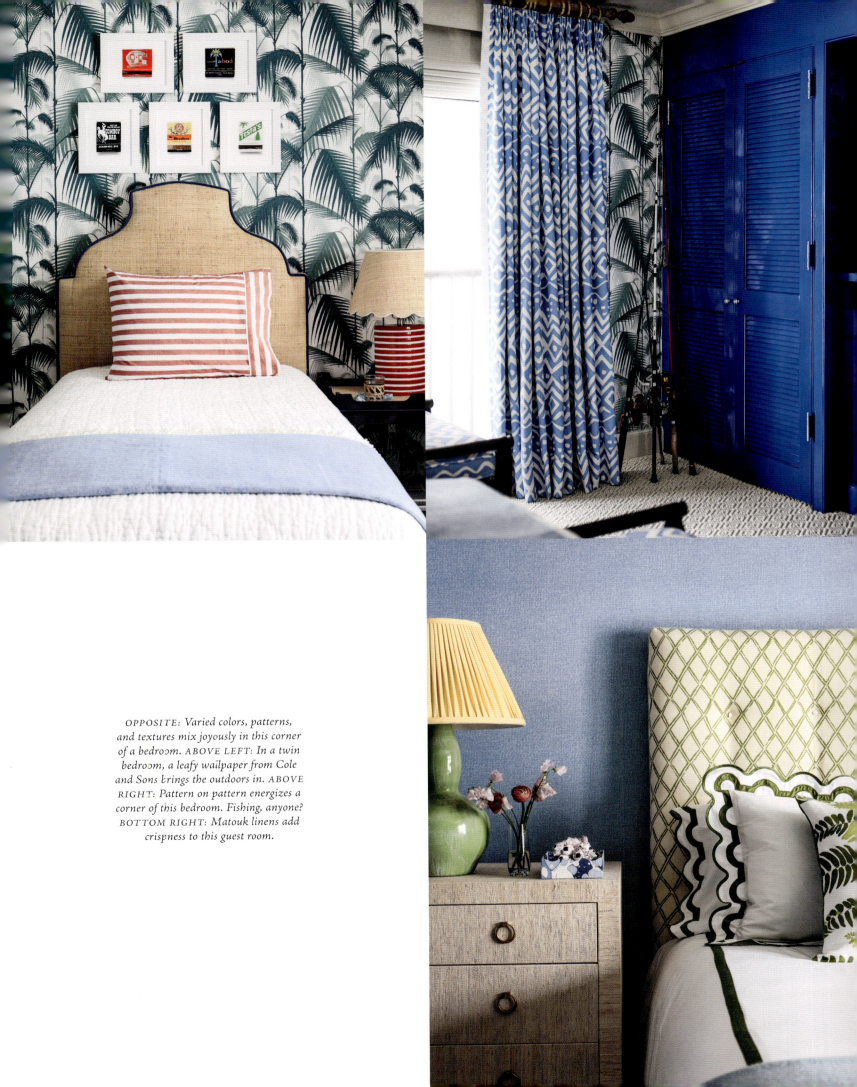

OPPOSITE: Varied colors, patterns, and textures mix joyously in this corner of a bedroom. ABOVE LEFT: In a twin bedroom, a leafy wallpaper from Cole and Sons brings the outdoors in. ABOVE RIGHT: Pattern on pattern energizes a corner of this bedroom. Fishing, anyone? BOTTOM RIGHT: Matouk linens add crispness to this guest room.

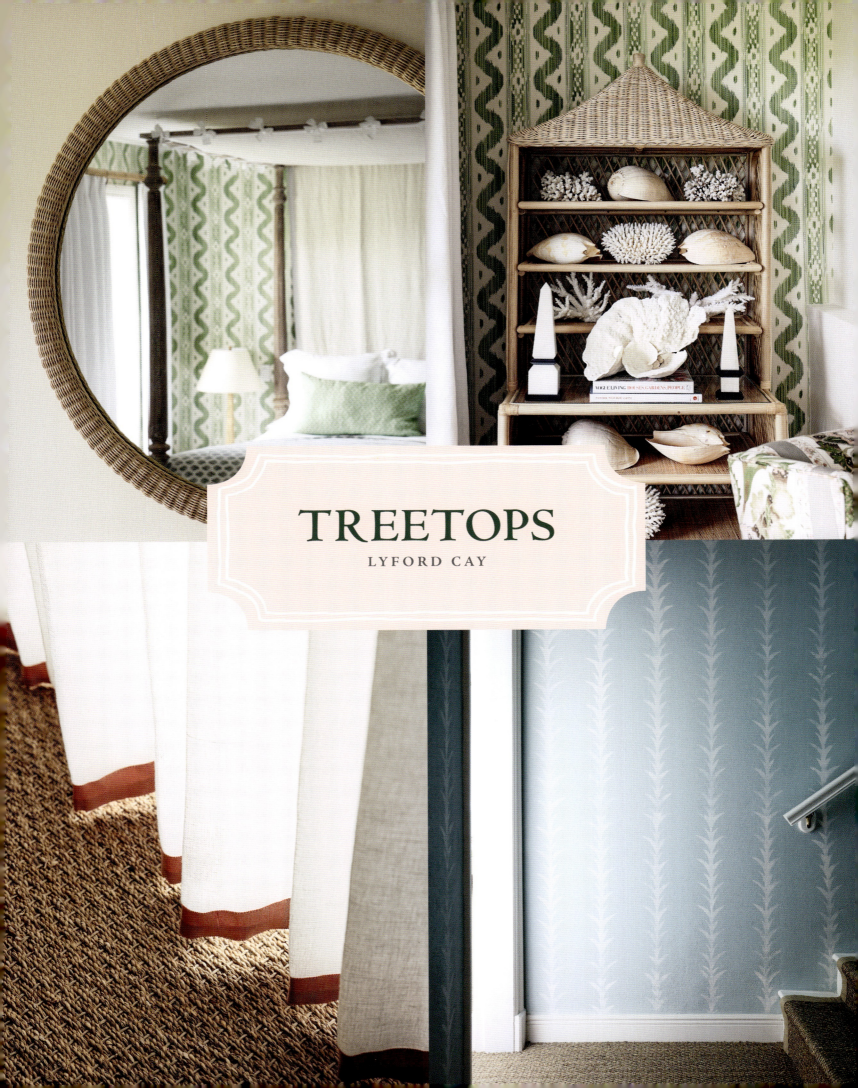

TREETOPS
LYFORD CAY

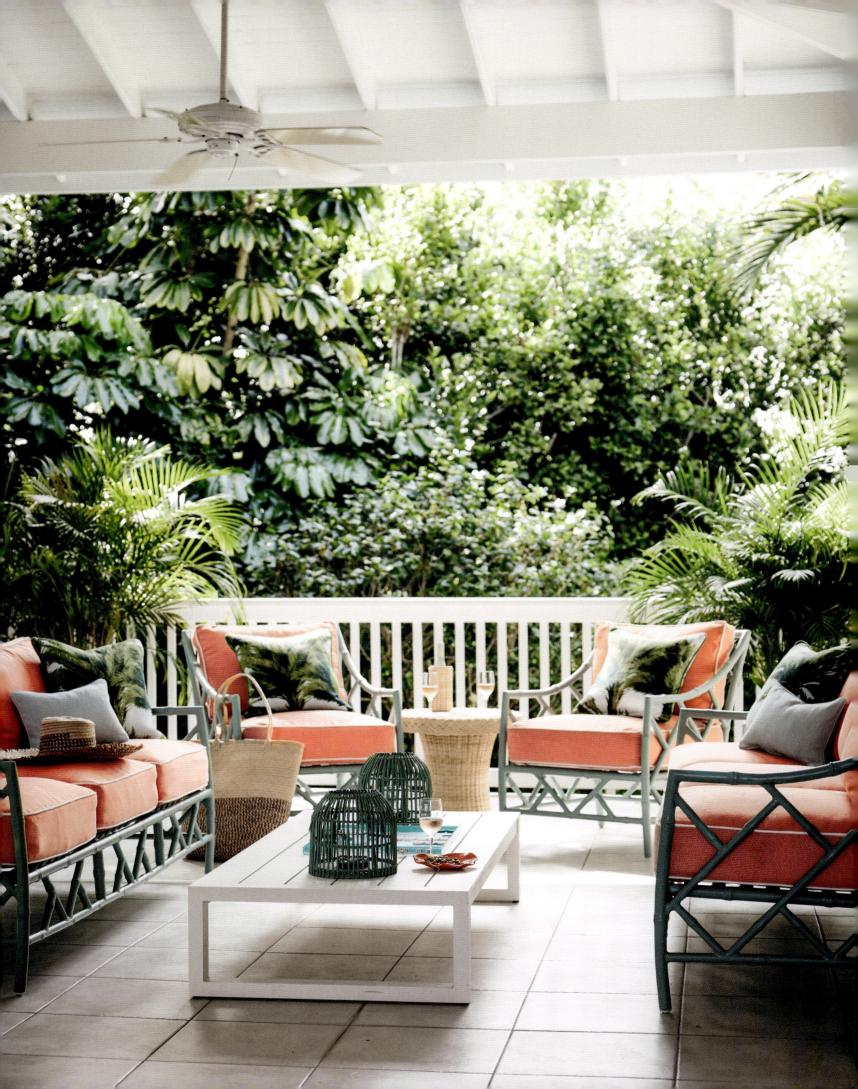

About thirty years ago, a small group of lovely townhouses called Treetops were being built in Lyford Cay. We all wondered who was in charge of such pretty architecture. My dear friend John clued me in: "Oh, it's a super-talented Swedish/Canadian developer named Orjan Lindroth."

Soon thereafter, I was invited to a dinner party on the longest, hottest night of the summer at a house notorious for outdoor dining and no breeze. It was at that house and on that night that I met the magical Orjan. He did not have a chance. At John's urging, I managed to play it cool, and he eventually asked me to lunch. The rest is history.

I was delighted when a truly glamorous young family with three boys from Greenwich, Connecticut, asked me to help them with their newly purchased Treetops townhouse. Having been around for the completion of this project all those years ago, I knew the layout well. We quickly did a "Lyford Cay makeover," which meant repainting the kitchen and laundry instead of replacing them, covering tile floors with wall-to-wall seagrass, and creating a fresh new bit of magic on all three floors.

We wanted to add ice-blue lacquer to the walls and ceiling in the living room and paint a Lyford-esque trellis on the walls of the family room. The clients sent their own very talented painters, who aced these tasks in record time and set the framework for the next layers.

A container of the clients' lovely furniture from a previous house on Long Island helped us start the process, and a few fabulous purchases, including an extra-long, curved vintage rattan sofa for the TV room, helped to complete the magic.

After working on this amazing townhouse, nestled in mature tropical landscaping and boasting expansive views, I became a little wistful that Orjan and I did not keep the unit we once had there. Rather ironically, my ex-husband lives in that one now!

OPPOSITE: *On the cozy veranda overlooking the lush landscape, the outdoor furniture is by Celerie Kemble for One Kings Lane.*

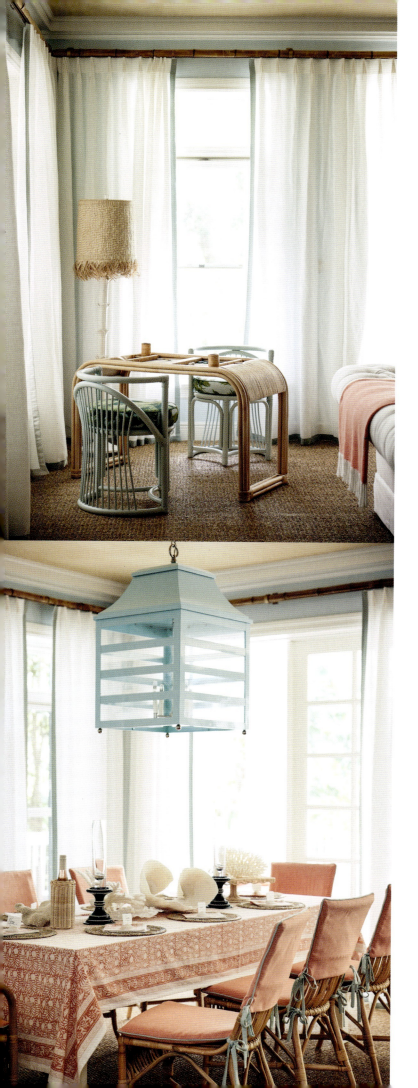
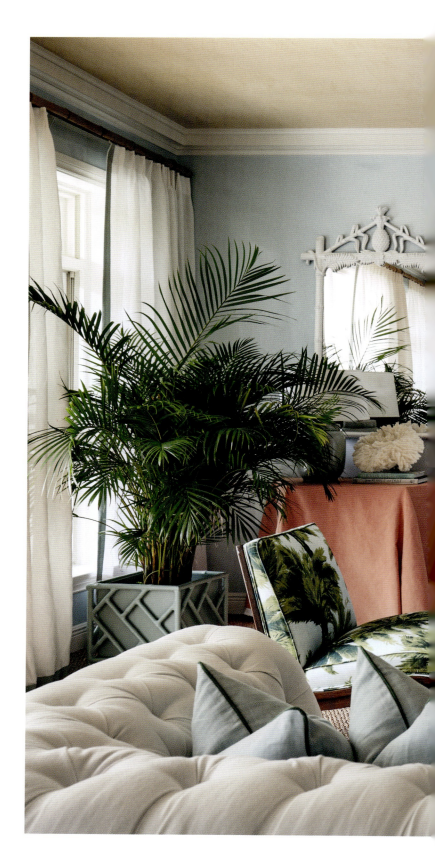

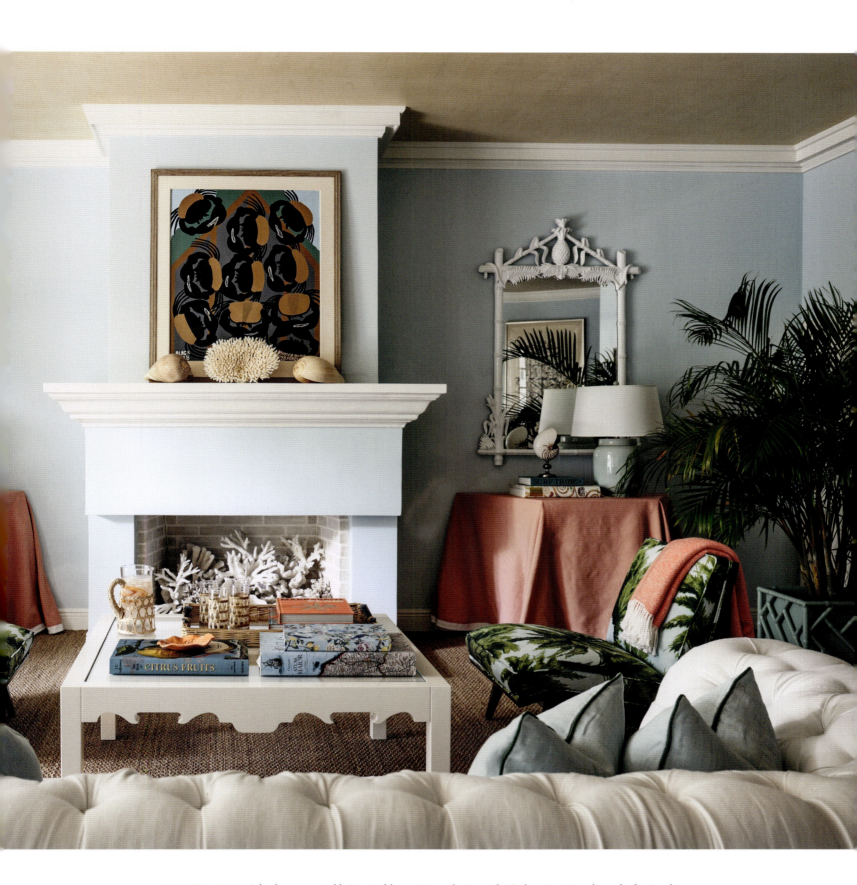

OPPOSITE TOP: A backgammon table inspired by a vintage design and a Bahamian straw lampshade give this corner of the living room a whimsical touch. OPPOSITE BOTTOM: In the dining area, we slipcovered the backs of Lindroth's Ca'Liza chairs to add color and comfort. A giant lantern from the clients' previous house was a perfect match for the room. ABOVE: In the living room, furniture from the clients' previous house was recovered and refreshed. The consoles covered in coral linen were made locally and the mirrors above them are vintage Gampel Stoll. A painting by Amos Ferguson hangs above the mantel.

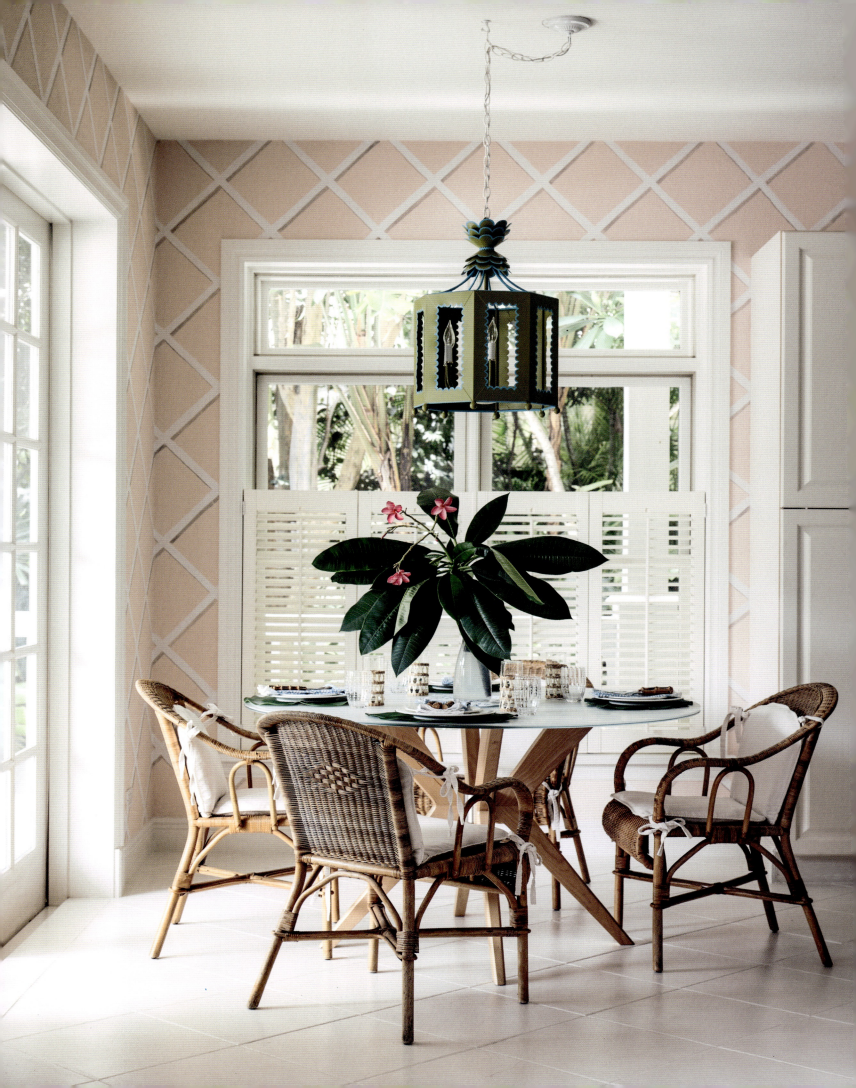

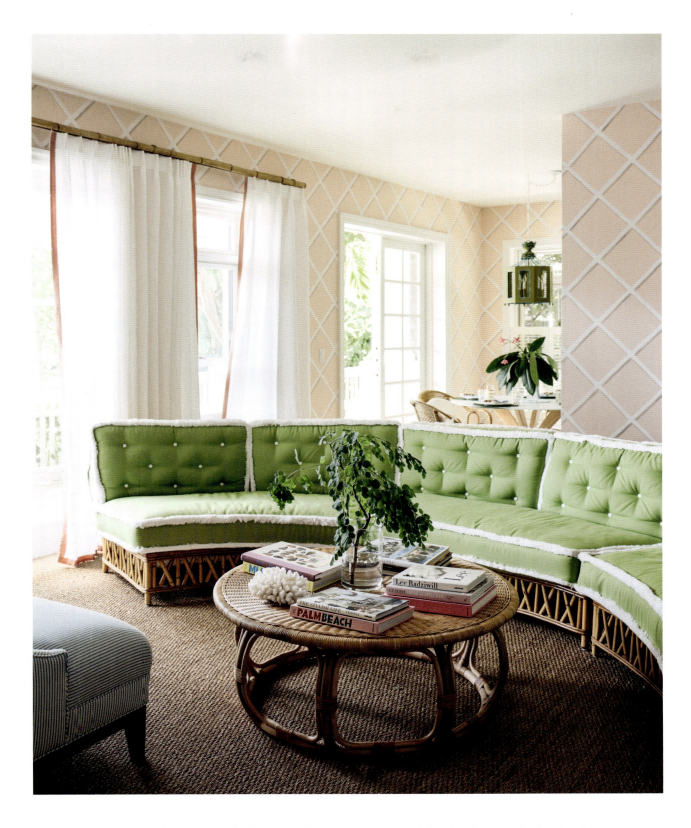

OPPOSITE: *The artisans of Floe Painting in Connecticut, recommended by the clients, brilliantly painted the trellis pattern on the walls. The lantern is from Stray Dog Designs.* ABOVE: *An extraordinarily good vintage curved rattan sofa, a favorite of mine, dominates the family room.*

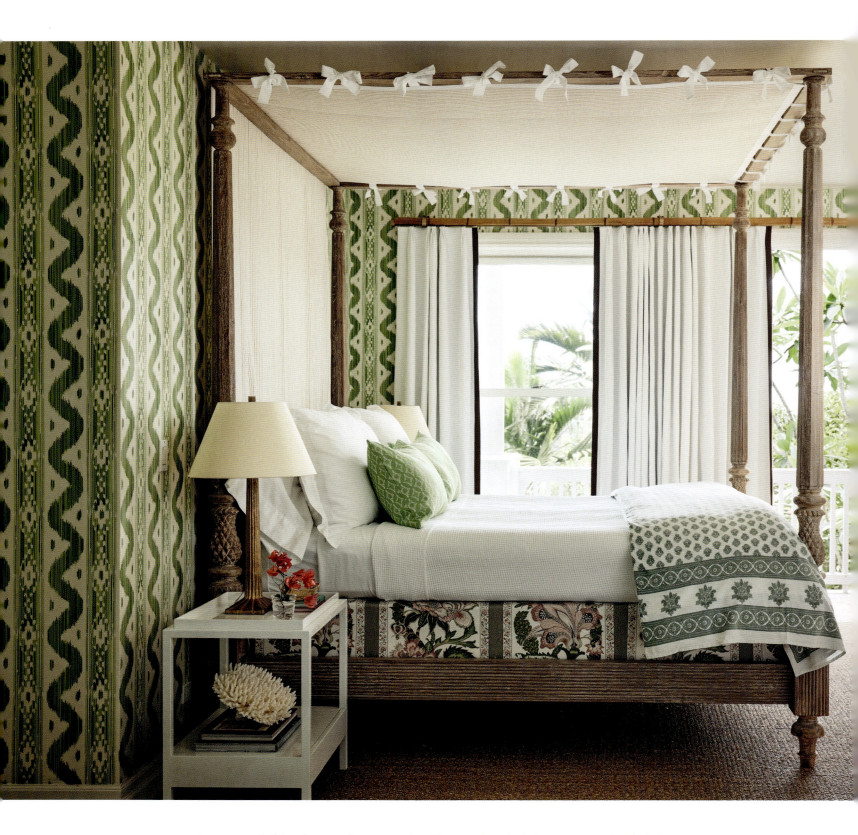

ABOVE: *Quadrille's Bali Hai wallpaper in a cheerful green echoes the lush greenery outside. The bed is from the Raj Company; its box spring and the club chair are upholstered in Schumacher's Anjou Stripe.*
OPPOSITE: *In this bedroom, China Seas' Melong Batik, bordered in a navy grosgrain, covers the walls. The nightstand is vintage.*

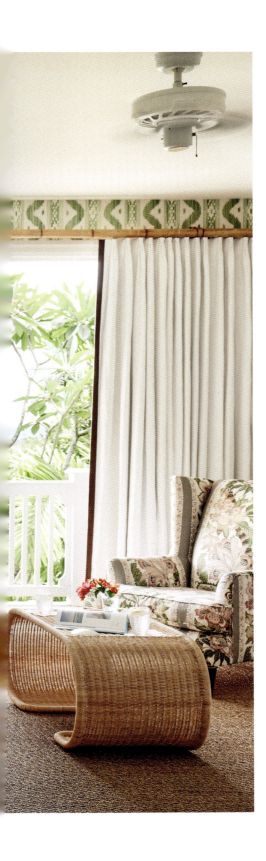
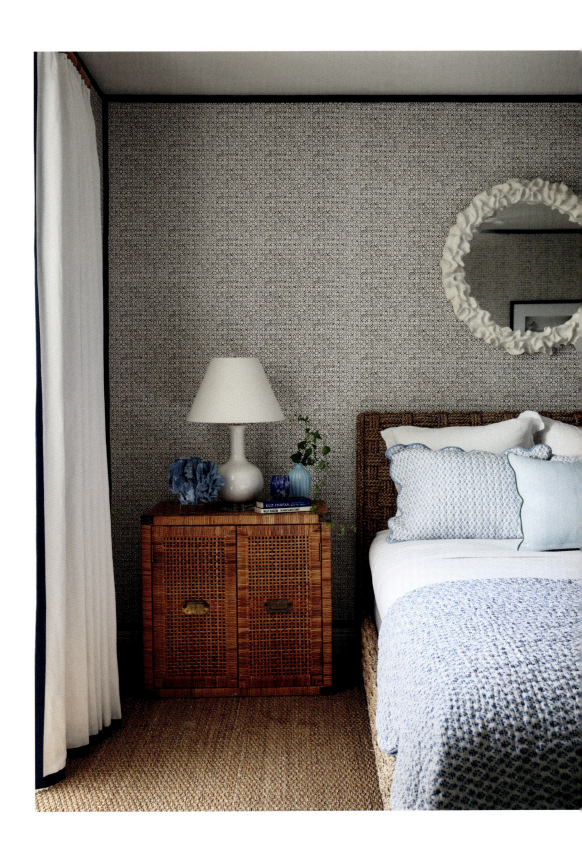

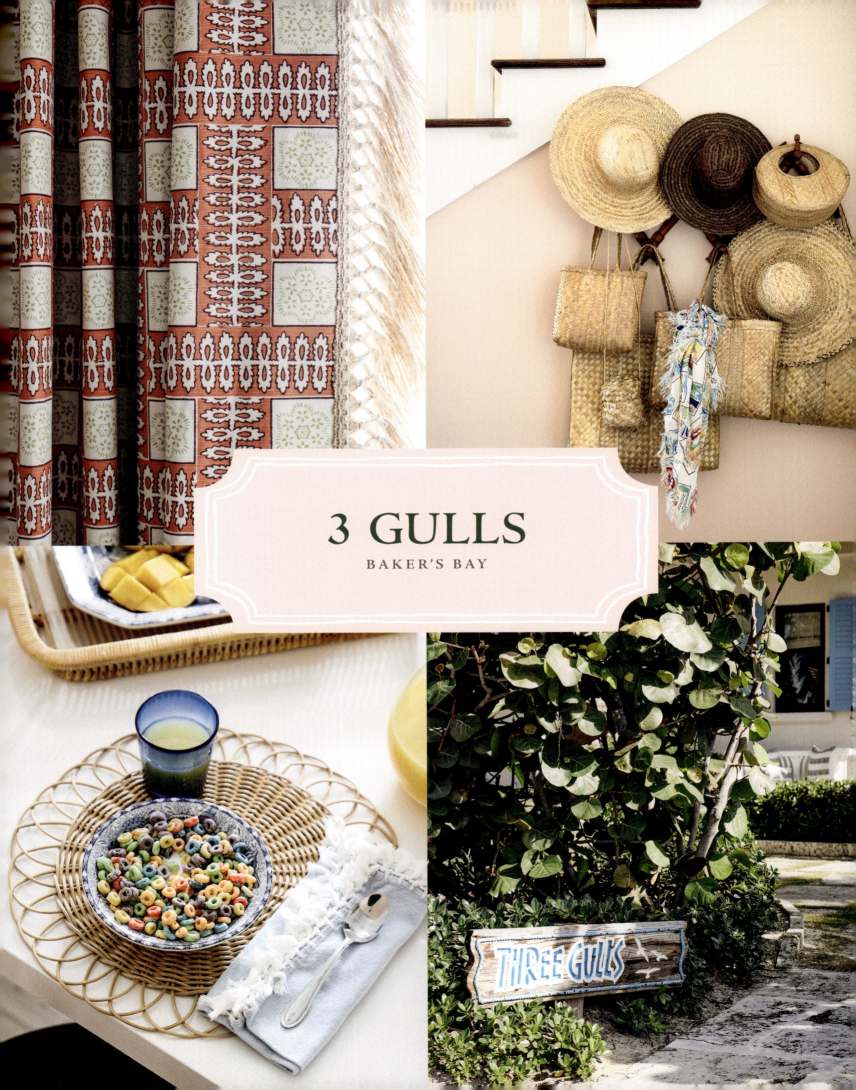

3 GULLS

BAKER'S BAY

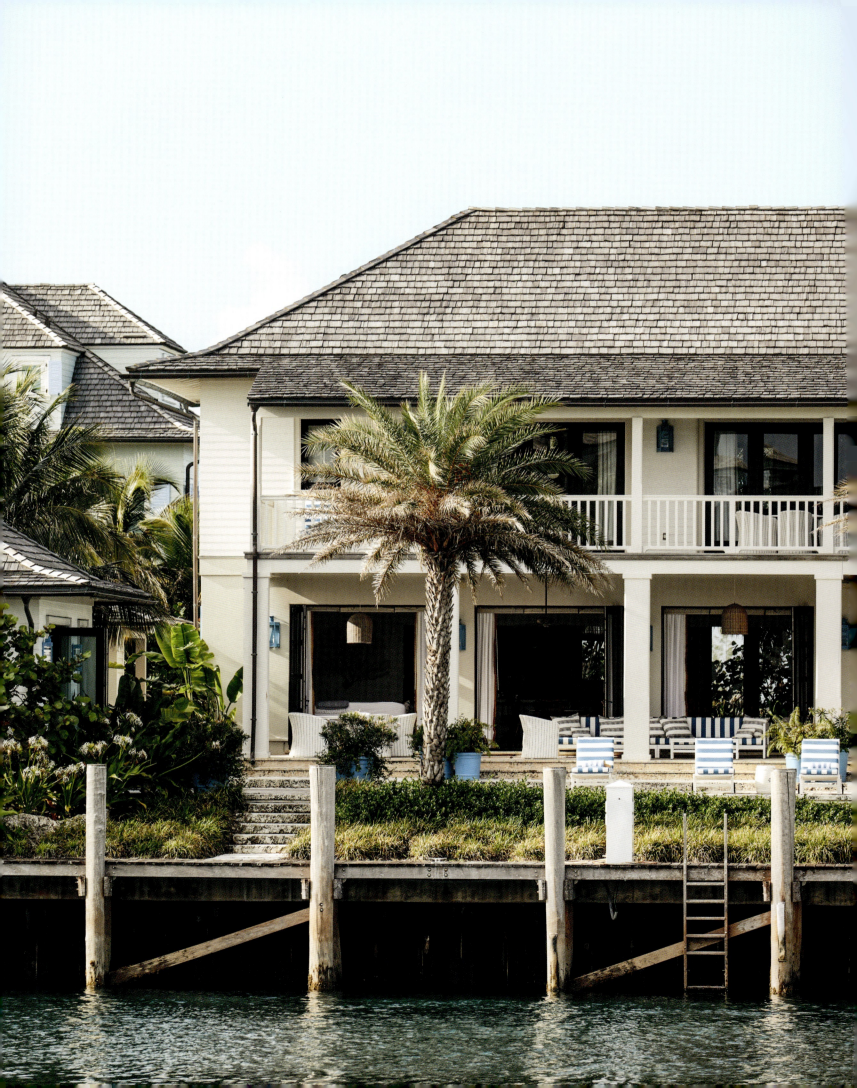

Located on the canal at Baker's Bay in the Abacos, 3 Gulls is a pretty house that we designed for a lovely American family with three daughters. The crystal-clear water around the Abacos makes the island chain a paradise for boating, perfect for this family of boaters, who keep a beautiful Hinckley picnic boat at their dock out front.

The house was one of the first built in Baker's Bay, and it needed an upgrade and a freshening. We clad the living room walls in shiplap and painted it a crisp white. We added mahogany floors. In the foyer, we covered the walls in a Nobilis faux-bois paper to make it cozy. We found a faux-bamboo Victorian cabinet, gave the exterior a whitewash, and painted the interior the palest of pinks. We then loaded the cabinet with sea finds and treasures, little antique watercolors of the Bahamas, and a few sailor's valentines. It is a perfect island-y moment for visitors arriving from far-flung places.

Getting to Baker's Bay is a planes, trains, and automobiles kind of affair. More accurately, it takes a plane, taxi, ferry, and golf cart. People are understandably a bit weary by the time they arrive, so we chose pure white sofas and pretty pastel accent colors to give the ground floor a soothing island vibe. Because the kitchen is visible through a cased opening in the living room, we covered the entire back wall in handsome encaustic tile.

We finished the house just in time for Hurricane Dorian to make a bit of a mess of it, so we jumped right back in to repair the damage for this charming family, whom we now call friends.

OPPOSITE: *A view of 3 Gulls from across the canal. Horizontal and vertical stripes dress the outdoor furniture in a playful way.*

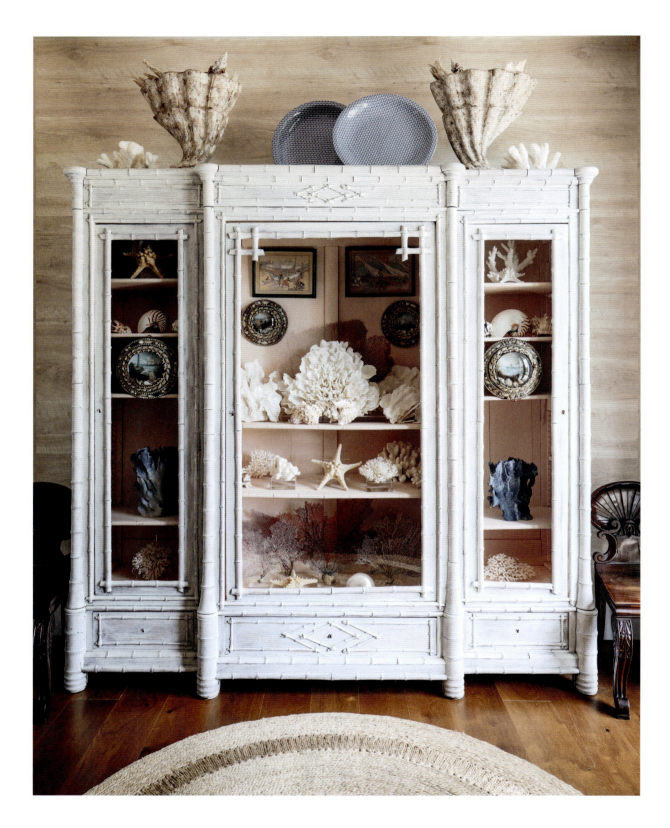

ABOVE: *A faux-bamboo Victorian cabinet is whitewashed on the outside and painted pink on the inside. It holds treasures and found objects relating to the sea. English mahogany chairs with shell-shaped backs flank the cabinet.* OPPOSITE: *A view from the foyer through the house and across the canal. A Nobilis faux-bois wallpaper and a chandelier from FS Henemader Antiques in Palm Beach lend warmth to the space.* OVERLEAF: *In the dining area of the calm, serene great room, the chairs are from Sika Design, the mirror is vintage, and the pendant is from Heath & Company.*

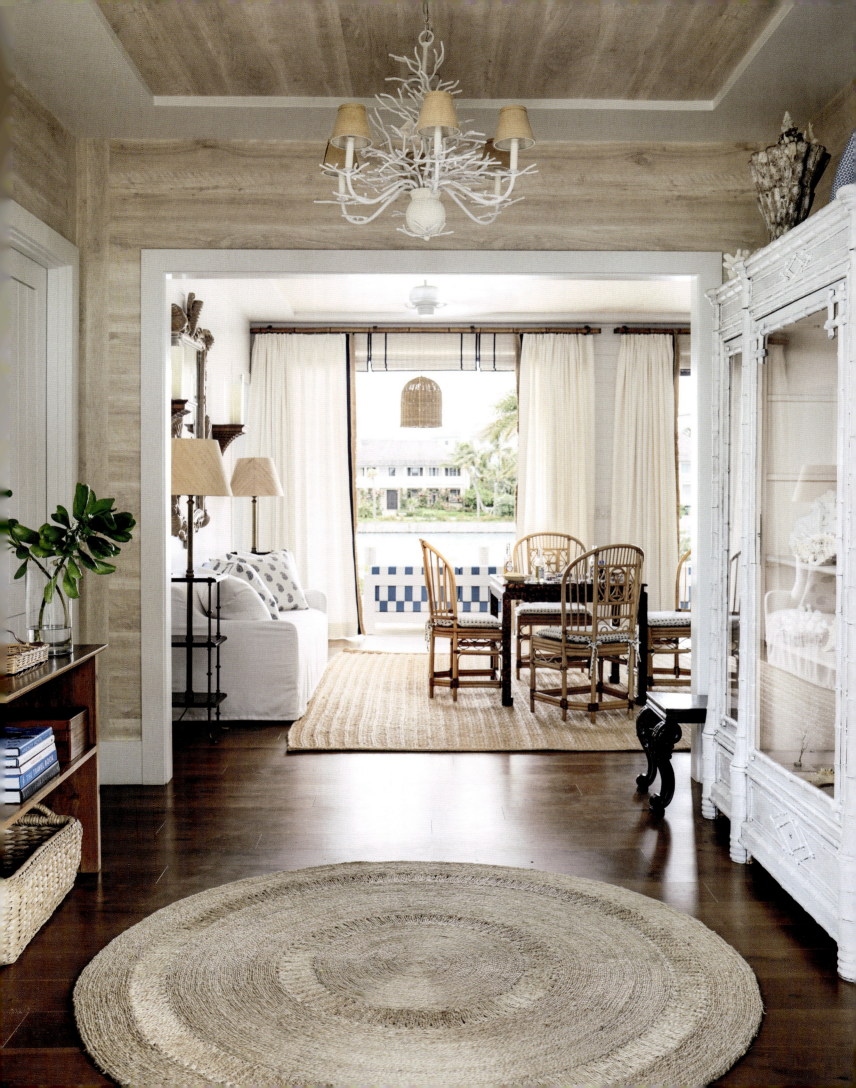

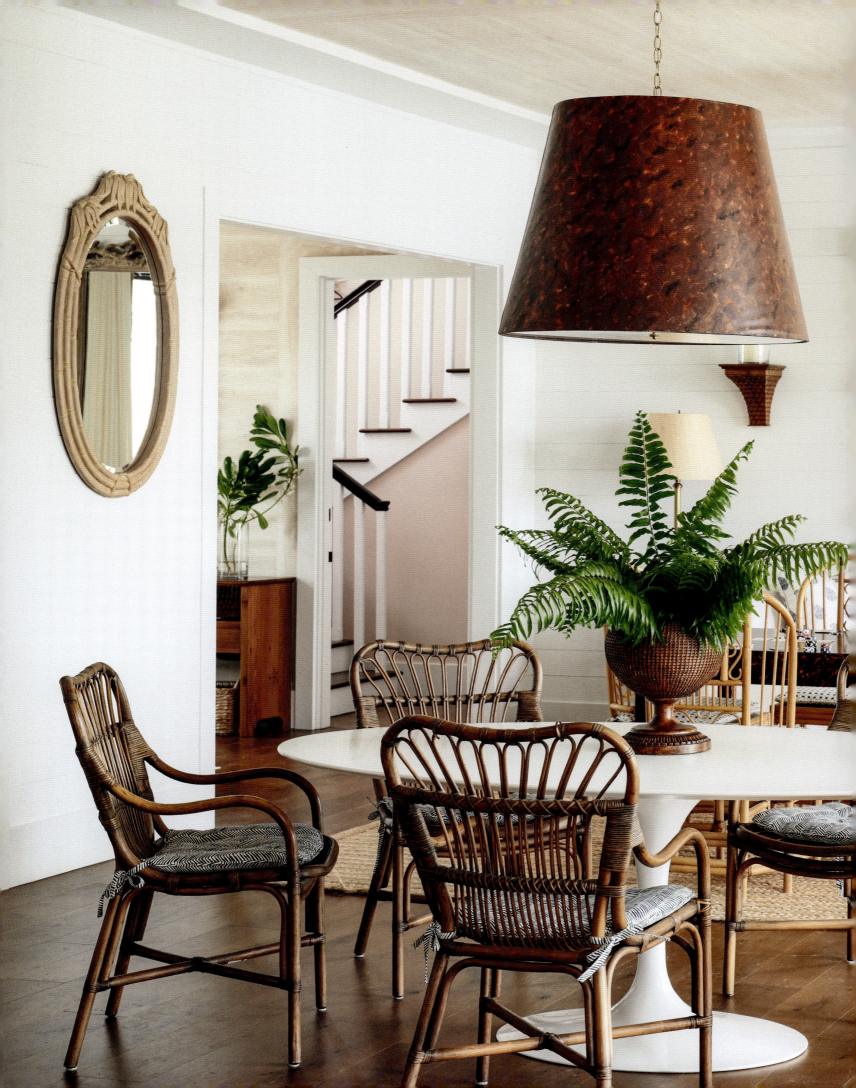

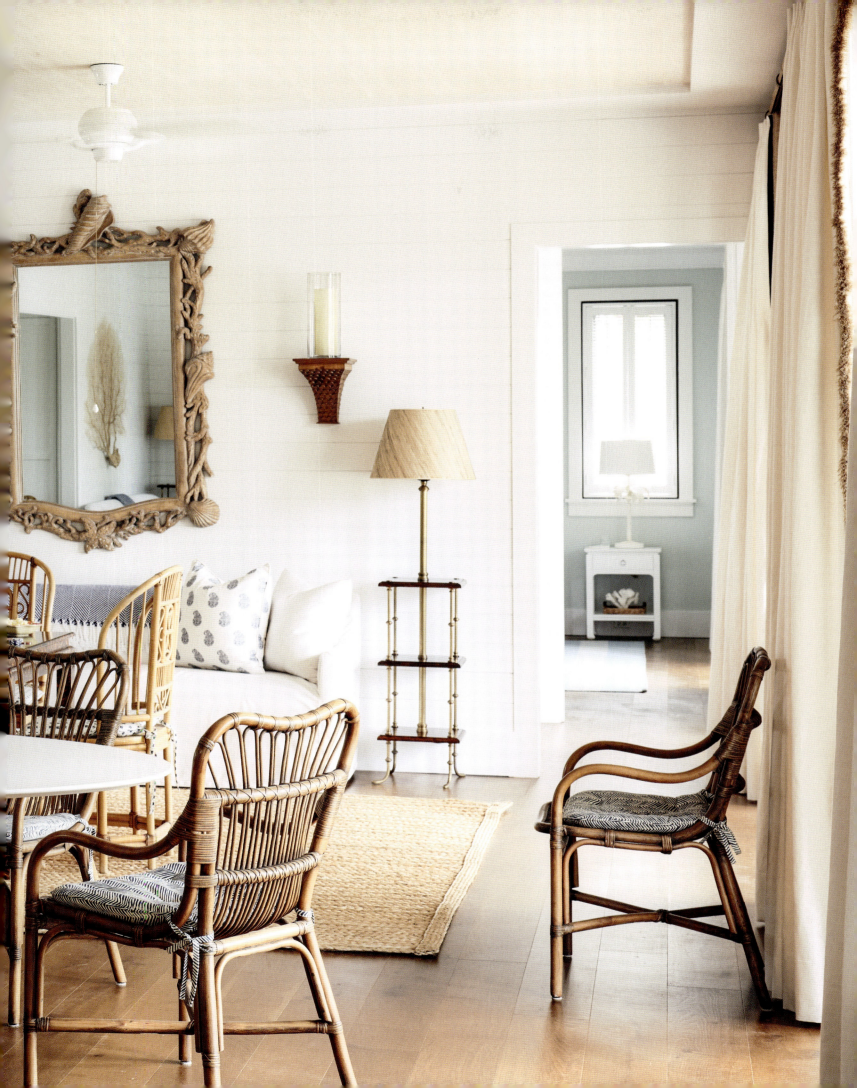

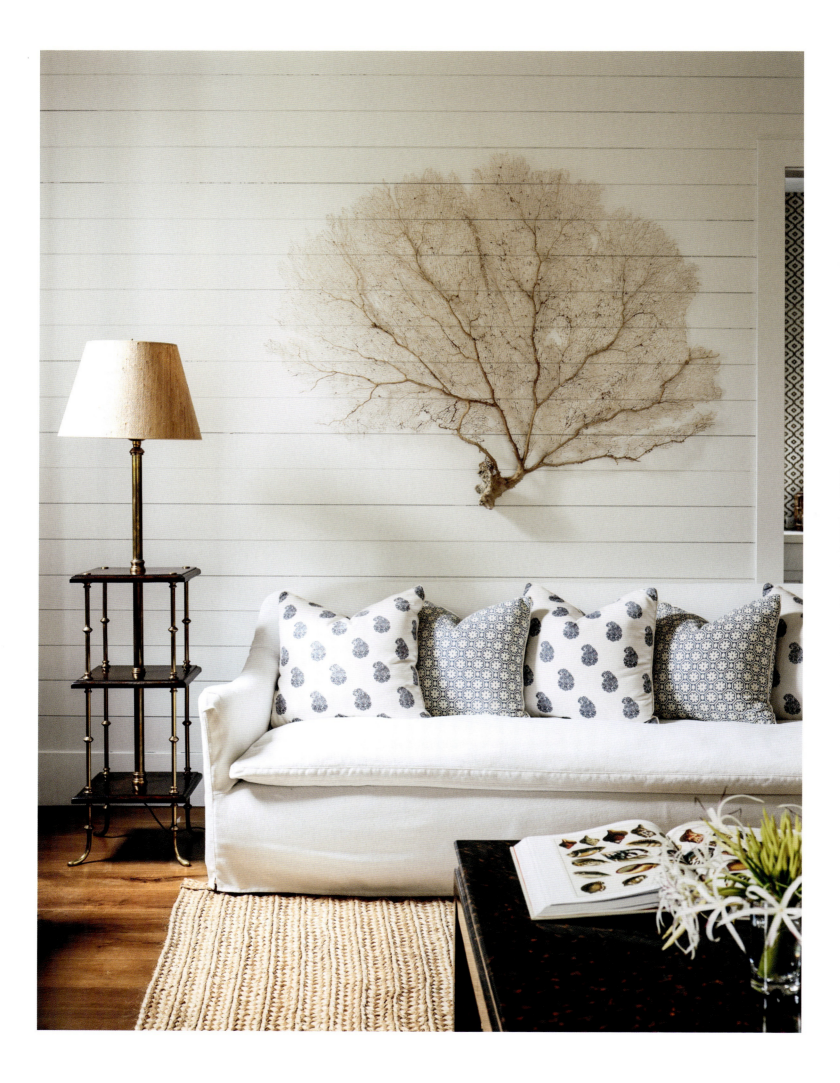

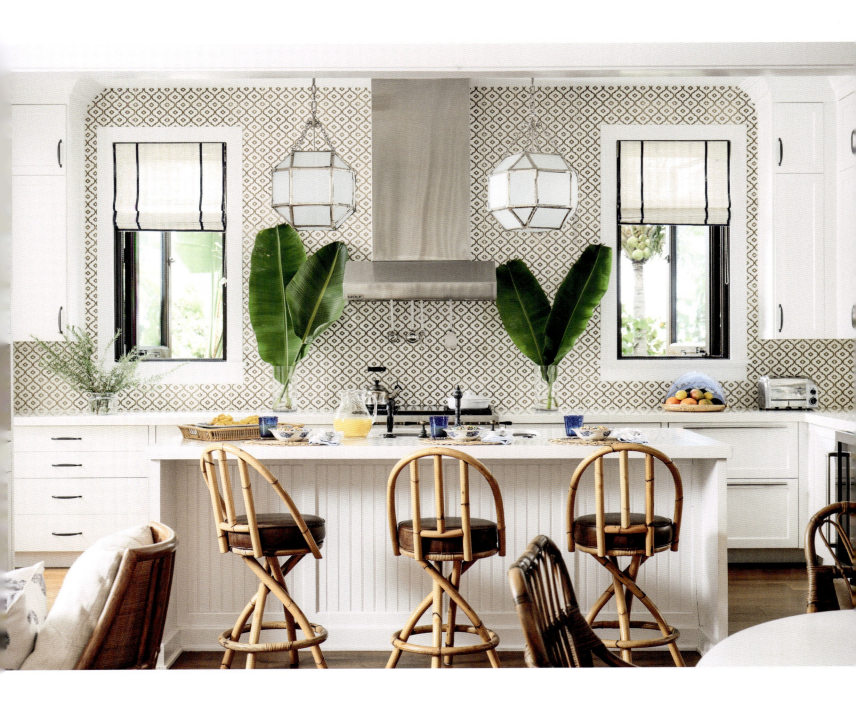

OPPOSITE: *A giant sea fan from FS Henemader Antiques adds a natural element to the newly installed shiplap walls.* ABOVE: *Vintage rattan barstools with brown leather cushions complement the taupe-and-white backsplash tile.*

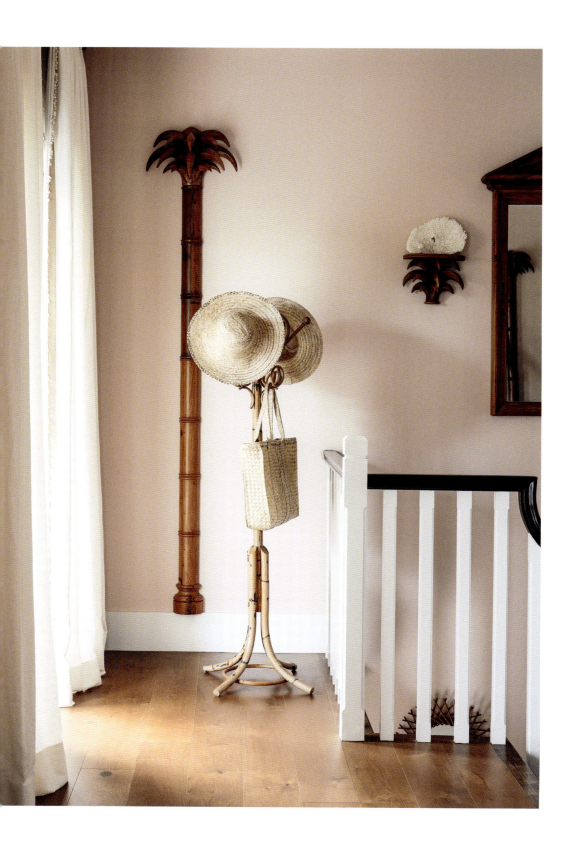

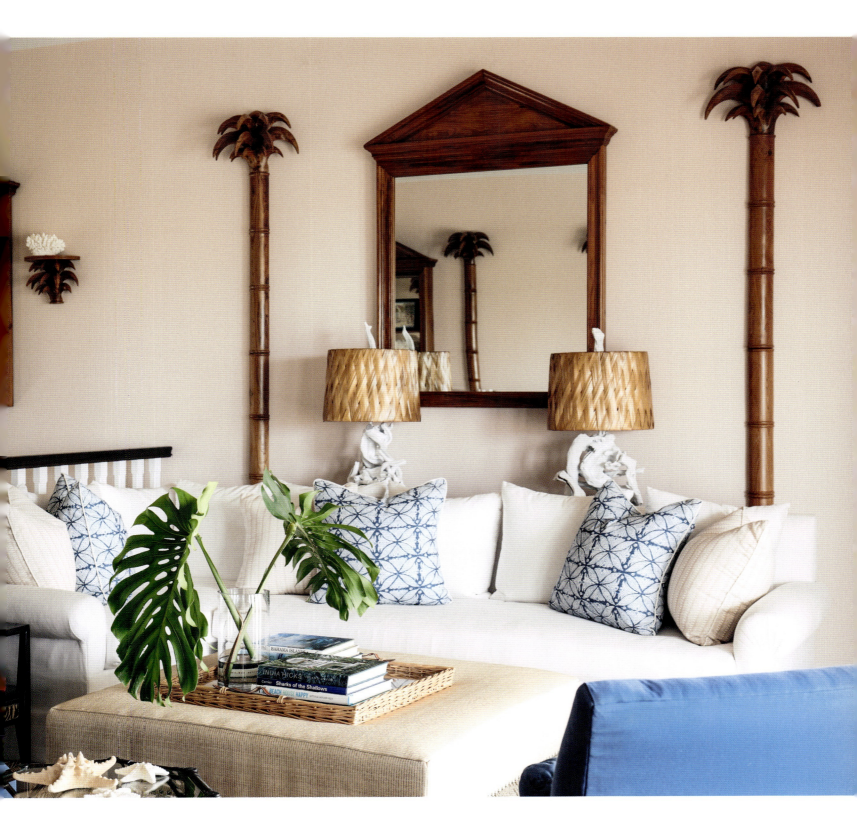

OPPOSITE AND ABOVE: *A series of pedimented mirrors, tall palm "pilasters," and palm brackets, all custom-made by the Raj Company after my designs, lend the staircase and upstairs sitting room a bit of architectural whimsy.*

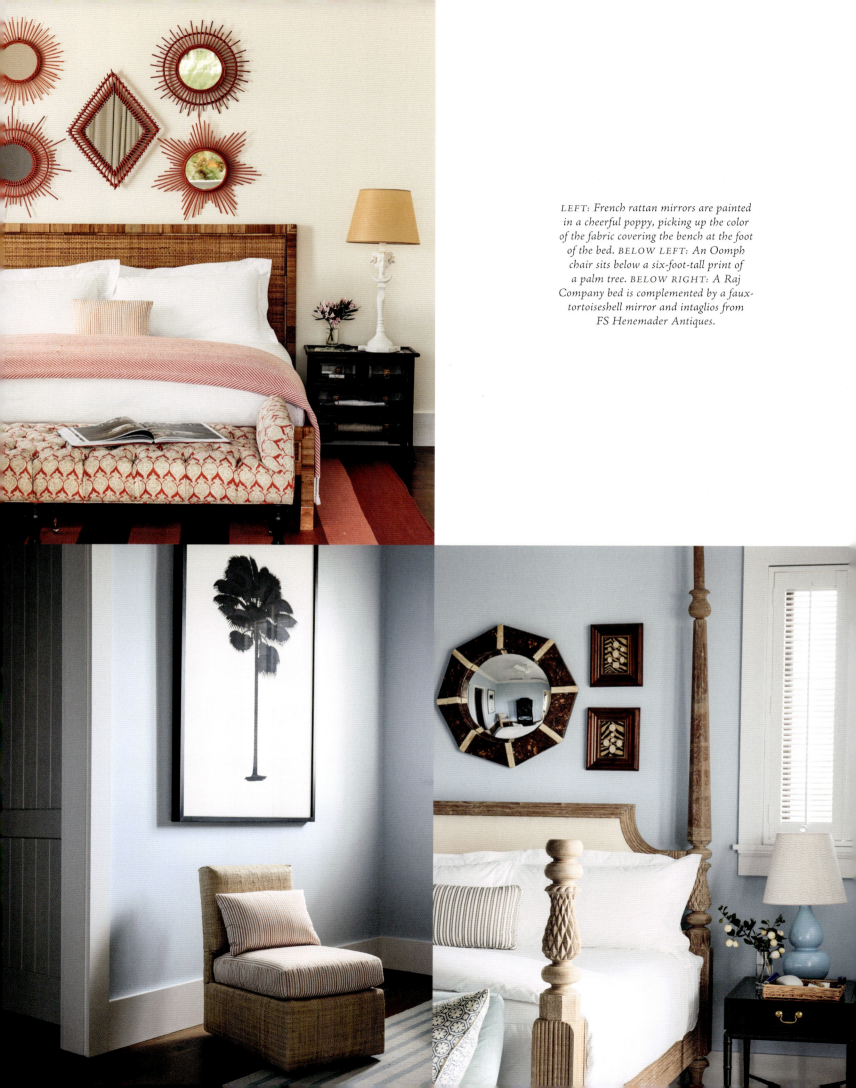

LEFT: French rattan mirrors are painted in a cheerful poppy, picking up the color of the fabric covering the bench at the foot of the bed. BELOW LEFT: An Oomph chair sits below a six-foot-tall print of a palm tree. BELOW RIGHT: A Raj Company bed is complemented by a faux-tortoiseshell mirror and intaglios from FS Henemader Antiques.

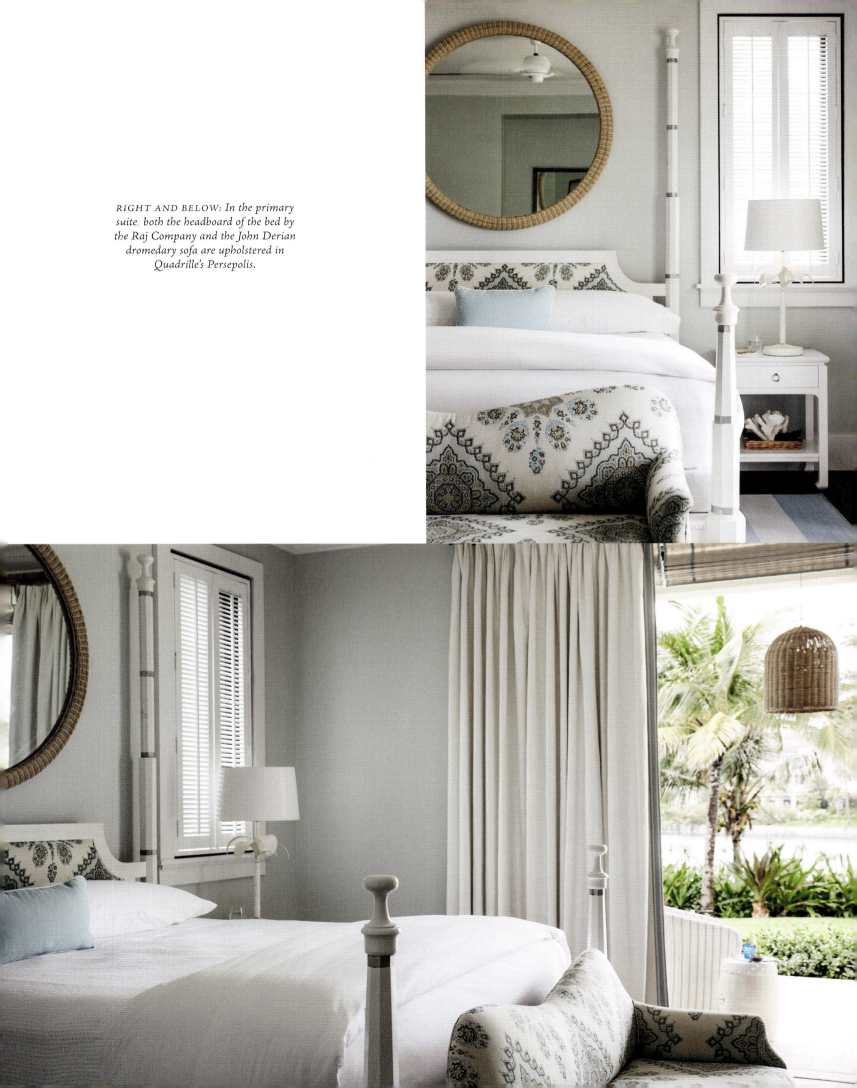

RIGHT AND BELOW: *In the primary suite, both the headboard of the bed by the Raj Company and the John Derian dromedary sofa are upholstered in Quadrille's Persepolis.*

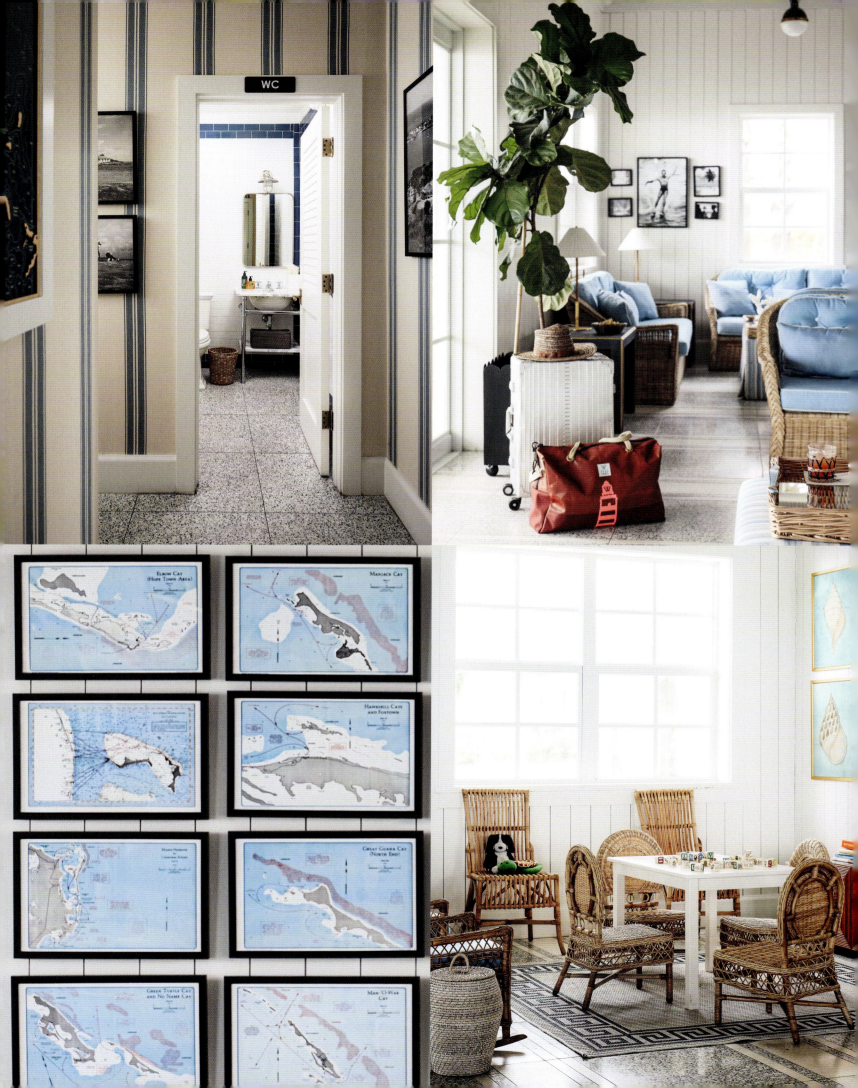

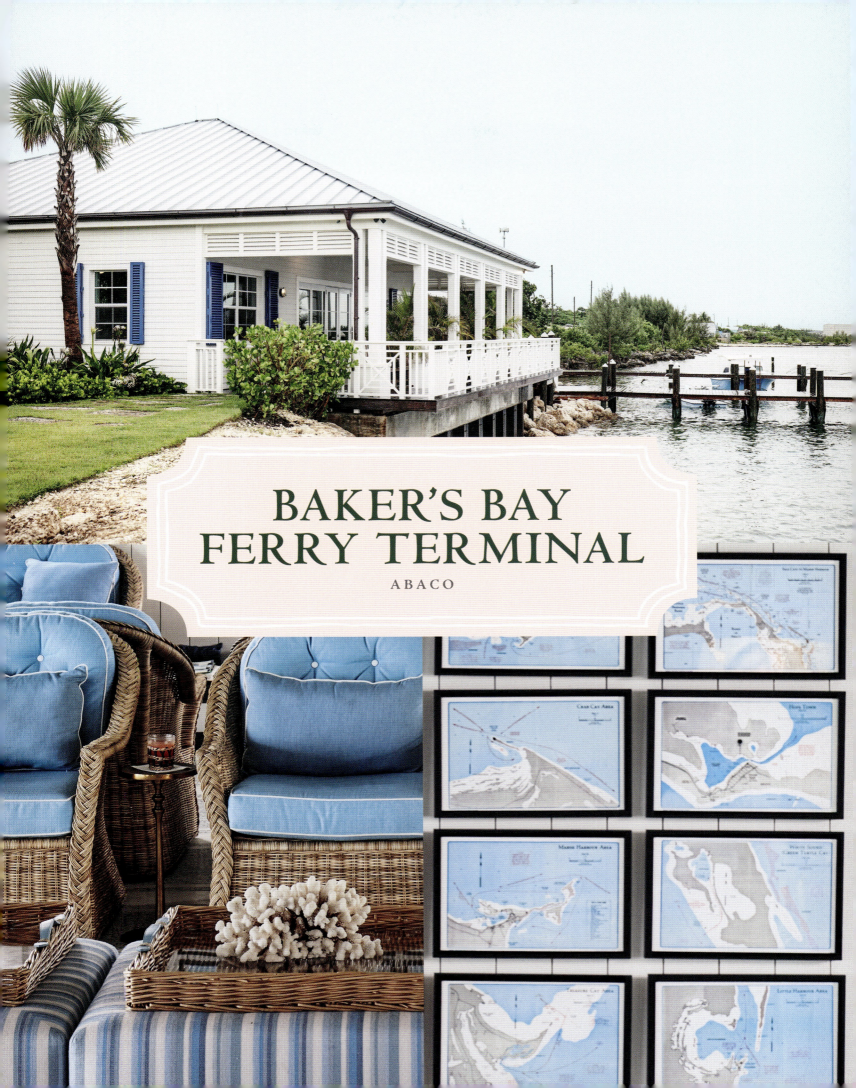

BAKER'S BAY FERRY TERMINAL

ABACO

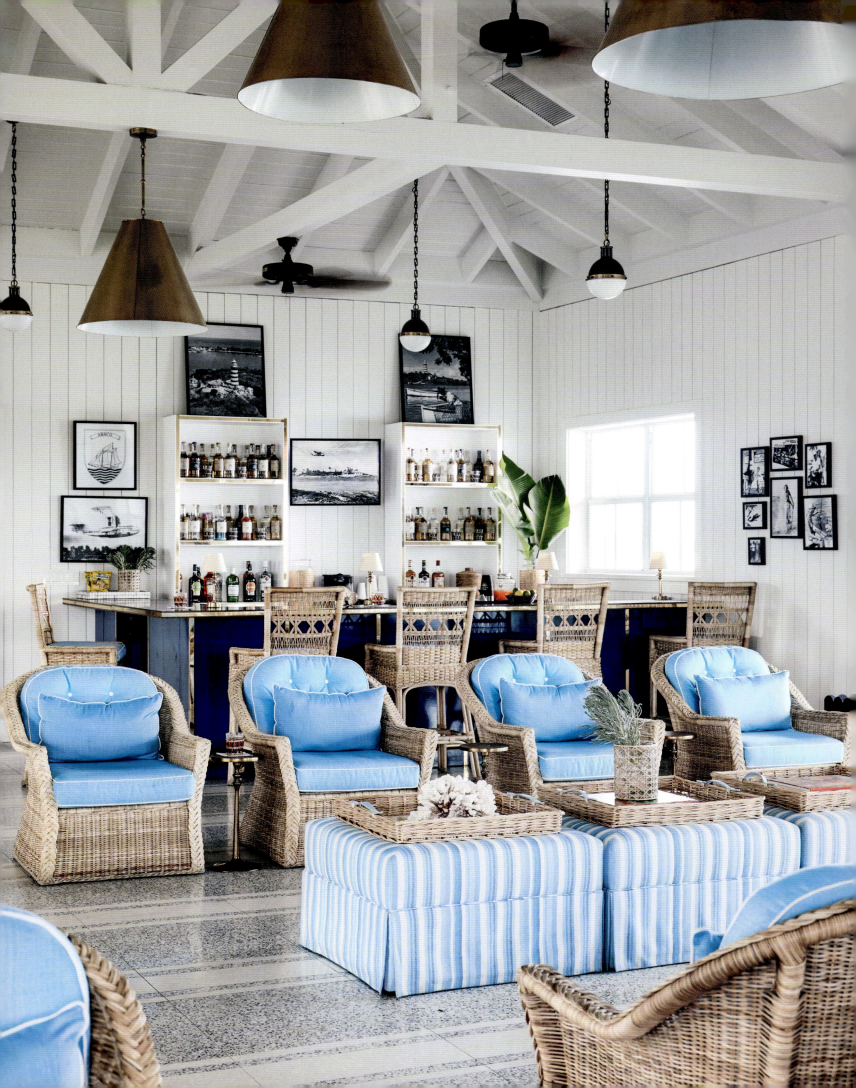

The Bahamas Out Islands, or "Family" Islands, are some of the most beautiful places on the planet. Crystal-clear water, warm breezes, and hundreds of small islands and cays are magnets for visitors, who tend to return again and again. These islands are, however, notoriously hard to get to.

When Discovery Land Company set about to build Baker's Bay back in the early 2000s, they knew that the last stretch of the journey needed to be polished. Unlike the charming if chaotic taxis and ferries between North Eleuthera and Harbour Island, a visit to Baker's Bay always started with a uniformed driver and a spiffy SUV at the airport, followed by a swank, fast boat filled with treats. The dock, however, was shared ground and had no proper shade during inclement weather or seating while waiting for the ferry.

In the aftermath of Hurricane Dorian, a plan was hatched to build a proper ferry terminal. Our mandate was to make it comfy for transient guests either excitedly on their way to Baker's Bay or heading home.

We started by cladding the ceilings and walls of the waiting room in shiplap and giving it a coat of shiny white paint. We covered the floors with striped terrazzo to evoke "train terminal nostalgia" and furnished the room with comfortable matching wicker sofas and club chairs, regimentally arranged as in a ferry, train, or bus terminal.

We got lucky when we stumbled upon an original set of painstakingly handmade, watercolor-washed boating charts all pertaining to the Abaco cays. To add to the ambience, we researched the archives for local photographs, including an amusing set of images of Bahamasair flight attendants over the decades and vintage images of local water-skiers and boaters.

OPPOSITE: *In the ferry terminal, rattan sofas and chairs are from Mainly Baskets. Lindroth trays with light blue handles were custom-made to fit the ottomans' dimensions. The navy-lacquered bar's brass accents and lamps contribute to the nautical theme.* OVERLEAF: *The striped terrazzo floors were inspired by those at the Cipriani in Miami, as well as by "train terminal nostalgia." Miraculously, we found a set of antique, handmade nautical charts of the Abacos. These charts, along with charming vintage black-and-white photographs of the Bahamas, adorn the walls.*

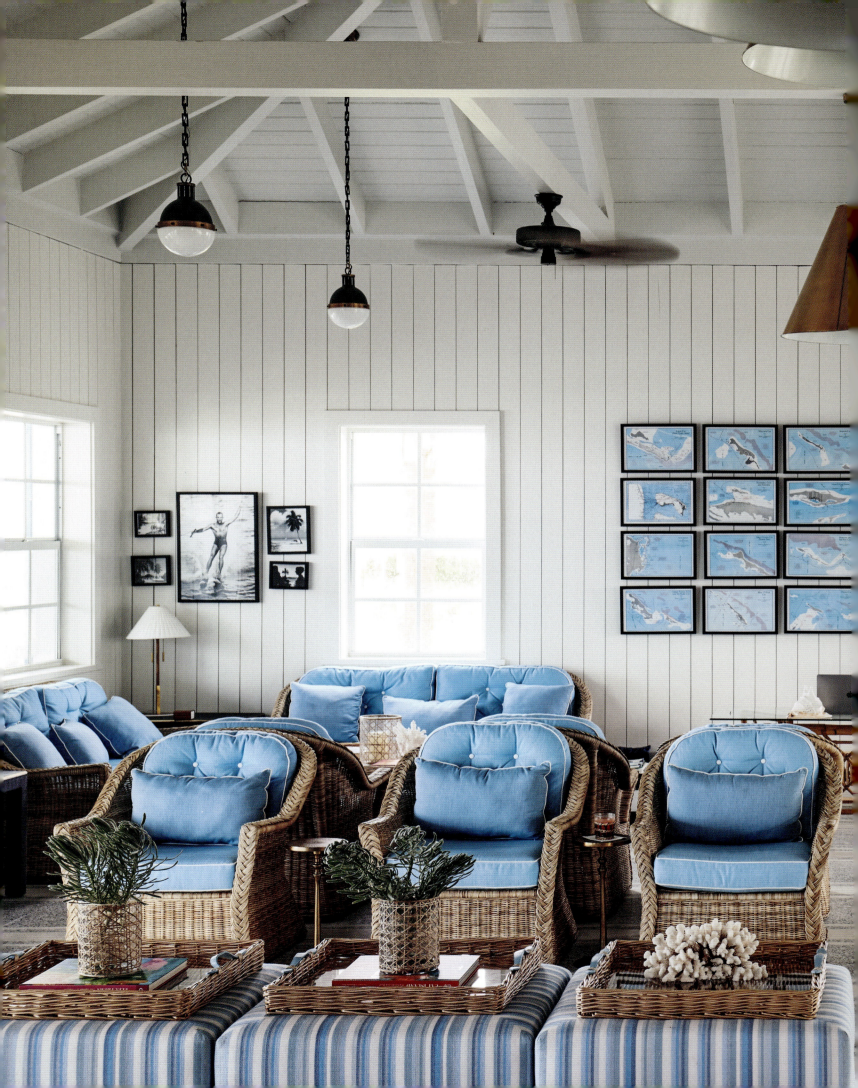

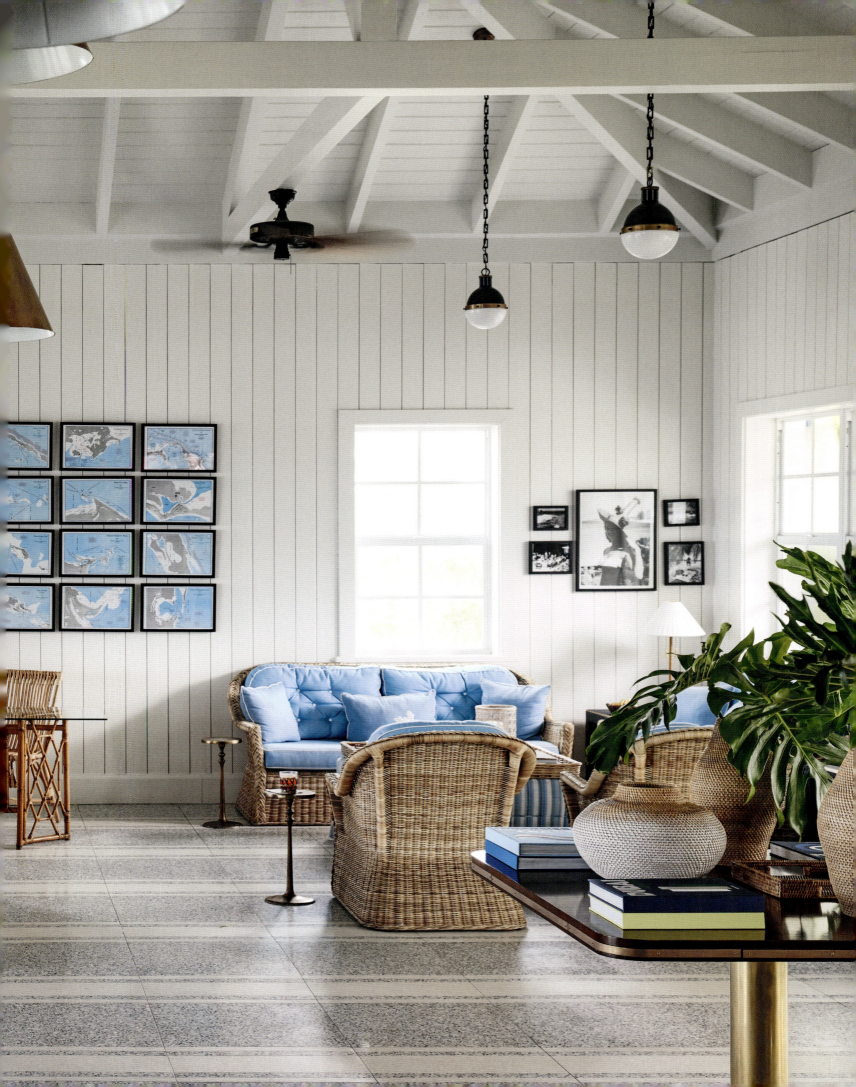

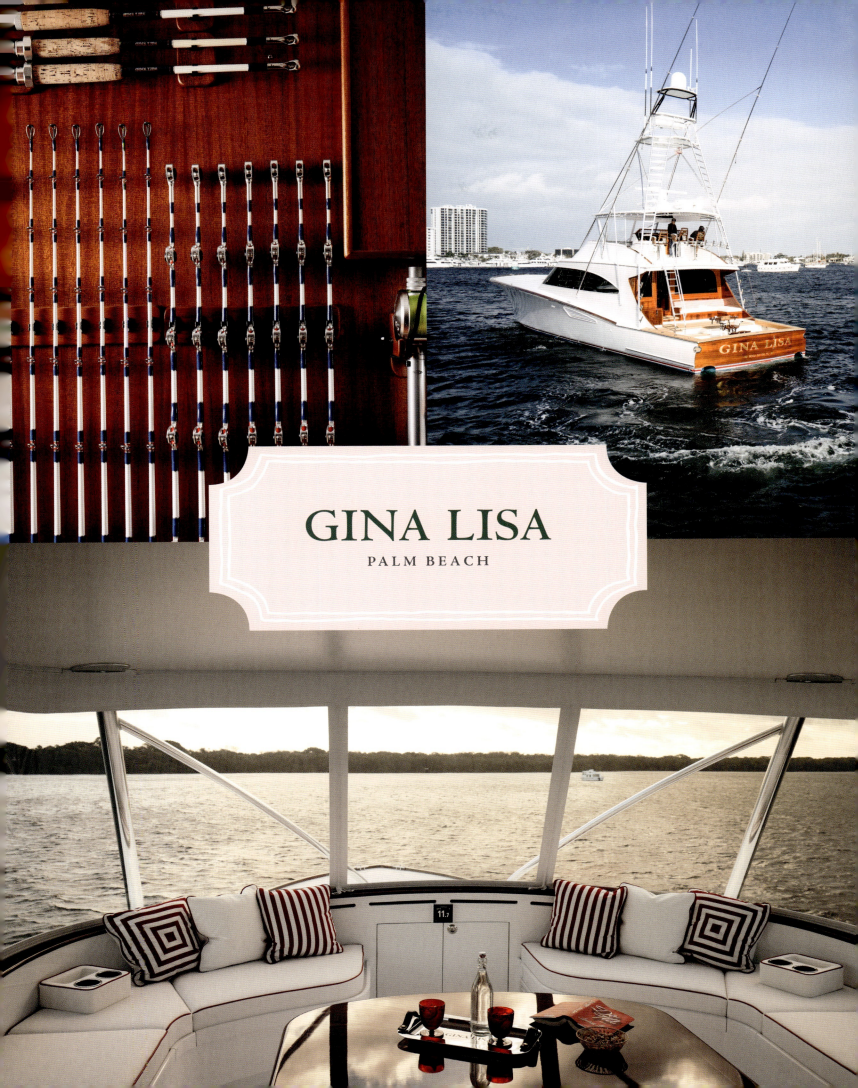

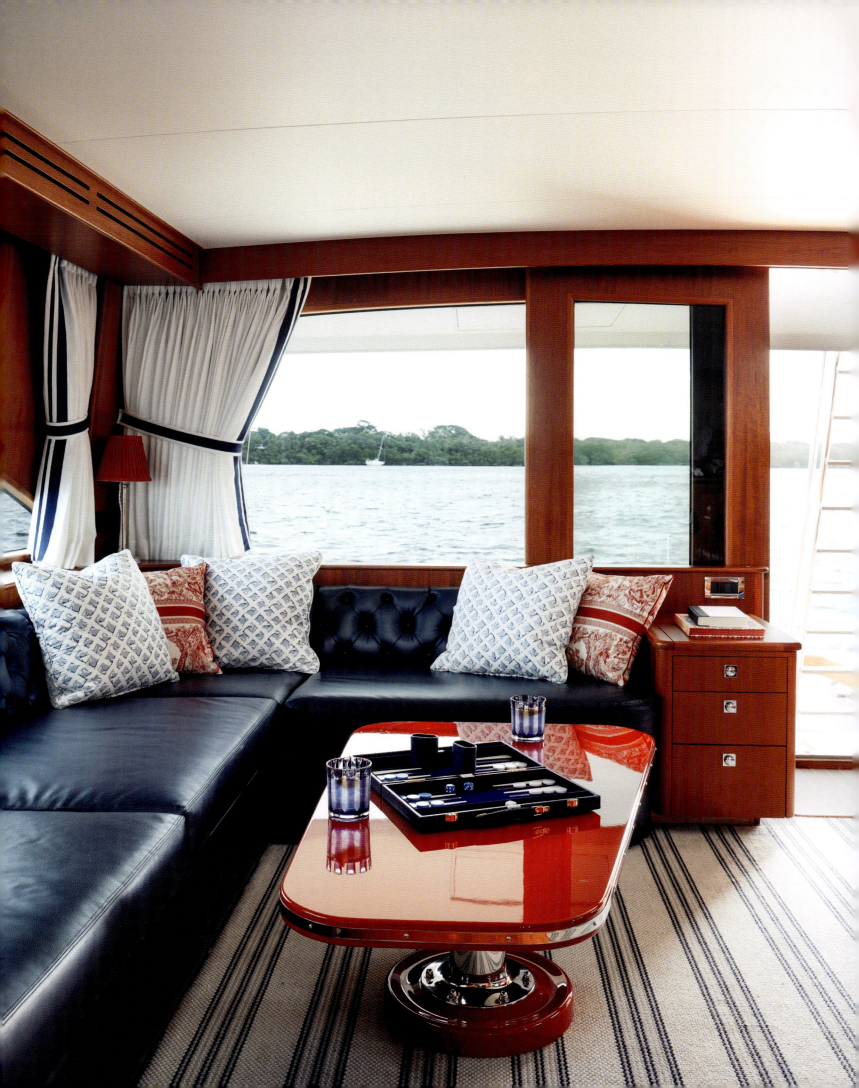

Imagine the extraordinary boon to a career when a woman with immaculate taste and vast experience walks into your shop and asks if you might be free to work on multiple amazing projects she has coming up.

And then imagine the thrill of being whisked two towns north of Palm Beach to a boatyard renowned for building the world's most important, sophisticated, and beautiful sport-fishing tournament boats entirely made of wood. To those of us *not* in the know, it is an inexpressible joy to witness the crafting of these very special boats in real time.

Our client had grown up participating in Bahamian sport-fishing tournaments with her beloved late father on the original *Gina Lisa*, which had been built in the same yard, Jim Smith Tournament Boats, in 2002. Her nostalgia for this important part of her life prompted her decision to build a new *Gina Lisa* in the traditional way, with the addition of some special finishes and details pinched from classic yachts of another era.

The process is slow. Only two boats are built at a time. The new, eighty-six-foot-long *Gina Lisa* took two years to complete. In addition to all the bells and whistles for maximum performance and speed, the boat has distinctly feminine touches in honor of her owner. The primary cabin and head are lined with de Gournay wallpapers, the custom-sized and -embroidered bedding is from Leontine Linens, the lamps have ruched silk shades with delicately embroidered borders, and there's even a walk-in closet.

The new *Gina Lisa* is a marvel of nautical power combined with high style, fittingly reflecting our client's exceptional taste and talent.

OPPOSITE: *The red-lacquered table was custom-made to fit the space. The rug is by Patterson Flynn.*

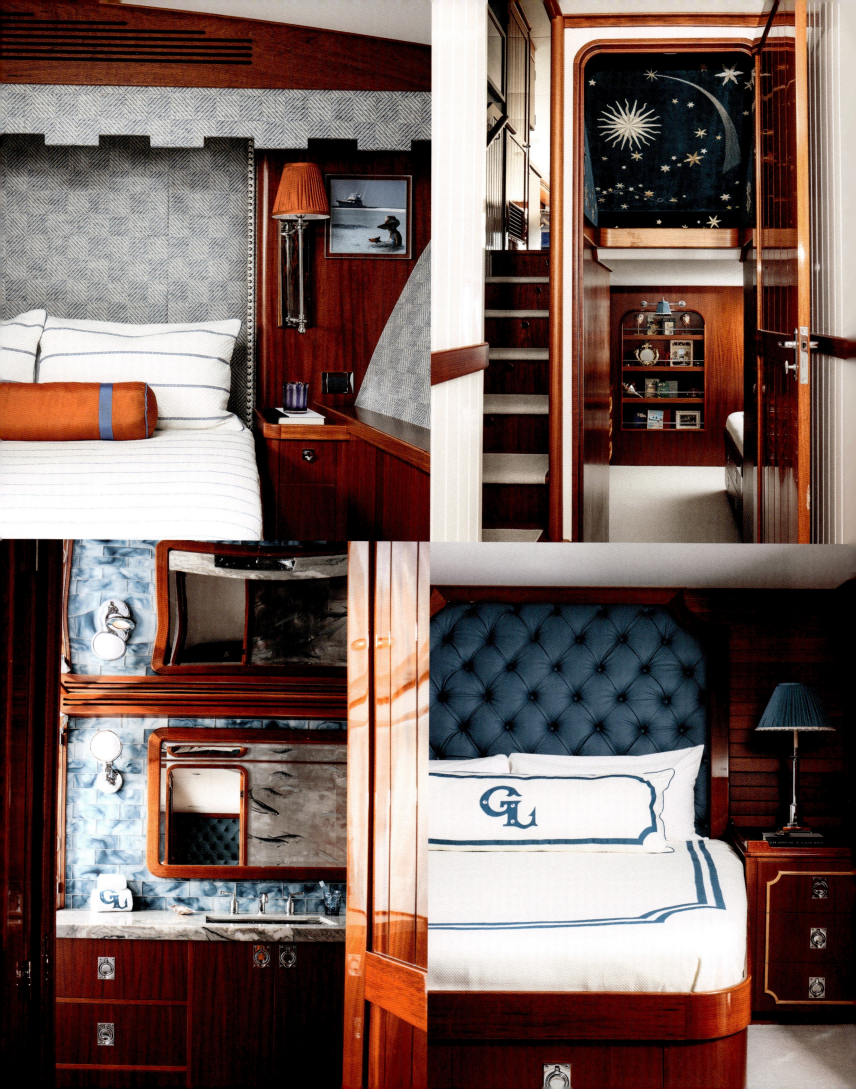

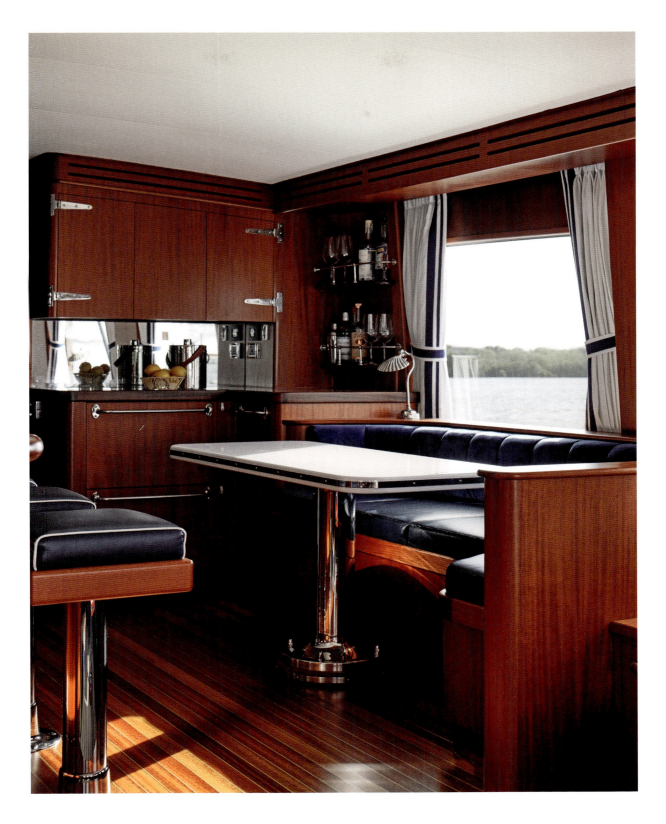

OPPOSITE TOP LEFT: *In the guest cabin, the bedding is from C&C Milano, the wallpaper is Phillip Jeffries' Diamond Weave, and the chrome sconces are by the Limehouse Lamp Company.* OPPOSITE TOP RIGHT: *At the entrance to the primary cabin, a de Gournay wallpaper is a celestial surprise. A beautiful aqua shirred-silk shade on a Besselink & Jones picture light illuminates built-in shelves.* OPPOSITE BOTTOM LEFT: *Tiles resembling ocean waves form the backsplash in the primary bathroom. A fish-themed de Gournay wallpaper is reflected in the built-in mirror.* OPPOSITE BOTTOM RIGHT: *In the primary cabin, a Besselink & Jones lamp with another aqua shirred-silk shade with white trim stands on the night table. The custom bedding is from Leontine Linens.* ABOVE: *A charming Limehouse Lamp Company shell lamp is trained on the dining banquette. The table was made at the boatyard.*

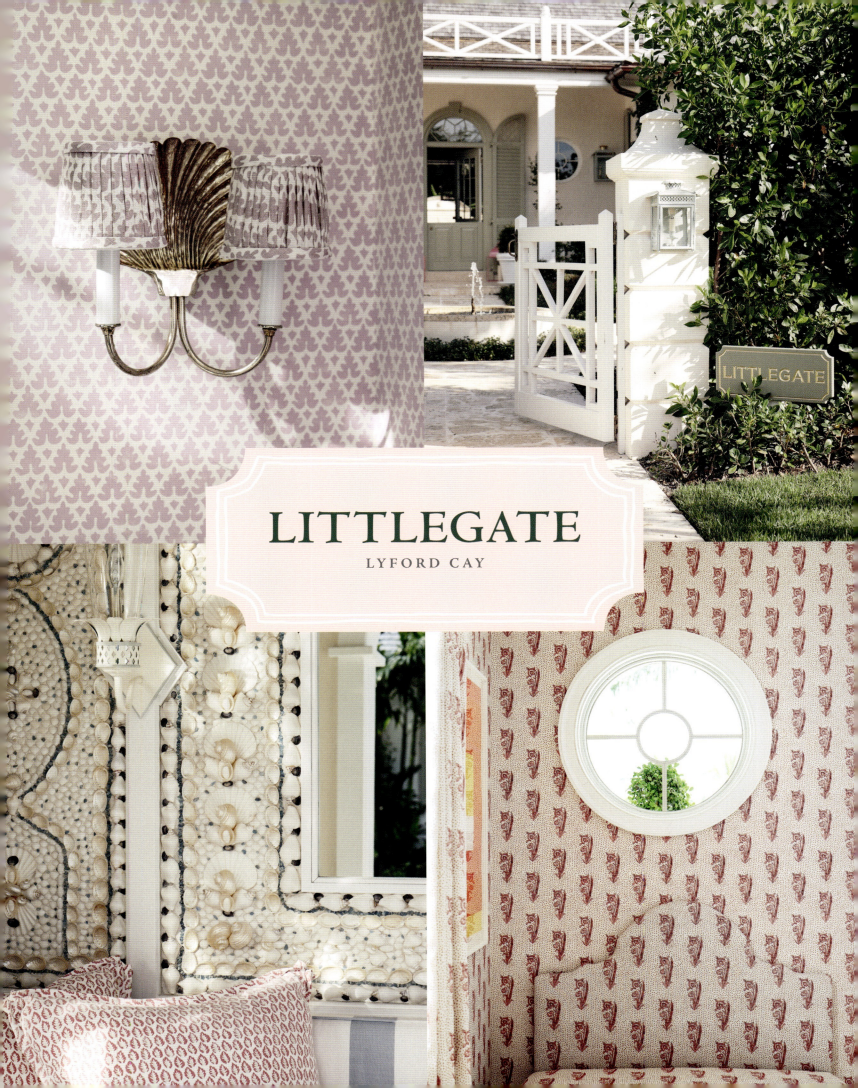

LITTLEGATE

LYFORD CAY

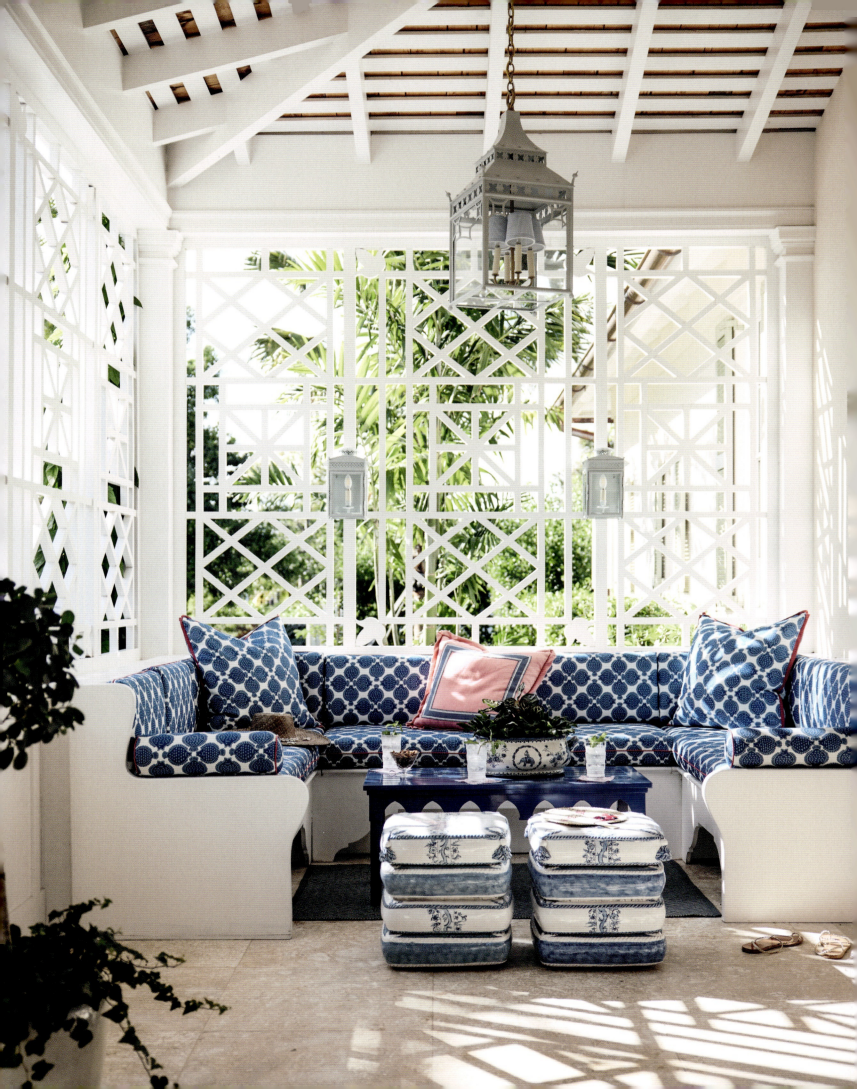

The interiors of Littlegate are among the most layered in Lyford Cay. Our client is a pro, having built and renovated many houses. She is good at it and has impeccable taste. She also happens to be uncommonly nice and generous.

My team handled the interiors, Kiko Sanchez and his colleague C. C. Davis were responsible for the architecture, and Fernando Wong designed the garden and hardscape. The result is one of the most successful houses in years at Lyford.

The house already existed. It had originally been designed by Henry Melich, a legendary local architect. Modest in size, it had one incredible room, perfectly proportioned and with a soaring tray ceiling. Its location, close to Lyford Cay Harbour, was a winning factor for our clients, who are boaters and keep a lovely boat in the cay.

Apart from the big room, the house and property needed a major rethink. Rooms were gutted to the studs, and the locations and sizes of all the windows were changed. A vaulted loggia now wraps around three sides of the house, doubling the living space. On one side, the loggia overlooks a formal garden; on another, it opens onto the pool and an enchanting, shell-encrusted folly. A guesthouse facing the pool completes the Littlegate compound.

As for the interiors, our client loves all manner of fabrics and wallpapers and is up-to-date on collections and makers. She is not afraid of color and taught us to be bolder and better at deploying it. A container of treasures from previous houses, including loved antiques and artwork, sconces and lanterns, was sent, and these items immediately gave the interiors a sense of gravitas. We are always grateful when the houses we help compose have references to our clients' history and lives. Littlegate is a supremely successful expression of our client's talent, charm, and generosity—and of a very well-lived life.

OPPOSITE: *The cushions on a Moroccan-style built-in banquette are covered in a Clarence House print. The lantern sconces are from Charles Edwards, and the pendant lantern was custom-made by Dana Creath.*

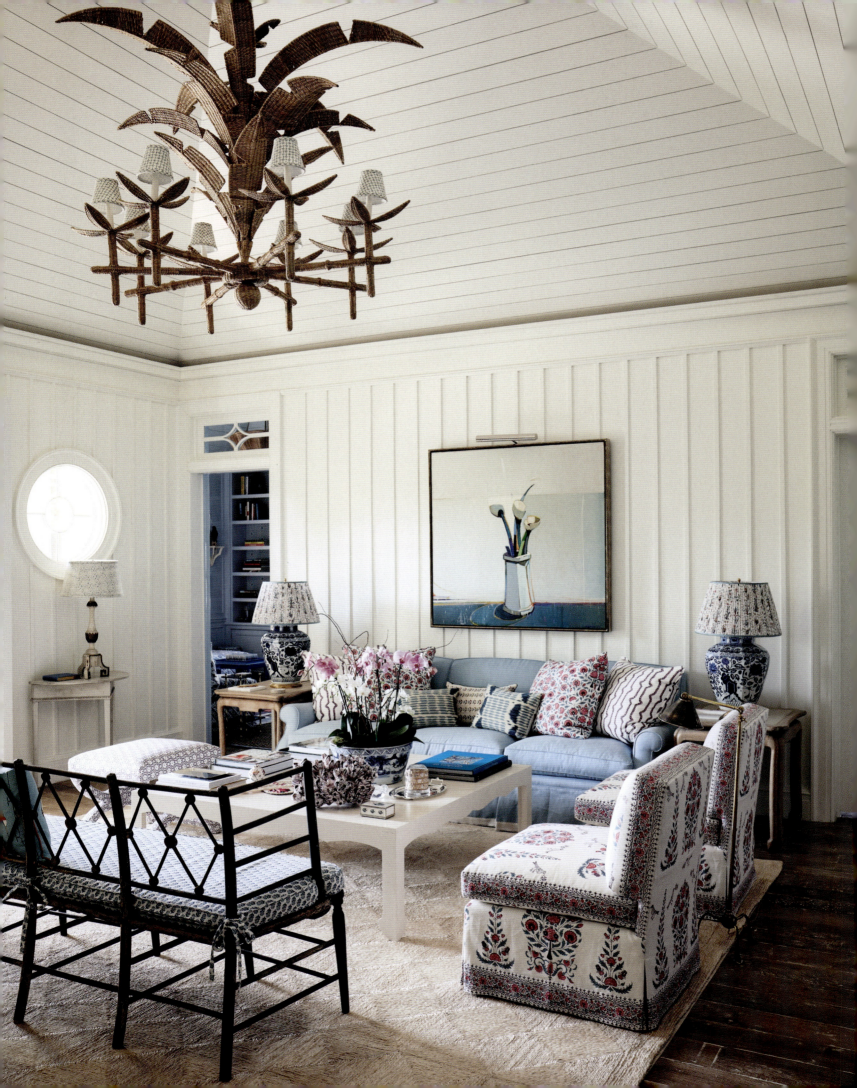

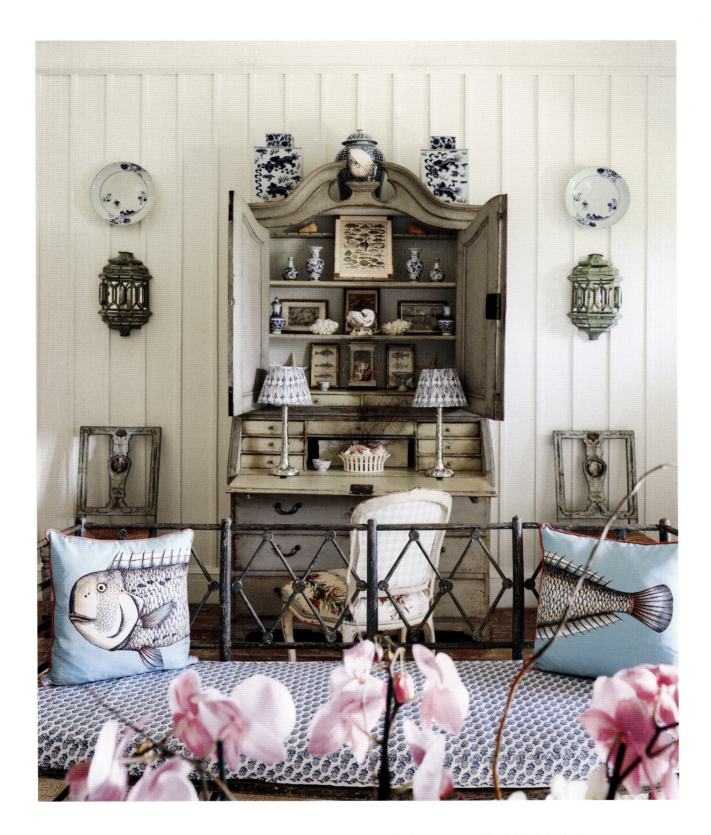

OPPOSITE: Board-and-batten walls and a shiplap ceiling give the living room an island feel. A Stark abaca rug grounds the room. The fabrics are from Quadrille, Lisa Fine Textiles, and Pierre Frey. ABOVE: The antique furnishings come from the owner's cache. We sourced accessories and other bits and pieces during construction.

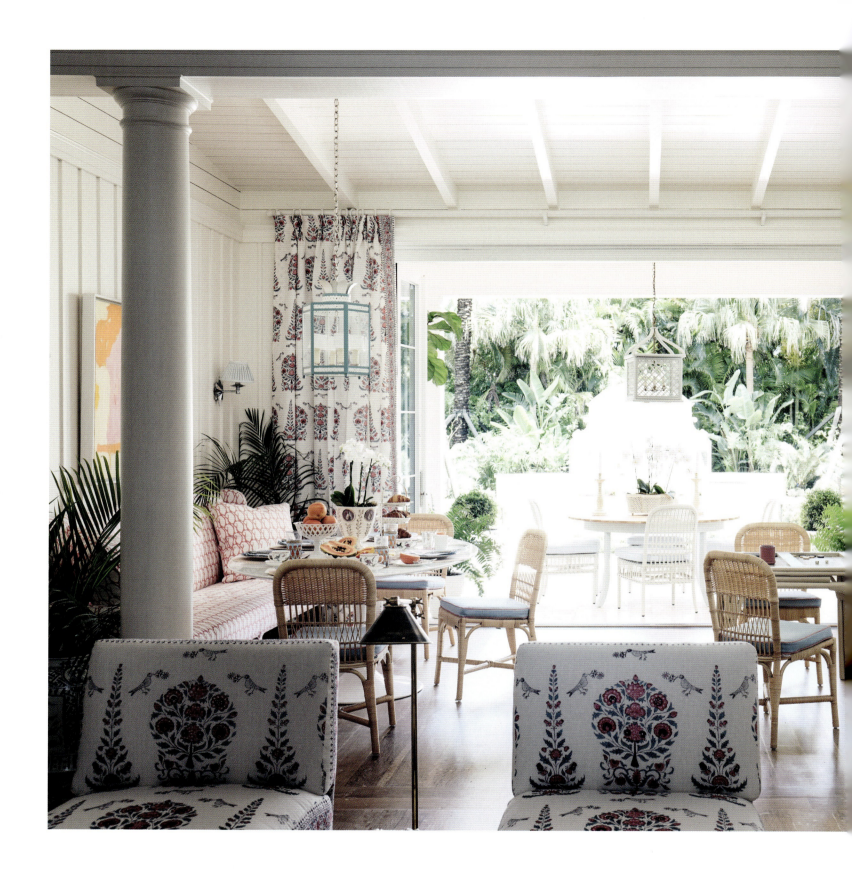

ABOVE: In the dining area, a Saarinen Tulip table is surrounded by a banquette and Bonacina chairs. A vintage backgammon table was decoupaged by Charlene Beaudet on Dixie Highway in West Palm Beach. OPPOSITE TOP: The kitchen is painted a Scandinavian blue, and the interior of the cabinets is covered in a Thomas Strahan wallpaper. OPPOSITE BOTTOM: A charming pantry with scalloped shelf trim and guardrails is both beautiful and wonderfully functional. OVERLEAF: The primary bedroom is a study in pattern on pattern. Centered on a Lindroth rattan bed, the room is wrapped in Mrs. Howell, a grasscloth wall covering by Mary McDonald for Schumacher. The bed and curtain fabric is Paolo Moschino's Palmyra.

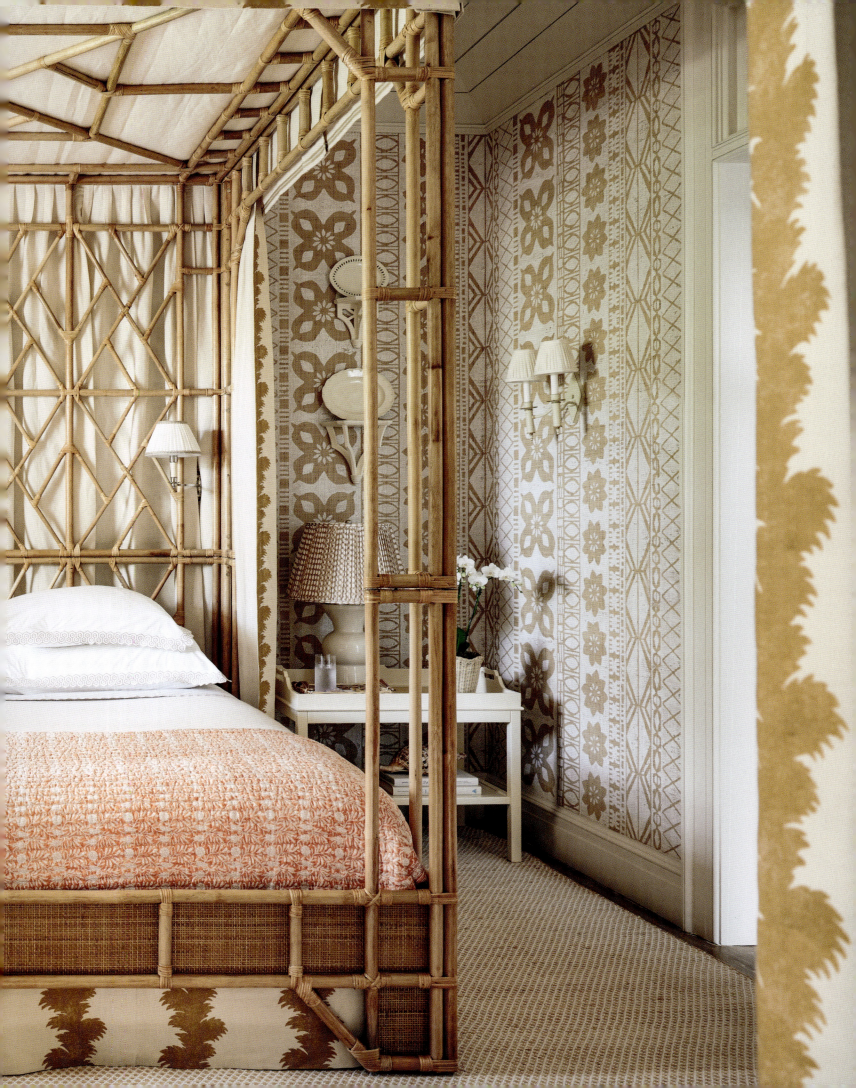

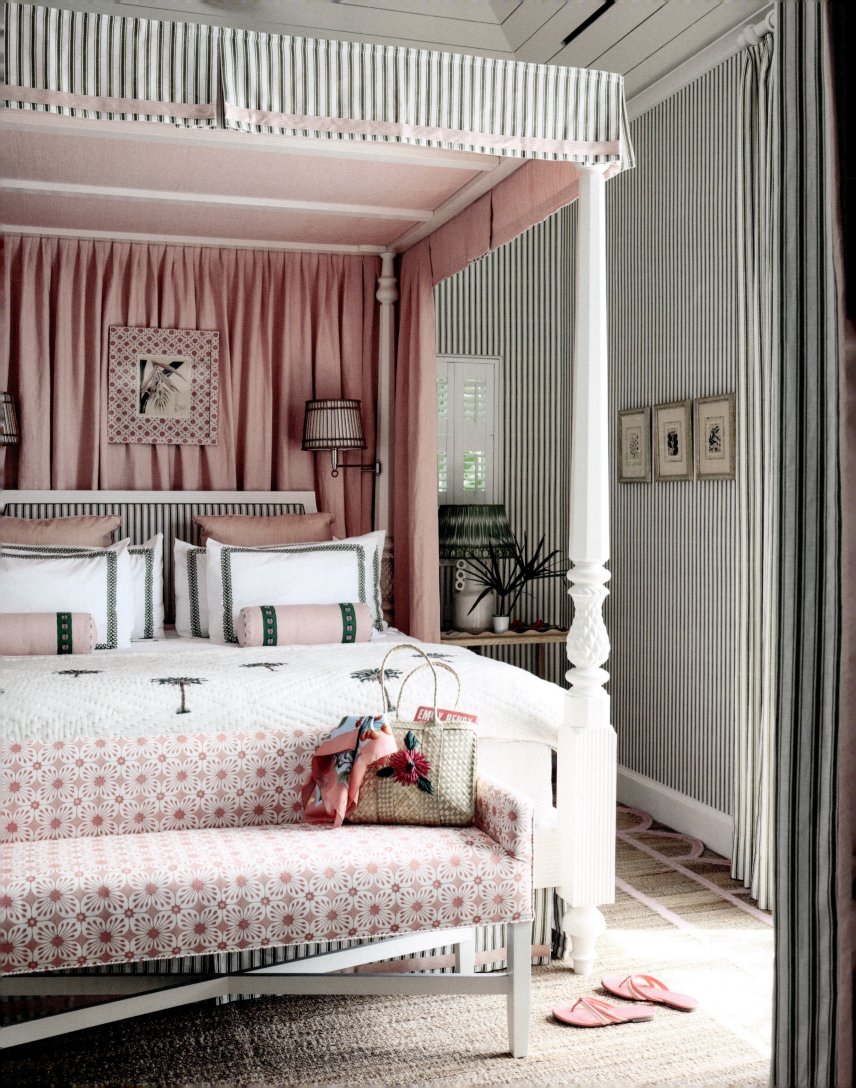

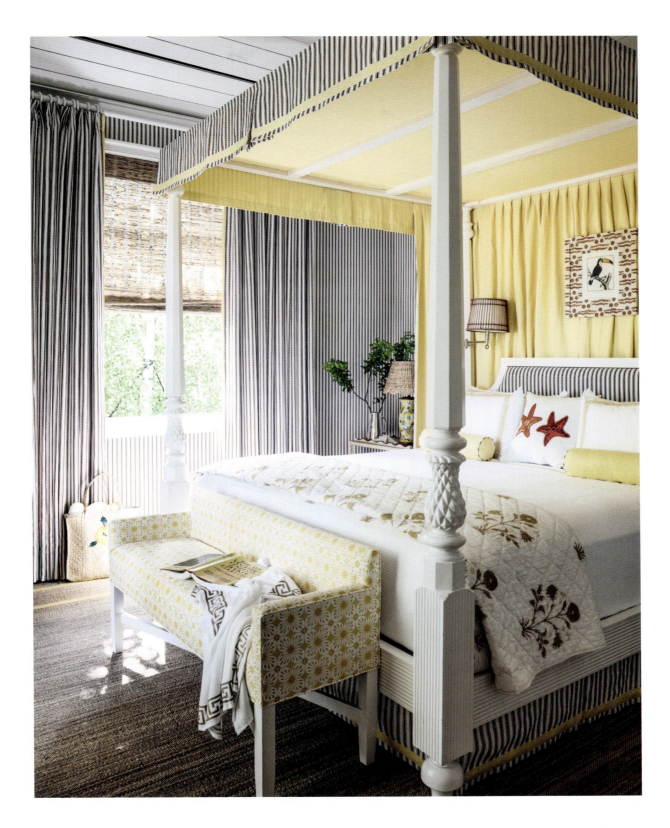

OPPOSITE AND ABOVE: *A pair of guest rooms in the cottage are nearly matching. Custom-colored stripes by Lisa Fine Textiles top the custom Raj Company beds and cover the walls in both rooms, one in green and the other in brown. The beds are lined with Pierre Frey linens, and the benches, from Oomph, are upholstered in a custom-colored fabric from Quadrille. The custom-colored rugs are from Jaipur with Love, and the artwork is from Casa Gusto.* OVERLEAF: *The sitting room is a celebration of pattern. Lisa Fine Textiles' Kalindi Reverse covers the walls and sofa; the club chairs are upholstered in Lisa Fine Textiles' Rambagh Reverse. An Oomph coffee table sits on top of a Stark abaca rug. The side tables are from KRB NYC.*

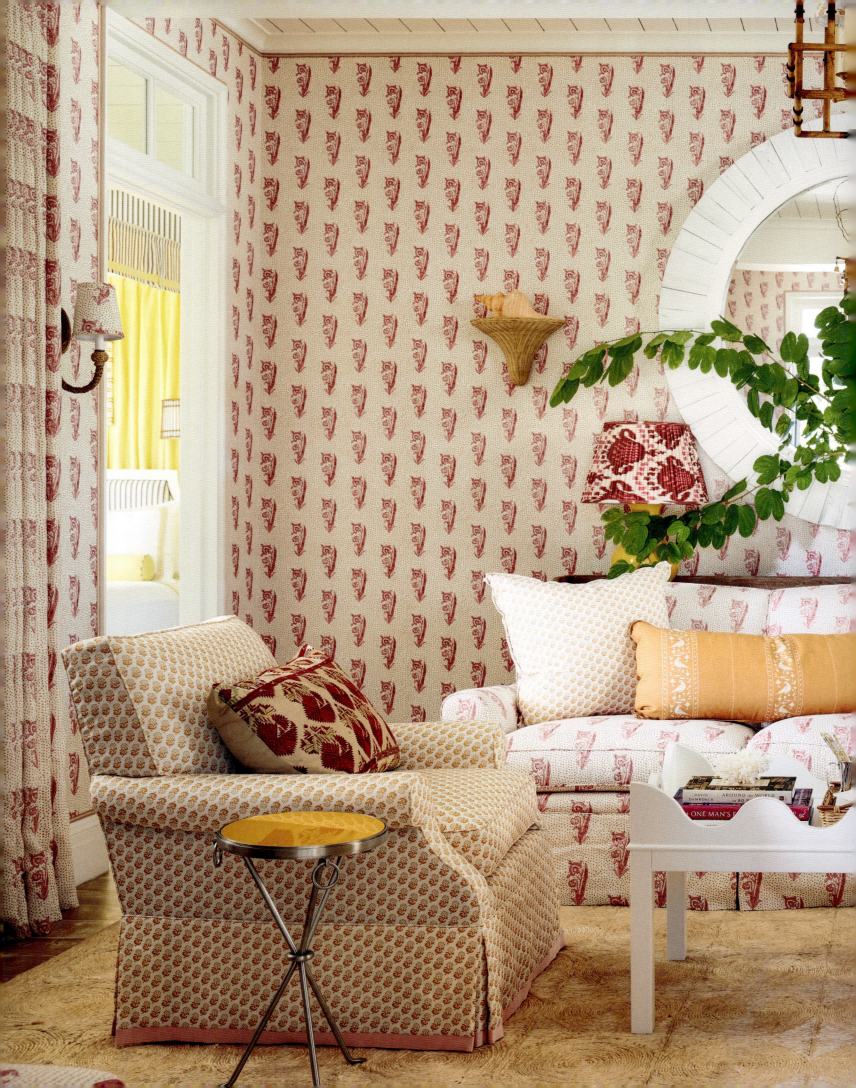

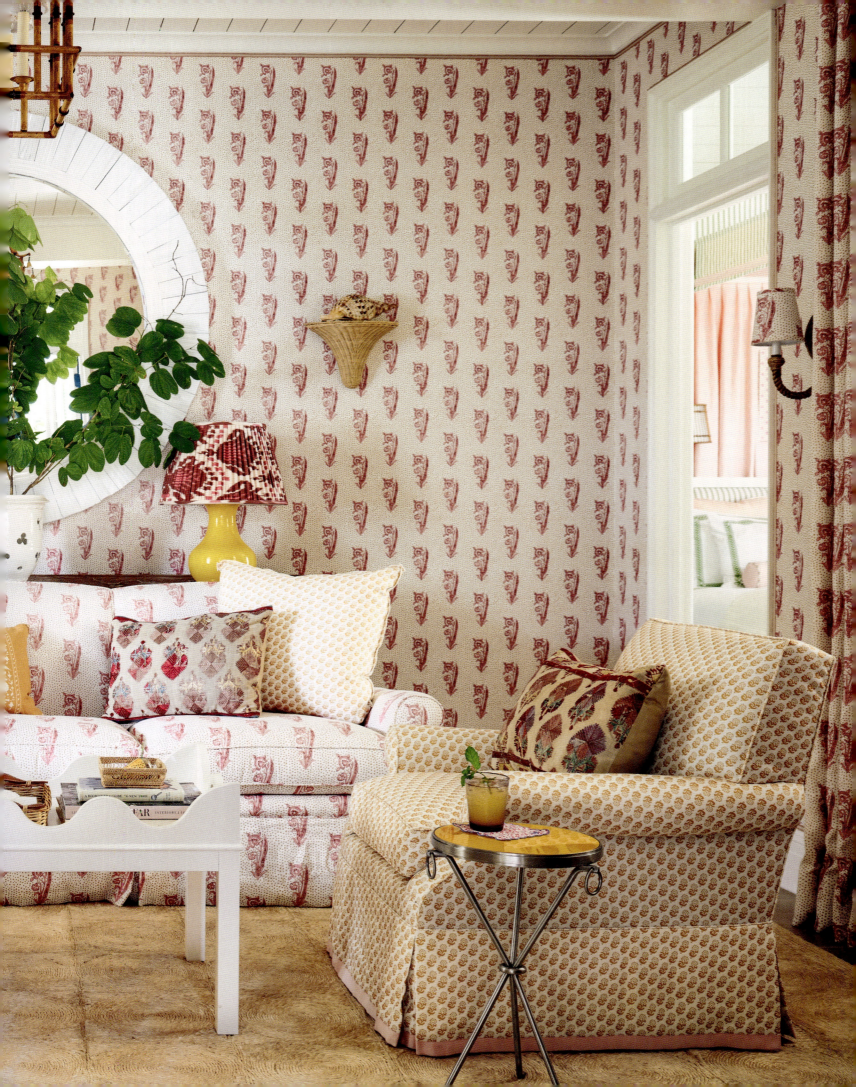

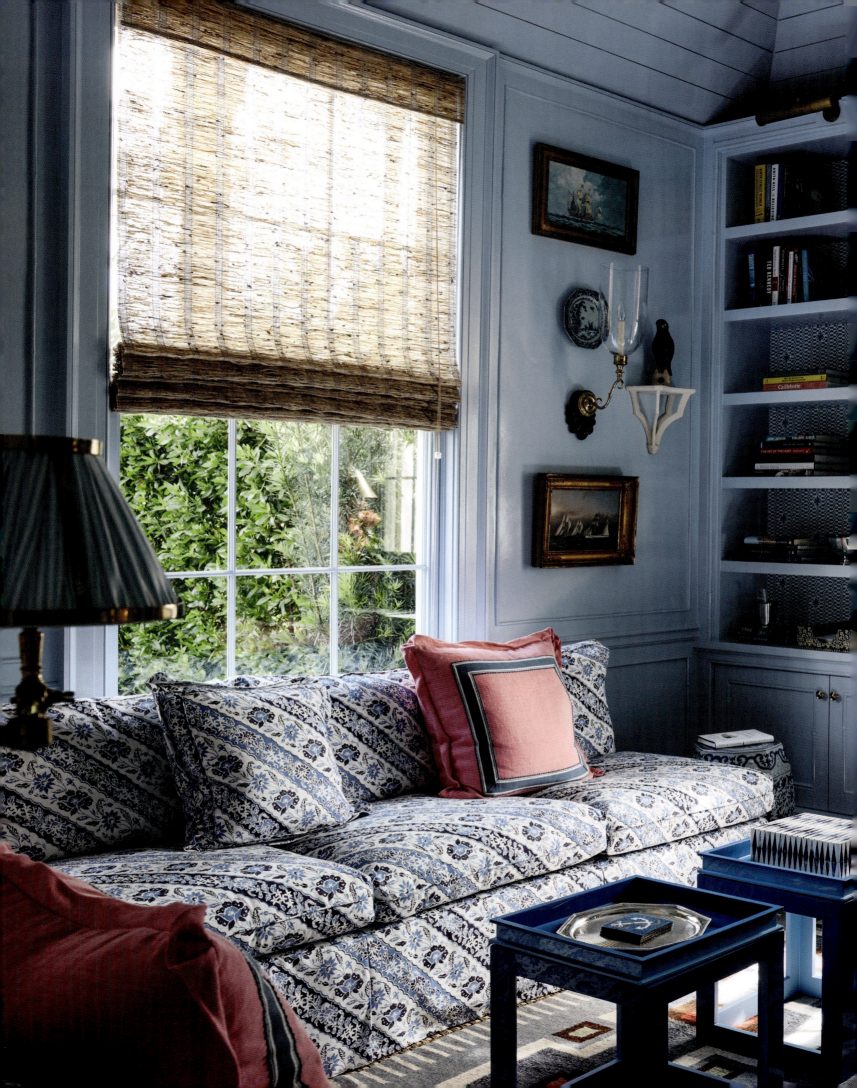

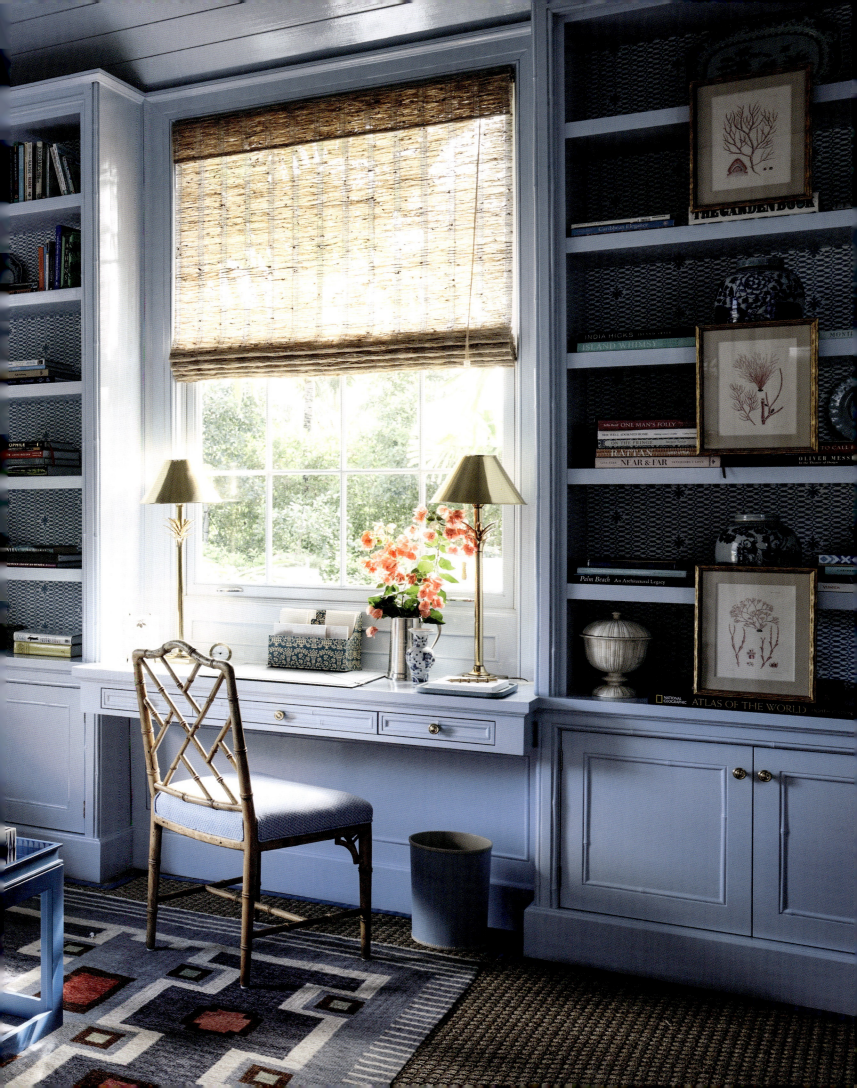

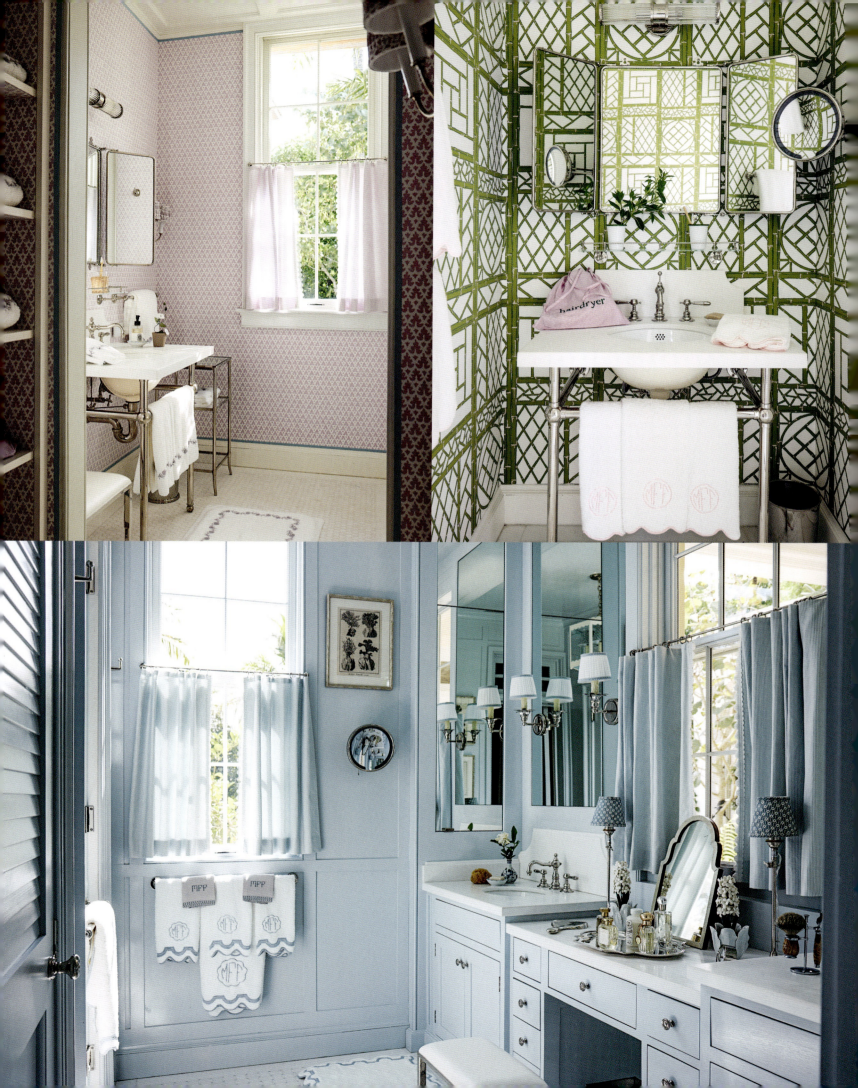

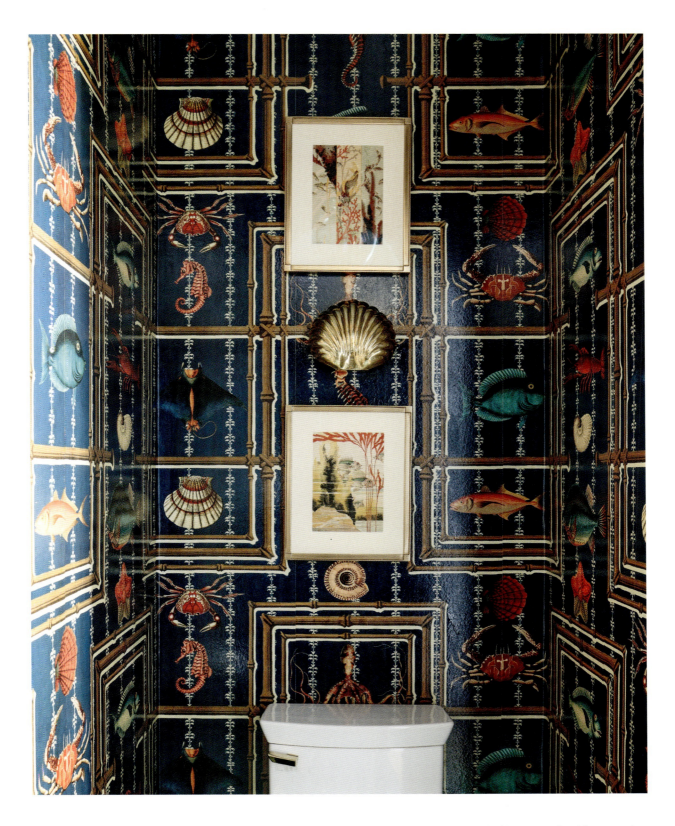

PRECEDING PAGES: *Every inch of the library's walls and ceiling is lacquered in a wonderful sky blue. A comfortable sectional sofa is upholstered in China Seas' Lim Diagonal. Two-toned lacquered cubes from the Lacquer Company serve as coffee tables.* OPPOSITE, CLOCKWISE FROM TOP LEFT: *A Sister Parish wallpaper in lavender completes this old-fashioned bathroom. Quadrille's Lyford Trellis wallpaper wraps this guest-cottage bathroom. The ice blue–lacquered primary bathroom is complemented by pinstriped ice-blue linen cafe curtains; the delicate sconces are from Coleen and Company.* ABOVE: *In the powder room, the wallpaper of sea creatures and bamboo—sourced on Instagram from Transylvania—was enchanting but needed a few coats of lacquer to make it more lustrous.*

LITTLEGATE . 221

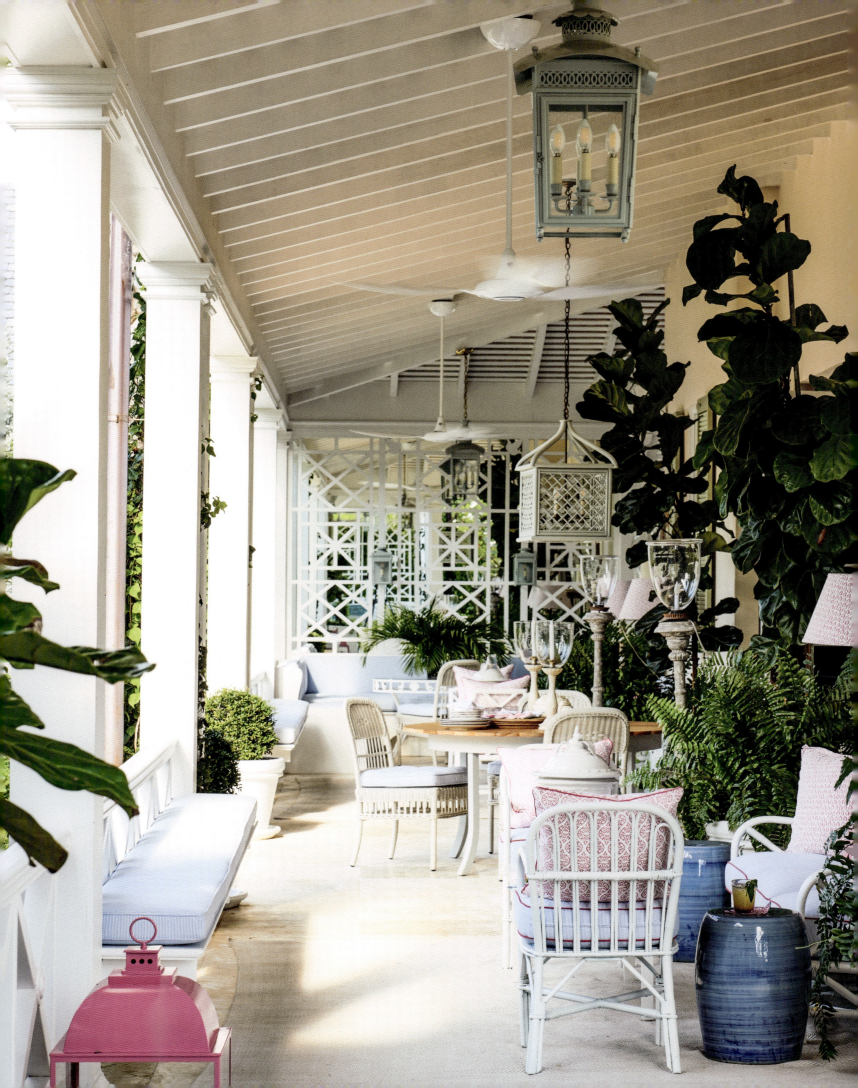

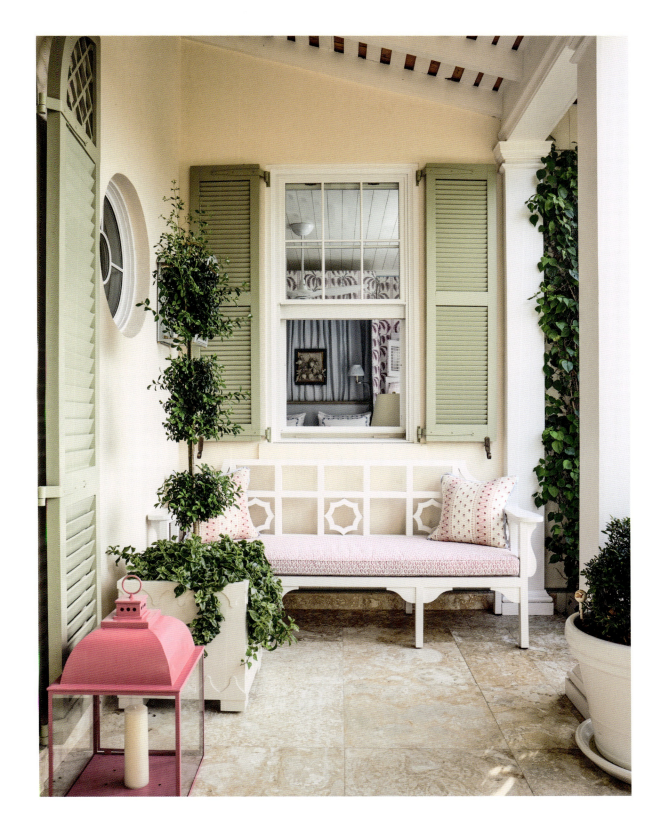

OPPOSITE: *The main loggia is furnished with built-in seating, vintage rattan seating from Dixie Highway, a dining table from Casa Gusto, and dining chairs from Highland House. A birdcage lantern from Soane Britain hangs over the dining table. Other lighting is from Charles Edwards. Standing lamps and bone hurricanes are from the Lindroth collection.* ABOVE: *Benches designed by FGS with cushions covered in a Peter Fasano performance fabric flank the front door.*

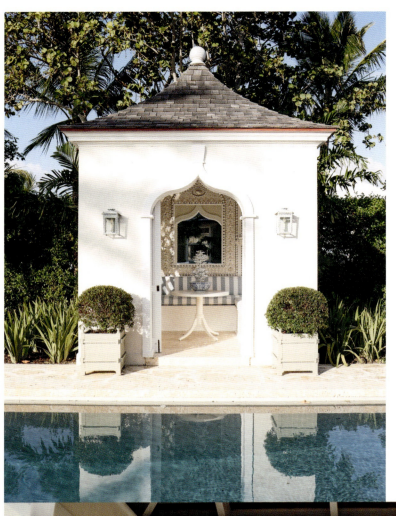

LEFT AND BELOW: *An enchanting garden folly houses an elaborate, shell-encrusted mirror designed by Linda Fenwick and an intimate seating area upholstered in a striped Perennials fabric.*
OPPOSITE: *Janus et Cie outdoor furniture flanks the beautifully landscaped pool area, which is nestled between the main house, the guest cottage, and the garden folly.*
OVERLEAF: *Littlegate from the sky.*

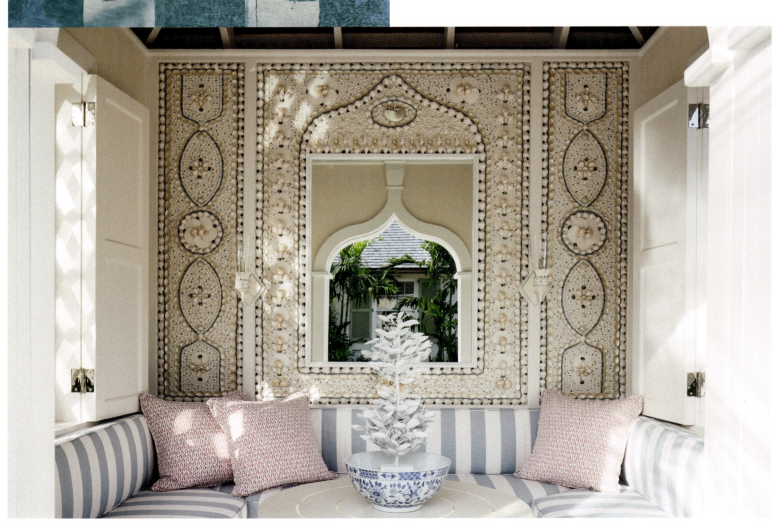

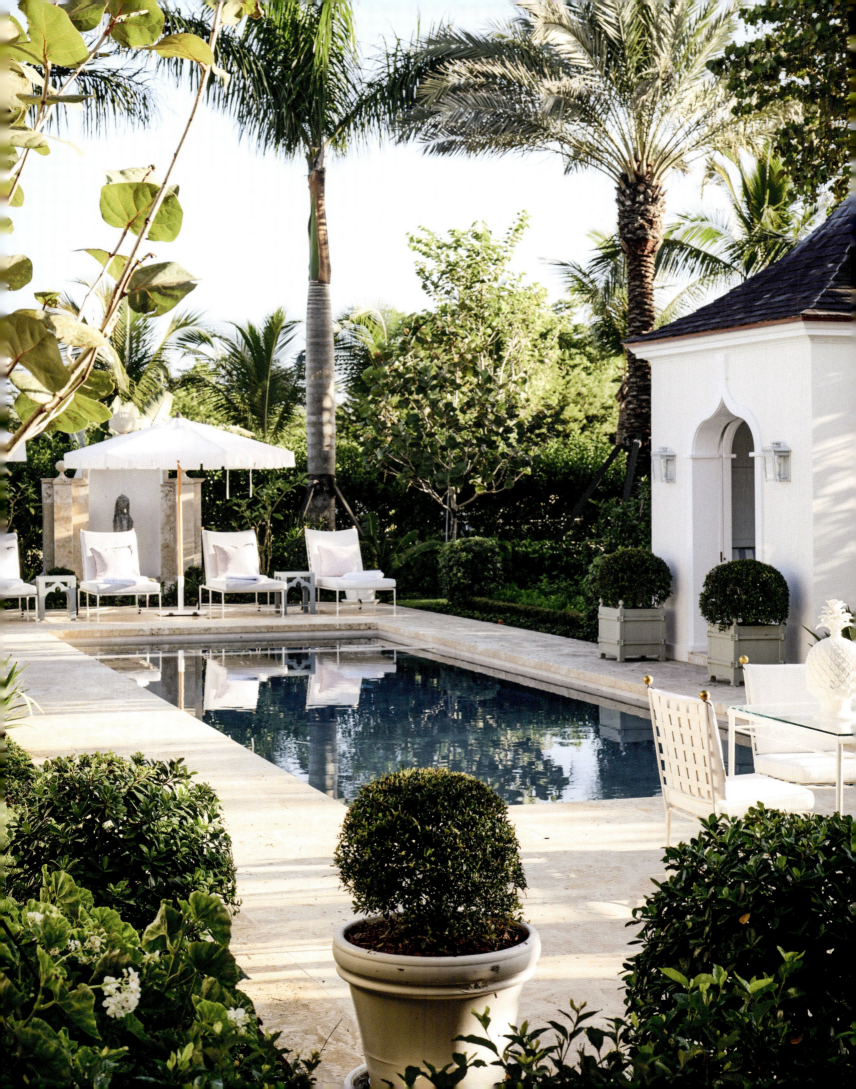

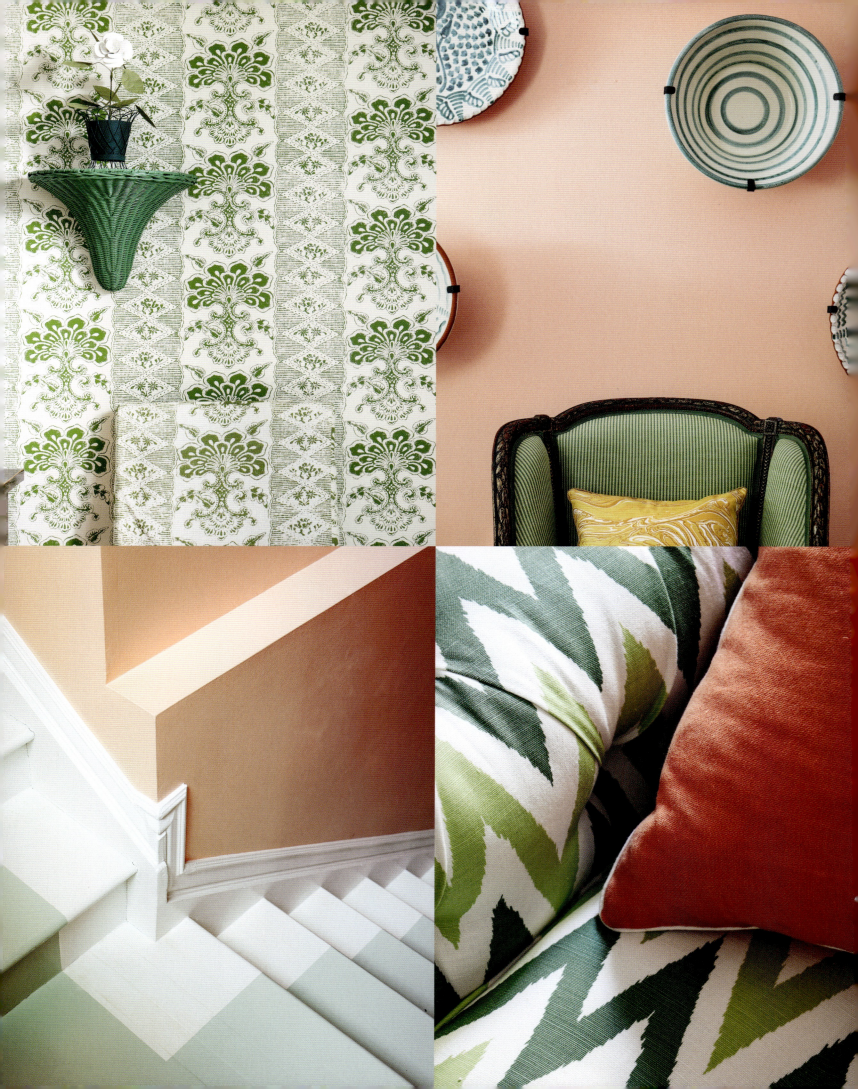

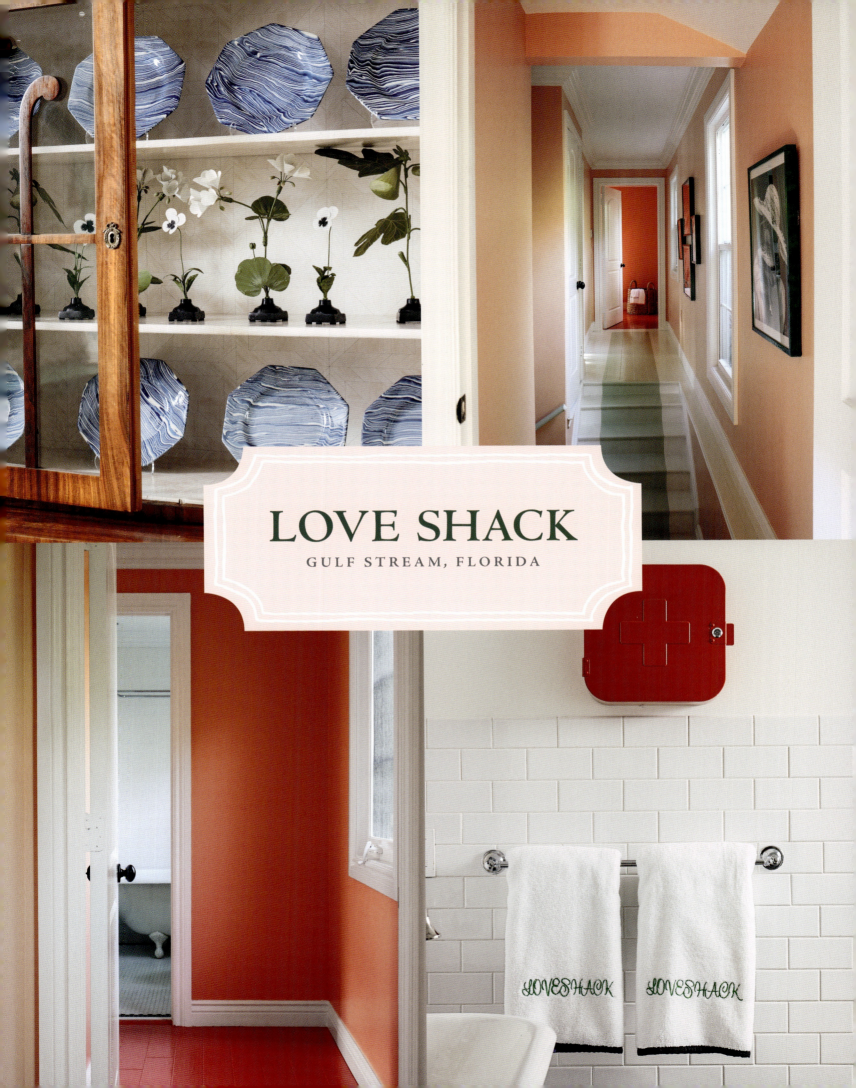

LOVE SHACK
GULF STREAM, FLORIDA

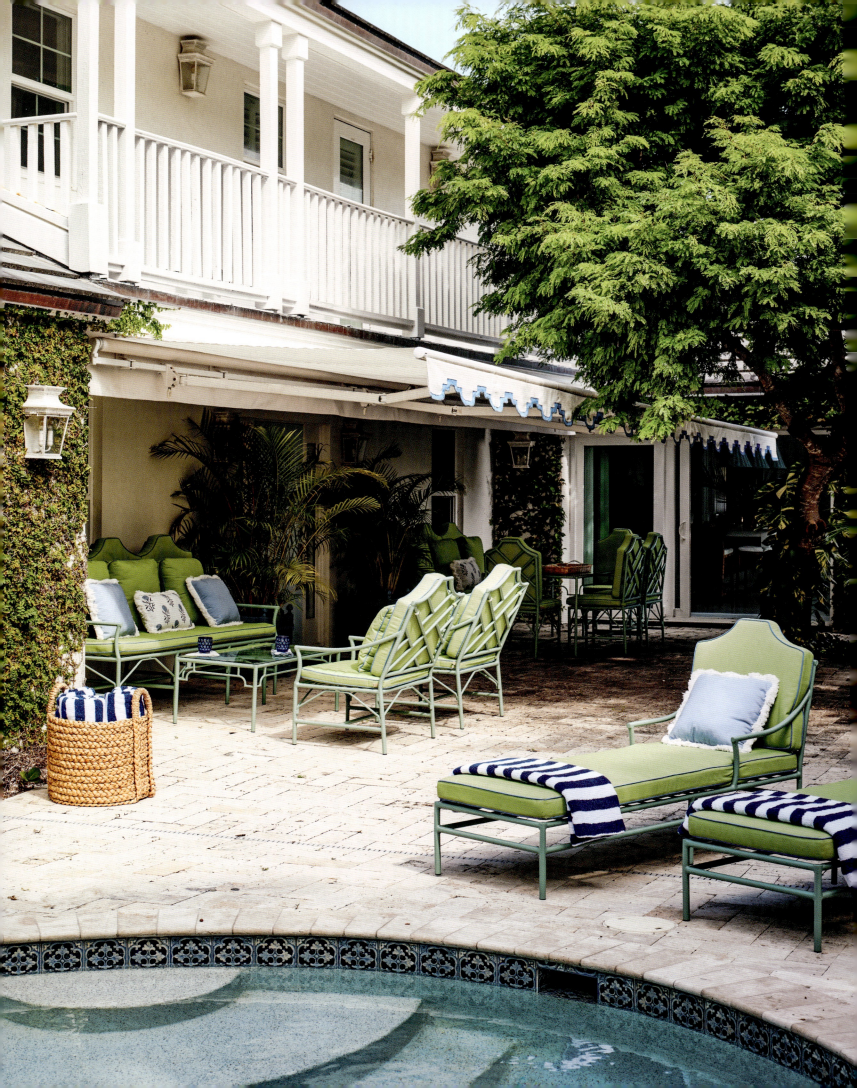

Serendipity is a favorite word and a favorite thing. When a beloved friend from college reached out to say that she and her husband had bought a house in Gulf Stream, Florida, imagine my surprise to find out that it was right next to my childhood school.

The Gulf Stream school was founded in the 1940s and started out as a single classroom for the children of families who wintered in town. The classroom was attached to the stables of the original Gulf Stream Polo Club. When I was in first grade, polo ponies were still being trained alongside tiny people (including me) playing in the adjacent playground.

My college friend immediately named her new house, bought sight unseen online, the Love Shack. Playing off this lighthearted name, we created a colorful, cozy house for her, her husband, and their boys, who visit from time to time.

The house had a slightly odd layout, so we swapped the larger but light-deprived living room with the smaller but light-filled entry, which we proceeded to paint a vibrant watermelon. Handsome furniture, upholstery, and art from New York arrived. We whisked the upholstery out to the workrooms, however, and replaced the silks and velvets with fresh, colorful, printed and solid cottons. The couple's beautiful antiques found a happy home in the dining room, which we enveloped in a cheerful, green-striped batik wallpaper.

The boys' small bedrooms were painted in bold colors, and more bold color was used for the tufted and fringed headboards. In the upstairs family room, a mile-long, vintage curved rattan sofa is ideal for watching TV. Such sofas are a Lindroth favorite and are scooped up whenever found for future use.

The couple is so happy in Florida that a new waterfront project, the Love Nest, is currently in the works. For me, it has been wonderfully serendipitous to work in a place filled with such happy childhood memories for a friend of such quality and magic.

OPPOSITE: *O'Brien Ironworks' Chippendale chaises, sofas, and chairs lend pizzazz—and comfortable seating—to this outdoor pool area.* OVERLEAF: *A giant vintage curved rattan sofa brings old Florida style to a room with walls covered in a Schumacher striped paper. We added a Nobilis faux-bois wallpaper to the ceiling to create a cozy place to watch television.*

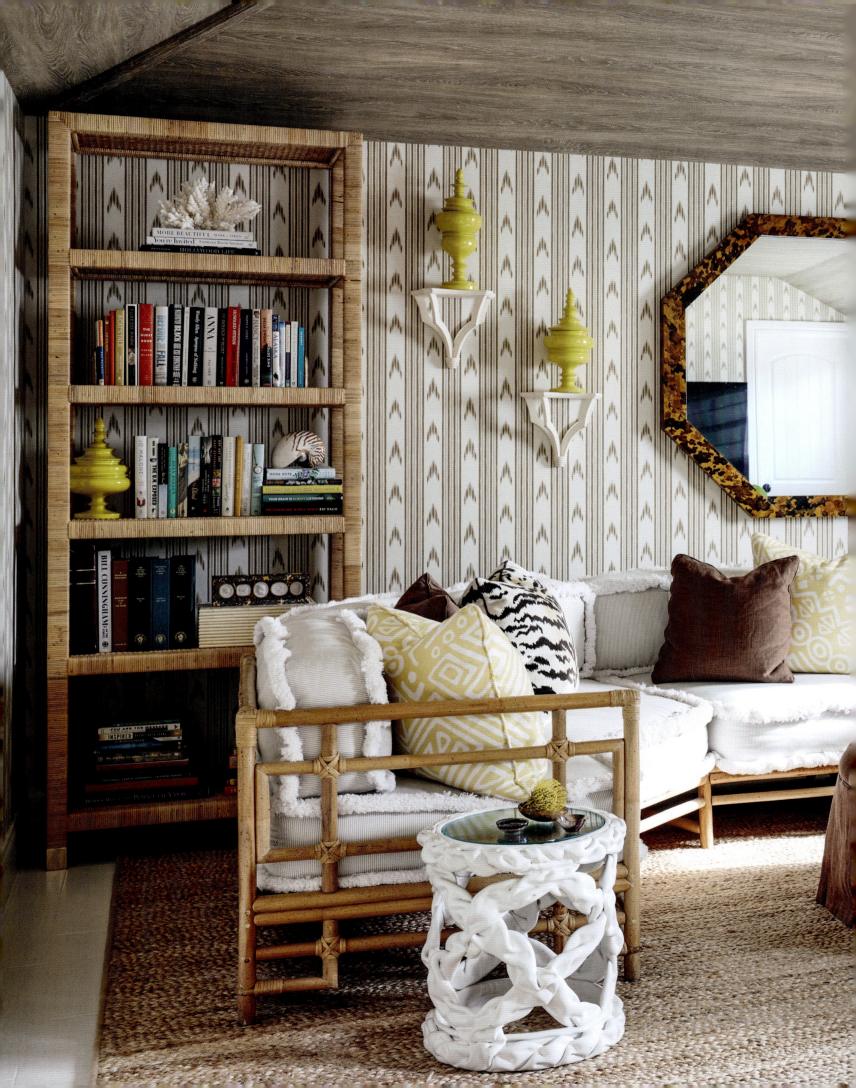

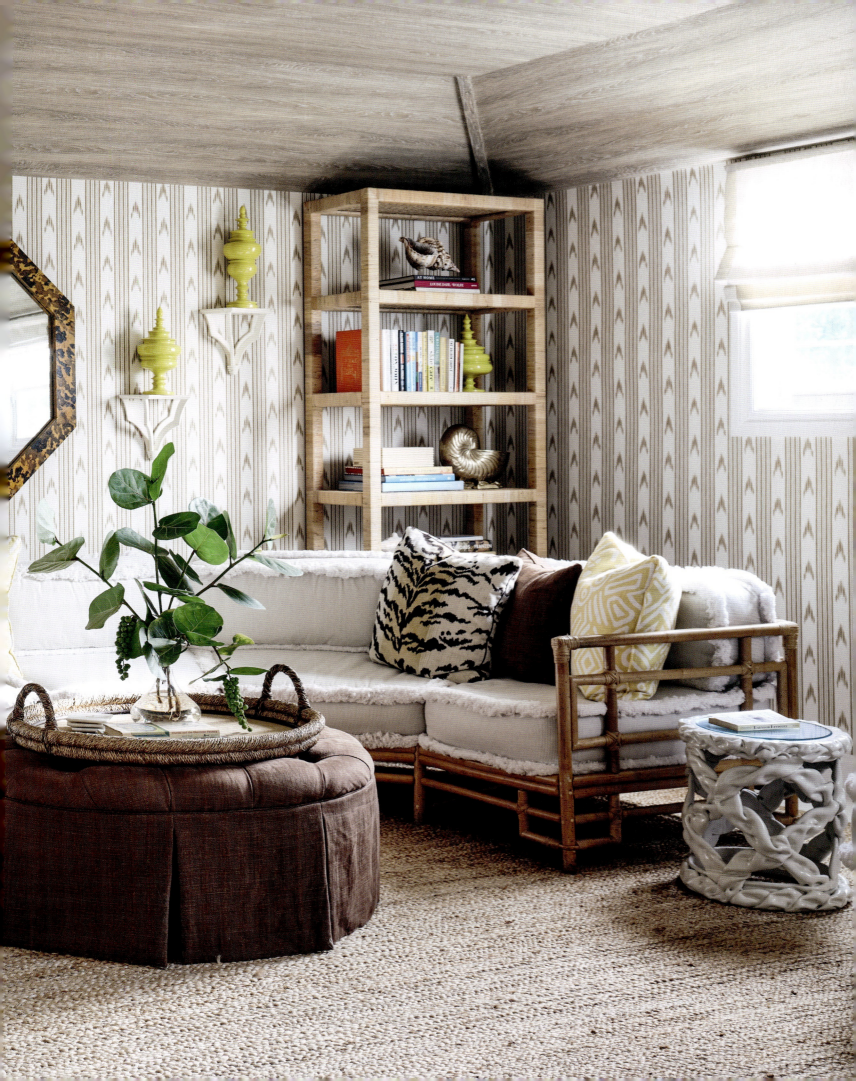

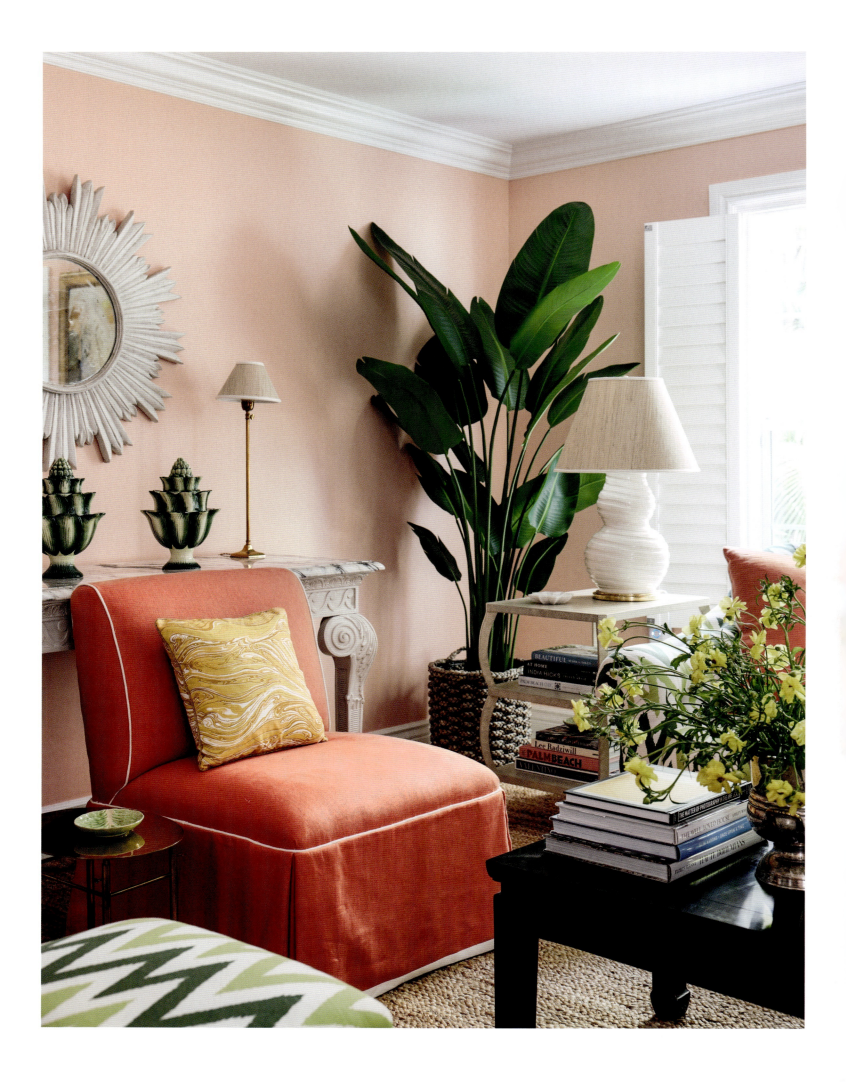

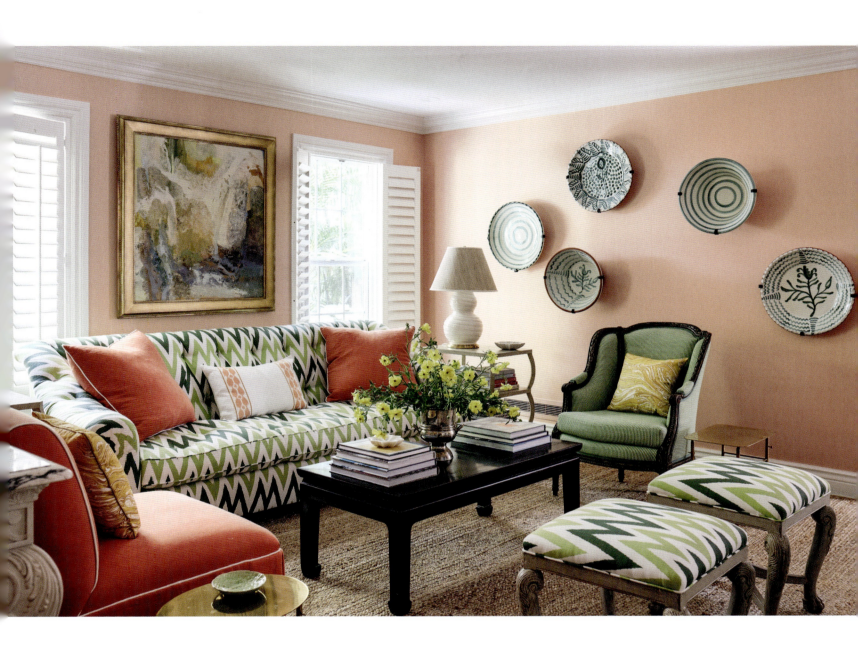

OPPOSITE AND ABOVE: *We painted the living room a cheerful watermelon and upholstered the clients' own sofa in a two-tone-green fabric from Quadrille.*

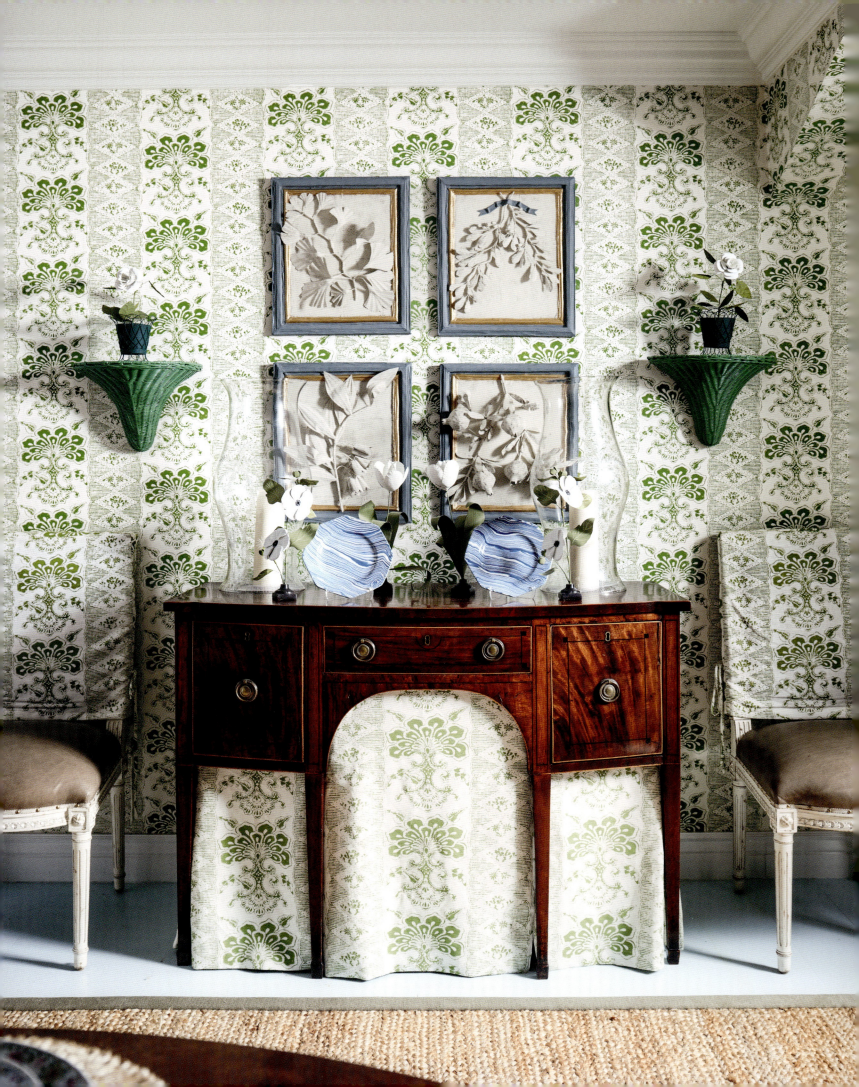

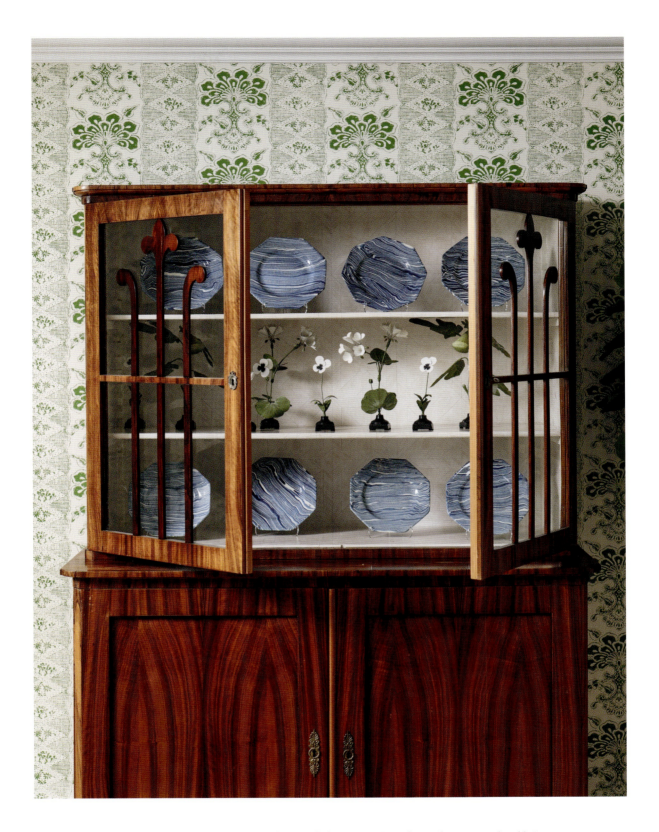

OPPOSITE: *Framed papier-mâché botanicals from Casa Gusto hang above a console table in a room enveloped in Quadrille's Chantilly Stripe wallpaper. We used the same pattern for the skirt of the console and the backs of the clients' own dining chairs to blend in.* ABOVE: *We filled the clients' cabinet with marbleized plates and tole flowers from Casa Gusto.*

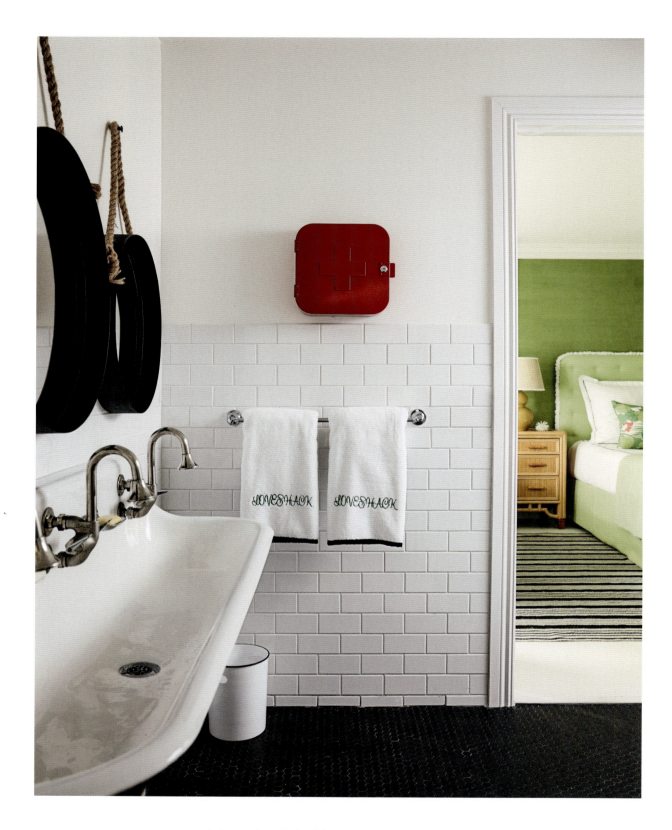

ABOVE: *A glimpse through the children's bathroom into the green bedroom.*
OPPOSITE TOP AND BOTTOM: *Vintage rattan furniture and fringed, tufted headboards add to the old Florida vibe.*

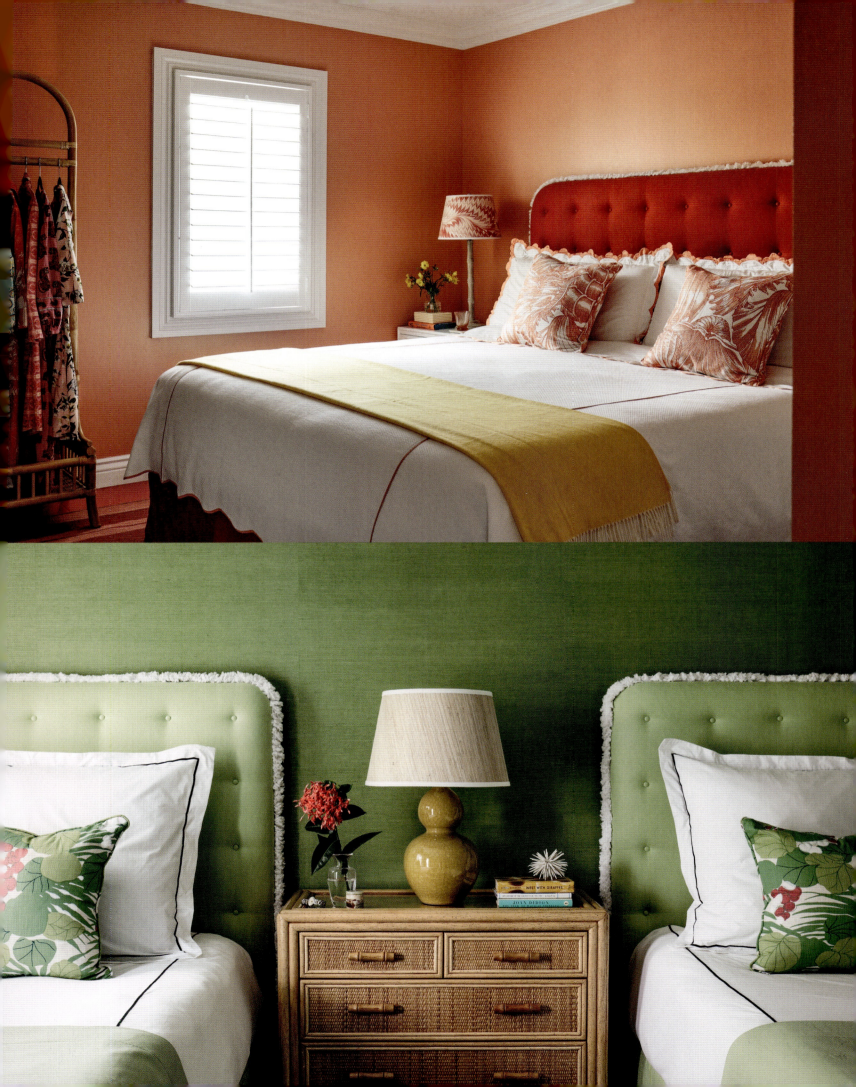

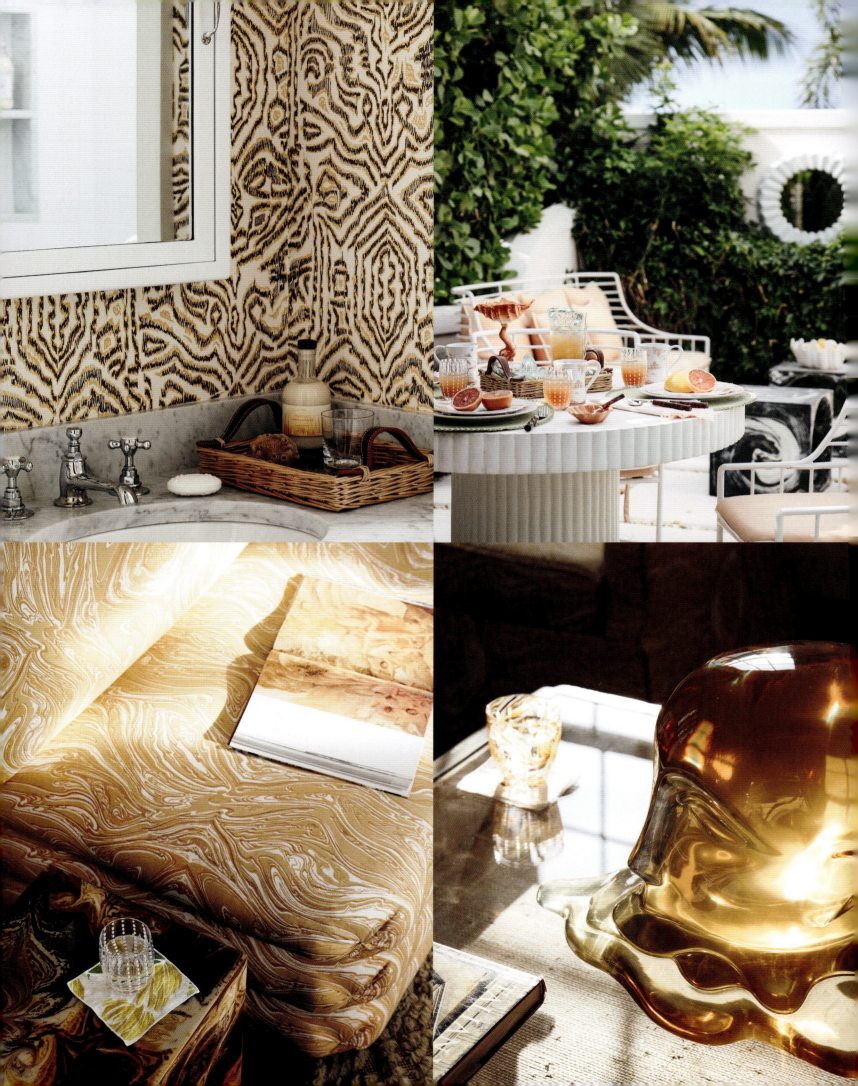

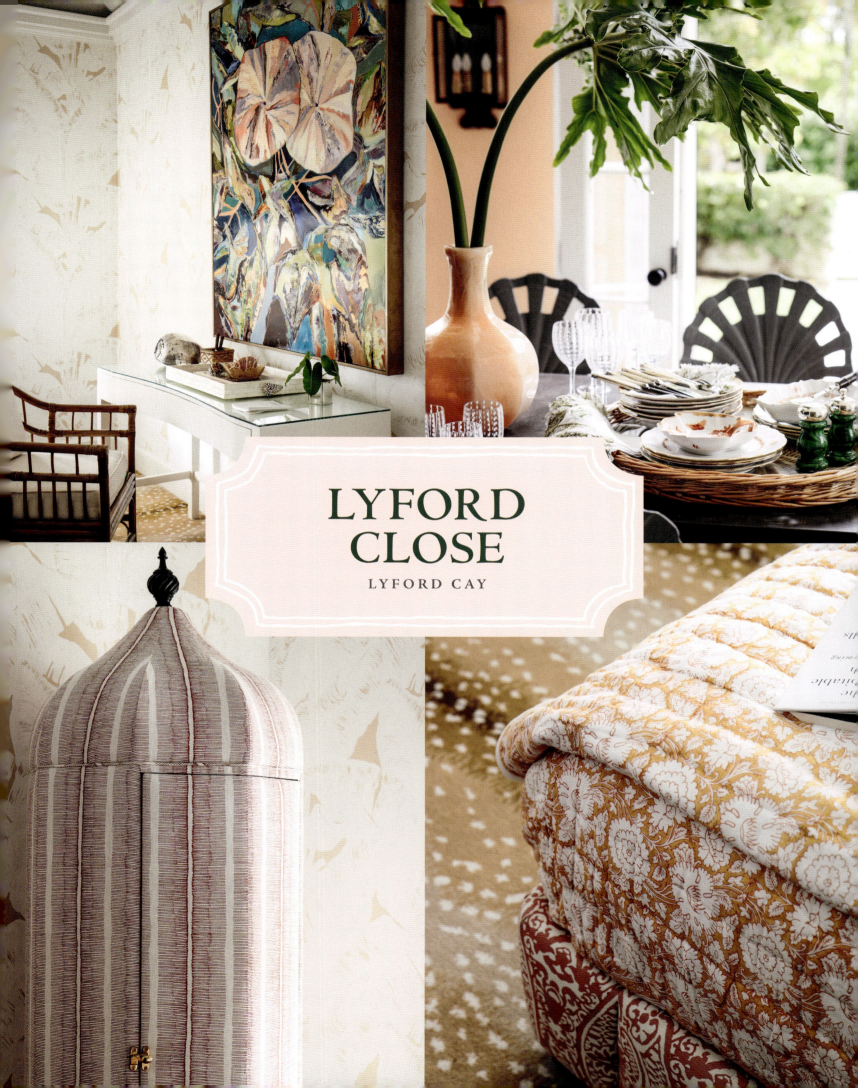

LYFORD CLOSE

LYFORD CAY

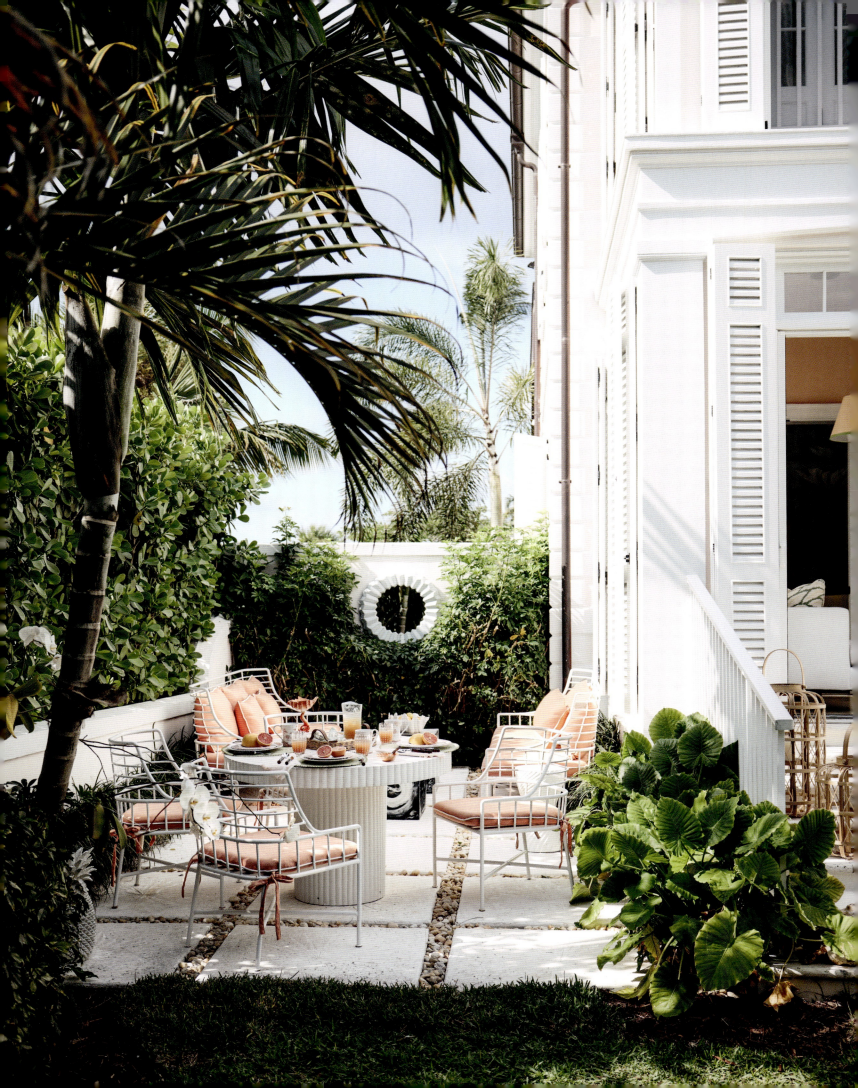

Lyford Close comprises a charming group of eight flats that were finished in the autumn of 2018 in Lyford Cay. The project was a collaboration between architect Kiko Sanchez and Orjan Lindroth, my late husband. The buildings are tropical Georgian in style and have all the signature features and DNA of Lyford. Top-hung white shutters shield sunlight and provide privacy. Louvers shed water and allow the tropical breezes to waft through the rooms. The ground-floor flats are nestled in lush, layered gardens. The upstairs flats have soaring tray ceilings.

One day I got a call from a very glamorous client, one of the happiest, prettiest, and best-dressed women of her generation. Her houses in New York and Long Island are beautiful, and she does not miss a style beat. For the Lyford Close flat, her instructions were clear: "I do not want a typical beach house. I want a sparkling jewel box." As a consequence, there is not a stick of rattan or wicker in the whole interior, a Lindroth first. In place of those materials, the flat has coral-stone walls in one room, antique mirrored glass in another, and the best lacquered bar in town. Dazzling nights are spent in the garden, which is lit by candlelight. We are all so delighted with the outcome.

OPPOSITE: *An inviting outdoor seating area is sheltered by a giant Clusia hedge.*

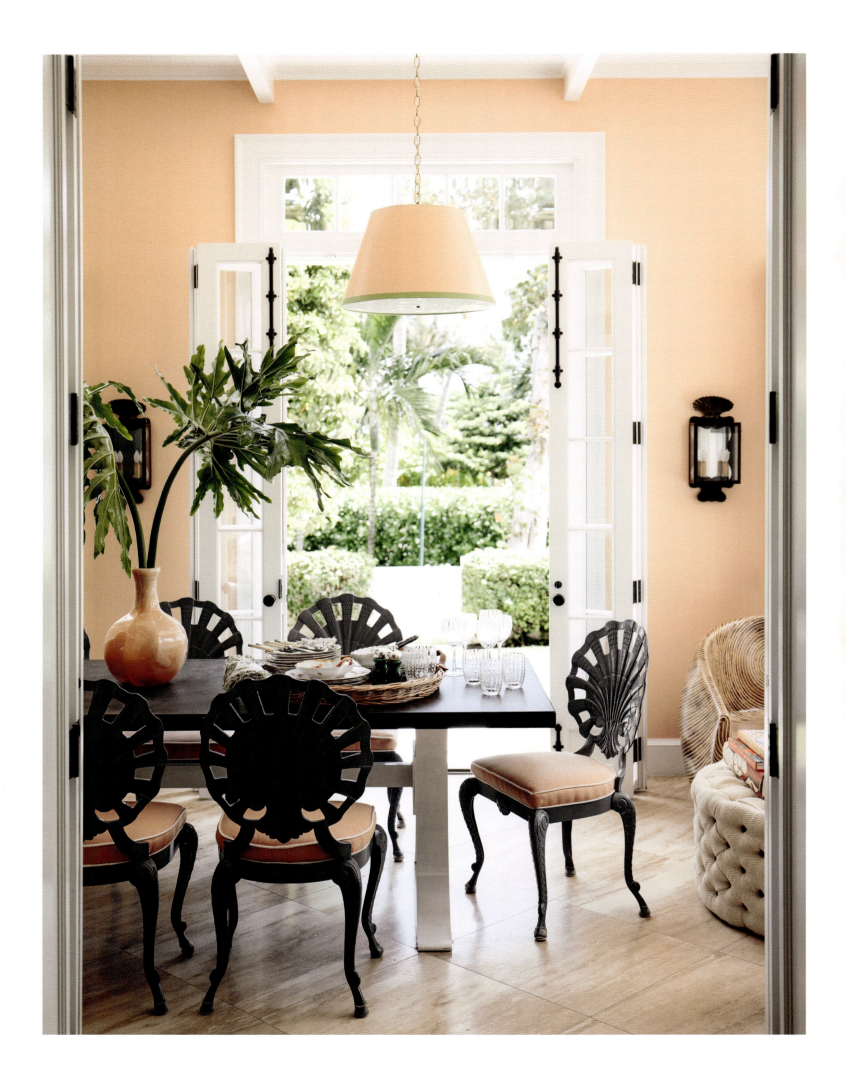

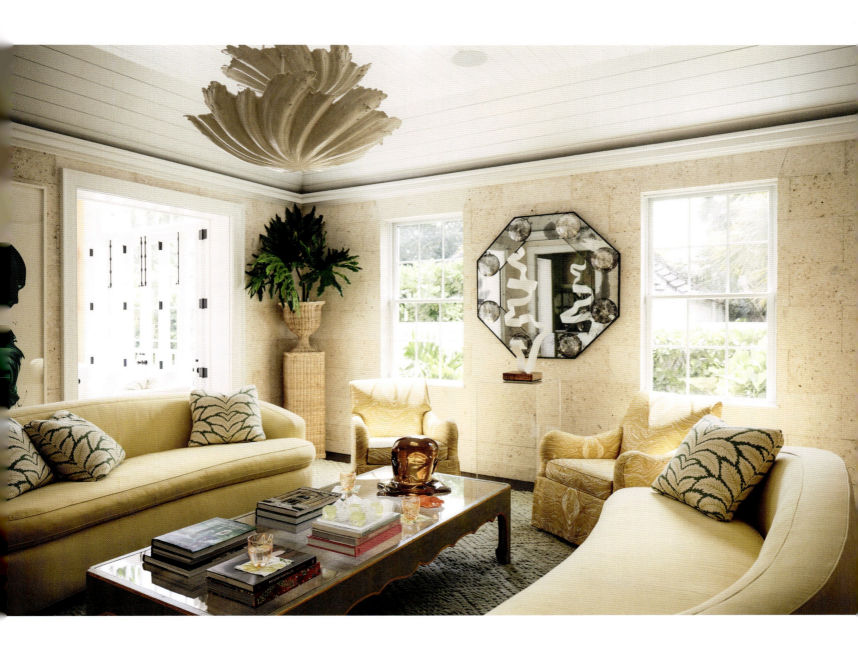

OPPOSITE: *The indoor dining area has an outdoor feel.* ABOVE: *In the living room, a Meg Braff marbled fabric covers the club chairs, and a WP Sullivan Shell chandelier from Liz O'Brien lights the room.* OVERLEAF: *The glamorous mirrored family room can double as a spare bedroom in a pinch.*

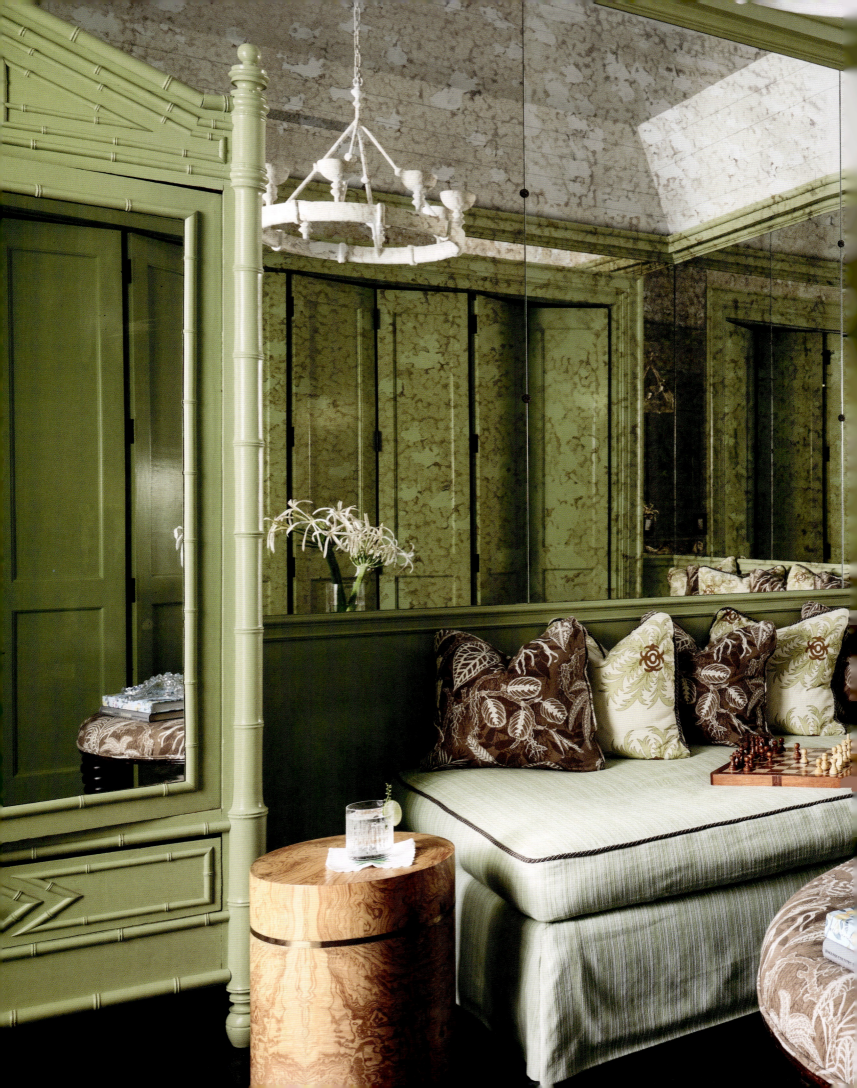

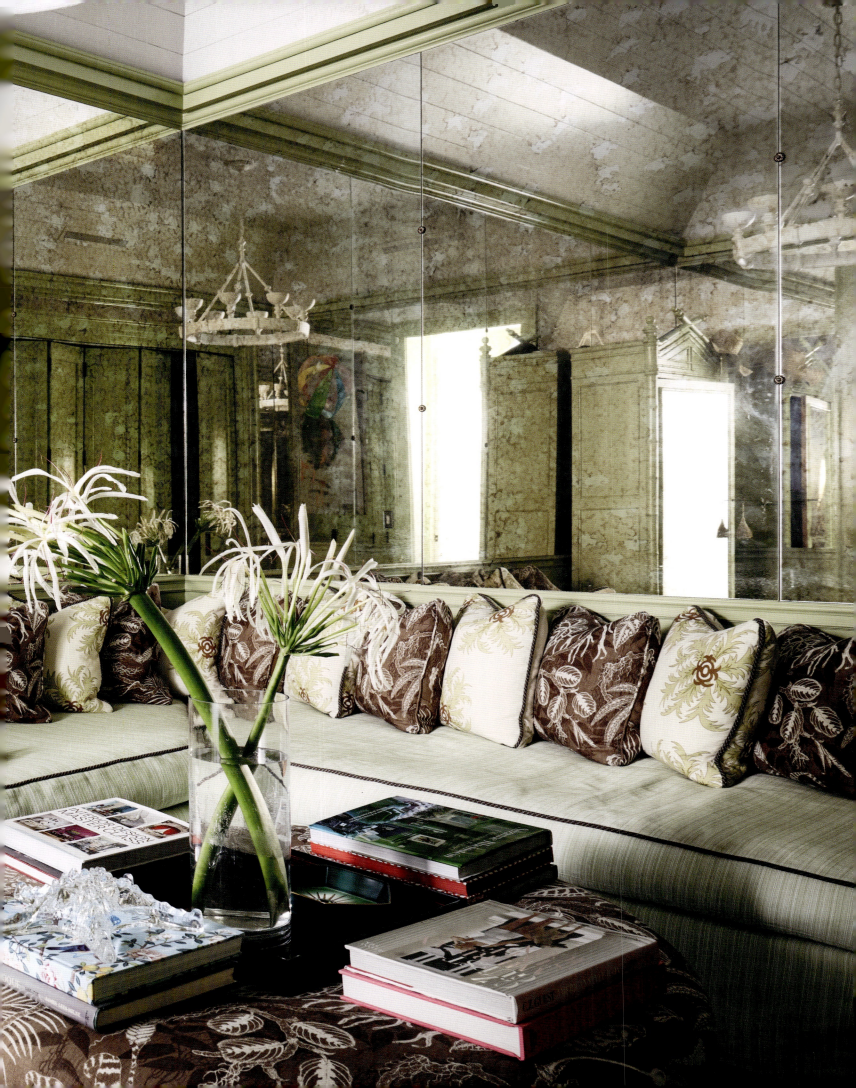

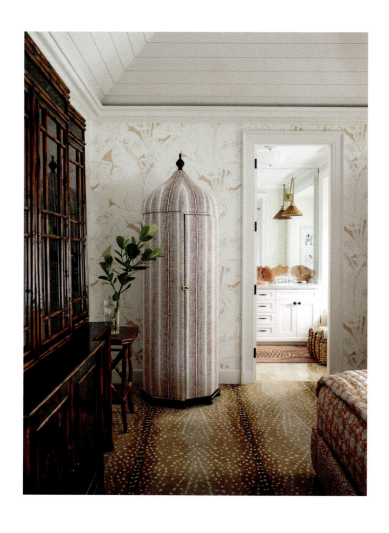
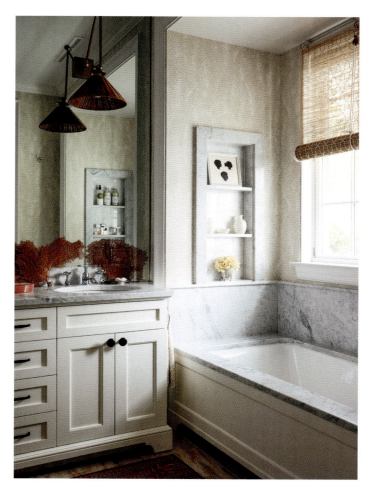
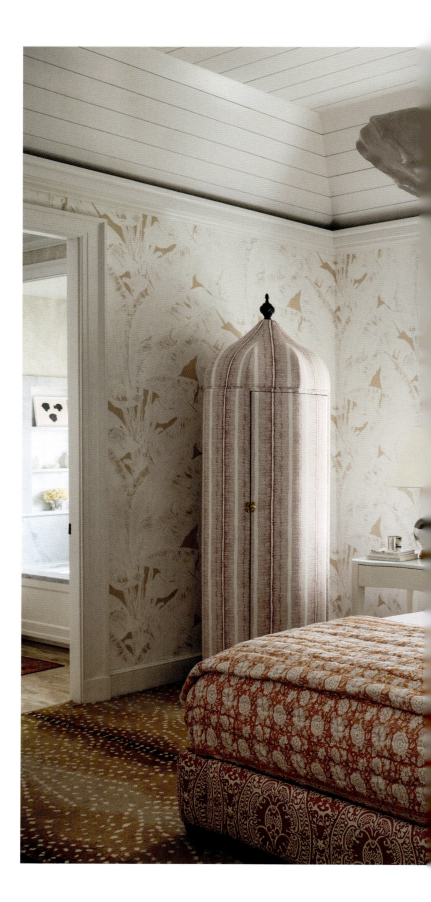

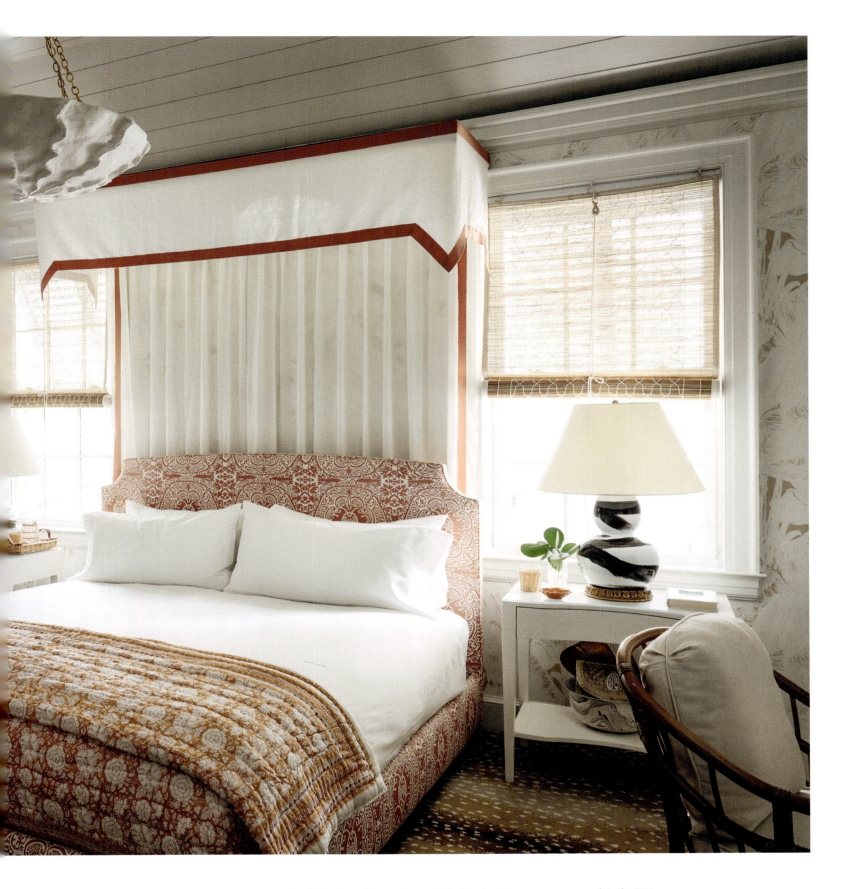

OPPOSITE TOP: *A quirkily shaped extra closet, a John Fowler signature, was sourced in the UK.*
OPPOSITE BOTTOM: *A corner of the primary bathroom.* ABOVE: *Stark's Antelope carpet and chik blinds from India, two of my favorites, help create an island look in the primary bedroom.*

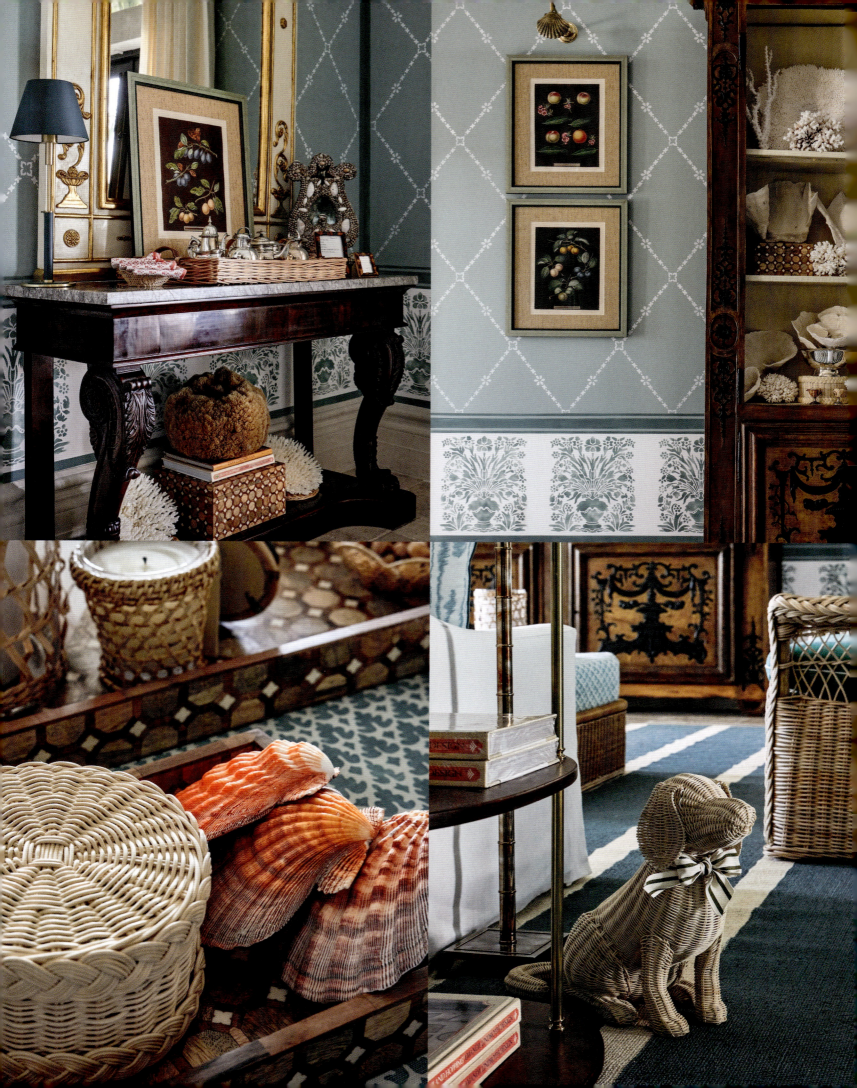

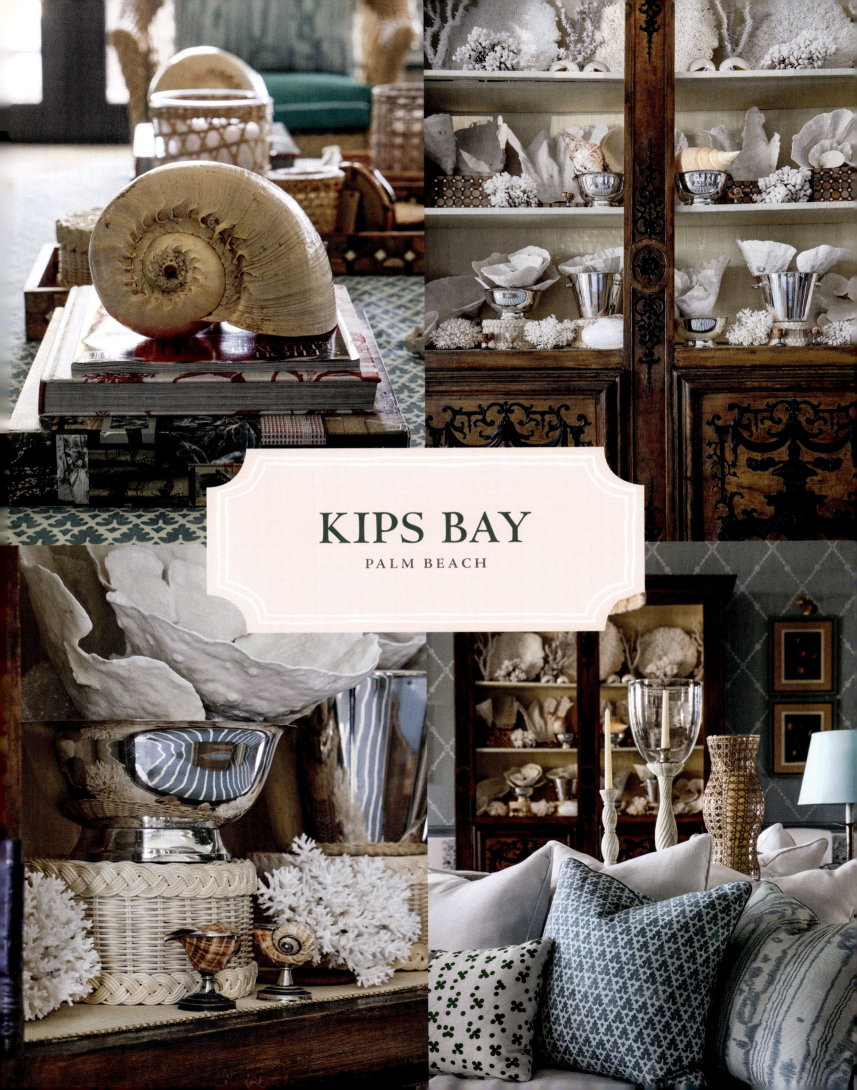

KIPS BAY

PALM BEACH

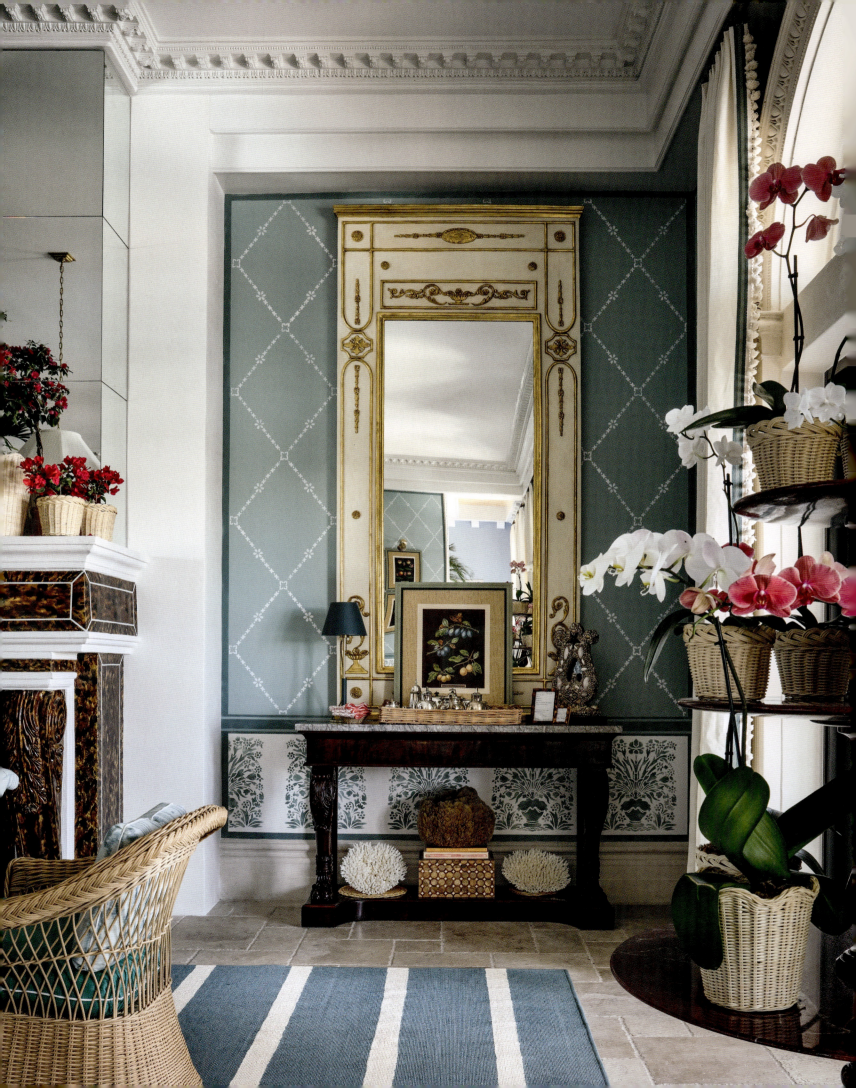

Our contribution to the 2023 Kips Bay Decorator Show House in Palm Beach is really a tale of teamwork. The entire Lindroth team enthusiastically pitched in to create the prettiest of rooms on an insanely short deadline.

It was early December 2022 when we got word that we had been offered the show house's living room. We were overjoyed because the photo of the room we received depicted a veritable ballroom. The opportunity to do something wonderful was simply too exciting to pass up, so we accepted the challenge immediately. And what a challenge it was!

We had only about eight weeks to pull it together, including the two-week Christmas holiday, when our offices were closed and everyone was off. Zoom calls between the Nassau, Palm Beach, and Charleston offices lasted hours and hours. A furniture plan was created, wall stencils were designed in CAD, and the stencils were cut. Custom Quadrille and Christopher Farr fabrics were printed.

Beautiful antiques were borrowed from Cedric DuPont and FS Henemader. Rare prints were borrowed from Graham Arader. Huge planters were borrowed from Accents of France and loaded with giant palms from Fernando Wong Outdoor Living Design. Bungalow Classic created the sublime pendants. Urban Electric loaned us the other beautiful lighting. The room was fresh and light in color and spirit yet punctuated with antiques and silver.

Getting the room installed was the greatest of team efforts. Giant Penske trucks were rented and loaded with treasures collected along Dixie Highway in West Palm Beach. When the hand-painted, striped sisal rug needed some love the night before opening, Team Lindroth drove the Penske back to Home Depot, donned white painter's jumpsuits, and got down on the floor to fix it.

We accessorized the room with many signature Lindroth elements. Shells and coral, tiers of orchids, books, trays, and other objects created visual interest. Our goal was to fashion a supremely comfortable room. Long white sofas anchored the center; club chairs and slipper chairs provided an abundance of seating. Our hope was that people would feel free to sit down and enjoy the room. There was a welcoming spirit from the opening-night party until closing day. The room made us all feel proud, and I have never been more grateful to or appreciative of my team and their incredible dedication.

OPPOSITE: *We borrowed a console and a mirror from Cedric DuPont for the show house.*
OVERLEAF: *Giant palms infuse our very layered and grand Kips Bay room with an island-y ambience.*

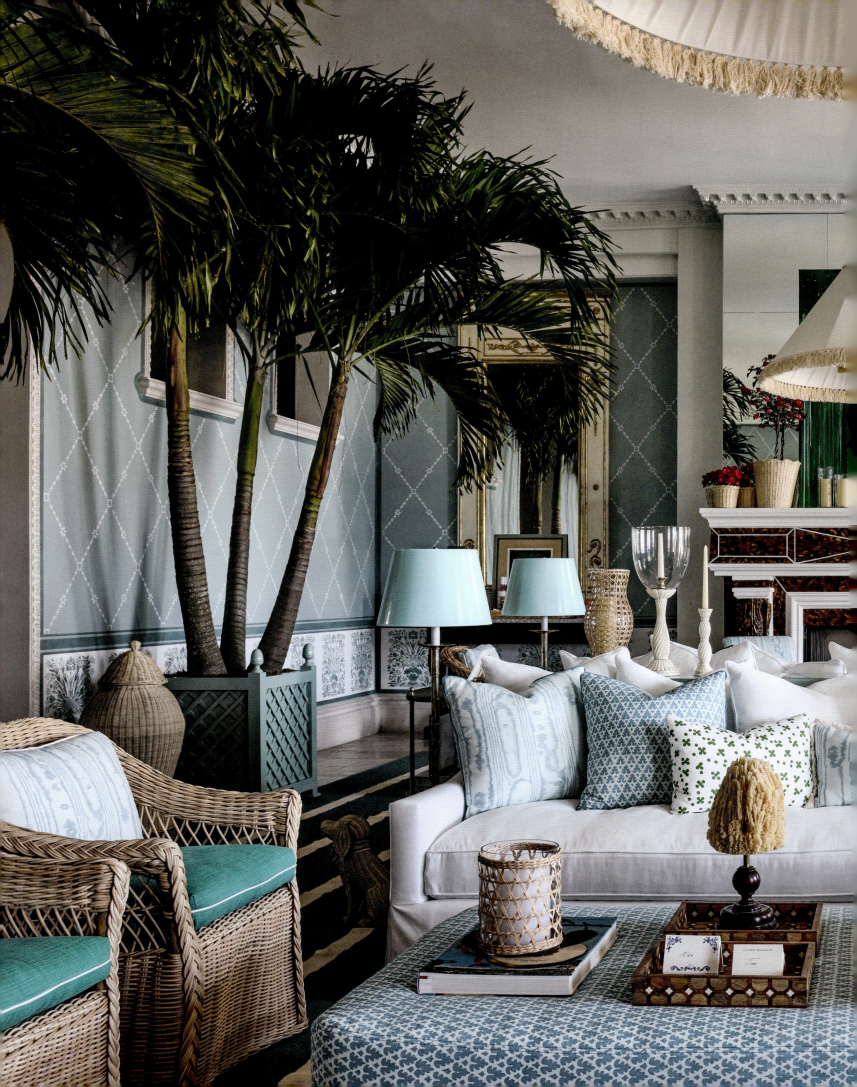

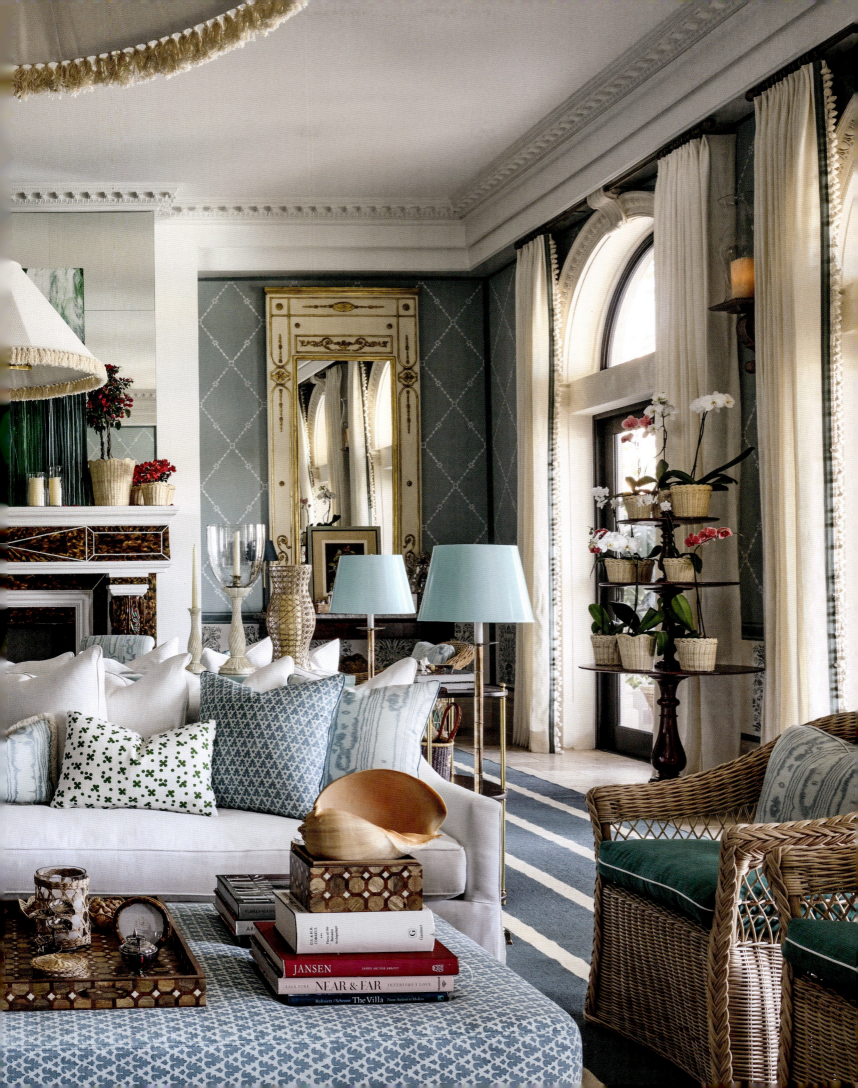

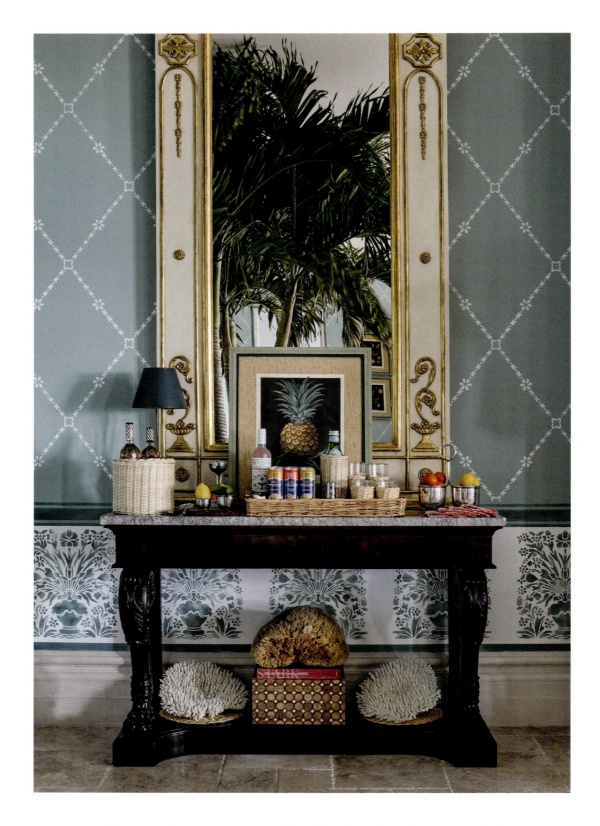

ABOVE: *To create an abundant and welcoming bar table, we layered it with a George Brookshaw print borrowed from Graham Arader in New York, shells, and rattan baskets.* OPPOSITE: *George Brookshaw fruit prints borrowed from Graham Arader hang on Brian Leaver's stenciled walls. A pendant from Bungalow Classic is suspended in front of a giant cabinet from Cedric DuPont.*

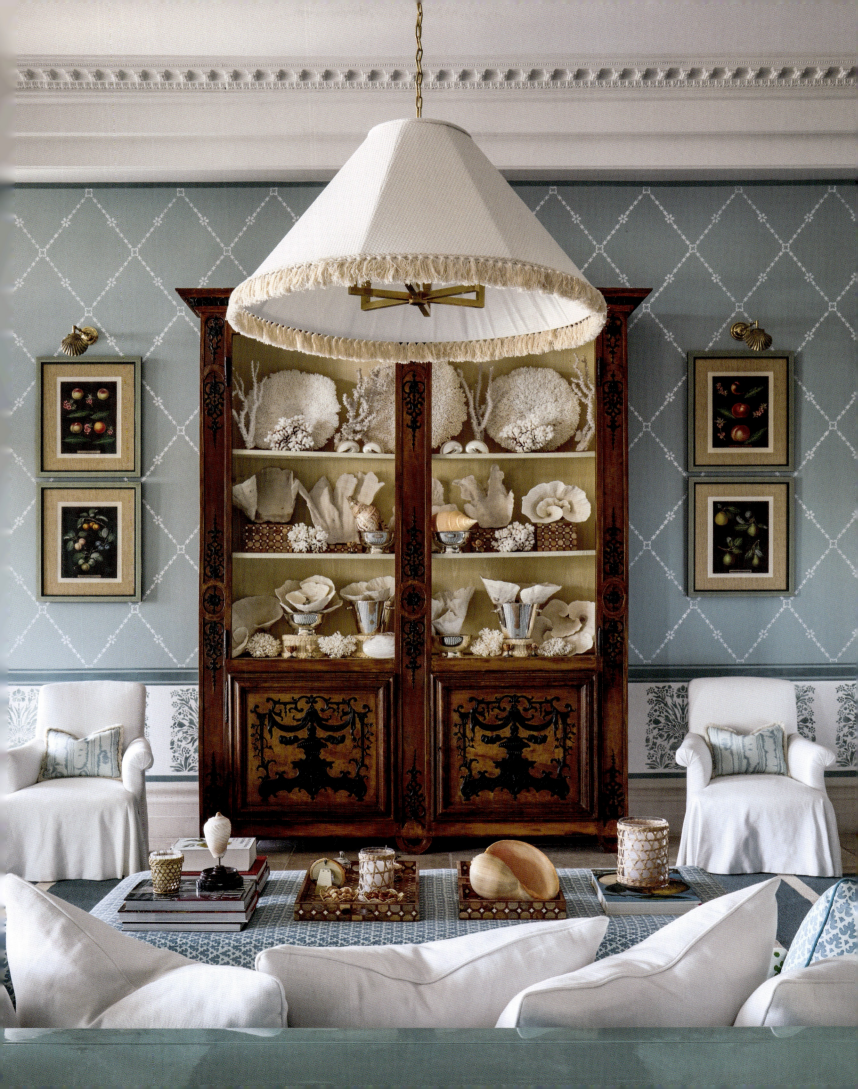

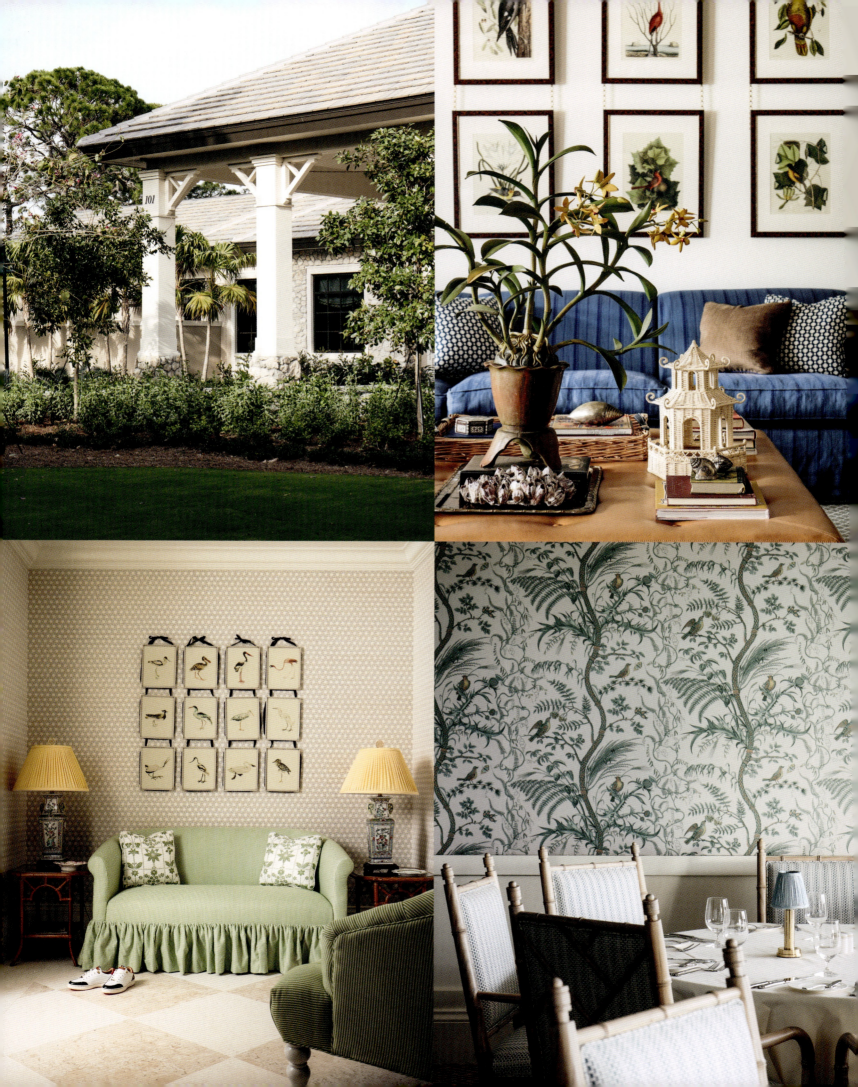

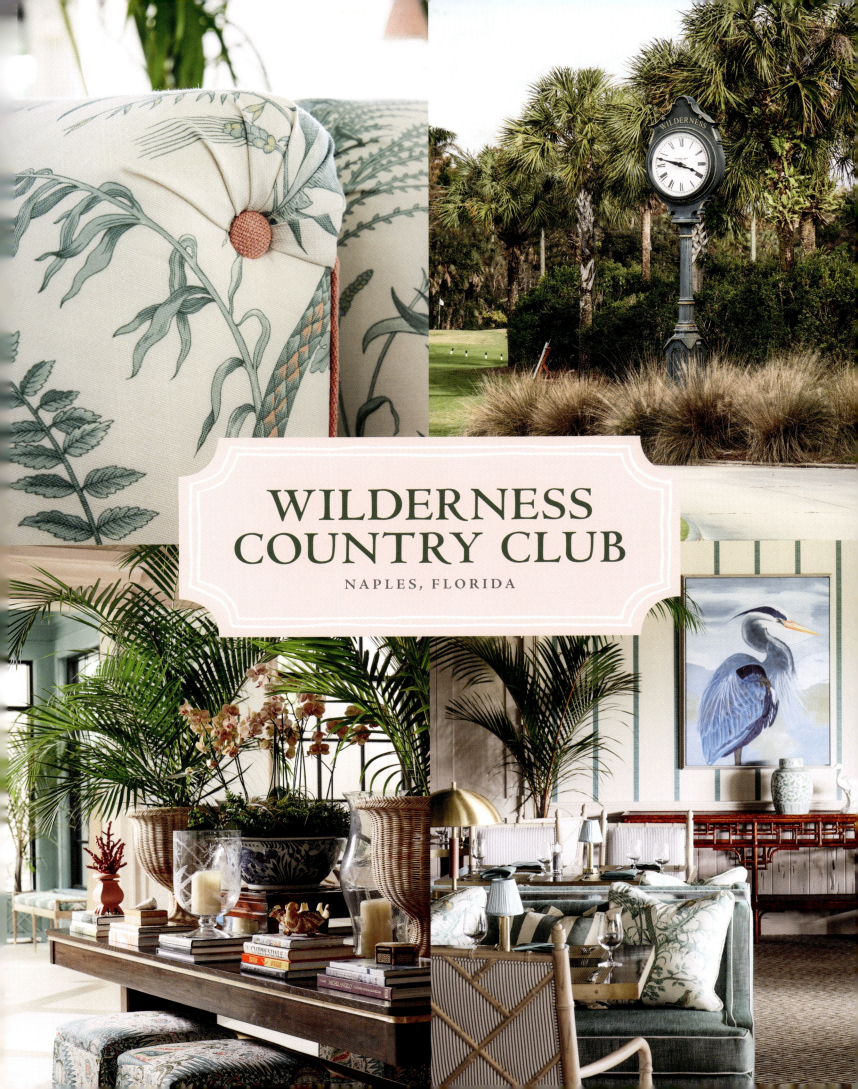

WILDERNESS COUNTRY CLUB

NAPLES, FLORIDA

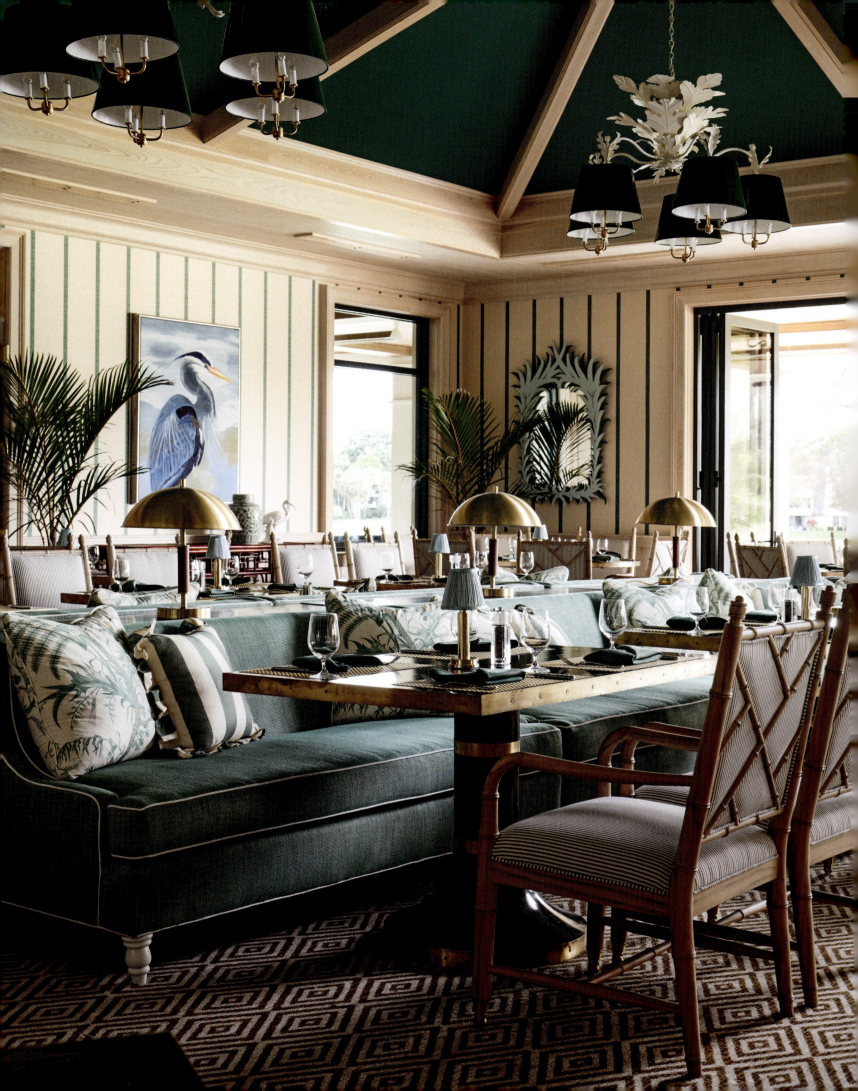

There are many intangibles to consider when designing country clubs. It must be kept in mind that clubs hold a lifetime of memories for members. They are often the places where birthdays and weddings are celebrated, where sportsmanship and games are learned, and where children and adults forge fast friendships. In short, there is a lot at stake when tasked with designing these nostalgia-filled places.

At Wilderness Country Club in Naples, Florida, we were approached by two irresistibly adorable sisters to help with a rebuild-from-scratch for a very loyal and growing membership. The old clubhouse had simply become worn out and had been prone to flooding. A committee was formed to plot a way to fund a new clubhouse.

When we first went to visit, we were completely astonished by the natural beauty of the surrounding landscape. The area was first settled in the 1920s by a pioneering family named Frank, who homesteaded hundreds of acres. A treasure-filled Frank house still exists!

The club was created in the 1970s by a property developer who also built the surrounding condominium units. It was the first gated community in Naples. The units are low-slung and nestled in dense tropical vegetation. Teeming with birds and wildlife, the club is a certified Audubon sanctuary.

Understanding the particular DNA of Wilderness was critical. We asked a million questions about how people dine, where they have cocktails, and where and when cardplayers gather. After getting a feel for the routines and habits of the members, we embarked on creating an interior that looked like it might have been there for decades. Borrowing from the lush exterior, we selected leafy fabrics and wallpapers, natural elements, bird paintings and prints, and lots of pecky cypress detailing. The interiors are just right, and the membership is delighted.

OPPOSITE: *In the club's casual dining area, the tables are by the Raj Company, the upholstery is by Powell's, and the custom chandeliers are by Whitman Designs.* OVERLEAF: *In the main dining area, Brunschwig & Fils' Bird and Thistle pattern covers the walls and sofas. The custom lanterns are by Whitman Designs.*

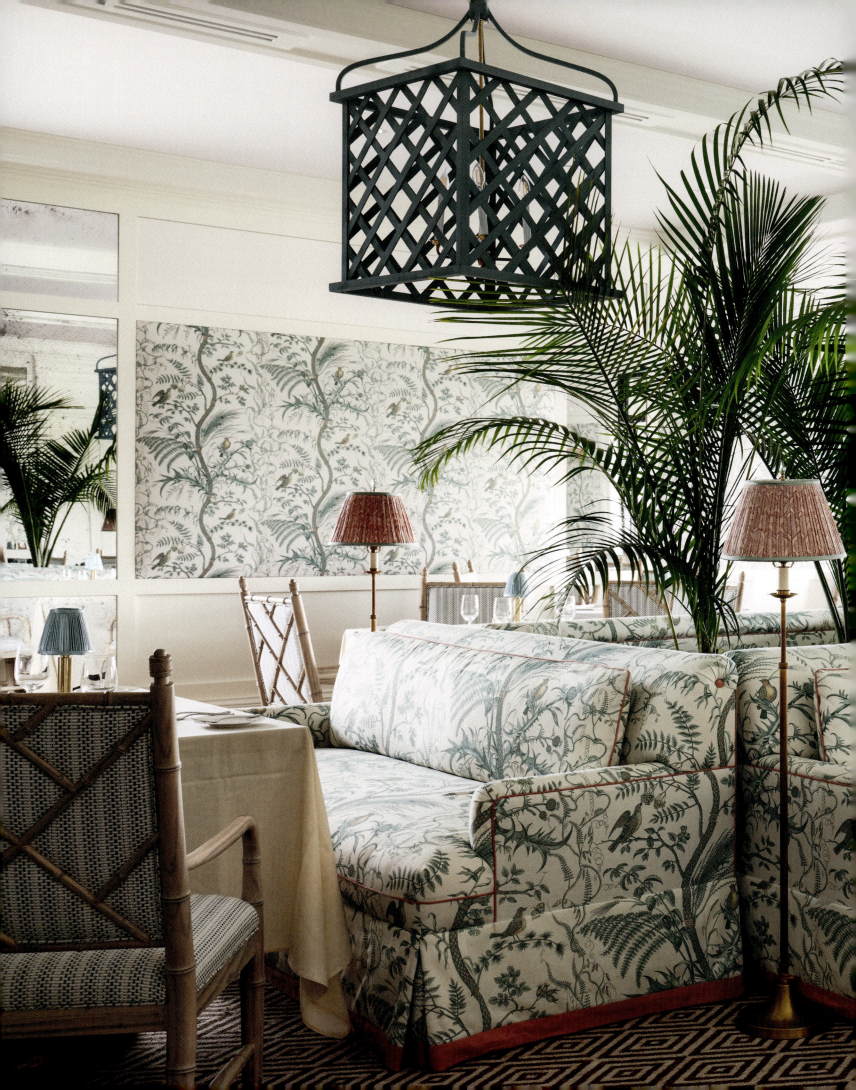

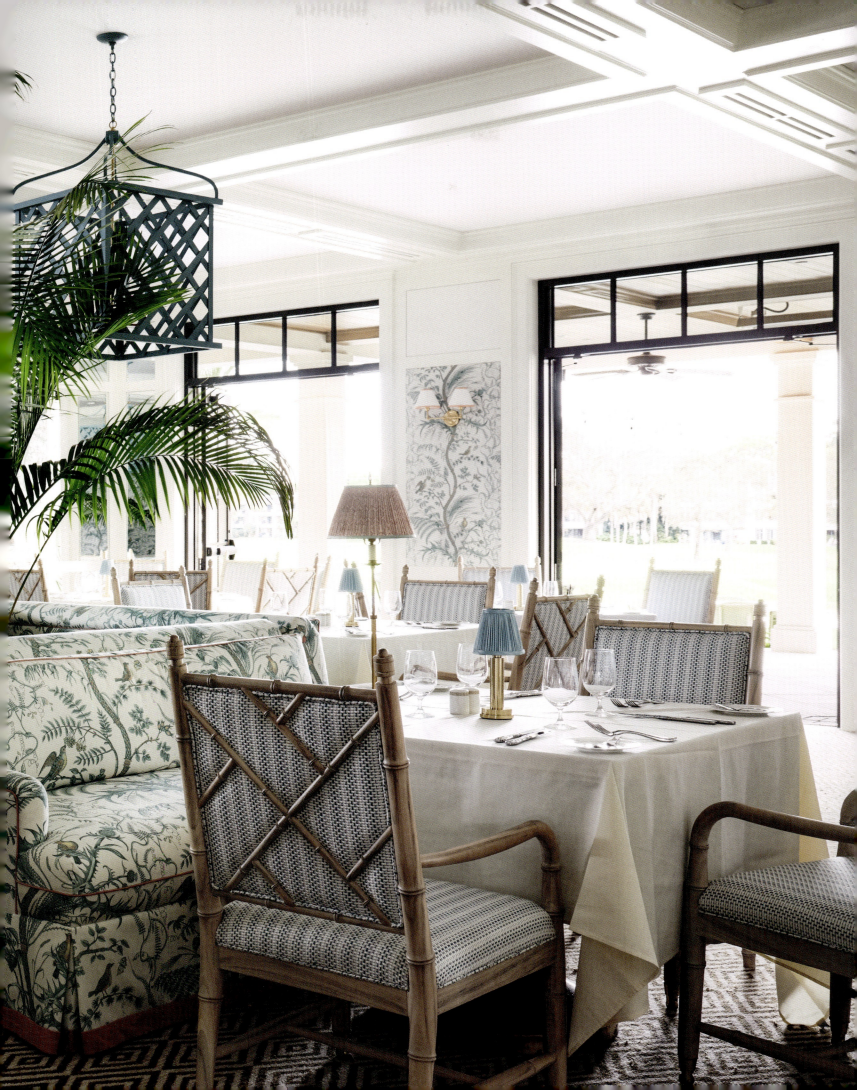

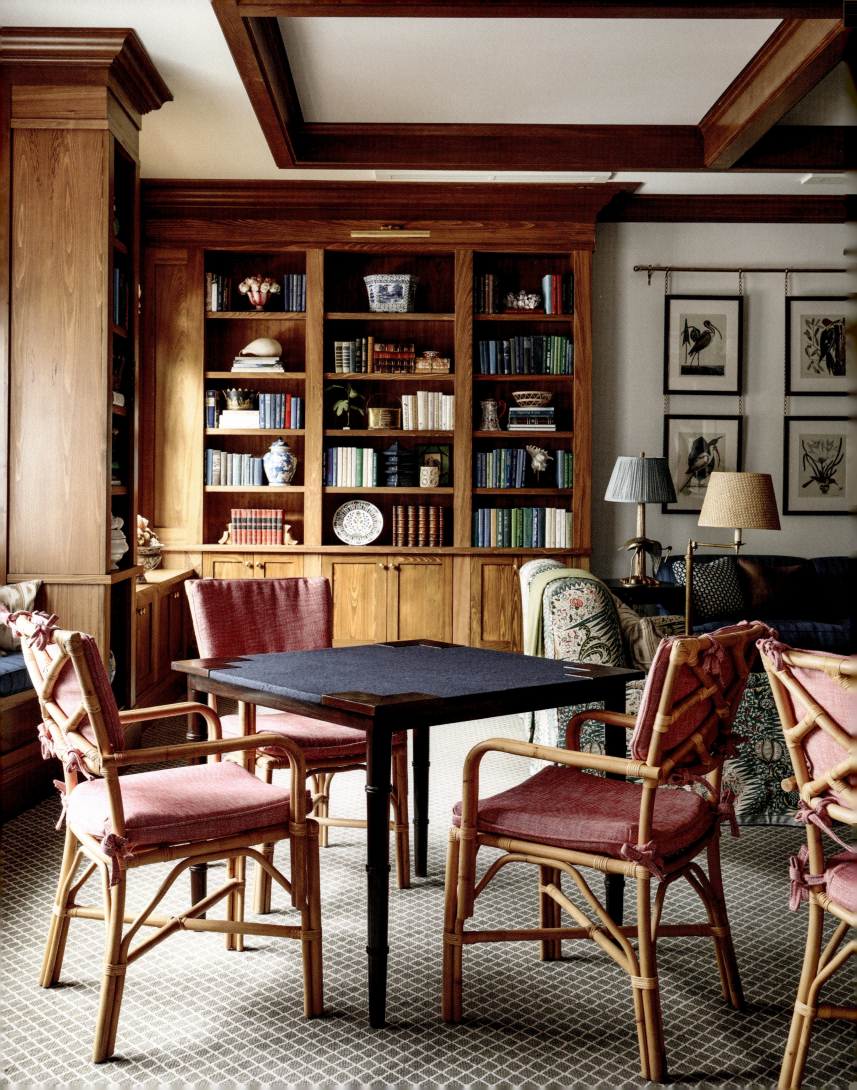

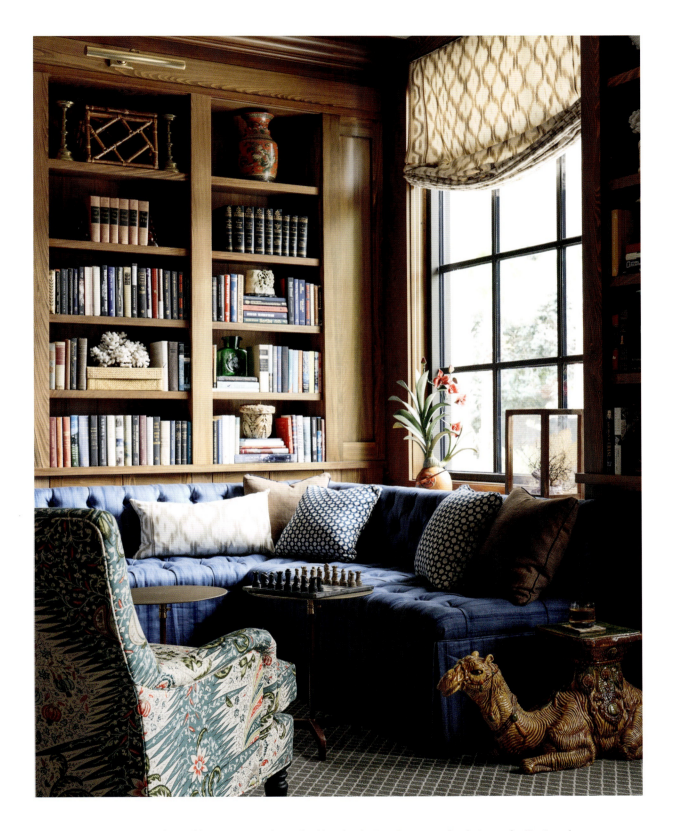

OPPOSITE: In the Wilderness Room, the card table is by the Raj Company, the chairs are by Kenian, the club chair is upholstered in Quadrille's Les Indiennes, and the rug is by Stark. ABOVE: The corner banquette, upholstered in Peter Dunham's Malabar fabric, is by Associated Interior Design Service.

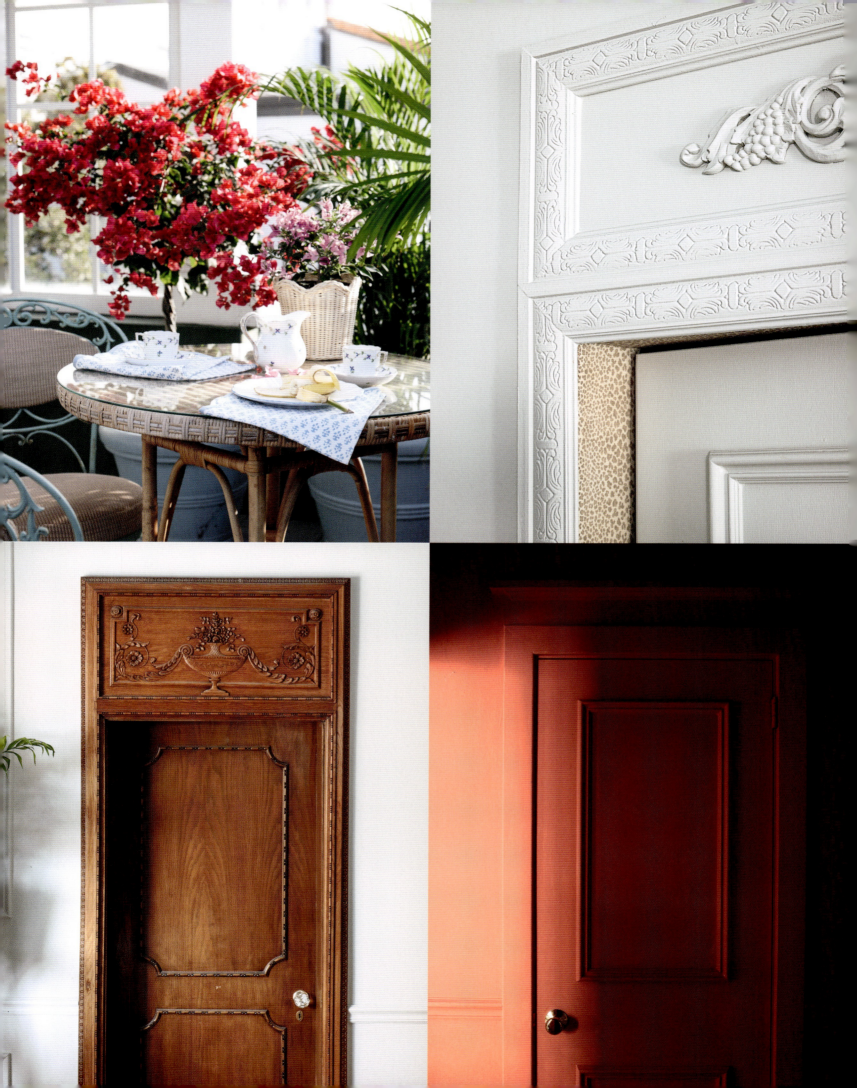

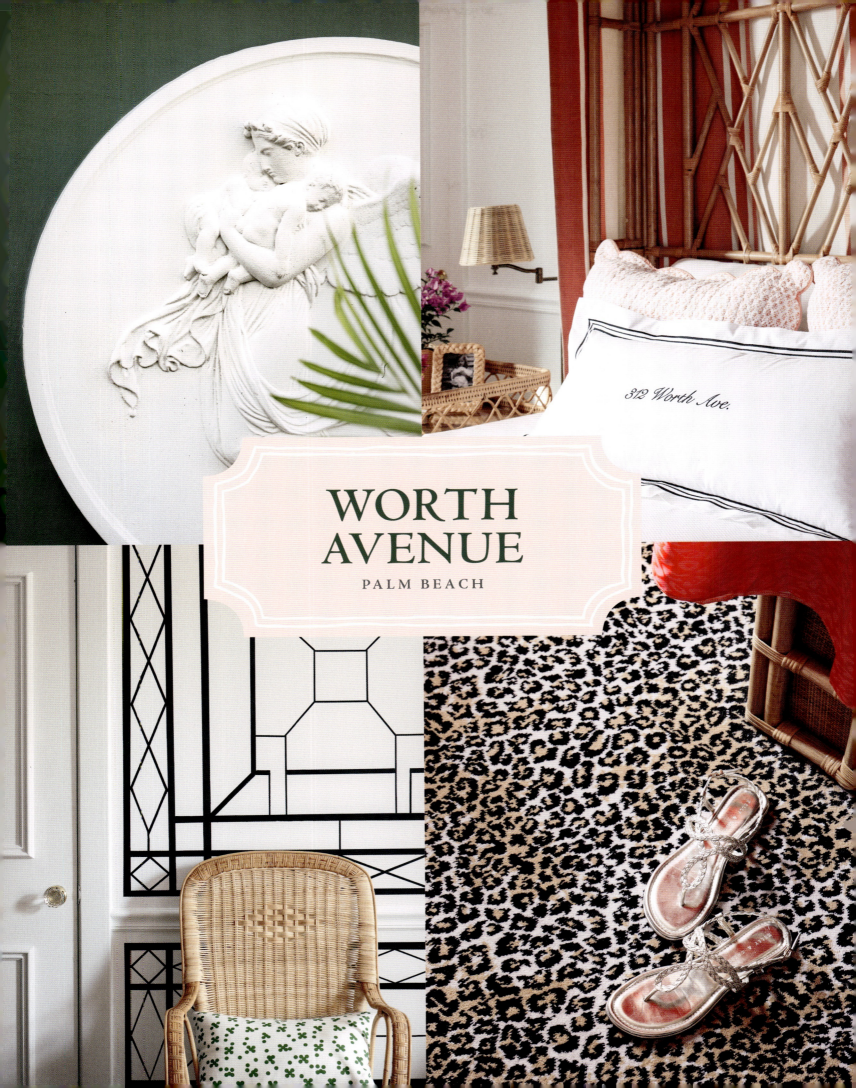

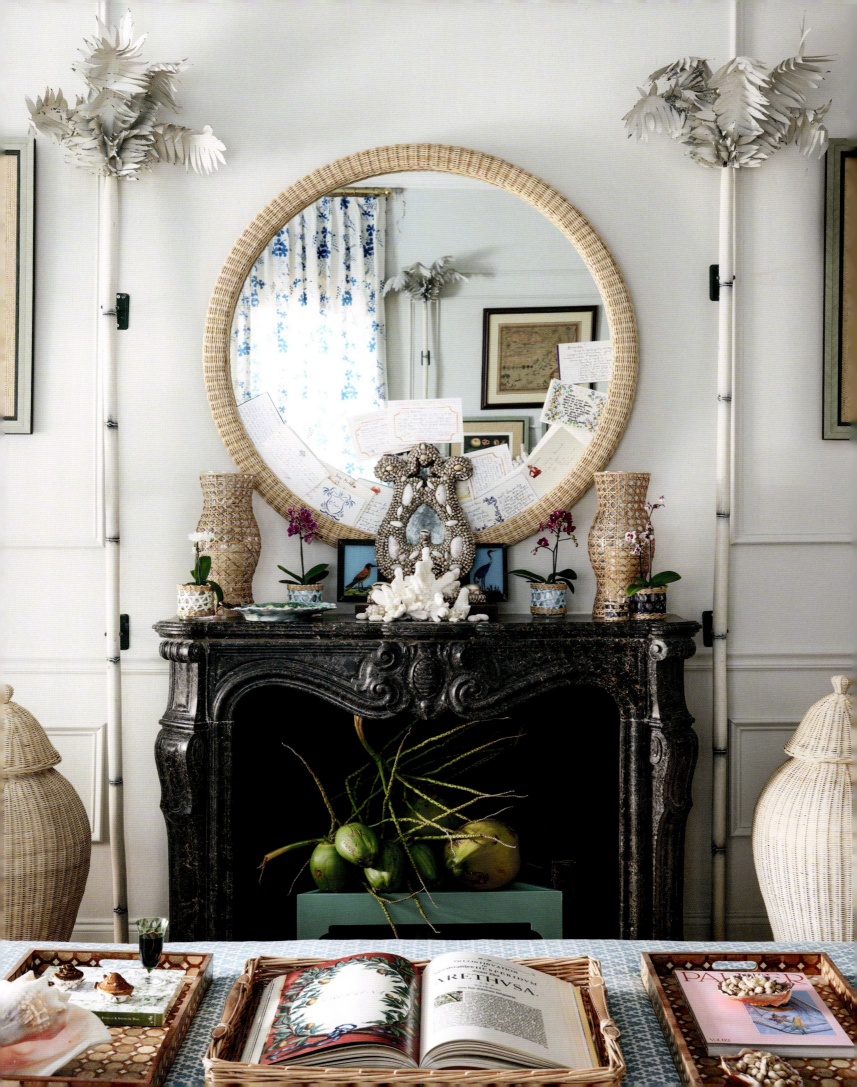

My apartment on Worth Avenue is a hidden gem, tucked away on a charming 1920s Palm Beach "via." It has two swirling staircases on the exterior and views of swaying palms and terra-cotta rooftops from the windows and terrace. It feels like the 1920s inside, too, an example of the magic that legendary architects Addison Mizner and Marion Sims Wyeth created at one end of Worth Avenue and is still so palpable today.

The preexisting ice-green walls in the living room are reminiscent of images of C. Z. Guest's Palm Beach house. Favorite Quadrille floral prints were gifts from best friends, the two Johns—Fondas and Knott. The slender "palms" flanking the curtains on one side of the room and the fireplace on the other were purchased from a fabulous Italian princess in Nassau after decades of admiration and persuasion. Wicker and rattan furniture and accessories from my own collection are scattered throughout.

In the bedrooms, the hand-painted patterns on the walls were inspired by a house designed by Stéphane Boudin of Maison Jansen that lies in ruins in Nassau. It had been created for Olive, Lady Baillie in the late 1950s.

My daughter Eliza's childhood four-poster beds and all the upholstery were taken out of storage in Nassau and shipped aboard a 1940s-era DC-3. I was told it would be easier to clear customs if I was aboard the cargo plane, so I agreed to fly with my items. But on the morning of the flight, the plane developed mechanical problems during its incoming flight. I lost my nerve and flew commercial to meet it in West Palm Beach. All went smoothly, and I regretted missing that funny adventure on an eighty-year-old plane full of my treasures!

Nostalgia for old Palm Beach is strong in this special place.

OPPOSITE: *The mantel of the faux fireplace holds a million of my favorite things: orchids, cane hurricanes, shells, a shell-encrusted grotto mirror (a gift from my best friend, John), and, tucked into the frame of the mirror above, dozens of notes and invitations from friends.* OVERLEAF: *The living room is filled with more of my favorite things: shells, rattan, crisp white upholstery, and hand-screened, batik, and block prints.*

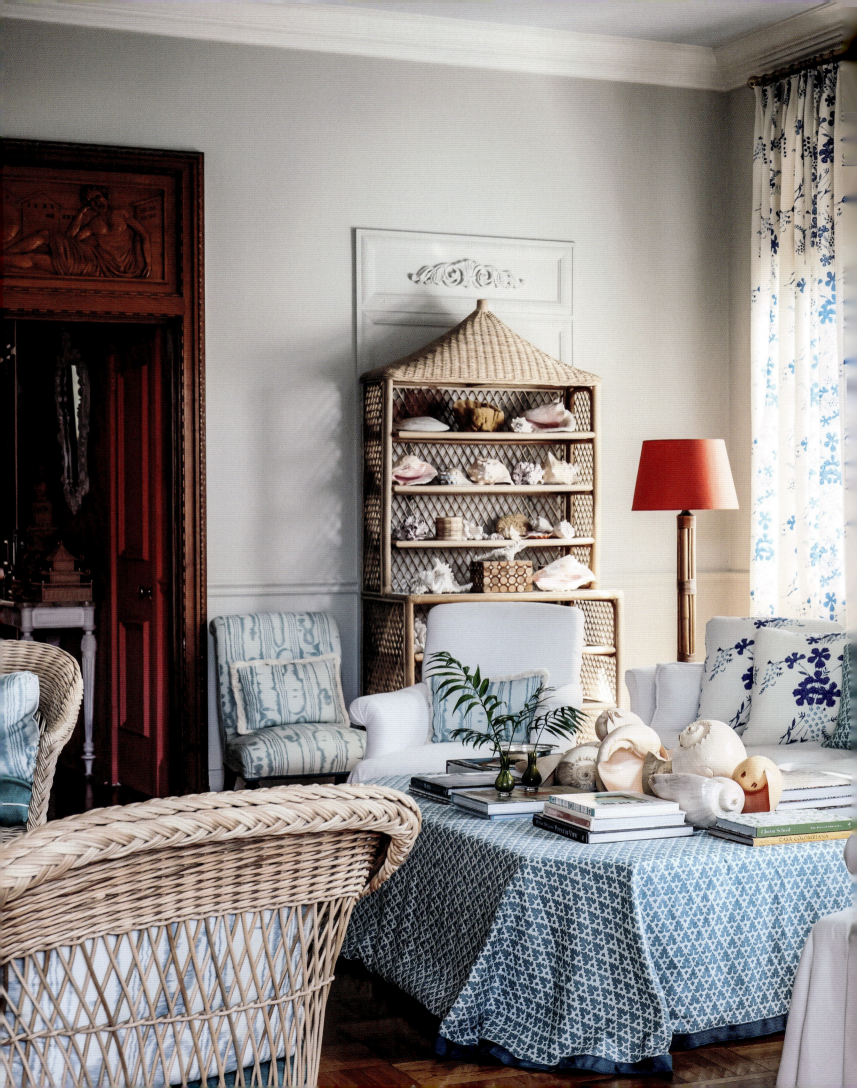

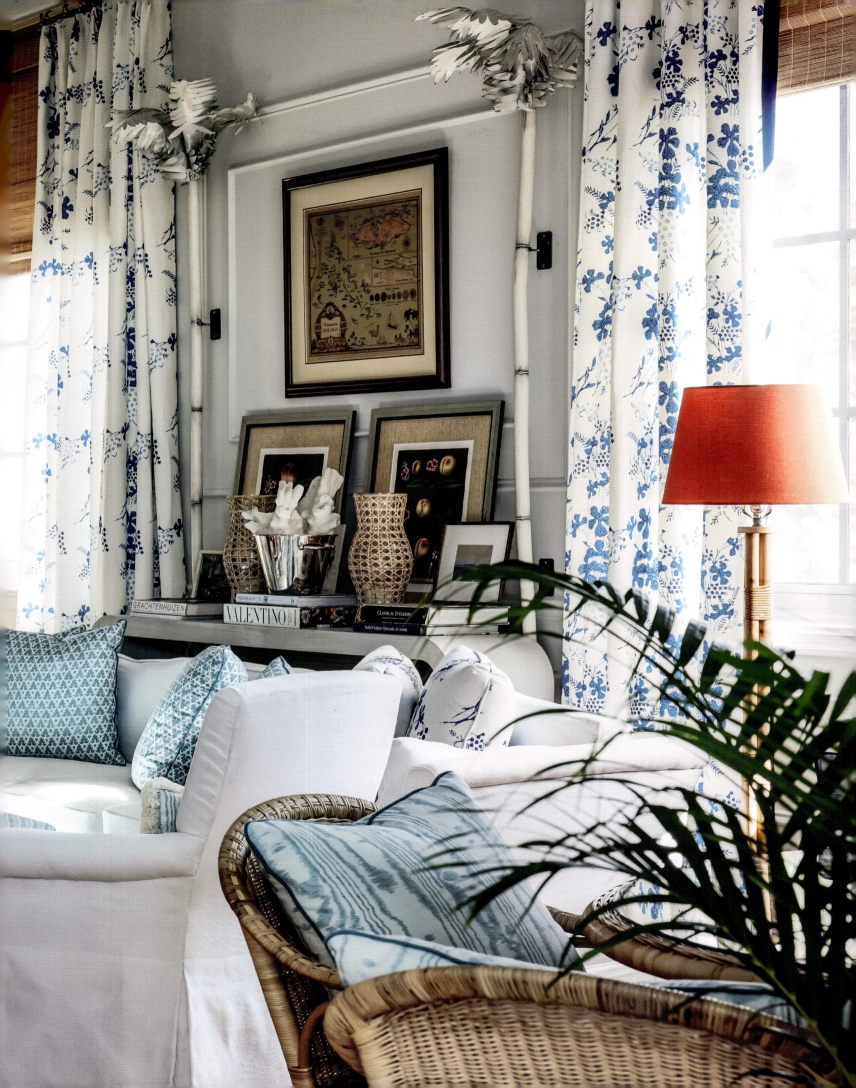

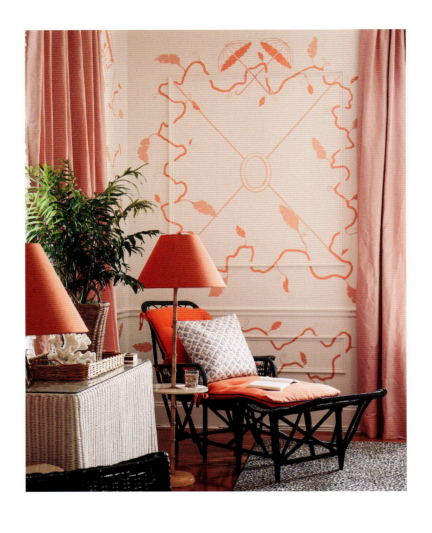
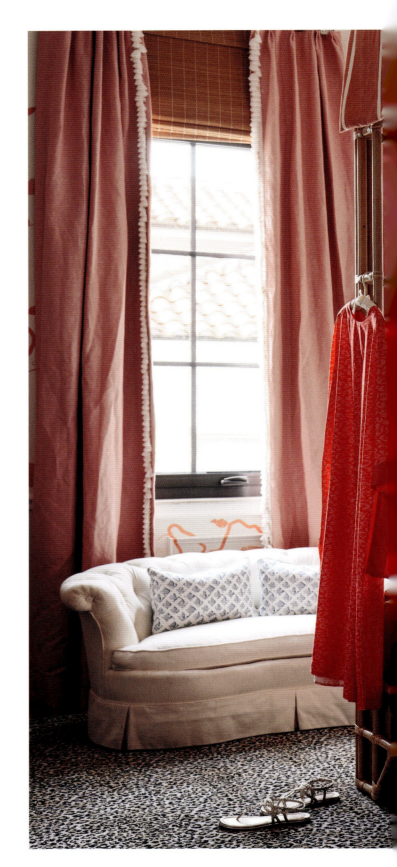
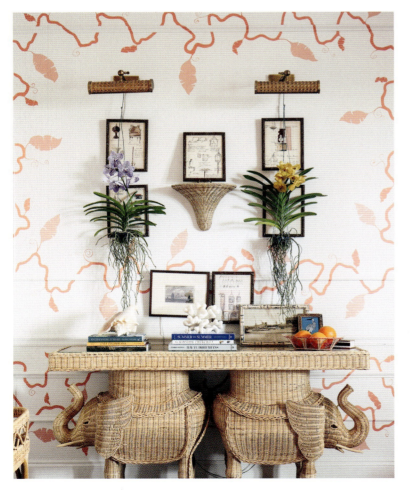

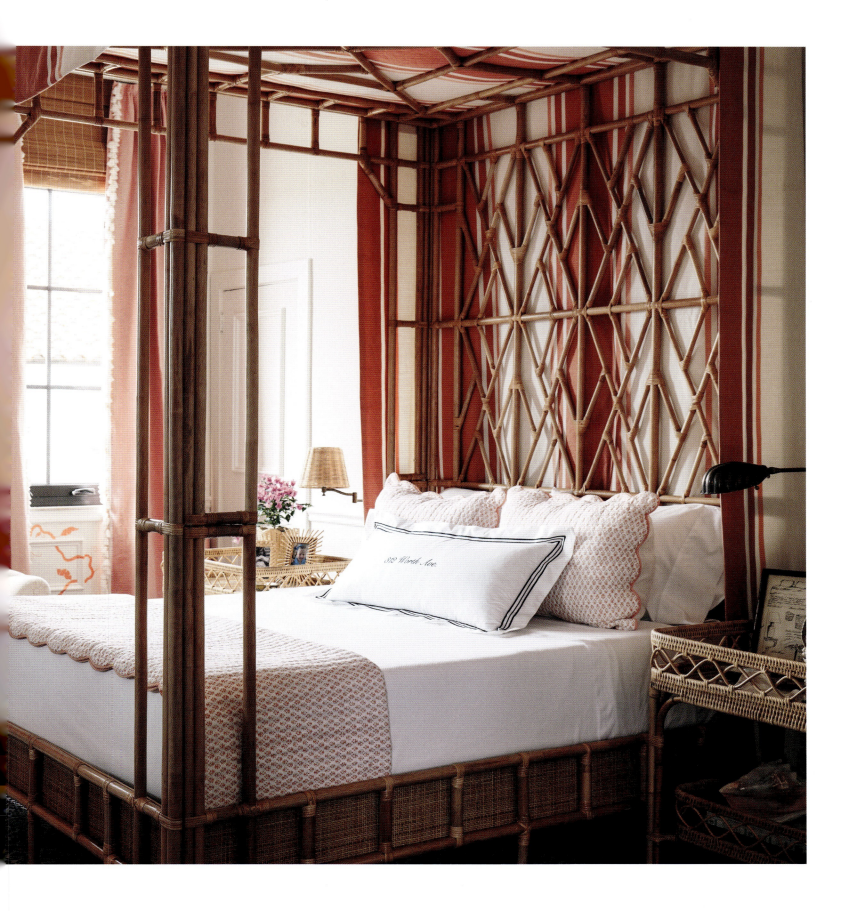

OPPOSITE TOP: *A corner of the primary bedroom features a segment of the room's whimsically painted walls, a black rattan chaise, and pink linen curtains.* OPPOSITE BOTTOM: *Over a whimsical Lindroth double-elephant rattan console, Vanda orchids are suspended from Lindroth cane picture lights.* ABOVE: *My rattan bed, draped in a Quadrille stripe and dressed with Lindroth batik pillowcases and quilt, stands on a leopard-print carpet.*

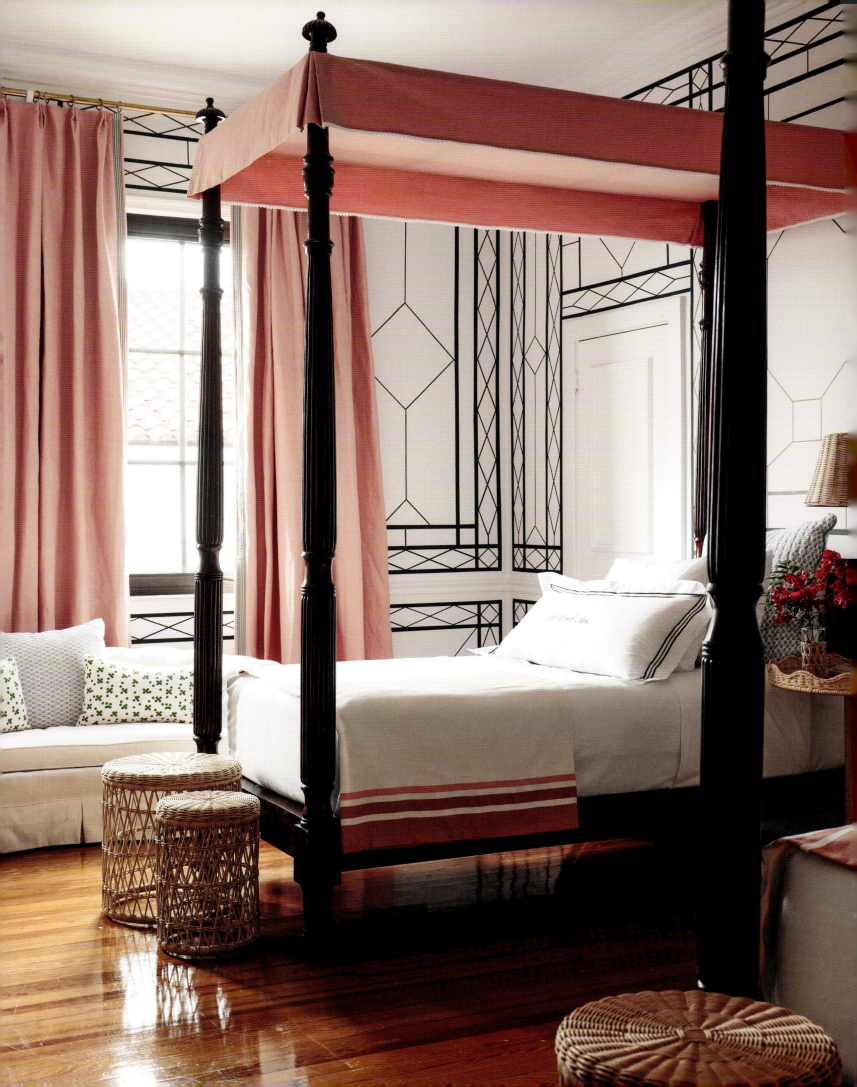

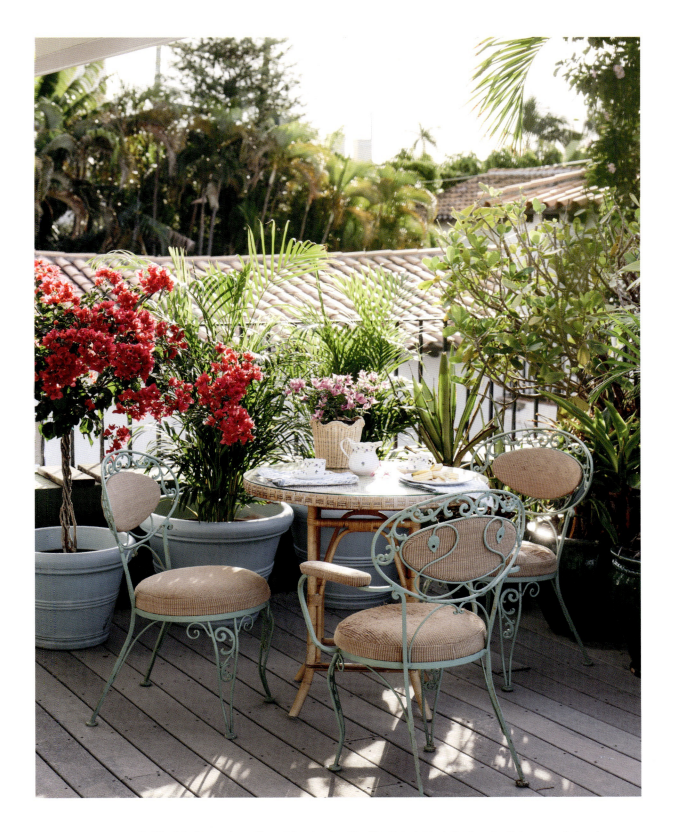

OPPOSITE: *In Eliza's bedroom, the walls were hand-painted by Floe Painting in imitation of a dining room designed by Maison Jansen in a now-abandoned house in Nassau. Her childhood beds were made by the Raj Company.*
ABOVE: *A welcoming corner of the terrace is furnished with whimsical vintage chairs.*

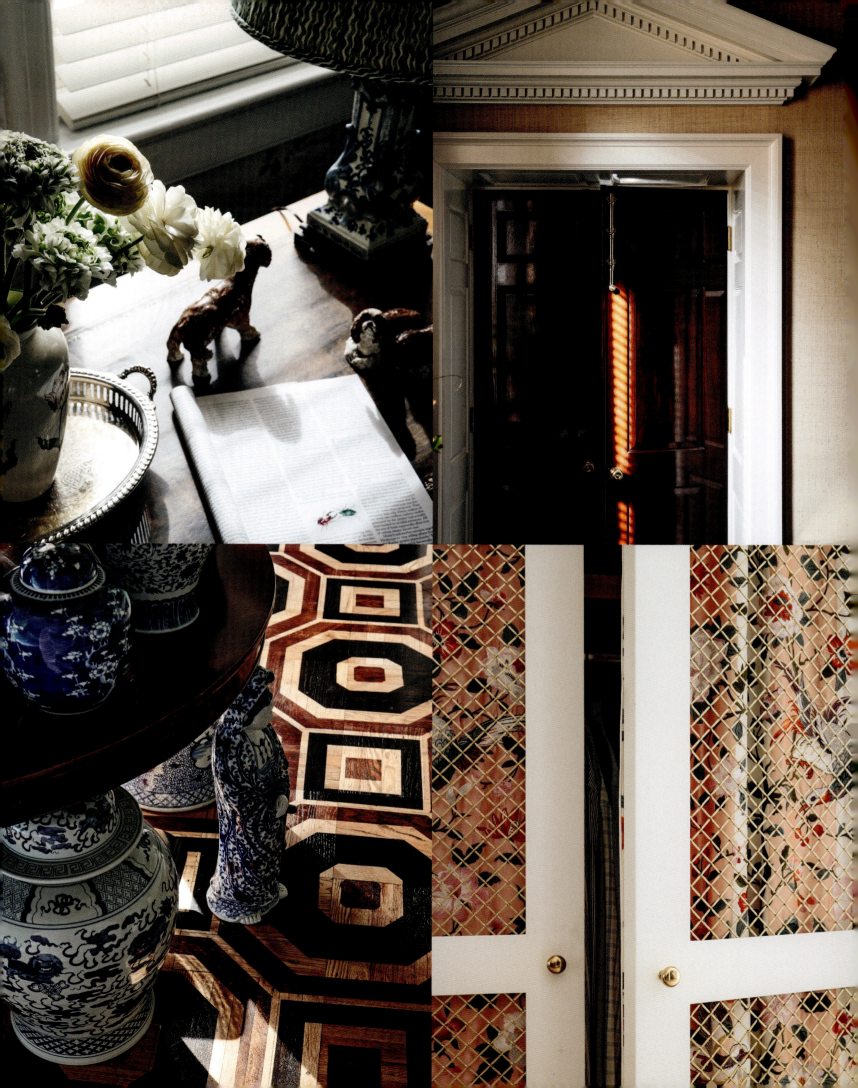

FIFTH AVENUE

MANHATTAN

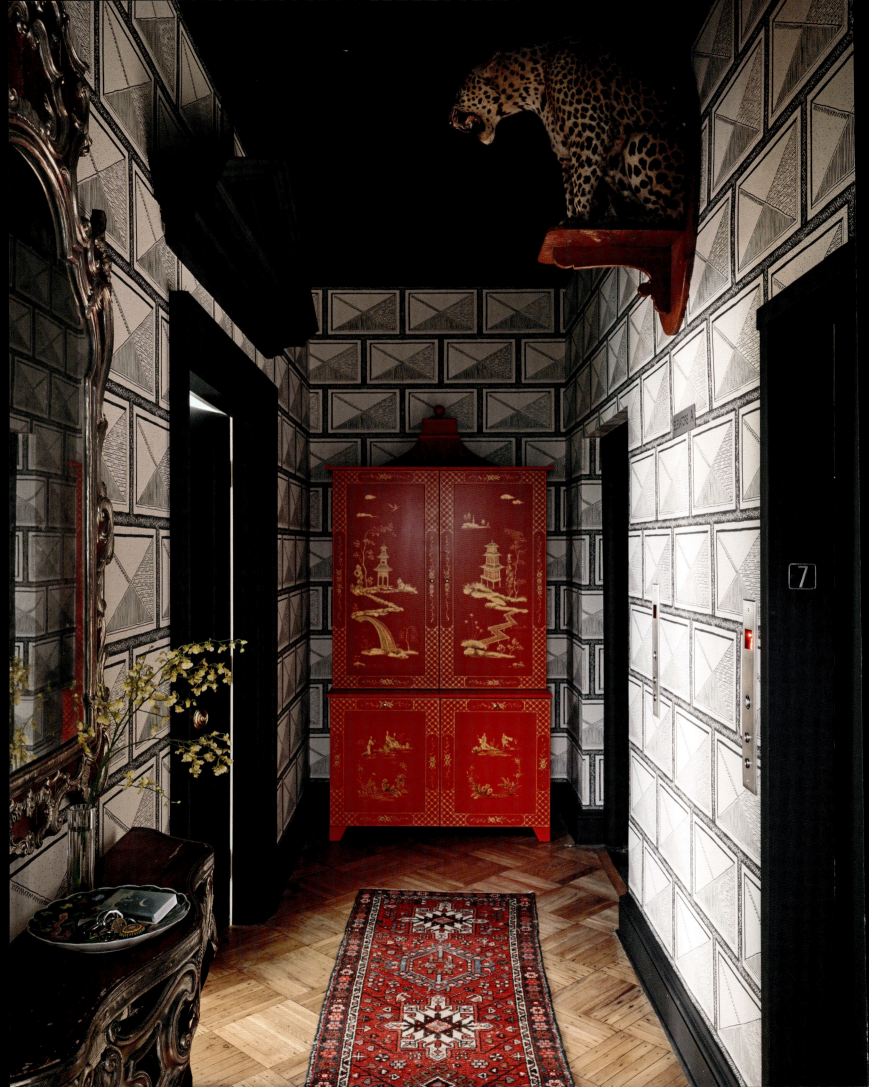

This is a story of two best friends, John and Amanda, and two clients, a style-obsessed husband and wife. On the same night in 2015, the husband reached out to John Fondas and the wife reached out to me with the same request: to design their new house in Southampton.

The husband had seen an *AD* story on John's house in Lyford Cay; the wife had been keen on my stories in *House Beautiful*. They had no idea we were lifelong friends. The upshot is that we have been working together on their projects ever since.

John and I jumped for joy at the opportunity to work on the house in Southampton. A bit of perfection from a bygone era, it is an immaculately proportioned beach house on the best street with a great living room and three small bedrooms. Our clients have talent and Old World elegance and are likely the only folks who would not have succumbed to the temptation to tear it down.

Fast-forward to 2021 Manhattan: Our track record with this couple led to an unimaginable dream project. As luck would have it, Sir John Richardson, the notable Picasso expert and diarist, had lived in their building on lower Fifth Avenue in Manhattan. In the mid-1990s, Richardson engaged Ernesto Buch, a Cuban classical architect, to build a veritable English country house in a loft conversion in this building. The spaces are impeccable and the classical details dazzle.

Our clients bought the apartment from Richardson's estate and asked John and me to help tidy it up. A year-long renovation of the kitchen and bathrooms ensued, but the Richardson maximalist look endures today, largely owing to John's grand gestures. Strong wallpapers and fabrics, combined with our clients' bold modern art, contributed to the dazzling renaissance of one of the best apartments in New York.

OPPOSITE: *A bright red lacquered cabinet, designed as a chic solution for storing garbage cans, gleams against the monochrome sgraffito wallpaper. An unexpected taxidermy leopard appears ready to pounce from its lofty perch.*
OVERLEAF LEFT: *In the library, the sofa is upholstered in a magenta-striped performance fabric by Peter Dunham that serves as a beautiful and durable landing pad for kids and Cavalier King Charles Spaniels alike. A large and significant giltwood Federal mirror hangs on the back wall. The Lego Taj Mahal on the coffee table was assembled by the children.* OVERLEAF RIGHT: *A favorite pastel-and-acrylic drawing by Heidi McFall,* Barbara #4, *adds personality and a modern touch to the handsome library, which serves as a workspace during the day and an impromptu dining room at night.*

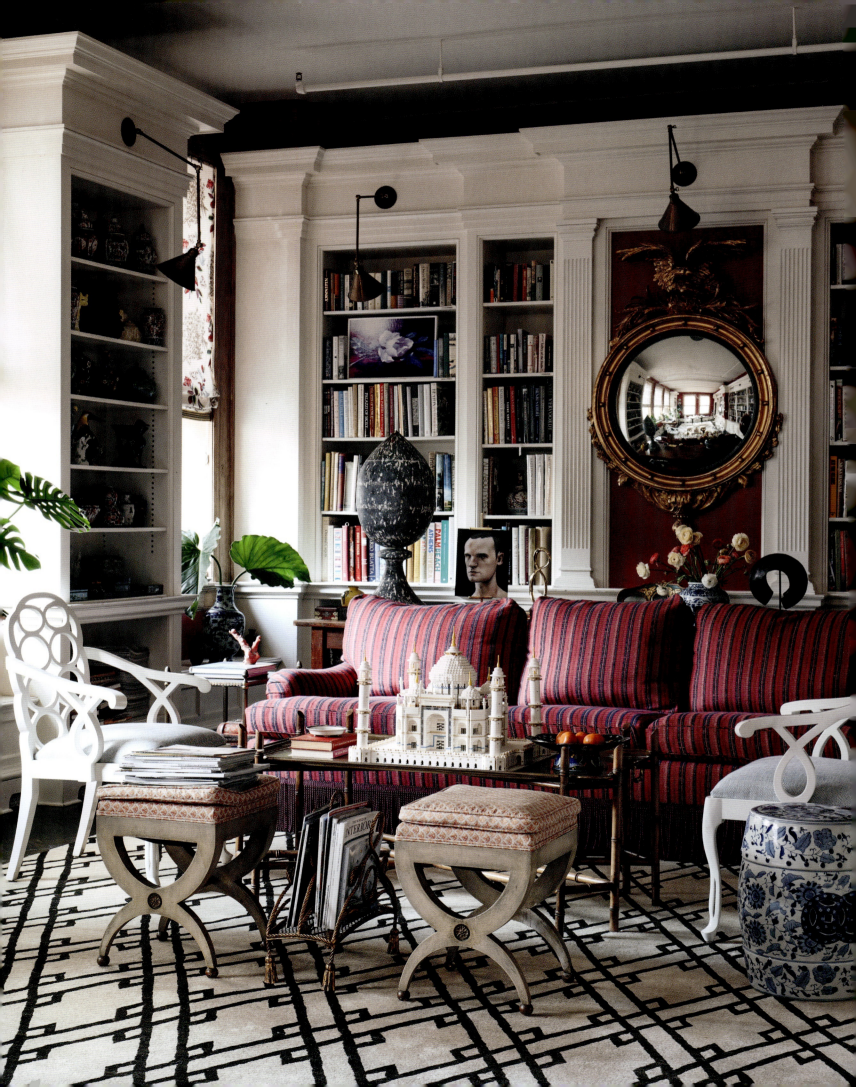

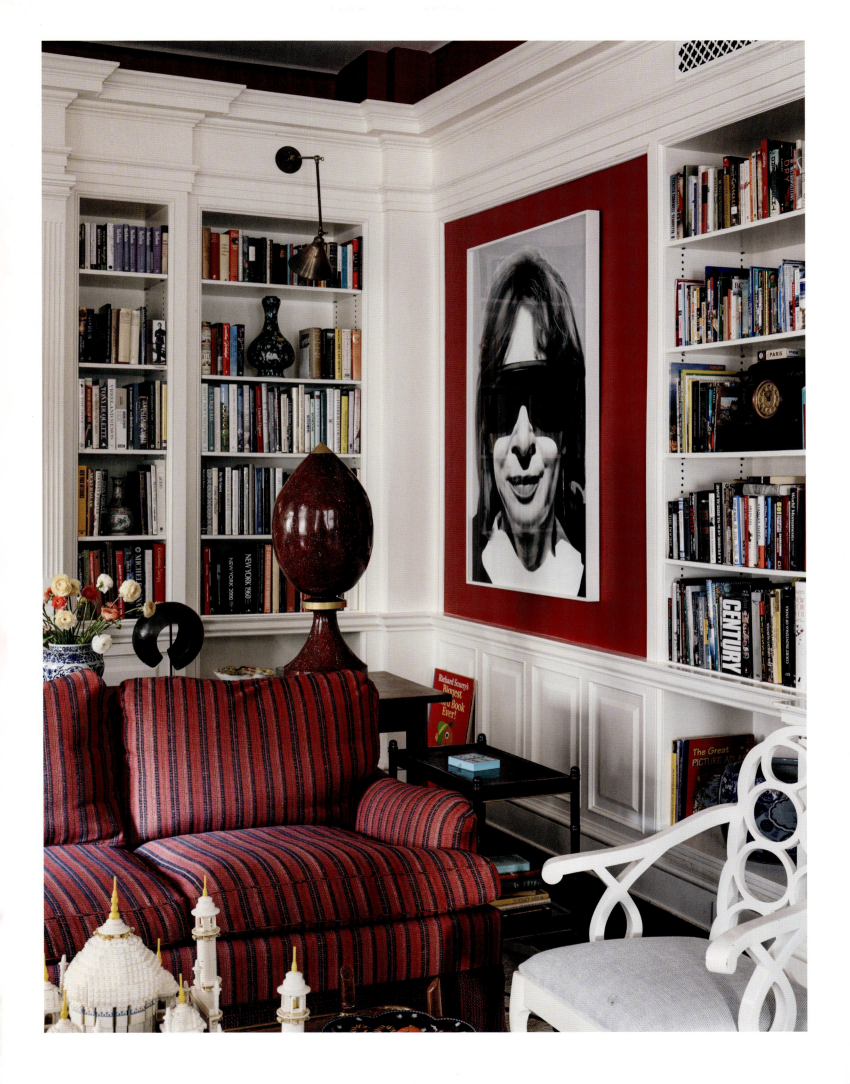

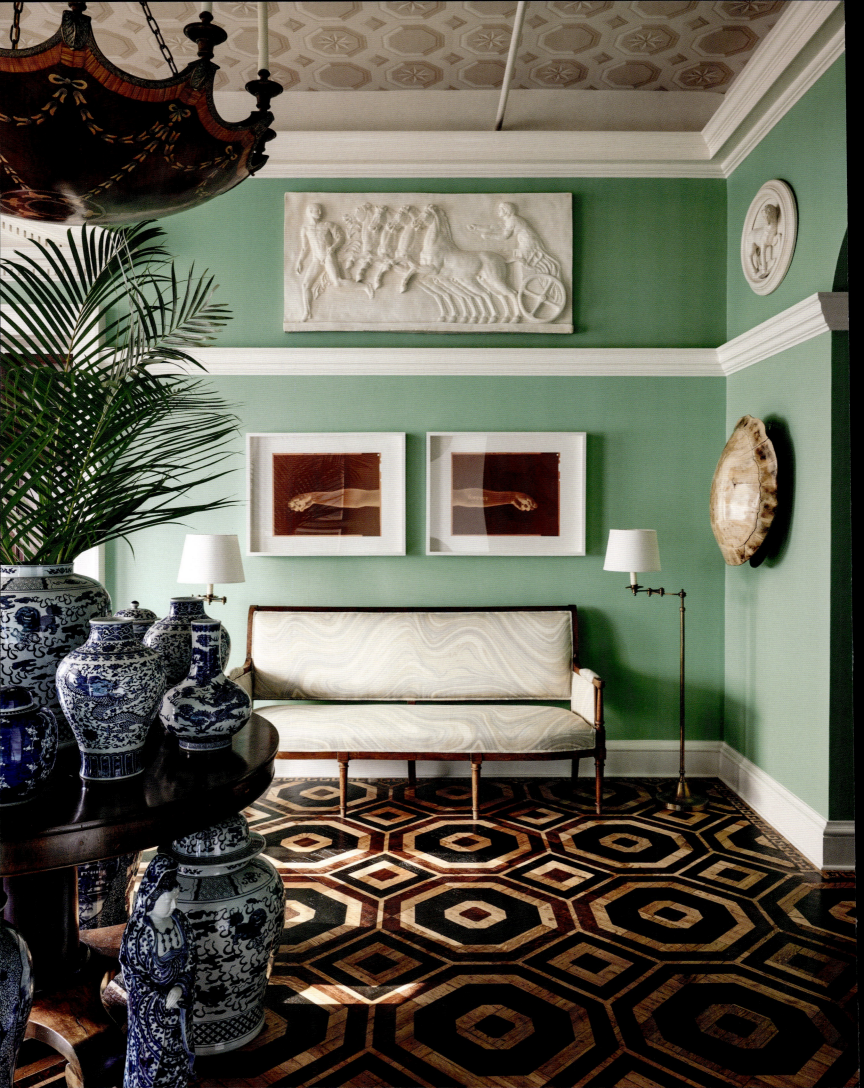

OPPOSITE: In the foyer, arsenic-green walls dramatically offset former resident Sir John Richardson's collection of antique plaster bas-reliefs. A trompe l'oeil Schumacher wallpaper on the ceiling cleverly mirrors the hand-stained octagonal pattern on the floor. The floor's rich wood tones are in turn echoed in the overscale Maitland-Smith umbrella chandelier, which hangs over a collection of blue-and-white vases. ABOVE: The strong influence of classical style on the original architect, Ernesto Buch, is a constant throughout the apartment. An impressive classical overdoor creates a dramatic view from the foyer into the library.

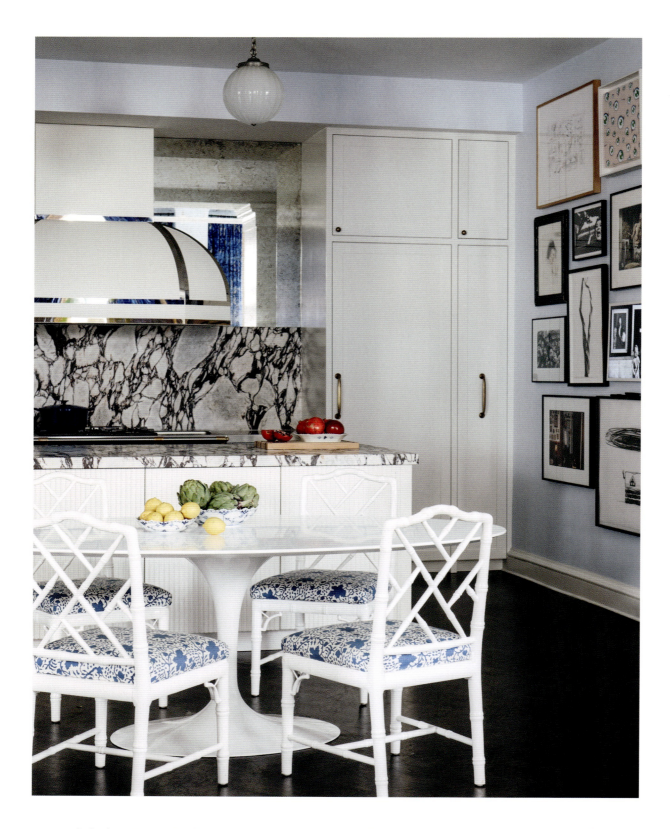

ABOVE: *In the kitchen, Calacatta Viola marble and antique mirror surround a custom brass and nickel–strapped range hood by Lacanche. A classic Saarinen Tulip table is a frequented breakfast and homework spot.* OPPOSITE: *The clients' set of postmodern prints by Christopher Wool hangs in the living room, adding an edgy vibe to the space. Below the chair rail, the brick-like plaster wainscot adds architectural interest to the room. Vintage Frances Elkins Loop chairs surround a family heirloom breakfast table.* OVERLEAF LEFT: *Drapes in Jim Thompson's cobalt-blue Malachite fabric frame a nineteenth-century chinoiserie secretary purchased in Charleston.* OVERLEAF RIGHT: *In the family room, the Ping-Pong table is in playful contrast to the antique grandfather clock and classical bas-relief. Natural grasscloth on the walls and a hand-blocked Indian paisley fabric by John Robshaw for the curtains underscore the casual use of this room.*

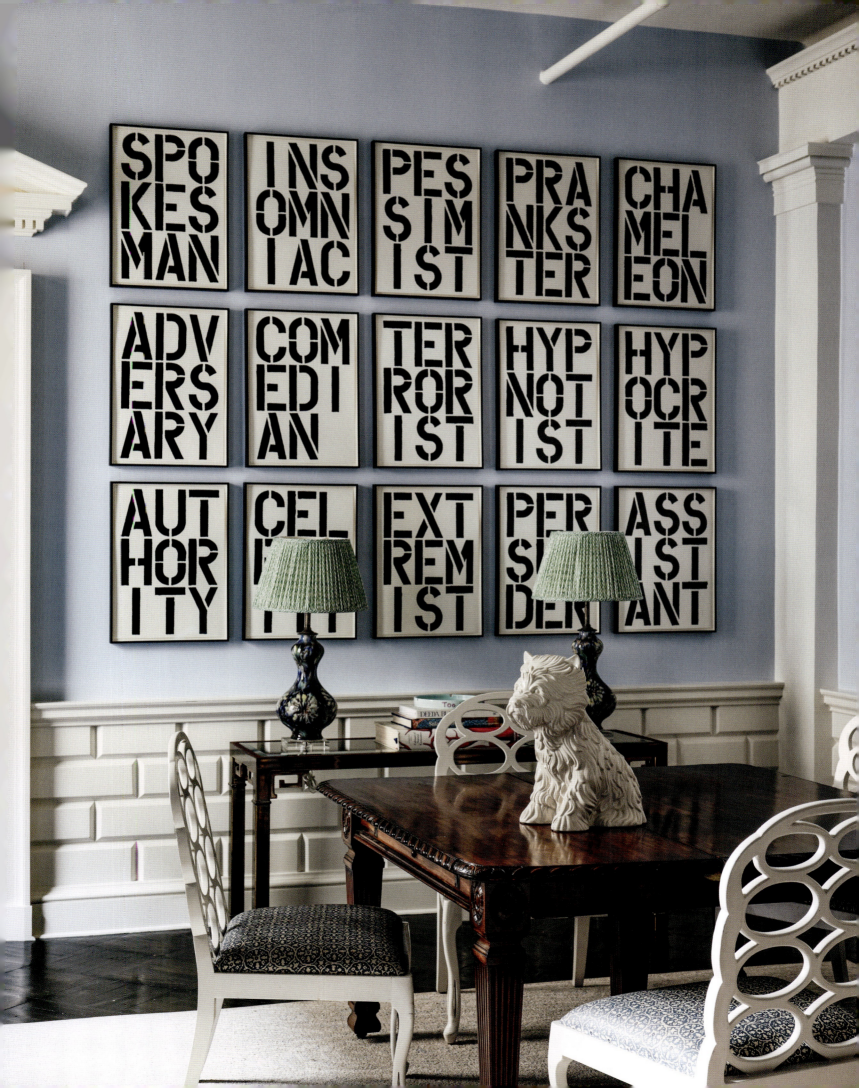

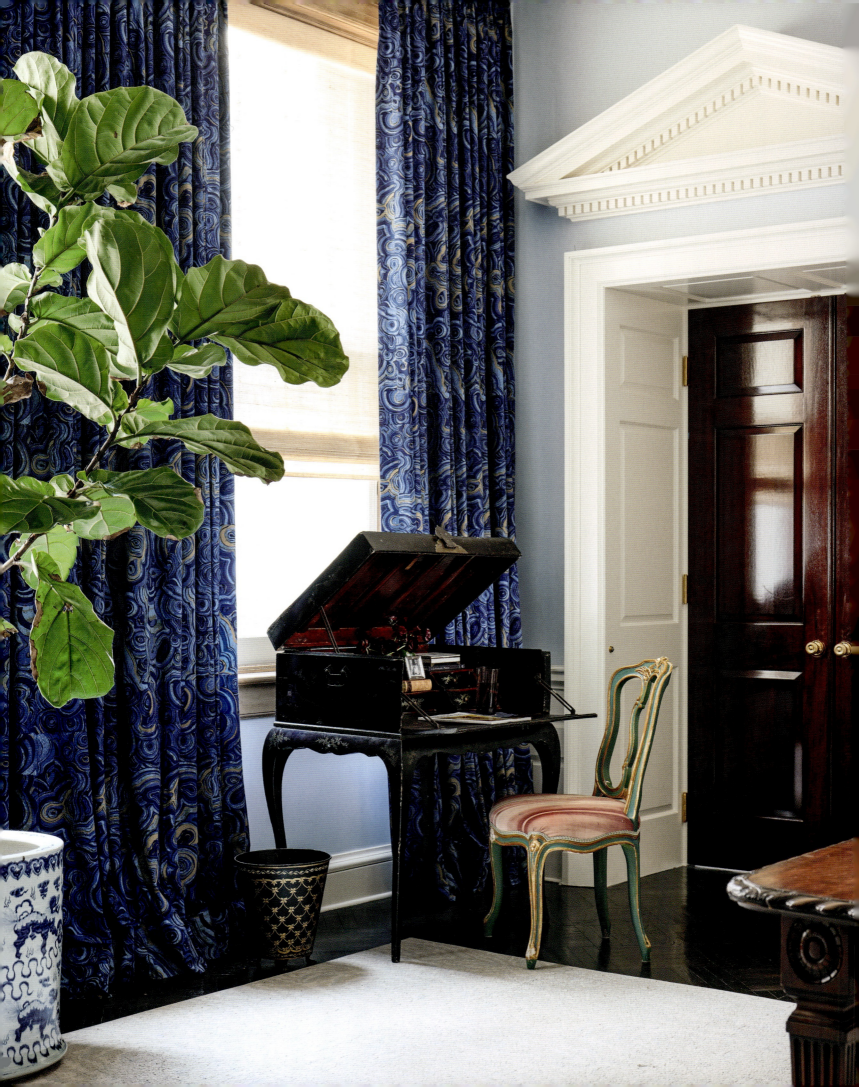

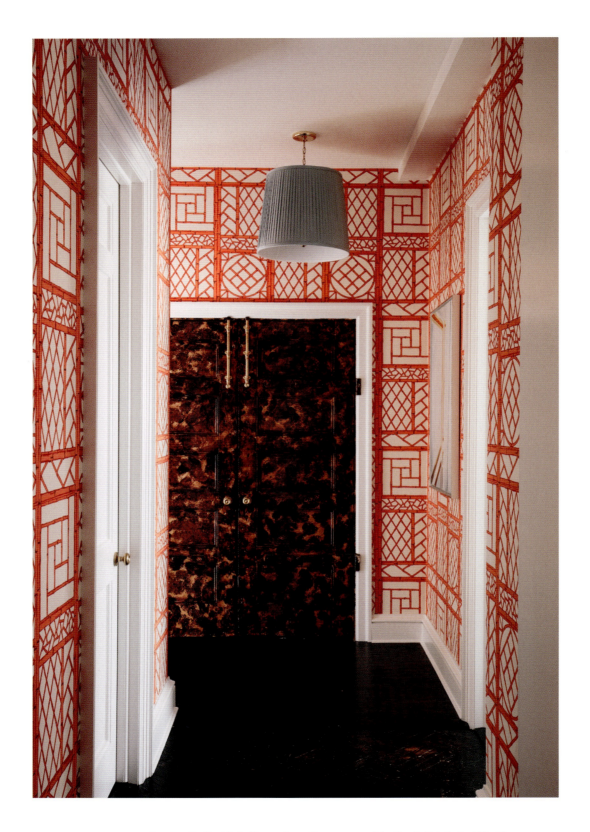

ABOVE AND OPPOSITE: *In this hallway, the walls are covered in Quadrille's Lyford Trellis, a nod to its designer, my friend Tom Scheerer. Decorative painter Hayden Gregg was brought in to enliven the elevator door and bookshelves with a tortoiseshell finish.*

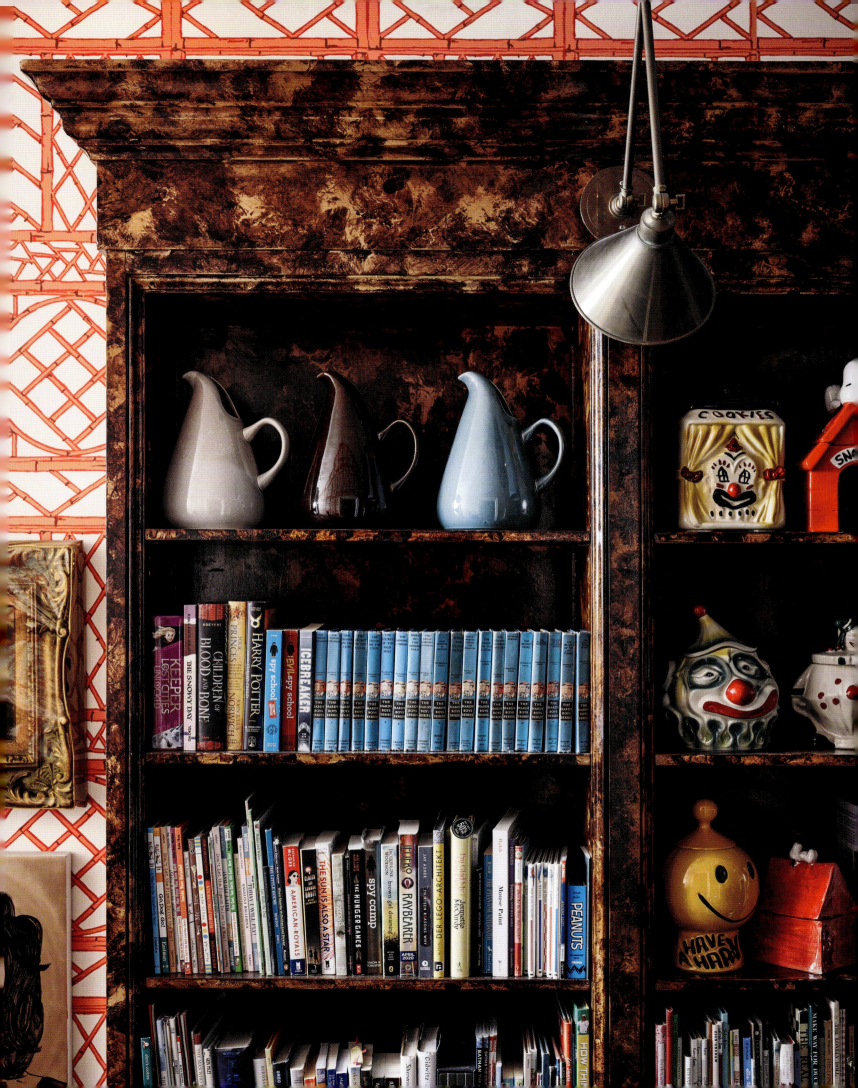

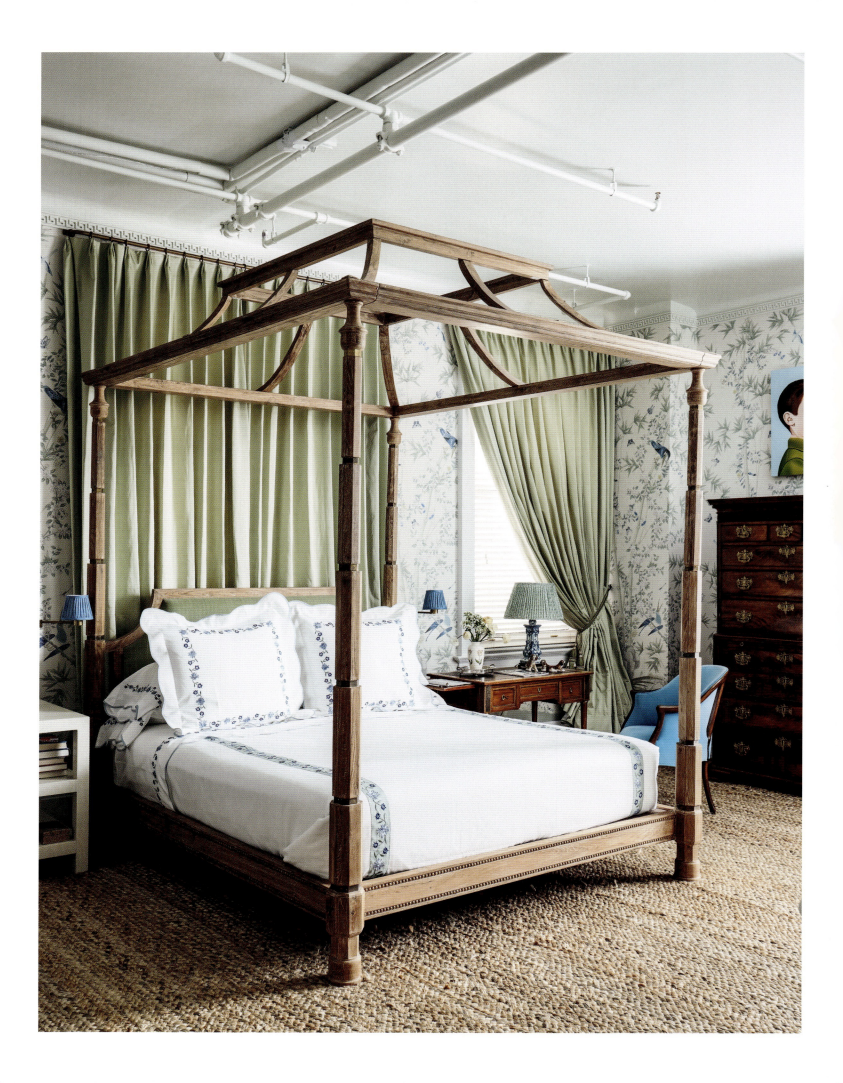

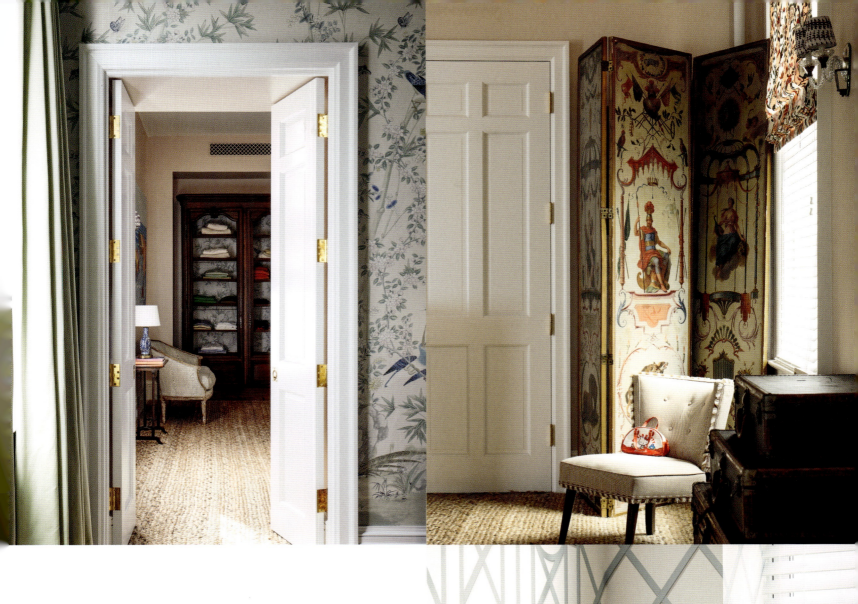

OPPOSITE: In the primary bedroom, a soft green Brunschwig & Fils silk backs the hand-carved bed and curtains the windows. The bedding is from Leontine Linens, and the walls are covered in Schumacher's Brighton Pavilion wallpaper. The wall-to-wall jute rug adds a casual, island touch.
ABOVE LEFT: A cheerful pink coats the walls in the primary dressing room.
ABOVE RIGHT: An antique Pompeian screen adds a classical note in the primary dressing room.
BOTTOM RIGHT: A Jim Thompson trellis wallpaper surrounds a solid Carrara marble tub by Urban Archaeology. Waterworks taps gleam.

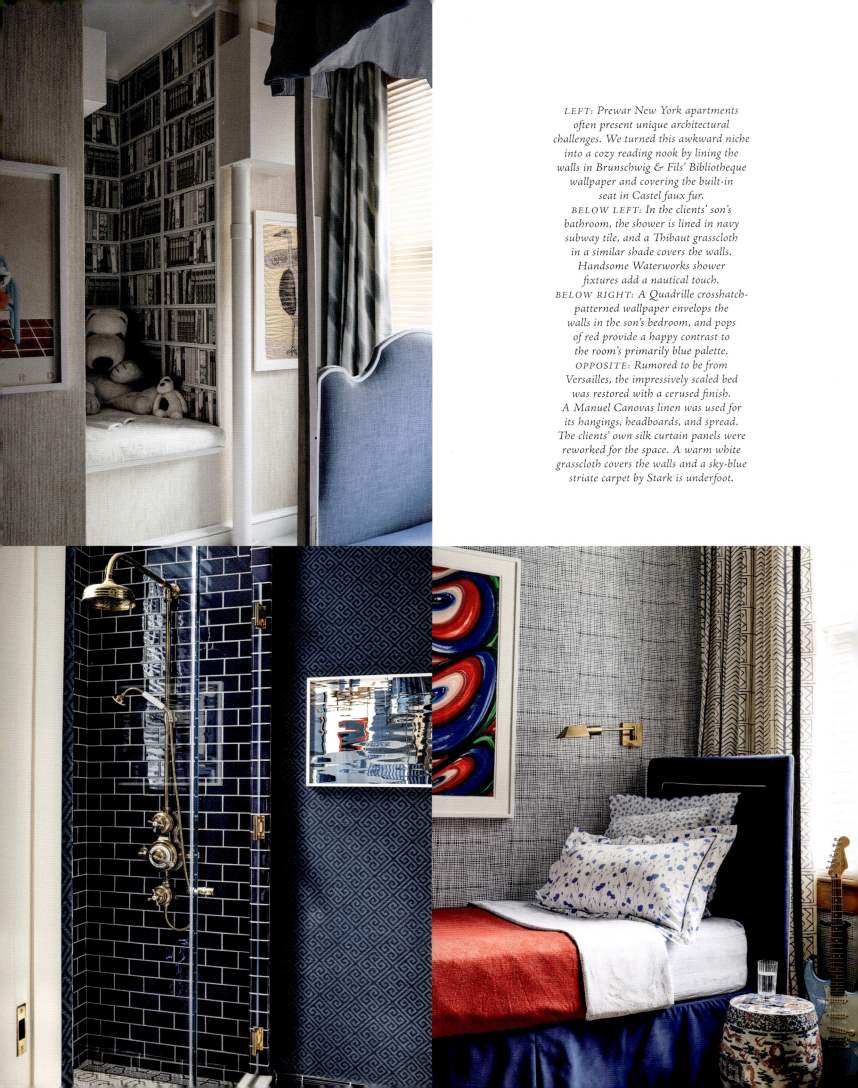

LEFT: Prewar New York apartments often present unique architectural challenges. We turned this awkward niche into a cozy reading nook by lining the walls in Brunschwig & Fils' Bibliotheque wallpaper and covering the built-in seat in Castel faux fur.
BELOW LEFT: In the clients' son's bathroom, the shower is lined in navy subway tile, and a Thibaut grasscloth in a similar shade covers the walls. Handsome Waterworks shower fixtures add a nautical touch.
BELOW RIGHT: A Quadrille crosshatch-patterned wallpaper envelops the walls in the son's bedroom, and pops of red provide a happy contrast to the room's primarily blue palette.
OPPOSITE: Rumored to be from Versailles, the impressively scaled bed was restored with a cerused finish. A Manuel Canovas linen was used for its hangings, headboards, and spread. The clients' own silk curtain panels were reworked for the space. A warm white grasscloth covers the walls and a sky-blue striate carpet by Stark is underfoot.

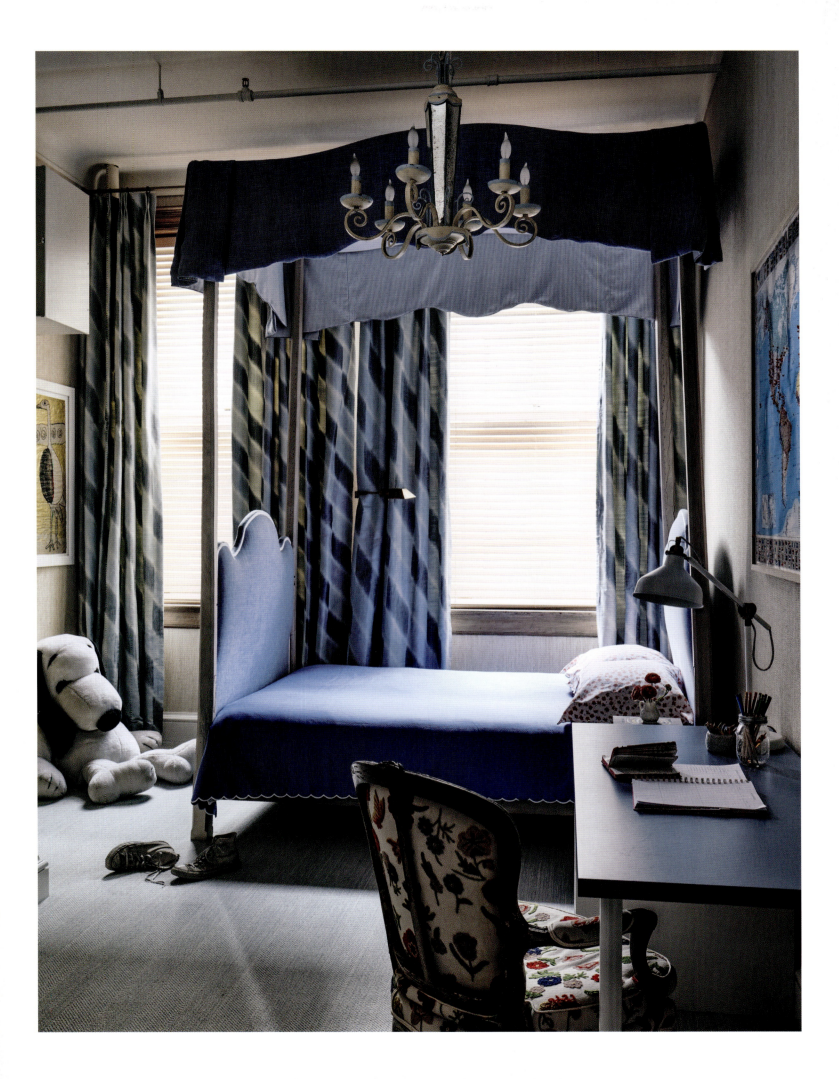

PACIFIC HEIGHTS

SAN FRANCISCO

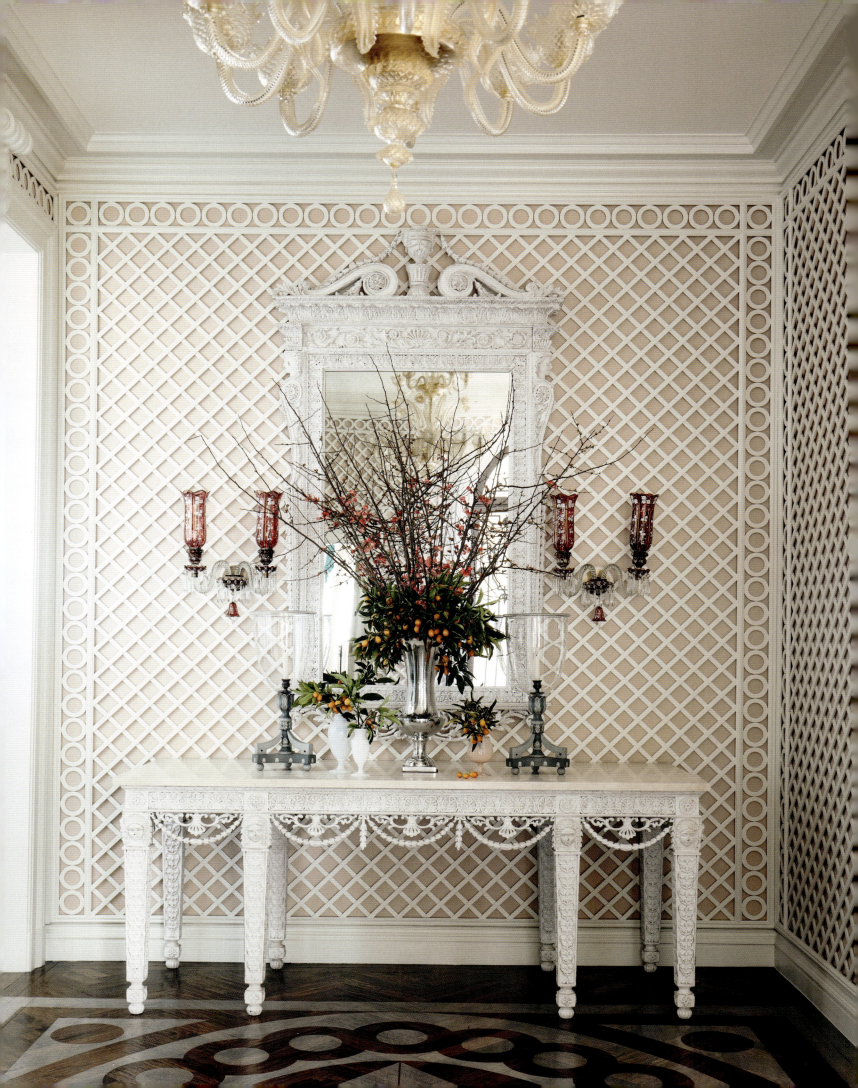

When I was a young reporter at *Women's Wear Daily* in New York, it was understood that the society ladies of San Francisco were in a different league. Publisher John Fairchild instructed his reporters to ask partygoers only in Paris and San Francisco to name the designers they were wearing. He explained to us that San Francisco's families had a longstanding tradition of attending the Paris couture shows and that they lived in beautifully decorated houses.

After we finished Windsong in Baker's Bay (see pages 30–49), our San Francisco–based clients asked us if we could spread our wings west and help them in California. We were thrilled at the opportunity and readily agreed. From my first glimpse of the house in the beautiful Pacific Heights neighborhood of San Francisco, I knew that John Fairchild's assessment of the city had been spot-on.

Our clients have young children, and the house needed an upgrade to accommodate their routines, studies, and activities. It was decided that a general rearrangement of rooms and floors was called for. We immediately realized that we had a lot of learning to do to become expert in a different vocabulary of curtains, rugs, and lighting than we use in the tropics.

I recall a certain Friday when we were presenting living room rugs to our clients, and nothing was quite right. After spending the whole weekend studying antique Savonnerie rugs and the offerings at auction sites and dealers, I reached the conclusion that all the rugs throughout the house would have to be hand-loomed to ensure the correct palettes, patterns, and sizes. This led us to Christine Vanderhurd in London, who built looms at her workshop in India to create our special rugs. Chandeliers were sourced from as far away as Spain. Furniture was hand-carved by Jonathan Sainsbury in the UK. Antiques were sourced from around the globe.

We wanted to create an environment that was not only cheerful and inviting for our clients' children but also gave a nod to San Francisco's time-honored formality. A mile-long playroom with a striped, tented ceiling and a star-studded "stage" curtain is a magical place for any child. The living and dining rooms channel the "grand" tradition of San Francisco, as described by Mr. Fairchild and imagined by me as a young reporter.

OPPOSITE: *A white trellis from Accents of France over salmon-pink walls complements a Jonathan Sainsbury console and mirror. The floor was painted by Brian Leaver.*

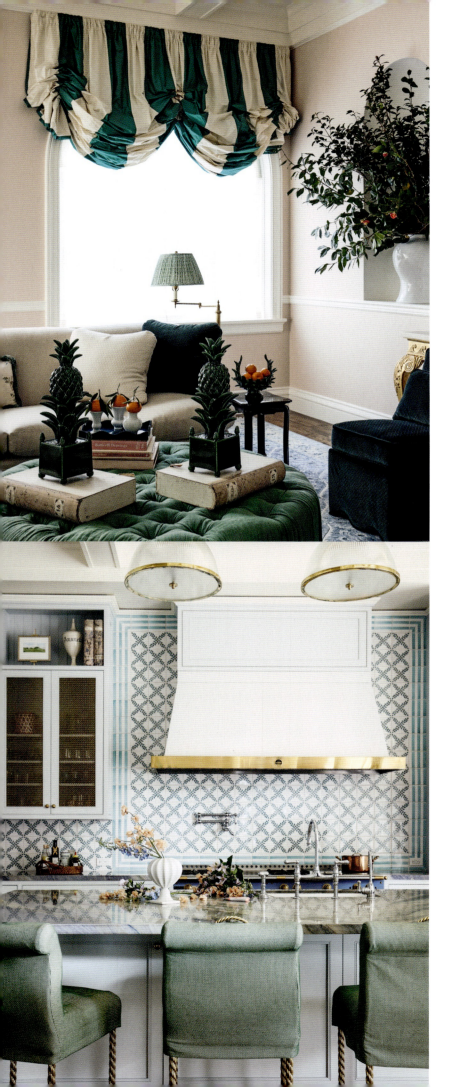
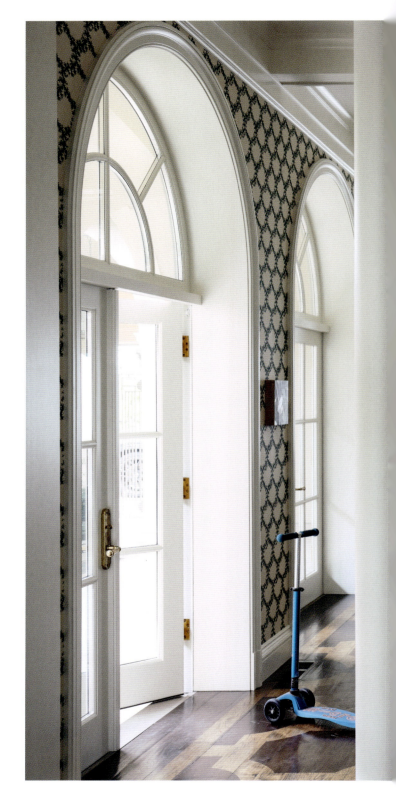

ABOVE LEFT: Billowing silk balloon shades in a cheerful stripe enliven the family room. LEFT: In the kitchen, the walls are covered in painted tiles from Balineum. The stools at the island are from Soane Britain.

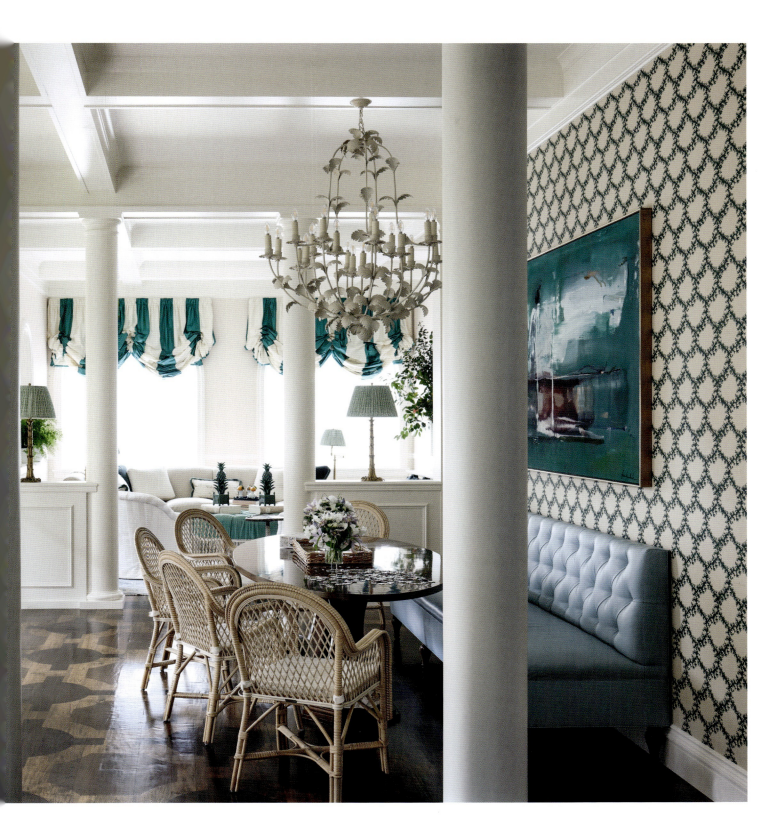

ABOVE: *A view from the kitchen of the breakfast room and family room. Soane Britain's Seaweed Lace wallpaper lines the wall behind a custom blue banquette by J. Quintana Upholstery. The Bonacina chairs are among our favorites.* OVERLEAF: *Everything in the dining room, including its custom Gracie panoramic wallpaper, beautifully embroidered chair backs by Penn & Fletcher, custom Vanderhurd rug, David Haag curtains, and antique chandelier from Nesle, vies for attention with its spectacular view of the Golden Gate Bridge.*

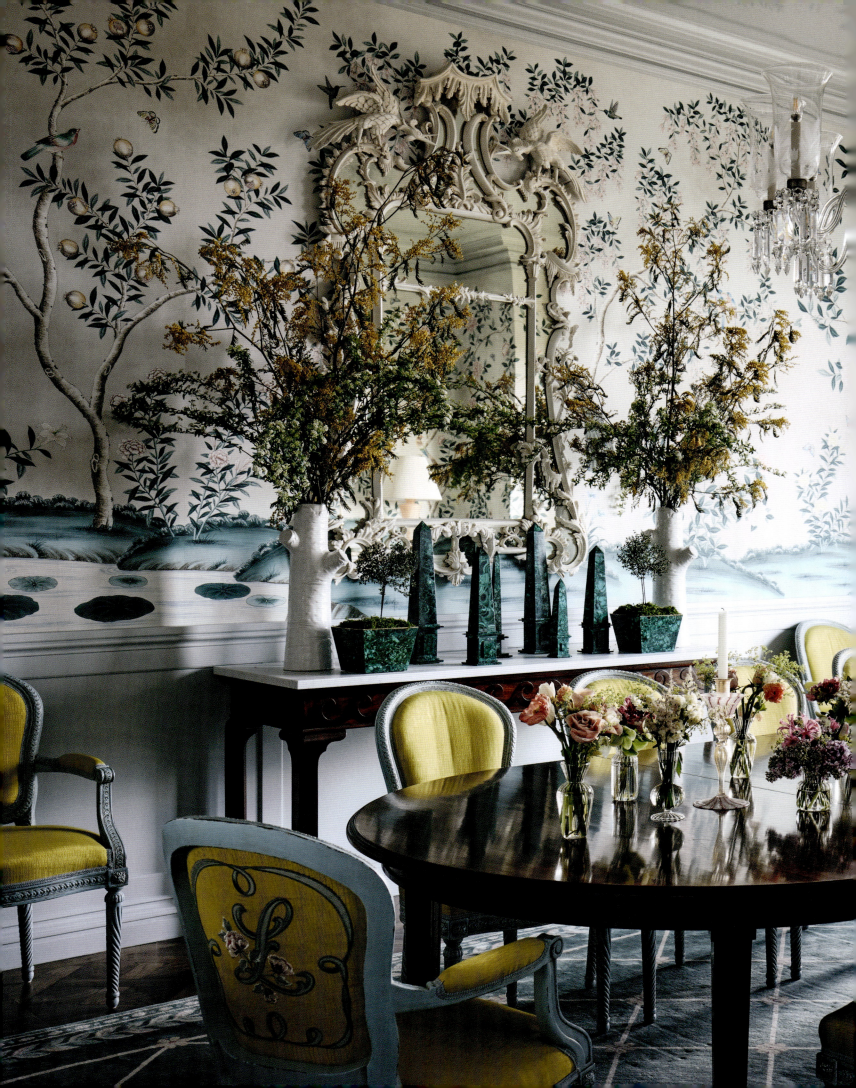

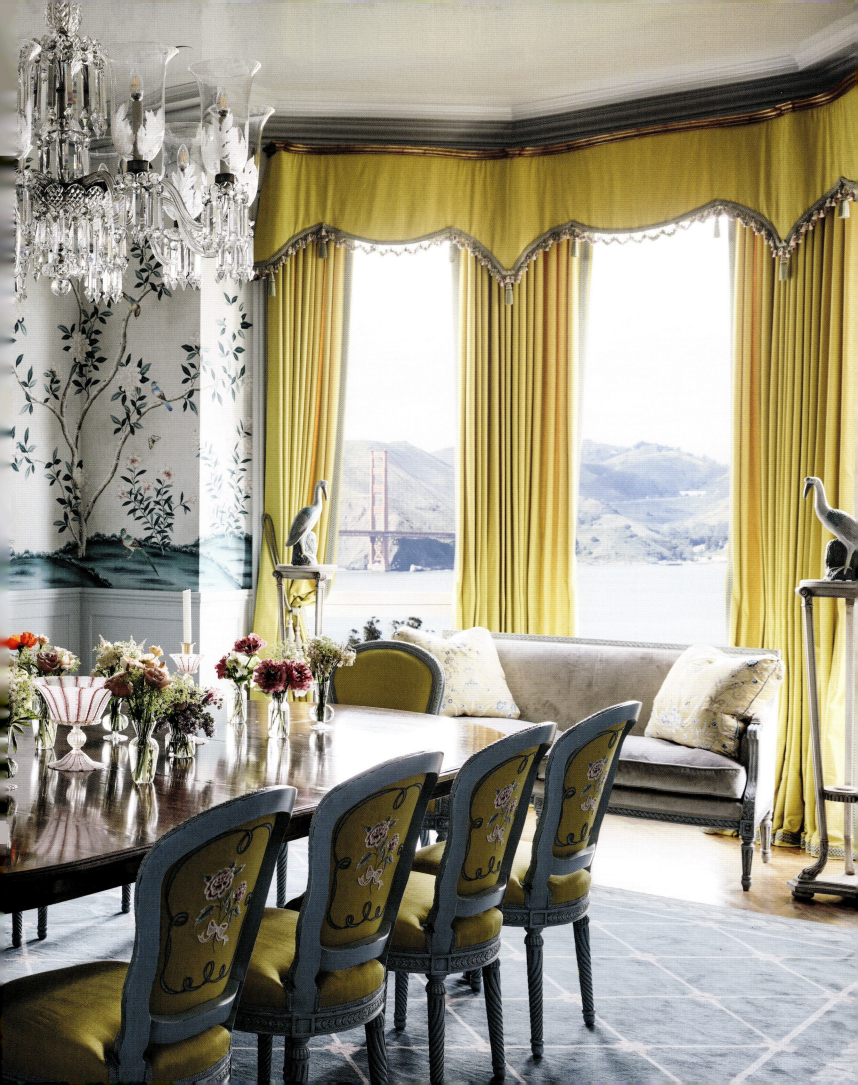

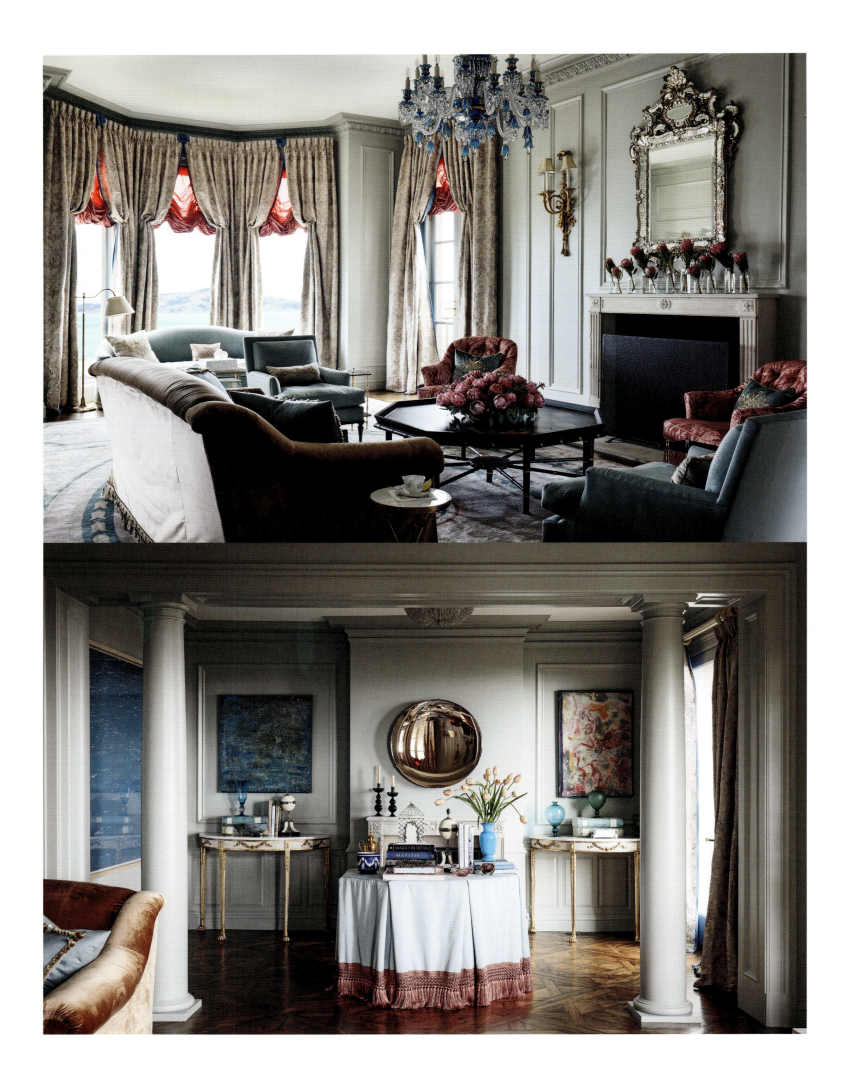

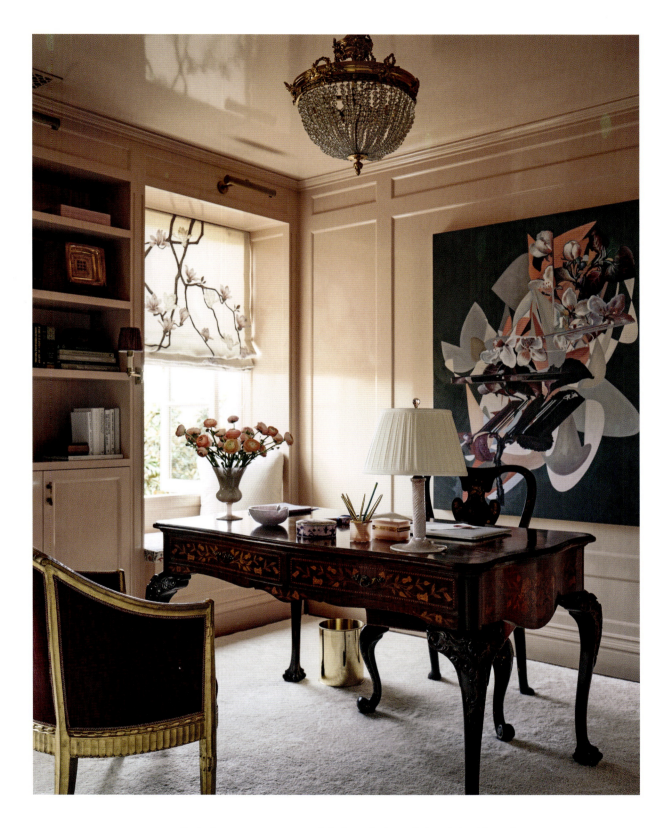

OPPOSITE TOP: *In the living room, crimson silk balloon shades peek from behind brocade curtains from Christopher Hyland. A rug inspired by an antique Savonnerie was handmade for the room by Vanderhurd. The chandelier is from Alcocer Anticuarios in Madrid, and the mirror is from Cedric DuPont Antiques.* OPPOSITE BOTTOM: *An alcove delineated by columns is a perfect place for the young couple to hang pieces of their art collection.* ABOVE: *In the study, pink-lacquered walls and ceiling envelop a desk from Alcocer Anticuarios and chairs from Carlton Hobbs.*

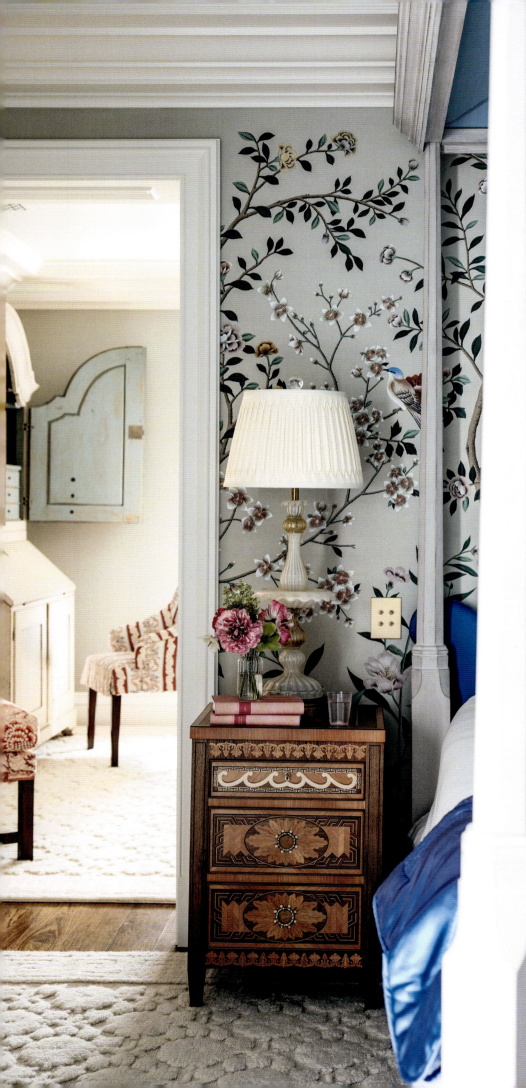

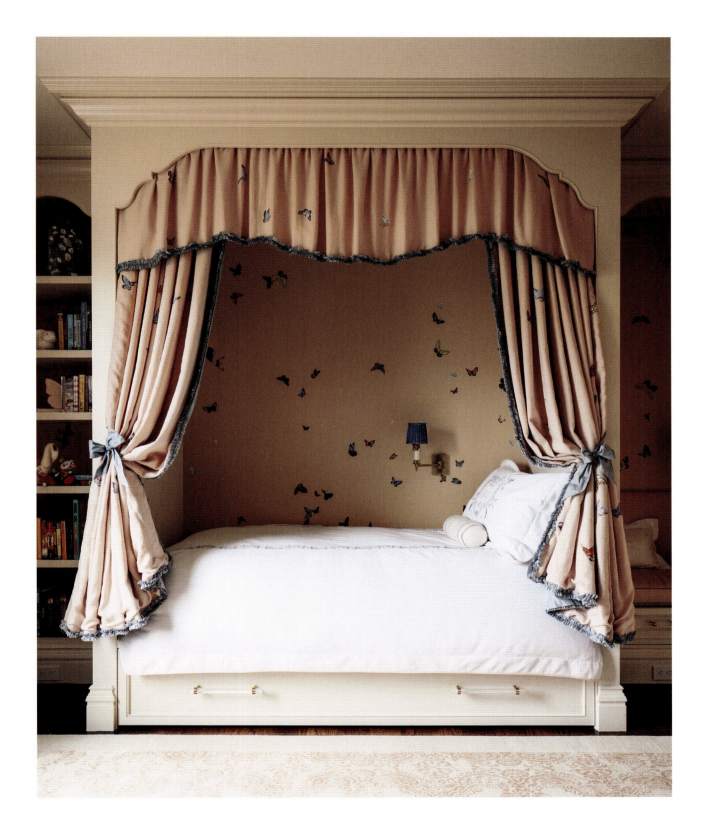

OPPOSITE: *In the primary bedroom, a de Gournay paper lines the walls, the bedding on the four-poster bed is from Leontine Linens, and the rug is by Cogolin.* ABOVE: *The charming sleeping alcove we designed is enveloped in de Gournay butterflies, both on the walls and on the hangings. The bedding is by Leontine Linens.*

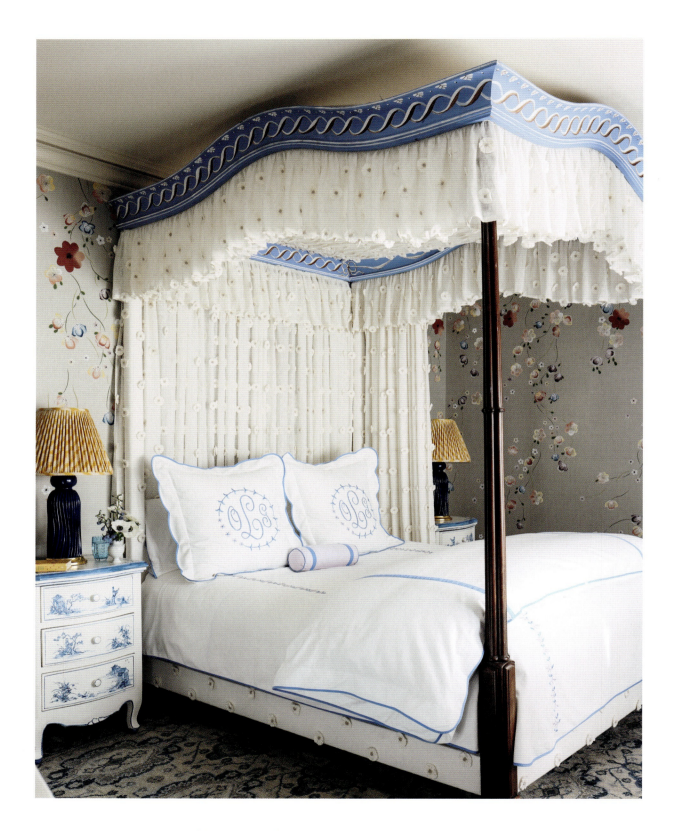

ABOVE: An English four-poster bed from a stately home was repainted and refreshed with hangings in a Schumacher tone-on-tone daisy fabric. The night tables, from Two Worlds Arts, were hand-painted. OPPOSITE TOP: The playroom, with sweeping views of San Francisco Bay, is tented in a blue-and-white-striped paper. OPPOSITE BOTTOM LEFT: A little "stage" with a star-studded curtain encourages performances. OPPOSITE BOTTOM RIGHT: We created an enticing reading nook in this windowed alcove.

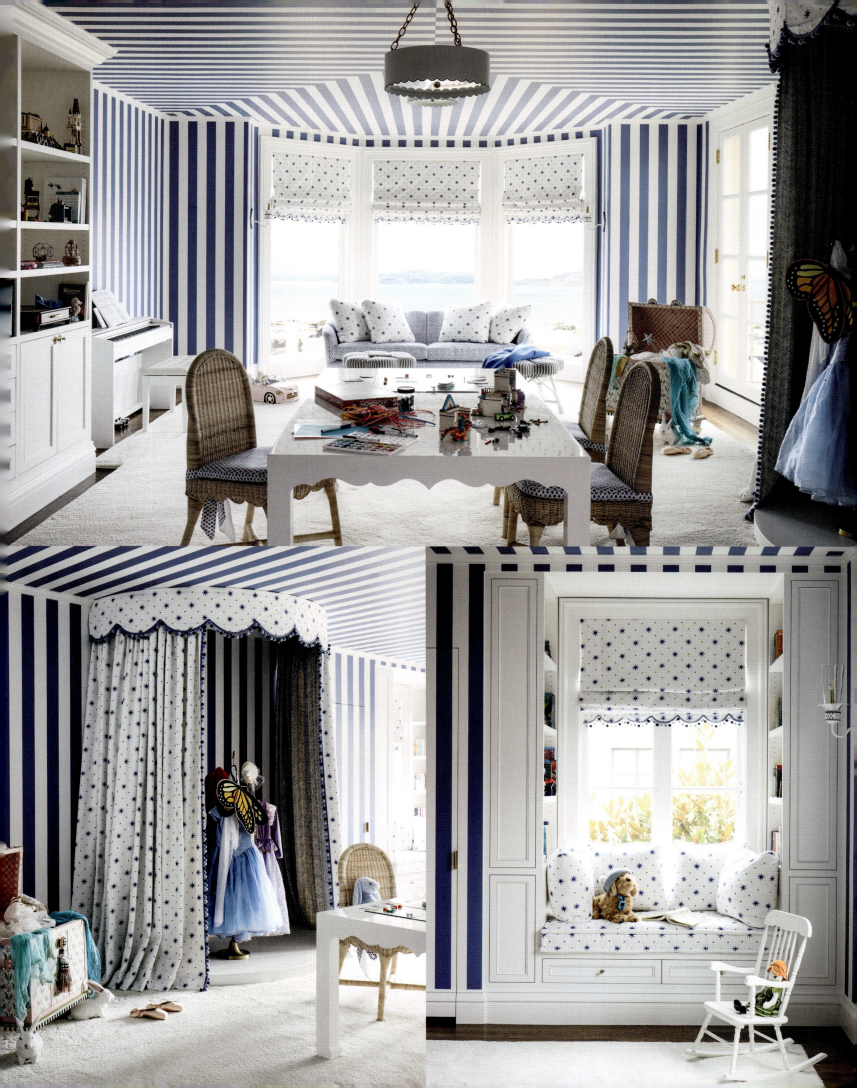

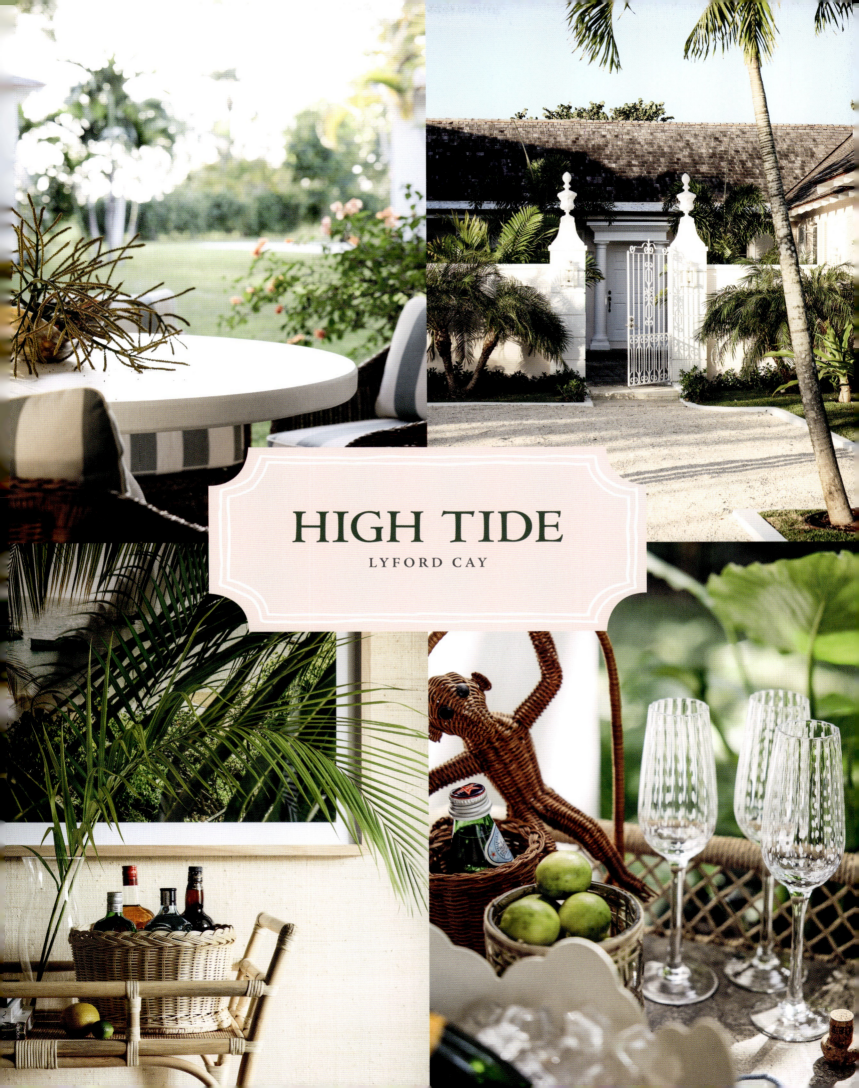

HIGH TIDE

LYFORD CAY

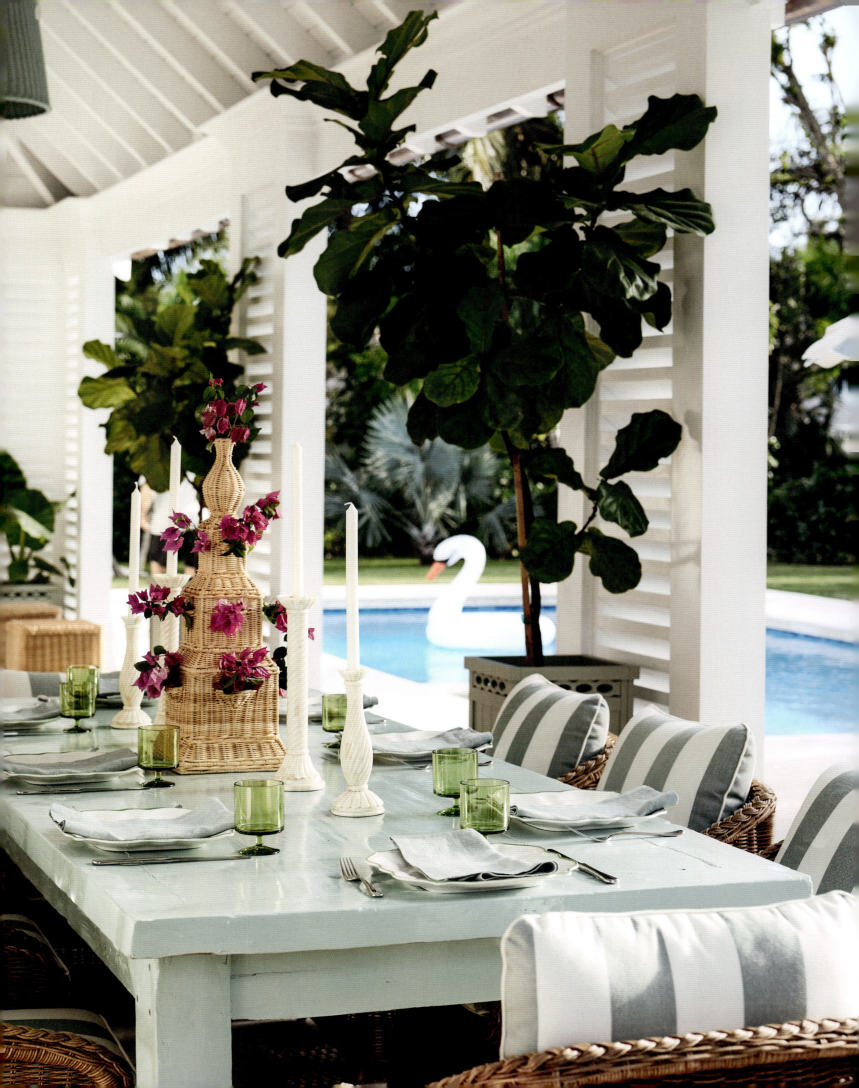

It is certainly a wonderful thing when previous clients call and ask you to work on a new project. That is just what happened in the spring of 2023, when our beloved clients who owned the house next door to High Tide wrote to say that they had bought their neighbor's house and asked if we could we tidy it up. The house has always been a favorite. A perfect little gem, it is in the Lyford-y Georgian style.

The project was right in our wheelhouse. The house had been rented to big families for decades. Every square inch needed love. With our clients, we determined what would be important to change, as well as what we could live with. The windows were all in perfect condition. The kitchen had recently been updated and needed only a fresh coat of paint to shine. Old travertine floors were polished. Bathrooms were updated and freshened.

Larger-ticket items like new roofs for both the main house and the cottage were nonnegotiable, however. Tearing down a previously enclosed veranda and replacing it with a wonderful new, high-ceilinged loggia, was the most significant change. A late-in-the-game addition to our plan, that loggia created a totally new world of outdoor living for the house.

Our builder insisted on removing a snarled hedge that was encroaching on the pool coping. I had been reluctant, as it shielded the house from the golf course. But the removal of the dense mess opened the house and cottage to miles and miles of lawn and landscaping. A tidy new hedge was installed for privacy.

The interior was updated with all our favorite idioms in the Lyford vocabulary: grasscloth wall coverings, cotton and seagrass rugs, rattan and wicker accents and furniture, hand-screened and block-printed fabrics. The exterior was painted the softest pink to complete High Tide's "Lyford upgrade." She is mightily proud again.

OPPOSITE: The new loggia heightened the clients' living and dining experience.
OVERLEAF: We covered the living room walls in a Thibaut grasscloth and the sofas in Bristol, a favorite Thibaut performance fabric.

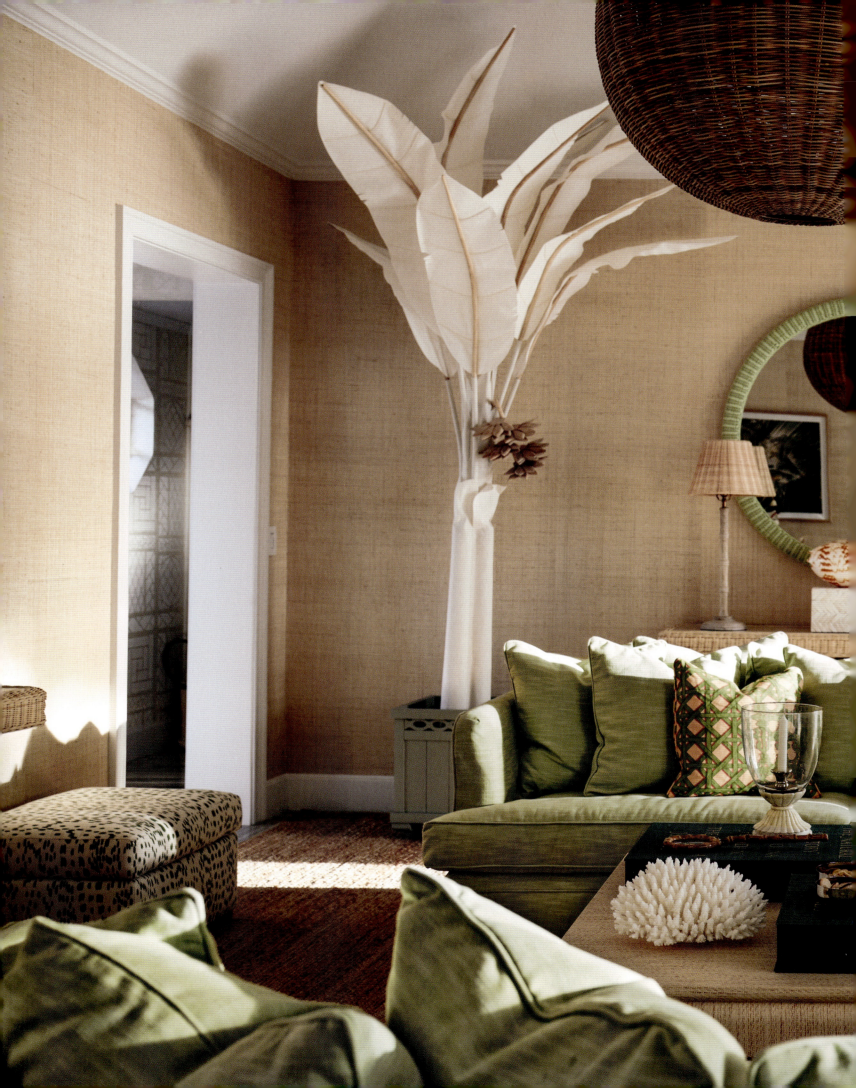

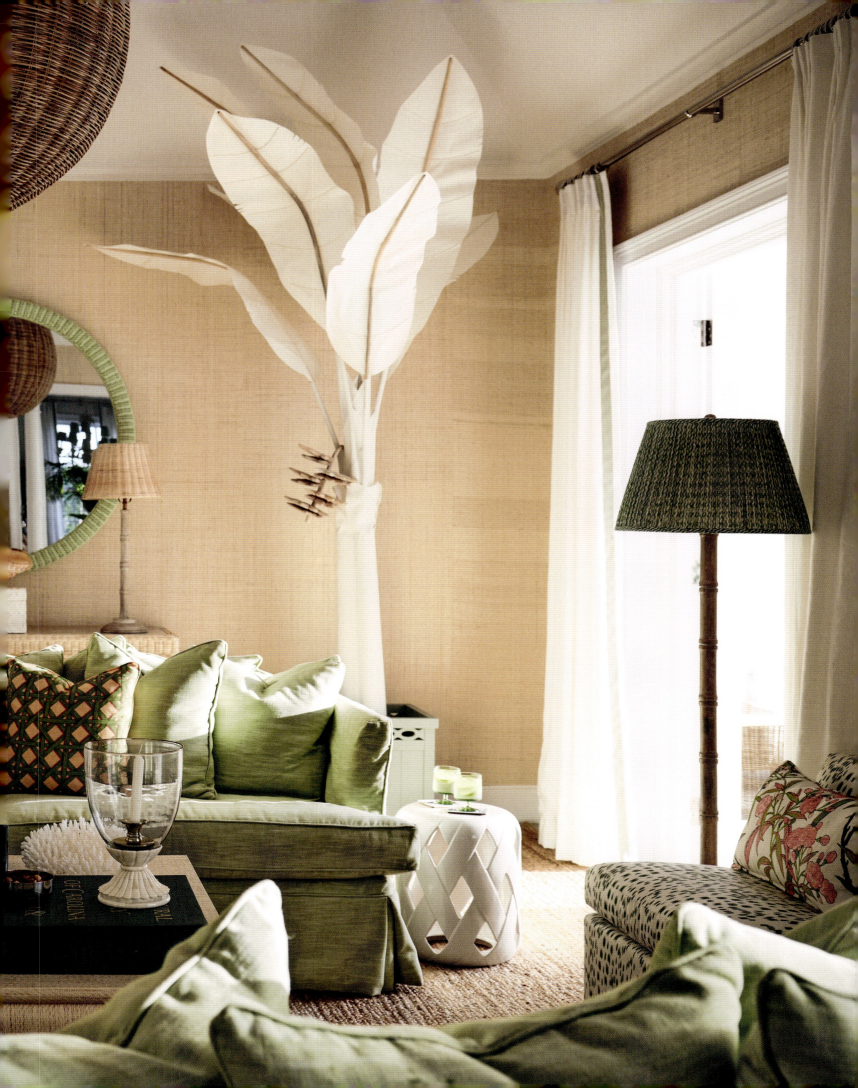

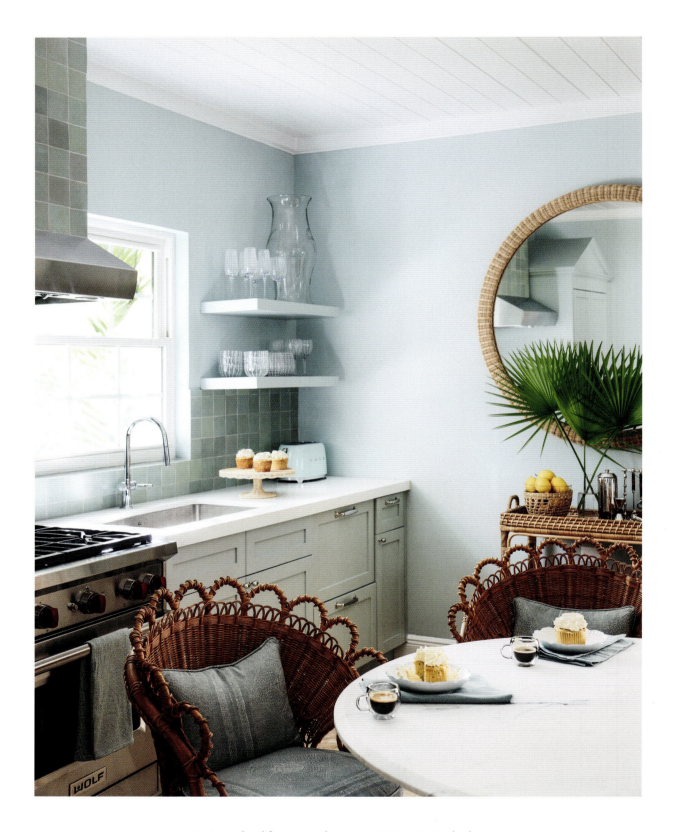

ABOVE: *A cozy breakfast spot in the cottage.* OPPOSITE: *In the dining room, Lindroth scalloped Hope Hill chairs surround a Saarinen Tulip table.*

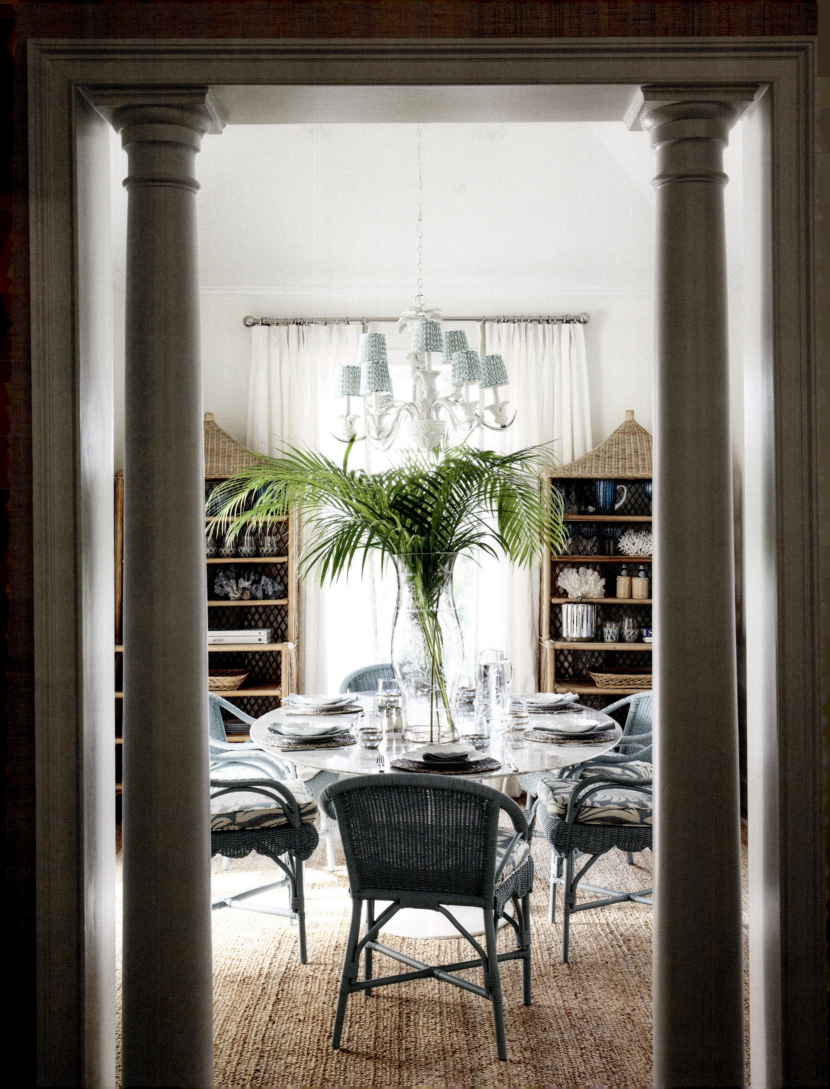

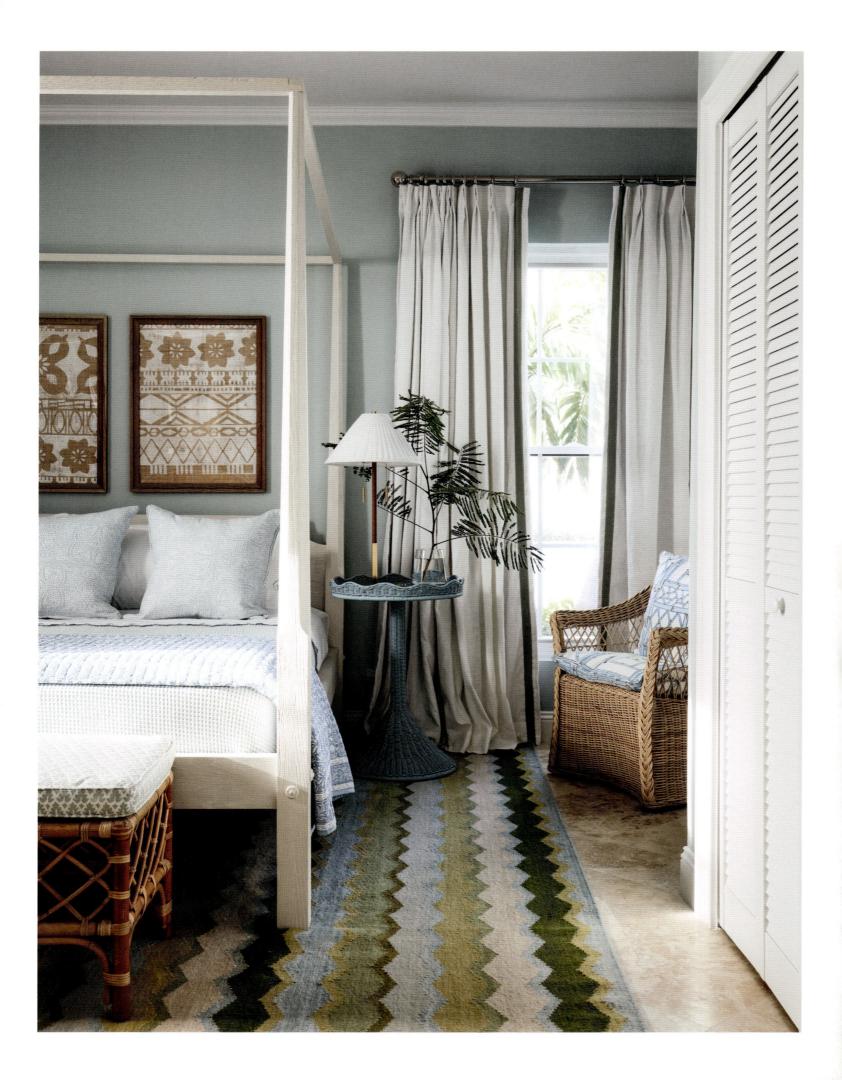

OPPOSITE: *In the primary suite of the guest cottage, a Dash & Albert rug establishes the color scheme.* RIGHT: *In a guest room, the bed features a Lindroth pagoda headboard and batik linens.* BELOW: *Celerie Kemble's Acanthus Stripe Sisal wallpaper for Schumacher imparts a trim look to this twin bedroom.* OVERLEAF: *A view of the new loggia and pool. The inflatable swans were a gift from the contractor, Ranardo Jules.*

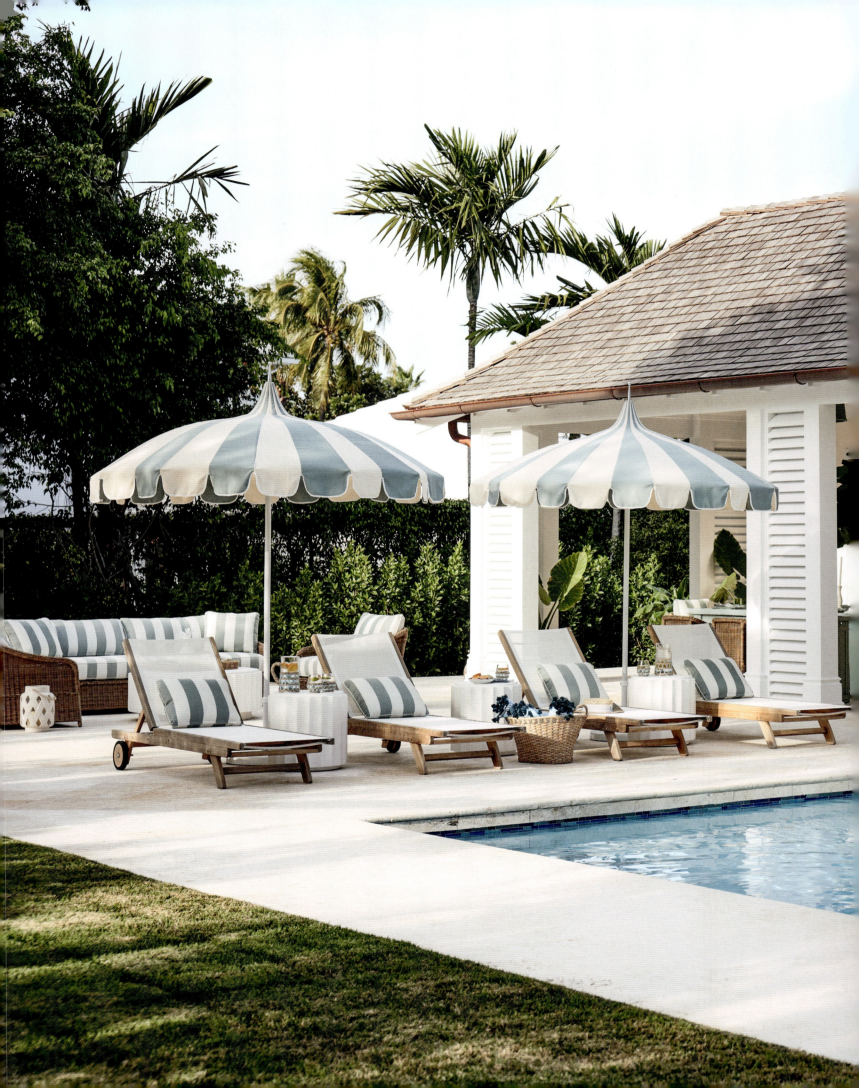

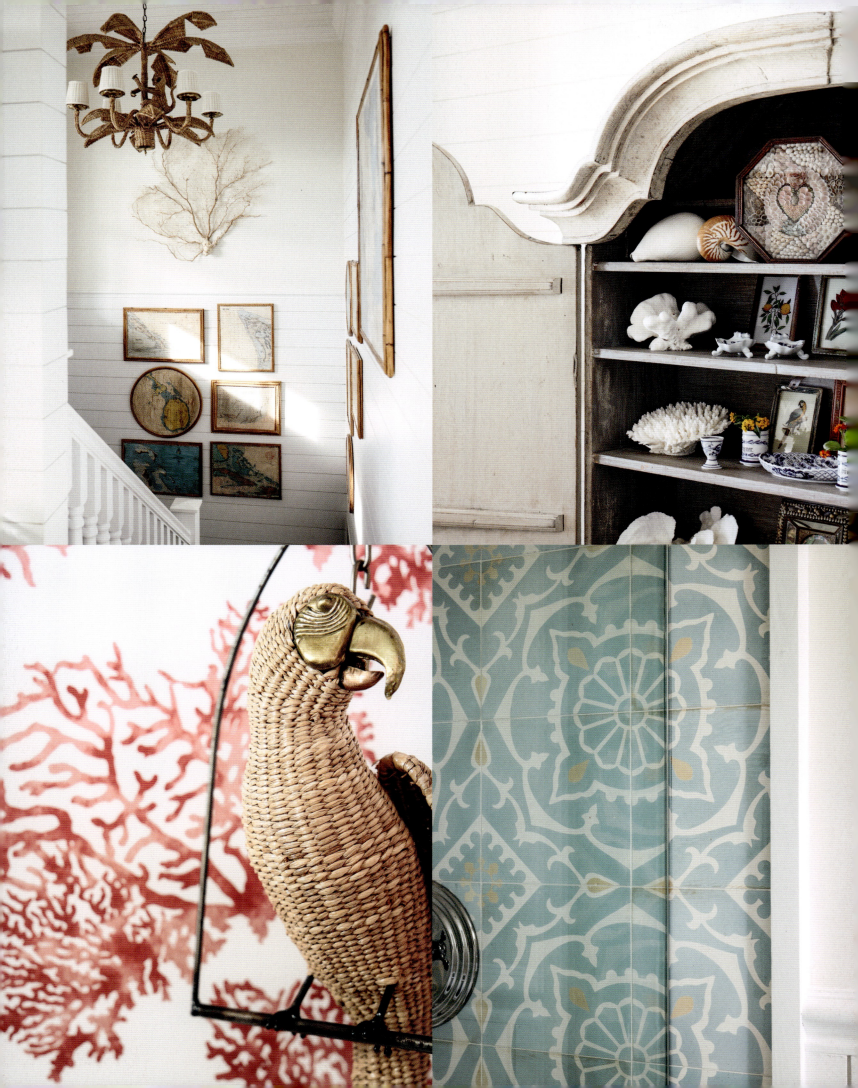

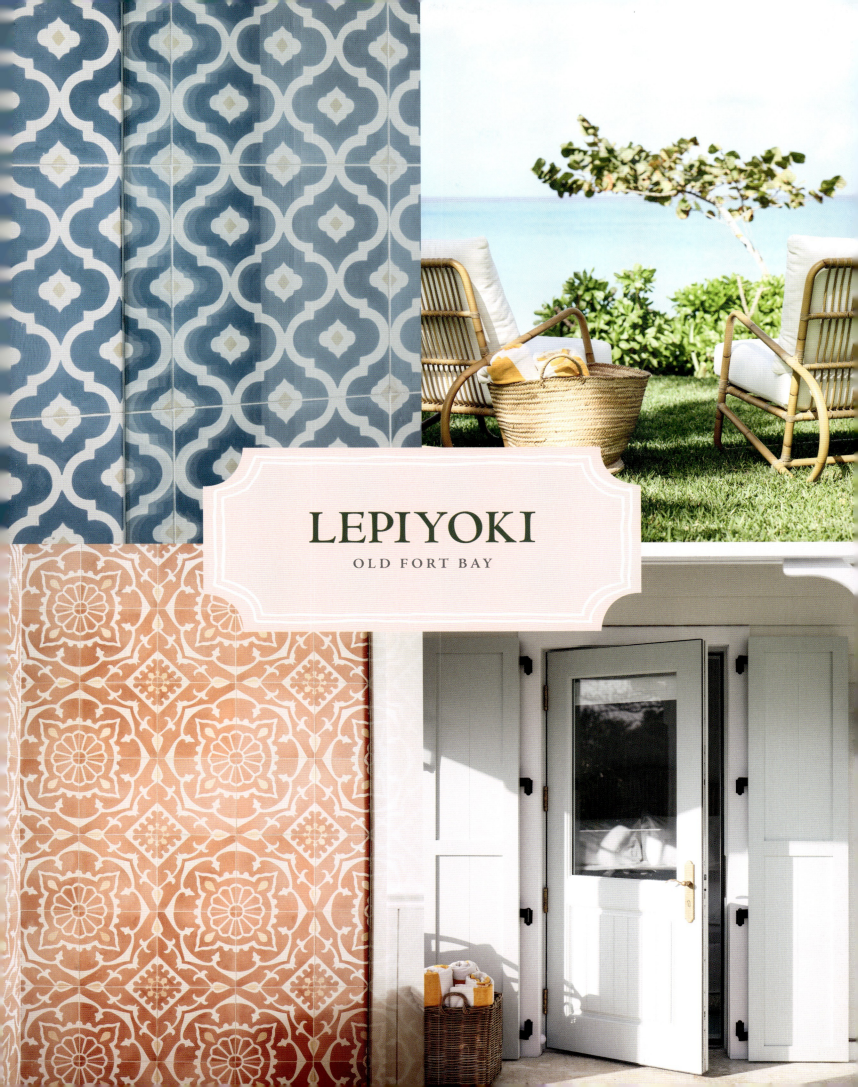

LEPIYOKI

OLD FORT BAY

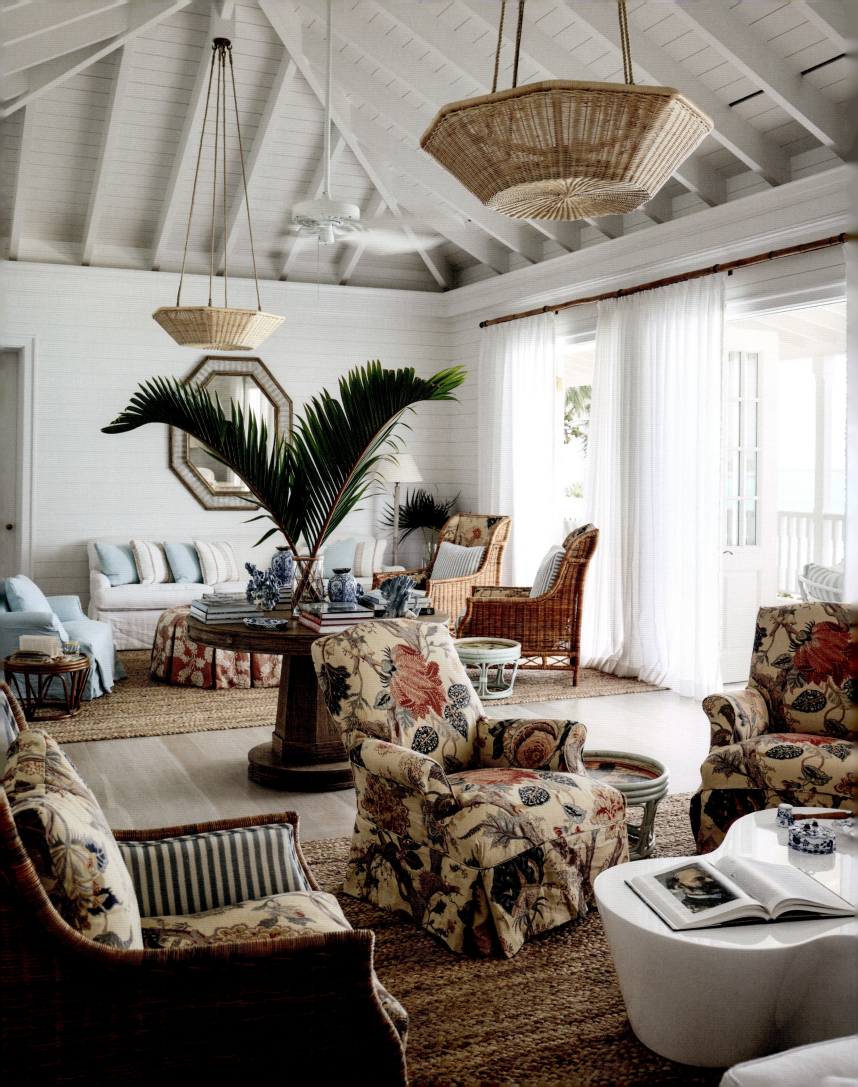

"Lepiyoki" is not derived, as one might imagine, from the name of some exotic Polynesian island. Rather, it is a charming acronym, made up of the first two letters of the names of the four children whose parents hired us to be part of the team who built this wonderful family house in Old Fort Bay, near Lyford Cay. The family, an international bunch, is London-based but has roots in Norway, Japan, and Europe. Both husband and wife have impeccable taste and style. The wife's mother was a professional designer.

The couple were interested in a classical house but wanted it to have a beachy vibe. They had seen a few houses in Harbour Island that had inspired them. With those in mind and armed with a copy of *A Living Tradition*, a book on Bahamian architecture that Orjan had helped create, they guided builder Darren Ginns and his team to realize their vision.

To furnish the interiors, thousands of emails were exchanged between my team and the clients. Midnight bidding happened nightly for months to make sure we acquired just the right treasures and artwork. Antique wicker beds were purchased through these auctions, rattan pieces were found in the antiques and vintage shops on Dixie Highway in West Palm Beach, and a few splurges, including some wicker chairs from Casa Gusto, proved irresistible.

The intense effort was worth it—the finished house brims with charm and surprise. A masterful blend of great architecture and layered but pared-back details, it is beach-house perfection. The whole team is delighted with the outcome.

OPPOSITE: *The living room is open to the cooling breezes and aqua views of Old Fort Bay.*

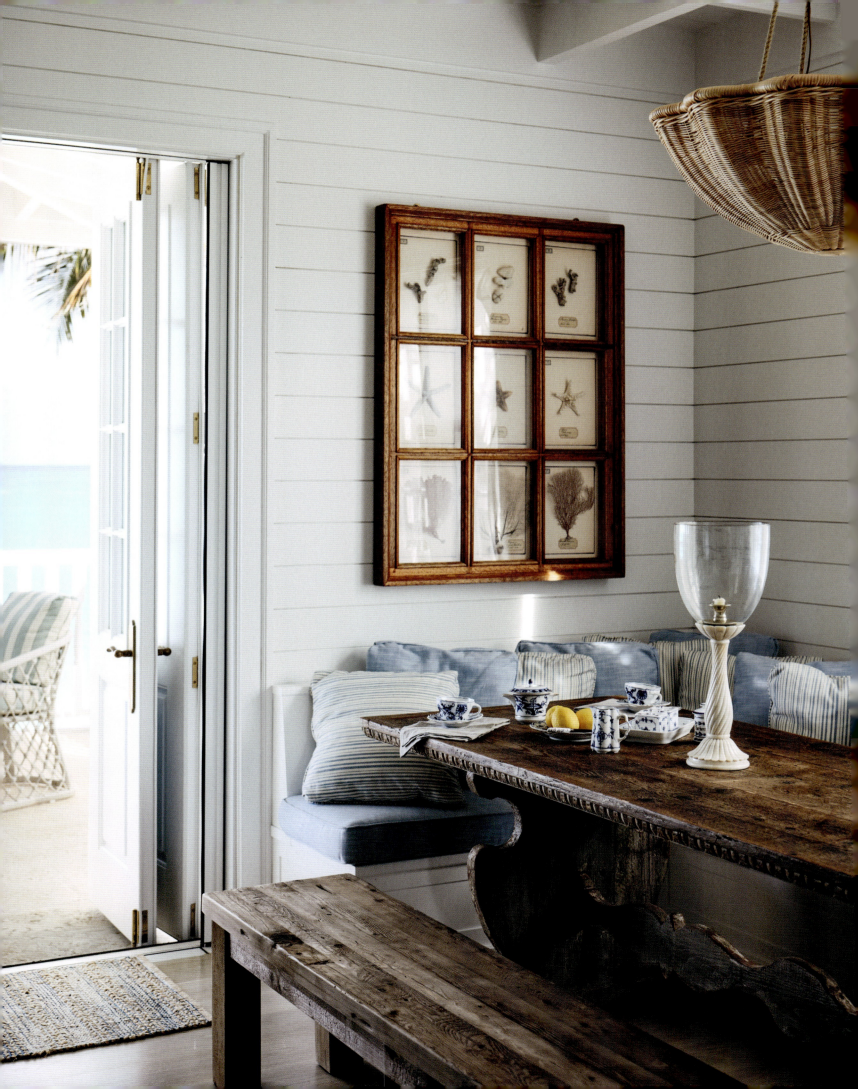

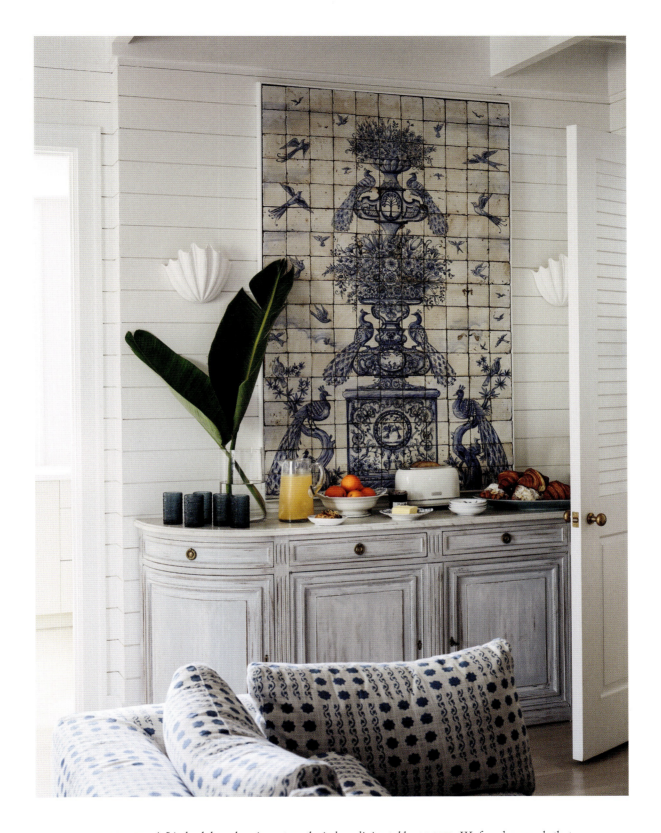

OPPOSITE: *A Lindroth bone hurricane tops the indoor dining table.* ABOVE: *We found a console that was just the right style and fit for a panel of hand-painted tiles from Devonshire of Palm Beach.*

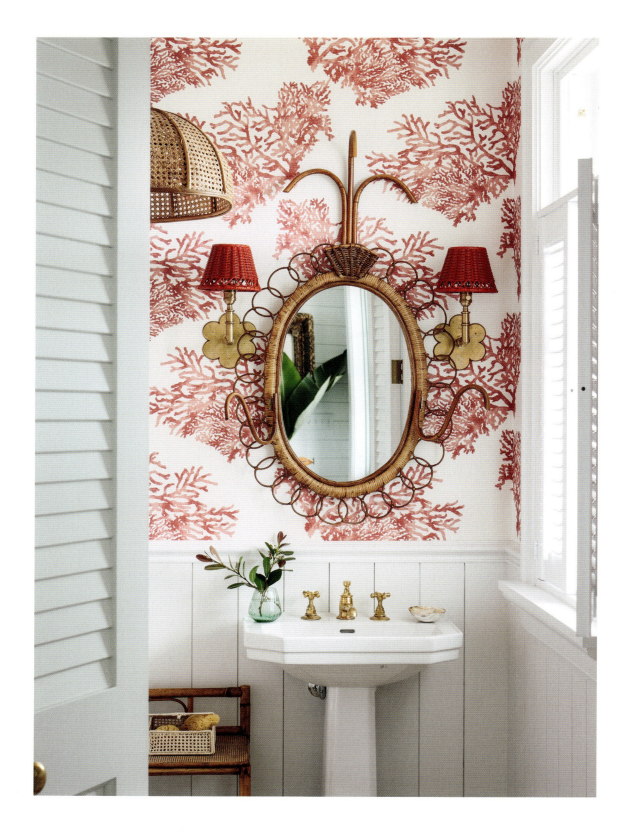

ABOVE: *In the cheerful powder room, the lighting is from Soane Britain and the mirror is from Justin Van Breda.* OPPOSITE: *In the entrance hall, a Soane Britain Rattan Daisy pendant is painted red for a pop of color. The botanical print is from Casa Gusto.*

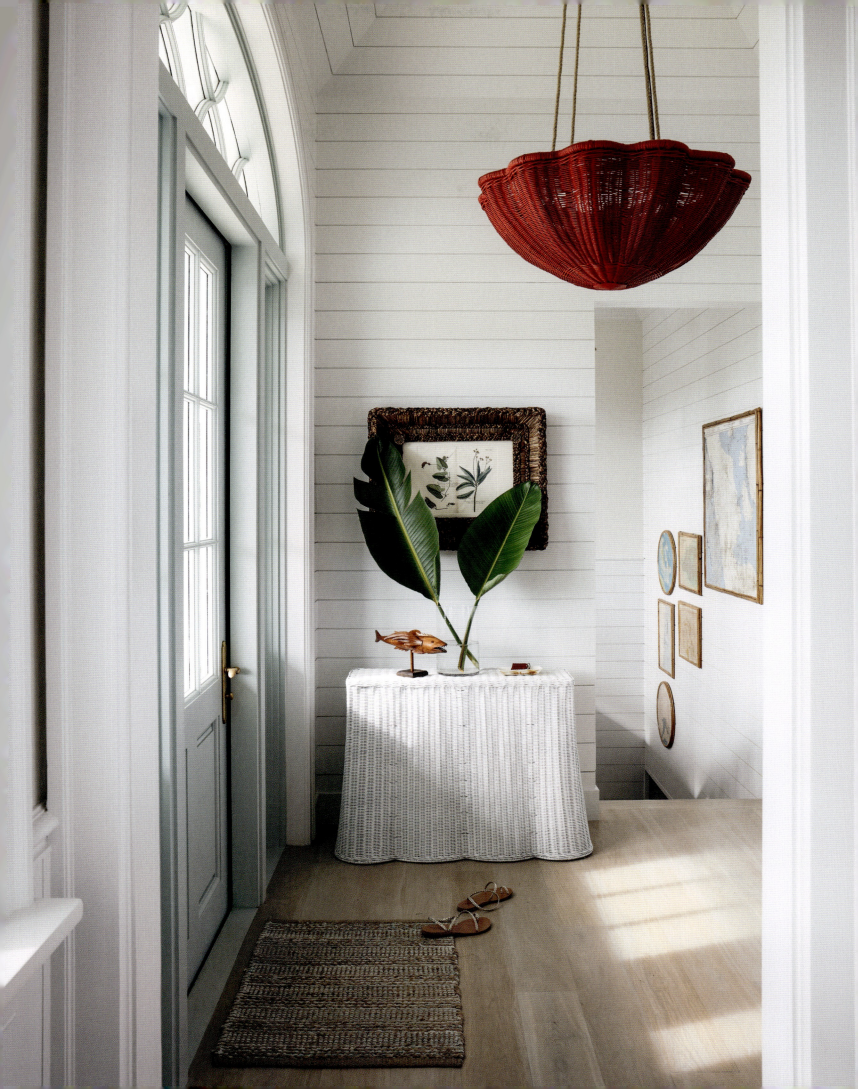

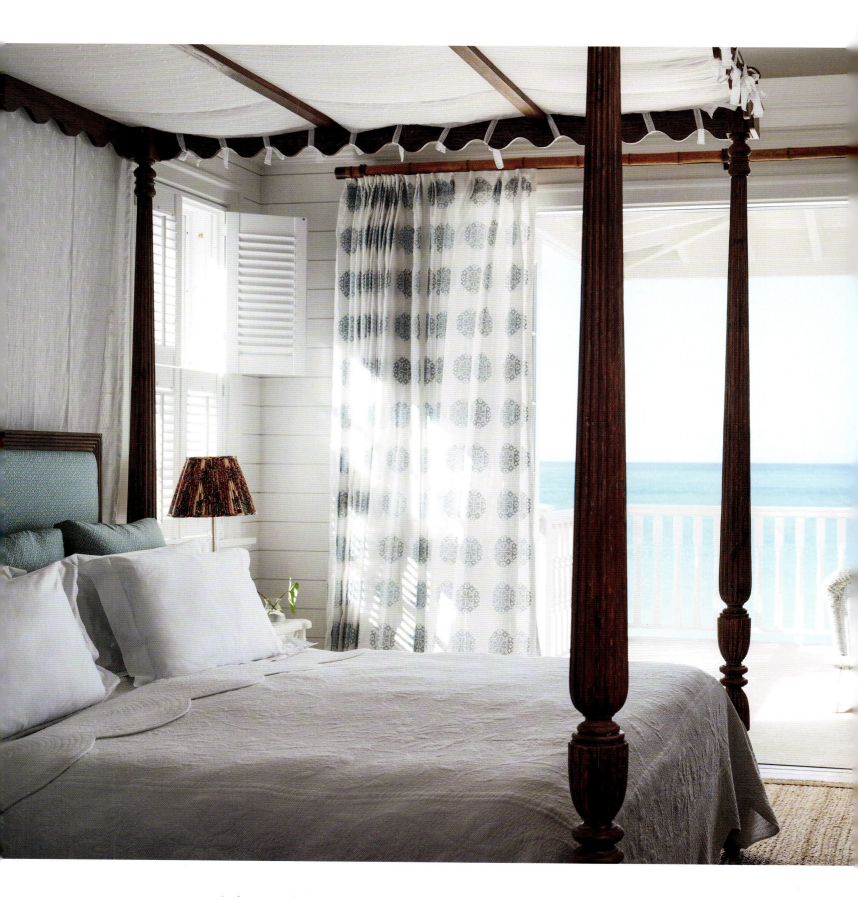

ABOVE: In the primary bedroom, with its expansive view of the sea, the bed is by the Raj Company and the curtain fabric is by Vaughan. OPPOSITE TOP: An oversize chaise for afternoon napping was a requirement. OPPOSITE BOTTOM: A freestanding tub in the primary suite sits atop an ice-blue encaustic-tile floor.

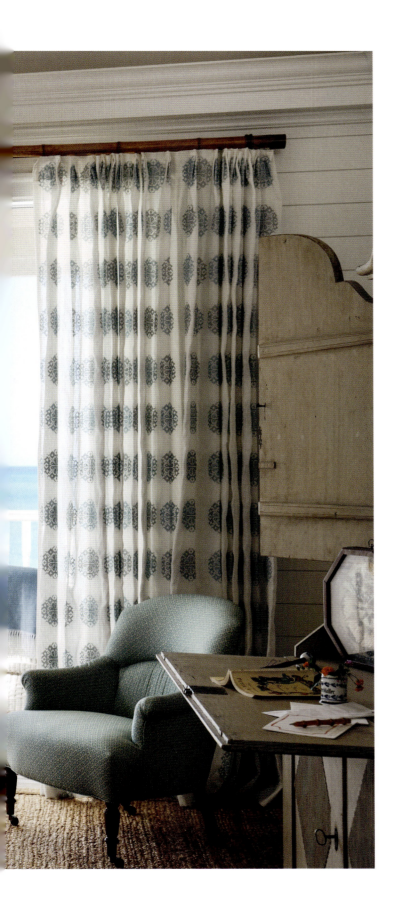
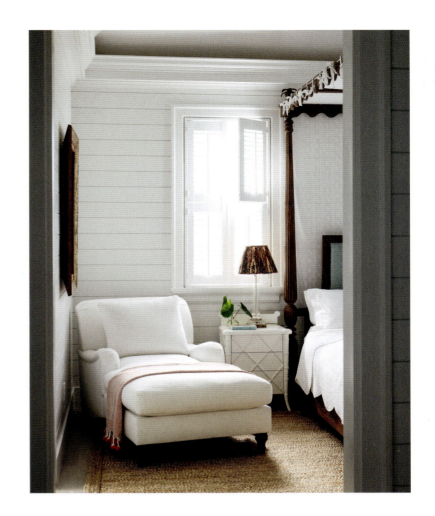
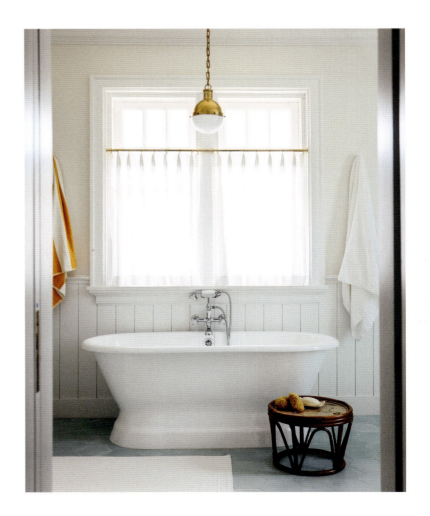

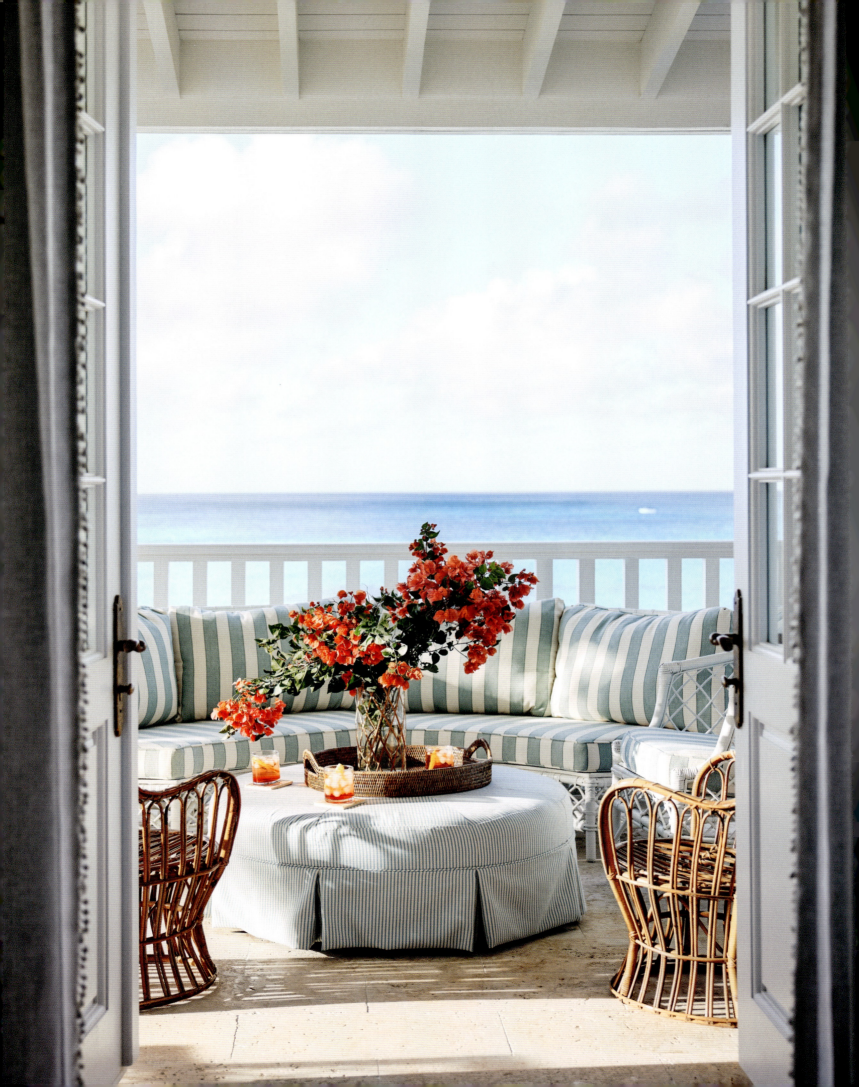

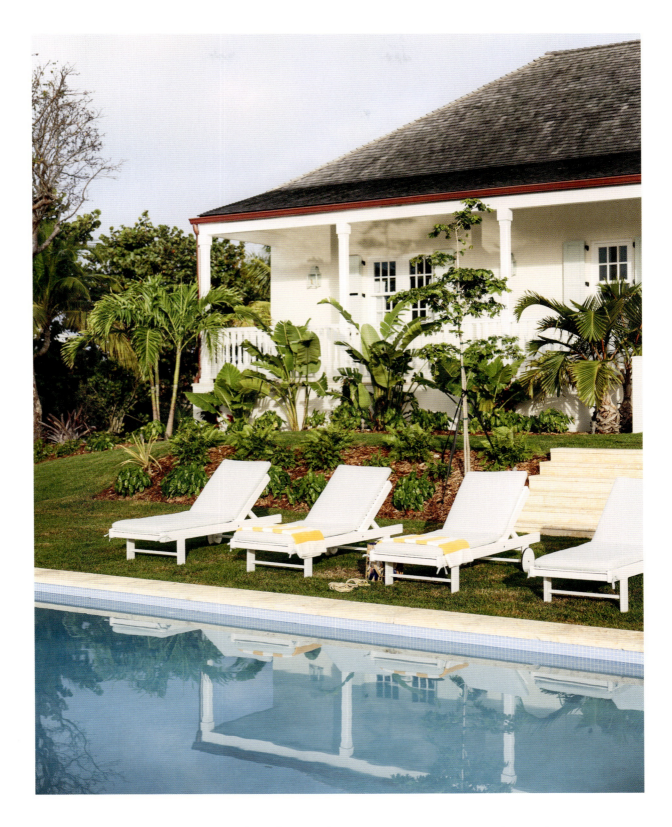

OPPOSITE: *A vintage Ficks Reed rattan sofa creates an inviting seating area on the veranda.*
ABOVE: *Two guest cottages flank the swimming pool.* OVERLEAF: *Lepiyoki, seen from the sea.*

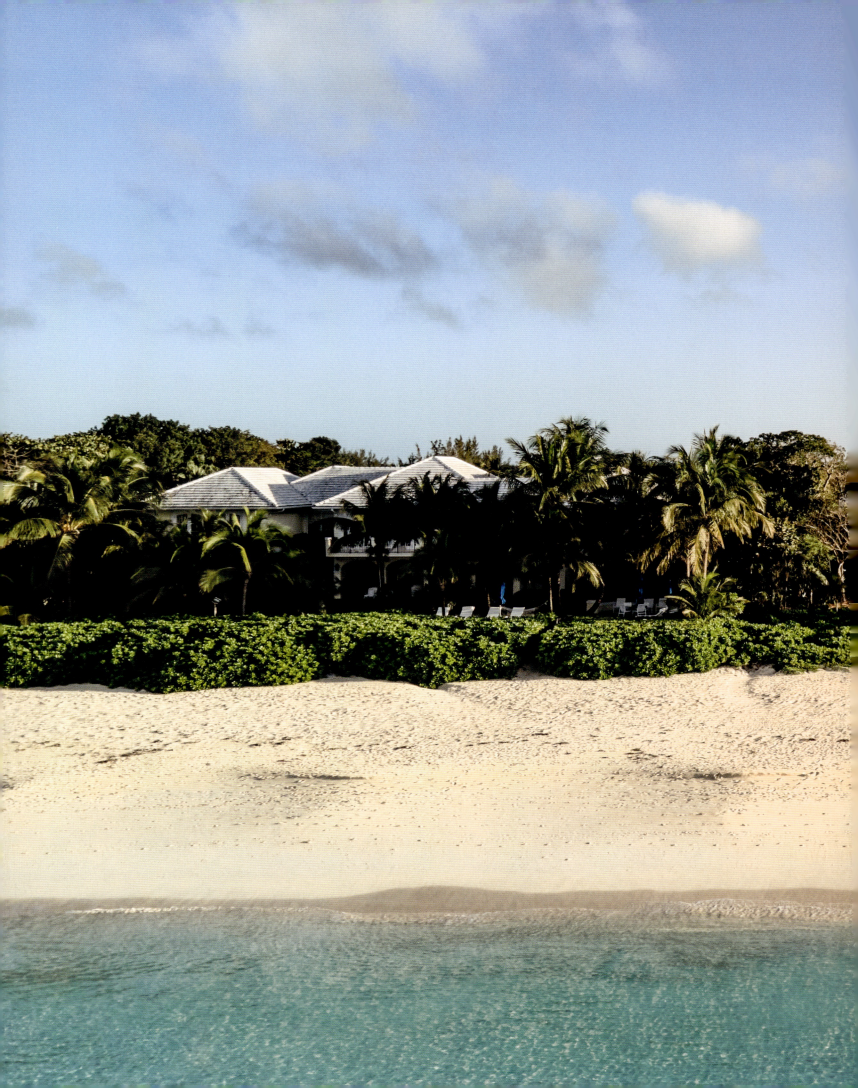

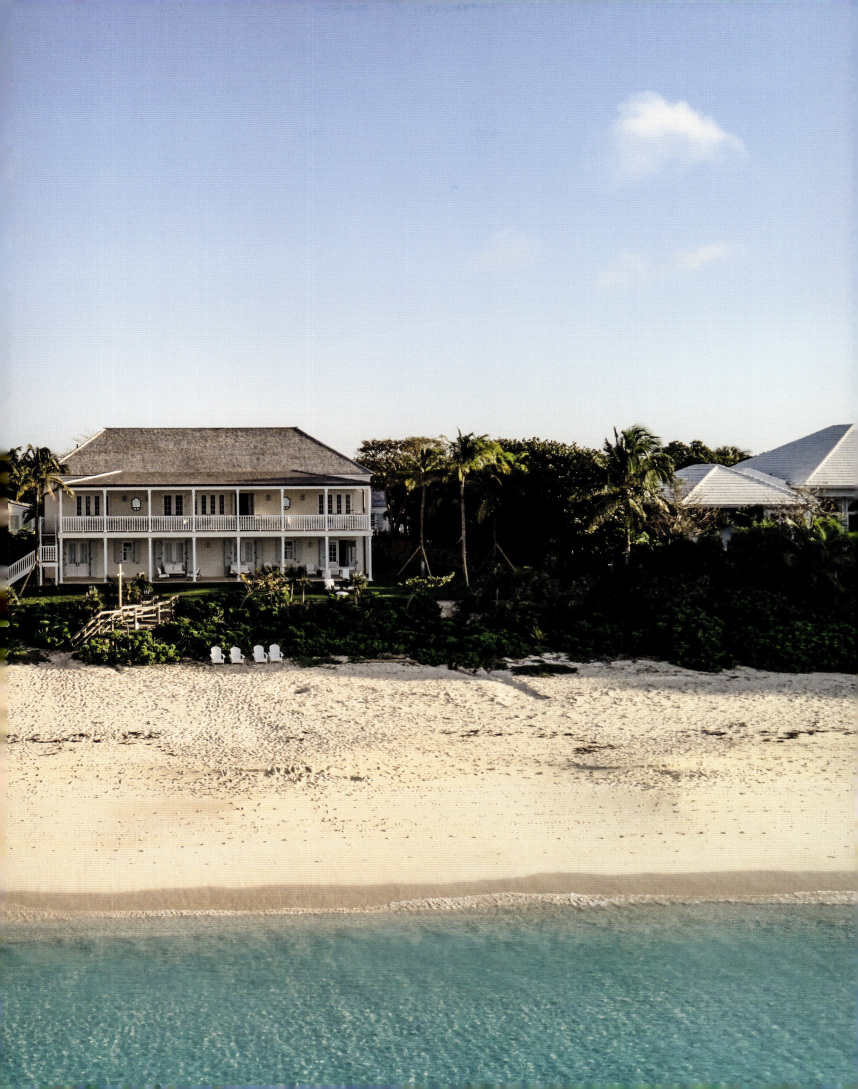

ACKNOWLEDGMENTS

What a happy day it was when Vendome's publishers, Mark Magowan and Beatrice Vincenzini, asked me to work on a sequel to *Island Hopping*! While we drew up a list of projects to include and organized the shoot schedule, we tossed around titles for the new book. When *Island Dreaming* was circulated as a candidate, everyone on my team immediately thought it was perfect. After all, our goal is aways to design interiors that have a dreamy timelessness.

The Vendome DNA is full of love and support. Our meetings are few, brief, and lighthearted, which is greatly appreciated. Thank you, Jackie Decter, for once again taking messy copy and polishing it. Thank you, Celia Fuller, for the amazing look of the book. And thank you, Jim Spivey, for the book's beautiful production.

Island Dreaming was photographed by Dylan Chandler, who has a perfect eye and is tireless about getting the right shot in the right light. I am so very grateful. My own amazingly talented decorating team stepped in to do the styling for the book. The coordination was crazy complicated, but the beauty of the images reflects their exceptional gifts. I am greatly moved by their dedication and enthusiasm.

I am also deeply grateful to Carlisle Burch for her charming illustrations.

It takes a village to create magic; it is not a solo act. Everyone in my office and home, and all my supportive and loving friends are dynamic and energetic forces of nature, committed to accomplishing our collective endeavors in a loving environment. During Orjan's illness, you all came to my rescue. I am beyond grateful for the kindness, support, and cover you gave Eliza and me.

Thank you to Amy, Eva, and Homer, who make life at home a place of great happiness and perfection. You bring good cheer to all ideas and tasks. Your many talents never cease to amaze me. Eliza and I thank you endlessly and love you dearly.

To my teams: in Lyford Cay: Celine, Caro, Daniella, Alexis, Nicole, Rishibha, Sofia, Mae, and Alexia; in Palm Beach: Jackie, and Sam; in Charleston: Miller, Mimi, Carlye Jane, and Jackie Thomson at Of Counsel PR. Thank you to the hardest-working ladies in the design world. The book is a true dream because of you.

To my Amanda Lindroth Collection team: Jennifer, Becky, Angie, Molly, Meg, Alex, Gracie, and Susan. No words can express my gratitude for the commitment and excellence you have brought. I am in awe of you all. I have learned so much from you.

Thank you to the many builders, architects, and other important consultants without whom we could not succeed at our jobs. I must also thank my style mentors: my mother, Marylew Redd, my beloved friend Jackie de Ravenel, and Teófilo Victoria and Maria de la Guardia, who taught me to understand classicism. I also thank Grace Harris, who brings youth, style, and enthusiasm to my life.

Thank you to all my clients and friends for your support and for opening your doors to us for this book. Special thanks to my Baker's Bay/San Francisco clients; your kindness and generosity changed my world. My gratitude is beyond imagination.

Thank you, Ashley Berhard, John Fondas, and John Knott for all the advice on the book and for your love.

I am thankful above all to my beloved daughter, Eliza. You are the wondrous, glorious magic.

Island Dreaming: Amanda Lindroth Design
First published in 2024 by The Vendome Press
Vendome is a registered trademark of The Vendome Press LLC

VENDOME PRESS US
P.O. Box 566
Palm Beach, FL 33480

VENDOME PRESS UK
Worlds End Studio
132-134 Lots Road
London, SW10 0RJ

www.vendomepress.com

Copyright © 2024 The Vendome Press LLC
Text copyright © 2024 Amanda Lindroth
Photographs copyright © 2024 Dylan Chandler

PUBLISHERS: Beatrice Vincenzini,
Mark Magowan, and Francesco Venturi
EDITOR: Jacqueline Decter
PRODUCTION DIRECTOR: Jim Spivey
DESIGNER: Celia Fuller

All rights reserved. No part of the contents of this book may be reproduced in whole or in part without prior written permission from the publisher.

*All photographs by Dylan Chandler,
with the exception of the following:
© Miguel Flores-Vianna, pages 30–49*

Distributed worldwide by Abrams Books

Illustrations by Carlisle Burch

ISBN 978-0-86565-452-5

Library of Congress
Cataloging-in-Publication Data available upon request

Printed and bound in China by
1010 Printing International Ltd

FIRST PRINTING

PAGE 1: Native vegetation on the dune at Baker's Bay on Great Guana Cay in the Abacos, Bahamas.
PAGES 2–3: A bougainvillea-dressed pendant, a favorite Lindroth detail, dangles over a lunch table set with Lindroth table linens, cutlery, and decorative items. PAGES 4–5: The classical library in a Manhattan apartment designed by architect Ernesto Buch, enlivened with our wonderful clients' objects, art, books, and furniture. PAGES 6–7: Aerial view of a lunch table at Albany in Old Fort Bay. Giant coconuts, papayas, and palm leaves create an organic and amusing tablescape.
PAGE 8: A glimpse into the living room of the organically designed Blue Skies.
PAGES 10–11: View of the Sea of Abaco.

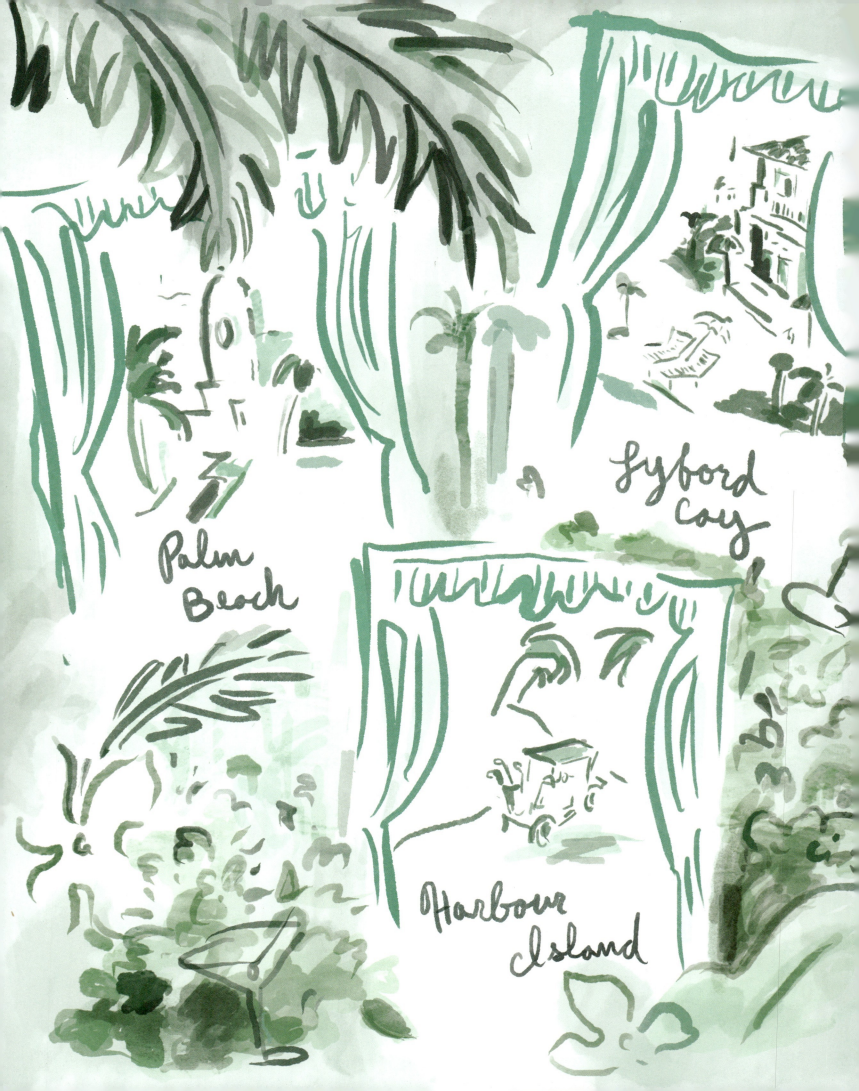